Archaeology of Empire in Achaemenid Egypt

EDINBURGH STUDIES IN ANCIENT PERSIA

SERIES EDITOR
Lloyd Llewellyn-Jones, Cardiff University

EDITORIAL ADVISORY BOARD
Touraj Daryaee, Andrew Erskine, Thomas Harrison, Irene Madreiter, Keith Rutter, Jan Stronk

TITLES AVAILABLE IN THE SERIES
Courts and Elites in the Hellenistic Empires: The Near East After the Achaemenids, c. 330 to 30 BCE
Rolf Strootman

Greek Perspectives on the Achaemenid Empire: Persia through the Looking Glass
Janett Morgan

Semiramis' Legacy: The History of Persia According to Diodorus of Sicily
Jan P. Stronk

ReOrienting the Sasanians: East Iran in Late Antiquity
Khodadad Rezakhani

Sasanian Persia: Between Rome and the Steppes of Eurasia
Edited by Eberhard W. Sauer

Plutarch and the Persica
Eran Almagor

Archaeology of Empire in Achaemenid Egypt
Henry P. Colburn

FORTHCOMING TITLES
Zoroastrian Scholasticism in Late Antiquity: The Pahlavi Version of the Yasna Haptaŋhāiti
Arash Zeini

Achaemenid Kingship, Alexander the Great and the Early Seleucids: Ideologies of Empire
Stephen Harrison

The Bactrian Mirage: Iranian and Greek Interaction in Western Central Asia
Michael Iliakis

Visit the Edinburgh Studies in Ancient Persia website at
edinburghuniversitypress.com/series/esap

Archaeology of Empire in Achaemenid Egypt

Henry P. Colburn

EDINBURGH
University Press

Edinburgh University Press is one of the leading university presses in the UK. We publish academic books and journals in our selected subject areas across the humanities and social sciences, combining cutting-edge scholarship with high editorial and production values to produce academic works of lasting importance. For more information visit our website: edinburghuniversitypress.com

© Henry P. Colburn, 2020, 2021

Edinburgh University Press Ltd
The Tun – Holyrood Road, 12(2f) Jackson's Entry,
Edinburgh EH8 8PJ

First published in hardback by Edinburgh University Press 2020

Typeset in 11/13pt Sabon by
Servis Filmsetting Ltd, Stockport, Cheshire

Croydon, CR0 4YY

A CIP record for this book is available from the British Library

ISBN 978 1 4744 5236 6 (hardback)
ISBN 978 1 4744 5237 3 (paperback)
ISBN 978 1 4744 5238 0 (webready PDF)
ISBN 978 1 4744 5239 7 (epub)

The right of Henry P. Colburn to be identified as the author of this work has been asserted in accordance with the Copyright, Designs and Patents Act 1988, and the Copyright and Related Rights Regulations 2003 (SI No. 2498).

Contents

List of Figures	vi
List of Tables	xii
Acknowledgements	xiii
Note on Conventions and Abbreviations	xvi
Series Editor's Preface	xviii
1. The Study of Achaemenid Egypt	1
2. Urban Experiences: Memphis	27
3. Rural Experiences: The Western Desert	95
4. Representation and Identity	131
5. Social Practices: Drinking Like a Persian	189
6. Coinage and the Egyptian Economy	221
7. Experiencing Achaemenid Egypt	246
Bibliography	259
Index	313

List of Figures

Map 1. Egypt, featuring places named in the text.
Map 2. The Achaemenid Empire showing major cities and routes.

Fig. 2.1. Sketch map of ancient Memphis. Drawn by the author after Petrie (1909a, pl. 1). 32
Fig. 2.2. Plan of the houses in the vicinity of the Palace of Merenptah. Image in the public domain from Petrie (1909a, pl. 27). 33
Fig. 2.3. Map of Saqqara. Drawn by the author after Thompson (2012, fig. 4). 34
Fig. 2.4. Map of Abusir. Drawn by the author after Bareš (1999, fig. 1). 35
Fig. 2.5. Plan of the Palace of Apries, Memphis. Image in the public domain from Petrie (1909b, pl. 1). 39
Fig. 2.6. Drawing of scenes from the pylon, Palace of Apries, Memphis. Image in the public domain from Petrie (1909b, pl. 9). 42
Fig. 2.7. Reliefs from the pylon of the Palace of Apries, Memphis, c. 6th–5th century BC. Limestone; H. 222 cm; W. 208 cm; D. 11.5 cm. New York, Metropolitan Museum of Art 09.183.1a1–23. Image in the public domain. 43
Fig. 2.8. Aramaic graffito and bronze and iron armour scales from the Palace of Apries, Memphis. Image in the public domain from Petrie (1909b, pl. 16). 45
Fig. 2.9. Arrowheads from the Palace of Apries, Memphis. Image in the public domain from Knobel et al. (1911, pl. 20). 46
Fig. 2.10. Drawings of the wooden tags from the Palace of Apries, Memphis, with Aramaic and Demotic inscriptions. Image in the public domain from Petrie et al. (1910, pl. 34). 51

List of Figures

Fig. 2.11. Bullae from the Palace of Apries, Memphis, featuring seal impressions. Image in the public domain from Petrie et al. (1910, pl. 35). — 54

Fig. 2.12. Drawings of seal impressions as preserved on the bullae from the Palace of Apries, Memphis. Image in the public domain from Petrie et al. (1910, pl. 36). — 55

Fig. 2.13. Additional sealings from the Palace of Apries, Memphis. Images in the public domain from Petrie et al. (1910, pl. 37) and Petrie (1909b, pl. 15). — 56

Fig. 2.14. Composite line drawing from impressions of PFUTS 136* (drawing by M. B. Garrison). Courtesy of the Persepolis Seal Project and the Persepolis Fortification Archive Project, the Oriental Institute of the University of Chicago. — 65

Fig. 2.15. Composite line drawing from impressions of PFATS 184s (drawing by E. R. M. Dusinberre). Courtesy of the Persepolis Fortification Archive Project, the Oriental Institute of the University of Chicago. — 66

Fig. 2.16. Glazed tile from Susa, Iran, 6th–5th century BC. Siliceous brick; H. 36 cm; W. 31 cm. Paris, Louvre Sb 3336. Image in the public domain from Toscanne (1916, fig. 1). — 68

Fig. 2.17. Drawing of the impression of Seal 100 from Gordion. Courtesy of the Penn Museum Gordion Archive, drawing by Elspeth Dusinberre. — 70

Fig. 2.18. Head from a statuette of a Persian king, c. 5th century BC. Greywacke; H. 17 cm. Strasbourg, Institut d'Égyptologie, Université de Strasbourg inv. 1604. Image in the public domain from Spiegelberg (1909a, pl. 16). — 73

Fig. 2.19. Detail of a stela from the Serapeum at Saqqara depicting Cambyses before the Apis bull, 524 BC. Limestone; H. 66 cm; W. 44 cm. Paris, Louvre IM 4133. Drawing by the author after Kuhrt (2007, fig. 4.3). — 77

Fig. 2.20. Plan of the House of Apis, Memphis. Drawn by the author after Anthes (1959, pl. 41). — 79

Fig. 2.21. Plan of the shaft tombs at Abusir. Drawn by the author after Coppens and Smoláriková (2009, fig. 1). — 84

Fig. 3.1. Satellite image of the Kharga and Dakhla Oases in 2019. Image © Google, ORION-ME, with place names added by the author. — 97

Fig. 3.2. Schematic drawing of a qanat. Drawn by the author after Wilson (2006, fig. 18.2). — 100

Fig. 3.3. Plan of the temple of Osiris at Ain Manawir, with

adjoining building. Drawn by the author after Wuttmann et al. (1996, fig. 4). 110

Fig. 3.4. Plan of the temple at Qasr el-Ghuweida. Drawn by the author after Darnell et al. (2013, fig. 2). 113

Fig. 3.5 **Left:** The Hibis temple in 1908. Image in the public domain from Winlock (1909, fig. 2). **Right:** The Hibis temple in 2012. Photograph by T. Landvatter, and reproduced by permission. 114

Fig. 3.6. Plan of the ground floor of the Hibis temple. Drawn by the author after Davies (1953, pl. 1). 115

Fig. 3.7. Line drawing of reliefs from the west wall of sanctuary (A) in the Hibis temple, depicting Darius as pharaoh making offerings to various Egyptian gods. From Davies (1953, pl. 2). Image © the Metropolitan Museum of Art. Reproduced by permission of the Metropolitan Museum of Art. 117

Fig. 3.8. Line drawing of reliefs from the west wall of room L in the Hibis temple, depicting Darius as pharaoh enthroned over the 'Uniting of the Two Lands'. From Davies (1953, pl. 26). Image © the Metropolitan Museum of Art. Reproduced by permission of the Metropolitan Museum of Art. 118

Fig. 3.9. Relief of Darius as pharaoh from the forecourt of the Hibis temple. Photograph by the NYU Excavations at Amheida Staff, 'Hibis, Temple Decorations (IV)', Ancient World Image Bank (New York: Institute for the Study of the Ancient World, 2009–), reproduced under a Creative Commons licence (CC BY 2.0). 119

Fig. 3.10. Line drawing of reliefs from the forecourt of the Hibis temple, depicting Seth slaying Apep. From Davies (1953, pl. 42). Image © the Metropolitan Museum of Art. Reproduced by permission of the Metropolitan Museum of Art. 120

Fig. 4.1. Statue exhibiting the 'Persian gesture', c. 500–450 BC. Greywacke; H. 28 cm. Baltimore, Walters Art Museum 22.208. Reproduced under a Creative Commons licence (CC0 1.0). 137

Fig. 4.2. Relief of the Great King enthroned receiving an official, Persepolis, Iran, c. 520–480 BC. Excavated from the Persepolis Treasury; originally the central panel of the eastern façade of the Apadana. Tehran, National Museum of Iran. Image © Jona Lendering and reproduced by permission. 137

List of Figures ix

Fig. 4.3. Statue of Queen Napir-Asu, c. 1340–1300 BC, from Susa, Iran. Bronze and copper; H. 129 cm. Paris, Louvre, Sb 2731. Image in the public domain from Lampre (1905, pl. 15). 138

Fig. 4.4. Naophorous statue with a trapezoidal dorsal pillar, 5th–4th century BC. Greywacke; H. 46.6 cm; W. 11 cm; D. 16.9 cm. New York: Metropolitan Museum of Art, 25.2.10. Image in the public domain. 145

Fig. 4.5. Graph showing duration in years of each Late Period pharaoh, based on the chronology in Lloyd (2010, xxxviii–xxxix). 146

Fig. 4.6. Graph showing number of statues datable to various Saite pharaohs, based on Leahy (1984b). 147

Fig. 4.7. Statue of Darius from Susa. Greywacke; H. 2.46 m. Tehran, National Museum of Iran 4112. Reproduced by permission of Jean Perrot and Rémy Boucharlat. 154

Fig. 4.8. Detail of the base of the statue of Darius from Susa. Image © Jona Lendering and reproduced by permission. 156

Fig. 4.9. Drawing of the Tell el-Maskhuta stela. Cairo JE 48855. Image in the public domain from Golénischeff (1890, pl. 8). 160

Fig. 4.10. Drawing of the Kabret stela. Image in the public domain from Ménant (1887, 145). 161

Fig. 4.11. Wooden naos door of Darius I, c. 522–486 BC. Wood and glass; H. 28 cm; W. 23.5 cm. London, British Museum EA37496. Reproduced by permission of the Trustees of the British Museum. 163

Fig. 4.12. Wooden naos of Darius I, c. 522–486 BC. Wood and glass; H. 41.5 cm; Base 35 × 28.5 cm. Mallawi Museum inv. no. 200. Image © Alain Guilleux and reproduced by permission. 164

Fig. 4.13. Stela of Pediusierpre, c. 522–486 BC. Limestone; H. 29 cm; W. 19 cm. Berlin, Ägyptisches Museum 7493. Image in the public domain from Burchardt (1911, pl. 8.1). 167

Fig. 4.14. Drawing of the stela of Djedherbes, excavated at Saqqara. Image © E. A. Bettles and reproduced by permission. 168

Fig. 4.15. Funerary relief. Limestone; H. 23 cm; W. 45 cm. Berlin, Ägyptisches Museum 23721. Image © Ägyptisches Museum und Papyrussammlung, Staatliche Museen zu Berlin. Reproduced under a Creative Commons licence (CC BY-NC-SA). 172

Fig. 4.16. Naophorous statue of Horwedja, c. 521–486 BC. Greywacke; H. 43 cm. Cleveland Museum of Art 1920.1978. Image in the public domain. 176

Fig. 4.17. Naophorous statue of Ptahhotep, c. 500–475 BC. Quartzite; H. 84.5 cm. New York, Brooklyn Museum 37.353. Reproduced under a Creative Commons licence (CC BY-3.0). 177

Fig. 4.18. Naophorous statue of Udjahorresnet, c. 519–510 BC. Basalt; H. 58 cm. Vatican, Museo Gregoriano Egiziano 22690. Image © Jona Lendering and reproduced by permission. 180

Fig. 5.1. Achaemenid phiale with floral motifs, c. late 5th century BC, excavated from a grave on the Acropole, Susa, Iran. Silver; H. 4.3 cm (1 5/8 in.), Diam. 18.4 cm (7 1/4 in.). Paris, Musée du Louvre, Sb 2756. Image in the public domain from de Morgan (1905, pl. 3). 194

Fig. 5.2. Lobed Achaemenid phiale with Old Persian inscription naming Artaxerxes I, c. 465–424 BC. Silver; Diam. 29.2 cm. New York, Metropolitan Museum of Art 47.100.84. Image in the public domain. 195

Fig. 5.3. Column capital in the form of a griffin from Persepolis, c. mid-4th century BC. Photograph by A. Davey from Wikimedia Commons reproduced under a Creative Commons licence (CC BY 2.0). 197

Fig. 5.4. Composite line drawing from impressions of PFS 170 (drawing by M. B. Garrison). Courtesy of the Persepolis Seal Project and the Persepolis Fortification Archive Project, the Oriental Institute of the University of Chicago. 201

Fig. 5.5 **Top:** Composite line drawing from impressions of PFS 1601* (drawing by M. B. Garrison). **Bottom:** Composite line drawing from impressions of PFATS 400 (drawing by E. R. M. Dusinberre). Courtesy of the Persepolis Fortification Archive Project, the Oriental Institute of the University of Chicago. 202

Fig. 5.6. Detail of a relief from the Persepolis Apadana showing Achaemenid bowls, c. 510–480 BC. Photograph by Phillip Maiwald from Wikimedia Commons reproduced under a Creative Commons licence (CC BY-SA 3.0). 203

Fig. 5.7. Silver phialai excavated at Tell Timai, Egypt, c. 5th-4th century BC. Cairo CG 53267, 53275, 53277. Images in the public domain from Vernier (1927, pl. 109). 206

List of Figures

Fig. 5.8. Silver phiale from the Tell el-Maskhuta hoard, c. 5th century BC. Silver; Diam. 20.2 cm. New York, Brooklyn Museum, 54.50.33. Image from the Brooklyn Museum reproduced under a Creative Commons licence (CC BY 3.0). 207

Fig. 5.9. Rhyton fragment, c. 5th century BC. Faience; H. 10.8 cm; L. 11.0 cm; W. 7.1 cm. New York, Brooklyn Museum, 48.29. Image from the Brooklyn Museum reproduced under a Creative Commons licence (CC BY 3.0). 209

Fig. 5.10. Ceramic rhyton from Suwa, c. 5th–4th century BC. Image in the public domain from Petrie (1906, pl. 37A). 209

Fig. 5.11. Silver Achaemenid bowls excavated at Tell Timai, Egypt, c. 5th-4th century BC. Cairo CG 53274, 53276. Image in the public domain from Vernier (1927, pl. 109). 210

Fig. 5.12. Achaemenid bowl from the Tell el-Maskhuta hoard, c. 5th century BC. Silver; H. 8.5 cm; Diam. 11 cm. New York, Brooklyn Museum 54.50.32. Image from the Brooklyn Museum reproduced under a Creative Commons licence (CC BY 3.0). 211

Fig. 5.13. Ceramic Achaemenid bowls from Tell Dafana. Image in the public domain from Petrie (1888, pl. 24). 213

Fig. 6.1. Tetradrachms from the Fayum hoard (CH 10.442) illustrating Buttrey's styles X (KM 1984.01.0330), B (KM 1984.01.0042) and M (KM 1984.01.0041), c. 410–350 BC. Silver. Ann Arbor, Kelsey Museum of Archaeology. Reproduced by permission of the Kelsey Museum of Archaeology, University of Michigan. 237

Fig. 6.2. Tetradrachms of Artaxerxes III, c. 340–338 BC (ANS 2008.15.39), and of Sabaces, c. 338–333 BC (ANS 1944.100.75462). Silver. New York, American Numismatic Society. Images in the public domain from the American Numismatic Society. 241

Fig. 7.1. Drawings of reliefs from the tomb of Petosiris at Tuna el-Gebel, c. 325–300 BC. Images in the public domain from Lefebvre (1923–4, pls. 7–8). 257

List of Tables

Table 2.1. Sealings from the Palace of Apries, Memphis. 60
Table 6.1. Fifth-century coin hoards from Egypt. 224
Table 6.2. Hoards with bullion or *Hacksilber* from Late Period Egypt. 225

Acknowledgements

This book began its life as a seminar paper at the University of Michigan. From there it ballooned into a doctoral dissertation, submitted to the Interdepartmental Program in Classical Art and Archaeology in 2014. I am enormously grateful to my dissertation committee chair, Margaret Root, for her persistent encouragement, insightful criticism and astute guidance of my work, on dissertation and book alike. Neither would exist without her, and I am honoured to count her as a mentor and friend. I am similarly grateful to Beth Dusinberre, both for her feedback on this project and for supporting my academic career from its very beginning. The other members of my dissertation committee, Sharon Herbert, Ian Moyer, Janet Richards and Terry Wilfong, also generously shared their knowledge of such diverse topics as ceramics, Greek intellectual history, and Egyptian culture, language and archaeology, and I thank them all for their invaluable help and their commitment to my success.

Many other friends and colleagues have generously given their time and expertise to this undertaking as well, both directly and indirectly, and it is undoubtedly improved as a result. I am especially grateful to Damien Agut-Labordère, Anna Boozer, Seth Button, Bleda Düring, Susanne Ebbinghaus, Mark Garrison, Wouter Henkelman, Ryan Hughes, Fatma Ismail, David Klotz, Tom Landvatter, Andy Meadows, Yelena Rakic and Peter van Alfen for their suggestions and advice on various aspects of my research. I should also like to recognise the contributions of Eugene Cruz-Uribe, who died unexpectedly in May 2018, to the study of Achaemenid Egypt. I never met Prof. Cruz-Uribe in person, and it will be clear from this book that I do not always agree with his interpretations. But it will be equally clear that anyone working on the Persian Period in Egypt has benefited enormously from his scholarly energy and his efforts to cast light onto this dark corner of Egyptian history.

During the 2015–16 academic year I was the recipient of a

fellowship from the Getty Research Institute which permitted me to make essential substantive revisions, including much new research. I am grateful to the Institute's staff, especially Alexa Sekyra, James Fishburne and Peter Bonfitto, and to the Department of Antiquities at the J. Paul Getty Museum, for their hospitality during my time there, and for continued access to the Getty's library facilities after the end of my fellowship. I am also indebted to the various institutions which have supported this research indirectly by providing me with paying work since leaving Michigan: the Division of Asian and Mediterranean Art at the Harvard Art Museums, the Department of Classics at the University of California, Irvine, the Department of Art History at the University of Southern California, and the Department of Ancient Near Eastern Art at the Metropolitan Museum of Art.

The procurement of illustrations for this book has been facilitated enormously by several museums which have adopted open access models for the dissemination of images of their collections; as an impecunious early-career scholar, it has been a godsend for me. I especially wish to recognise the American Numismatic Society, the Brooklyn Museum, the Cleveland Museum of Art, the Kelsey Museum of Archaeology, the Metropolitan Museum of Art, the Staatliche Museen zu Berlin, the University of Pennsylvania Museum of Archaeology and Anthropology, and the Walters Art Museum; I thank them all for their enlightened and forward-thinking policies. In a similar vein I am grateful to the Institute for the Study of the Ancient World at New York University and to Wikimedia Commons for making numerous excellent images publicly available. I also thank Elizabeth Bettles for permission to reproduce her drawing of the stela of Djedherbes, Beth Dusinberre, Mark Garrison and Margaret Root for permission to use images created by the Persepolis Seal Project, Jona Lendering, Tom Landvatter, Alain Guilleux, Jean Perrot and Rémy Boucharlat for permission to reproduce their photographs, and Abbie Renoux for drawing a map for me.

I am grateful to Carol Macdonald, David Lonergan and Sarah Foyle at Edinburgh University Press, and to Lloyd Llewellyn-Jones, the editor of Edinburgh Studies in Ancient Persia, for their assistance and support in the publication of this book. I very much appreciate their willingness to publish a work that defies easy categorisation. I am also indebted to Fiona Sewell for her precise and diligent editing of the text.

Last of all, I thank my parents, Allison and Dick, to whom this book is dedicated, for their encouragement of this and other projects, which began a very long time ago, well before I had ever heard the

word 'Achaemenid'. They have always known I would do something odd with my life, and have never discouraged me from taking the road less travelled. My wife Alexis has now joined me on that road, and her love, companionship and understanding have sustained me through the exigencies of academic life. I would not have come this far without her.

Note on Conventions and Abbreviations

The practice employed in this book for the writing of ancient names and terms and the use of abbreviations has been guided mainly by concerns for accessibility and familiarity. For names and toponyms, I have utilised the preferred spellings listed in the *UCLA Encyclopedia of Egyptology* where possible; otherwise I have endeavoured to use the most familiar form, such as 'Herodotus', 'Cambyses' or 'Kharga Oasis'. This inevitably leads to a degree of inconsistency, but I hope it will make the narrative easier to follow. Although not strictly correct, the term 'Demotic' is used throughout as a shorthand for 'demotic Egyptian'.

References to Greek texts are presented solely in translation, save where the Greek wording itself is relevant. Texts in Egyptian and Near Eastern languages are generally cited by conventional names, such as 'The Petition of Petiese', along with references to English translations or major editions where further information may be found. Papyrus documents are additionally cited according to the *Checklist of Editions of Greek, Latin, Demotic and Coptic Papyri, Ostraca, and Tablets* (Sosin et al. 2011). Old Persian texts are cited using the abbreviation system developed by R. G. Kent and employed by Kuhrt (2007). Objects in the Egyptian Museum in Cairo are referred to by either a Catalogue générale (CG) number or a Journal d'entrée (JE) number, if it has no CG number (see Bothmer 1974 for a full description).

The following abbreviations are employed as well, in accordance with normal disciplinary practice:

CH	*Coin Hoards* (London and New York: Royal Numismatic Society and American Numismatic Society, 1975–)
DS	Daskyleion Seal
Hdt.	Herodotus
IGCH	M. Thompson, O. Mørkholm and C. M. Kraay (ed.), *An*

	Inventory of Greek Coin Hoards (New York: American Numismatic Society, 1973)
MPS	Memphis Palace Seal
PF	Persepolis Fortification Tablet
PFATS	Persepolis Fortification Aramaic Tablet Seal
PFS	Persepolis Fortification Seal
PFUTS	Persepolis Fortification Uninscribed Tablet Seal
TADAE	B. Porten and A. Yardeni, *Textbook of Aramaic Documents from Ancient Egypt*, 4 vols (Jerusalem: Hebrew University of Jerusalem, Department of the History of the Jewish People, 1986–99)

Series Editor's Preface

Edinburgh Studies in Ancient Persia focuses on the world of ancient Persia (pre-Islamic Iran) and its reception. Academic interest in and fascination with ancient Persia have burgeoned in recent decades and research on Persian history and culture is now routinely filtered into studies of the Greek and Roman worlds; Biblical scholarship too is now more keenly aware of Persian Period history than ever before; while, most importantly, the study of the history, cultures, languages and societies of ancient Iran is now a well-established discipline in its own right.

Persia was, after all, at the centre of ancient world civilisations. This series explores that centrality throughout several successive 'Persian empires': the Achaemenid dynasty (founded c. 550 BC) saw Persia rise to its highest level of political and cultural influence, as the Great Kings of Iran fought for, and maintained, an empire which stretched from India to Libya and from Macedonia to Ethiopia. The art and architecture of the period both reflect the diversity of the empire and proclaim a single centrally constructed theme: a harmonious world-order brought about by a benevolent and beneficent king. Following the conquests of Alexander the Great, the Persian Empire fragmented but maintained some of its infrastructures and ideologies in the new kingdoms established by Alexander's successors, in particular the Seleucid dynasts who occupied the territories of western Iran, Mesopotamia, the Levant and Asia Minor. But even as Greek influence extended into the former territories of the Achaemenid realm, at the heart of Iran a family of nobles, the Parthian dynasty, rose to threaten the growing imperial power of Rome. Finally, the mighty Sasanian dynasty ruled Iran and much of the Middle East from the third century CE onwards, proving to be a powerful foe to Late Imperial Rome and Byzantium. The rise of Islam, a new religion in Arabia, brought a sudden end to the Sasanian dynasty in the mid-600s AD.

These successive Persian dynasties left their record in the historical, linguistic and archaeological materials of the ancient world, and Edinburgh Studies in Ancient Persia has been conceived to give scholars working in these fields the opportunity to publish original research and explore new methodologies in interpreting the antique past of Iran. This series will see scholars working with bona fide Persian and other Near Eastern materials, giving access to Iranian self-perceptions and the internal workings of Persian society, placed alongside scholars assessing the perceptions of the Persianate world from the outside (predominantly through Greek and Roman authors and artefacts). The series will also explore the reception of ancient Persia (in historiography, the arts and politics) in subsequent periods, both within and outwith Iran itself.

Edinburgh Studies in Ancient Persia represents something of a watershed in better appreciation and understanding not only of the rich and complex cultural heritage of Persia, but also of the lasting significance of the Achaemenids, Parthians and Sasanians and the impact that their remarkable civilisations have had on wider Persian, Middle Eastern and world history. Written by established and up-and-coming specialists in the field, this series provides an important synergy of the latest scholarly ideas about this formative ancient world civilisation.

<div style="text-align: right;">Lloyd Llewellyn-Jones</div>

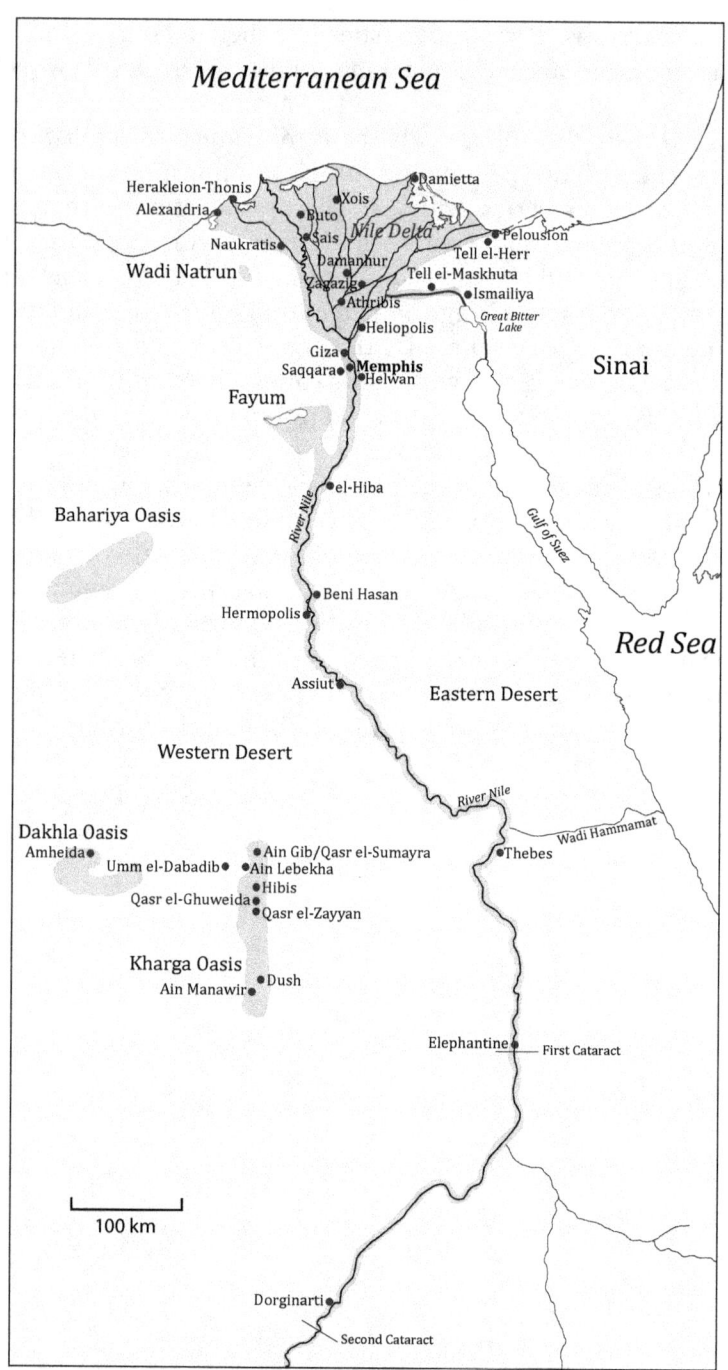

Map 1. Egypt, featuring places named in the text. Adapted by the author from a map from Wikimedia Commons under a Creative Commons licence (CC BY-SA 4.0).

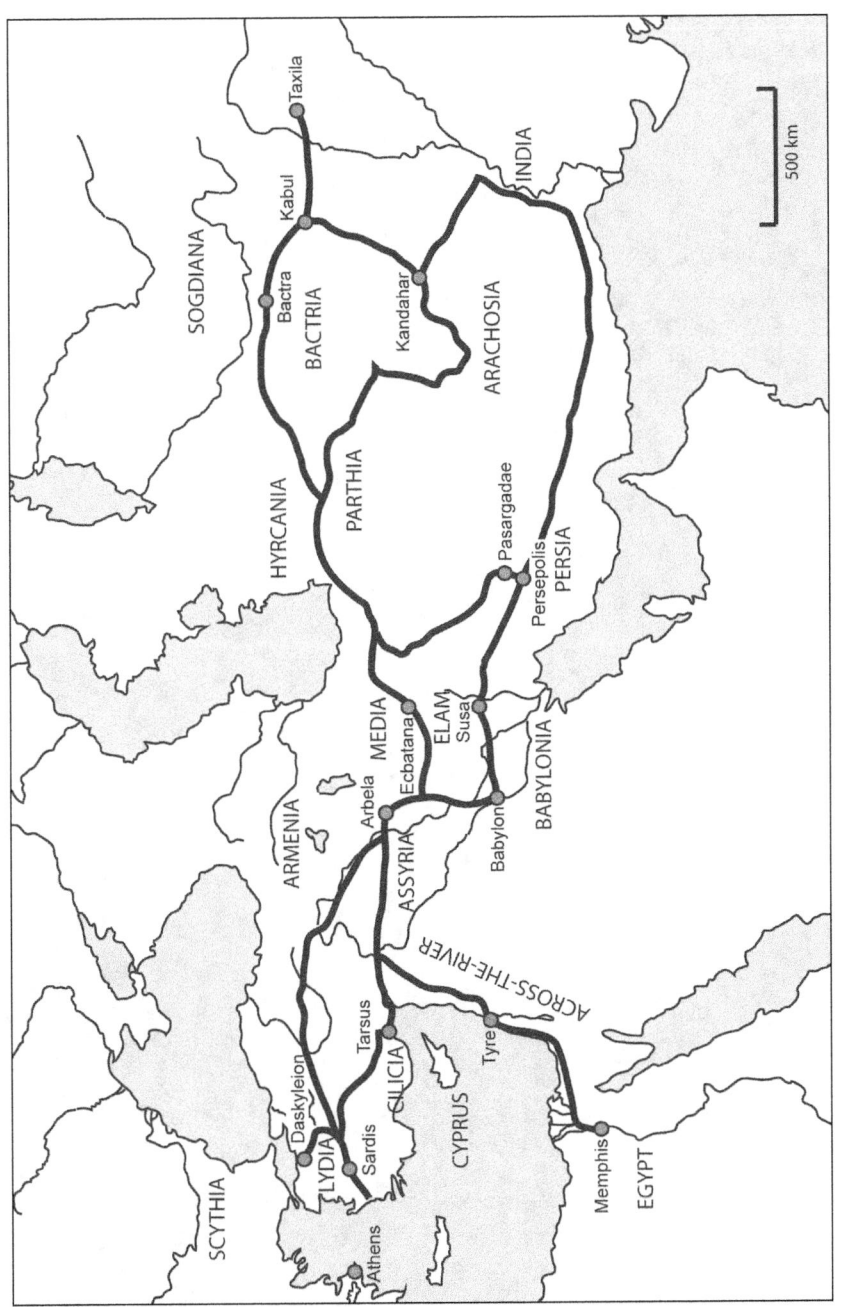

Map 2. The Achaemenid Empire showing major cities and routes. Drawn by A. J. Renoux.

1. *The Study of Achaemenid Egypt*

This is the statue of stone, which Darius the king ordered to be made in Egypt, so that whoever sees it in time to come will know that the Persian man holds Egypt.

<div align="right">Darius I</div>

THE PARADOX OF ACHAEMENID EGYPT

When the historian, ethnographer and raconteur Herodotus of Halicarnassus came to Egypt, probably sometime in the 440s or 430s BC, it had been a satrapy of the Achaemenid Persian Empire for nearly a century. Artaxerxes I was on the throne and his cousin Arshama was well into his tenure as satrap. Of course Herodotus, interested as he was in the causes and origins of the Persian Wars, was primarily concerned with an earlier period of Egyptian history, one that culminated in Cambyses' invasion c. 526 BC and the subsequent events that ultimately led to the accession of Darius to the throne in 522/1. So despite his fascination with Egypt, we have very little sense or understanding of the Egypt Herodotus actually would have seen. While the Egypt of Herodotus's day excited considerable interest on the part of the ancient Greeks, it has generated comparatively little interest on the part of modern scholars working on this critical period.

This is but one of the many paradoxes that characterises the study of Egypt during the period of Achaemenid rule, beginning with the invasion of Cambyses in 526 BC, and ending with the revolt of Amyrtaios in 404 (Manetho's 27th Dynasty).[1] For Egyptologists

[1] Quack (2011) has argued persuasively that the invasion of Egypt by Cambyses began in 526 BC, rather than 525, and Depuydt (2010) has likewise made a strong case that the invasion

the 27th Dynasty belongs to the so-called 'Late Period', the part of Egyptian history following the zenith of Egyptian power in the New Kingdom and the period of political disunity and competing dynasties known as the Third Intermediate Period (the 21st to 25th Dynasties). During the Late Period, by contrast, the Two Lands of Upper and Lower Egypt were again politically unified: first under the 26th or Saite Dynasty, then as an Achaemenid satrapy (the 27th Dynasty), with the Great King as pharaoh, again under Egyptian rulers (the 28th to 30th Dynasties), and finally once more under Achaemenid rule for a brief period between 340 and 332 (the 31st Dynasty or 'Second Persian Period'). According to the conventional terminology for the periodisation of Egyptian history this unity would constitute another 'kingdom', yet the term 'period' is retained, implying that the years between 664 and 332 BC were somehow less significant to the history of Egypt than those of the Old, Middle and New Kingdoms. Narratives of decline are certainly at play here. For example, one still finds books on the first millennium BC with titles like *The Twilight of Ancient Egypt* (Myśliwiec 2000) or *Afterglow of Empire* (Dodson 2012), leaving little doubt as to the authors' view on the comparative importance of this period. As J. G. Manning (2010, 11) has observed, the French term for the Late Period, *la basse époque*, captures this attitude succinctly; it is 'low in terms of both date *and* culture'.

For many Classicists, it is the other way around, with this period preceding the time when things become interesting: that all-important historical moment of Alexander's arrival c. 332 BC. With the establishment of the Ptolemaic kingdom Greek entered wider use as an administrative language in Egypt, making it the province of Greek papyrologists and historians. The main exception to this is Naukratis, the Greek trading colony in the western Nile Delta established in the late seventh century BC. Naukratis occupies a prominent place in overviews of Greek archaeology and history, such as John Boardman's (1999, 118–33) venerable handbook *The Greeks Overseas*. Yet only a single page in the most recent edition of this book (Boardman 1999, 141), which is still commonly assigned in undergraduate courses, is dedicated to the fifth and fourth centuries in Egypt. Of course the book is not about the Persians, but the near total omission of this period implies that nothing of importance happened in Egypt between 526 and 332 BC, at least not as far as

by Artaxerxes III took place in 340/39 BC rather than 343/2. Their chronological adjustments have been accepted here.

Classicists are concerned. And this is despite contemporary Greek fascination with the place (Vasunia 2001; Ruzicka 2012). Indeed, according to Herodotus (3.139), at the time of Cambyses' invasion, Greeks came to Egypt for three reasons: 'to do business, naturally, to take part in the fighting, or just to see the country' (trans. R. Waterfield), and it is clear that they continued to visit throughout the fifth century for these same reasons.

Despite this dismissal in much Egyptological and Classical scholarship, the period of Achaemenid rule in Egypt is one of paramount importance, for a variety of reasons. First, as a period of sustained foreign rule, it provides an excellent opportunity to examine assumptions about the conservatism and the impermeability of Egyptian social, cultural and economic institutions to external forces of change. Such institutions have been widely studied, at least with respect to the preceding pharaonic periods. Thus the identification of shifts in how people interacted with and conceived of these institutions in the context of the Achaemenid Empire offers grounds upon which to challenge these assumptions.

Egypt also has enormous potential as a case study for assessing the nature and impact of Achaemenid rule in an individual satrapy or region, an undertaking for which few comparable studies exist (e.g., Dusinberre 2013 for Anatolia; Khatchadourian 2016 for Armenia). Egypt is all the more inviting as the topic for such an investigation on account of the extensive tradition of research into the cultural history of its earlier periods. Additionally, given the continuities between the empire and modes of rule in subsequent periods that are often observed, Achaemenid Egypt may prefigure Ptolemaic Egypt in a number of important ways (Manning 2010). The research presented here has the potential to provide fresh perspectives on the Ptolemaic Period.

Finally, Achaemenid Egypt was a major feature of the intellectual, cultural, economic and political landscape of the Mediterranean and wider Near East. This was the Egypt known to Herodotus and other Greek writers of the fifth century, the Egypt which Athens invaded unsuccessfully around 460 BC. It was the source of the papyrus on which Aeschylus and Thucydides wrote, and also the grain that permitted Athens to build a naval empire. And it was the Egypt which the Persians themselves valued so highly that they spent much of the fourth century attempting to recover it. Egypt looms large in the eastern Mediterranean during the Classical Period of the Greeks, and yet this same Egypt is itself still poorly understood.

The difficulty of understanding this period, for Classicists and

Egyptologists alike, is perhaps best expressed by another paradox, that of the divergent approaches typically taken to the 27th Dynasty. On the one hand, there is the common view that Egypt was largely unaffected by Achaemenid rule; on the other, there is the view that Achaemenid rule was necessarily oppressive and harsh, resulting in frequent revolts. Though these views are not entirely mutually exclusive, it is not so straightforward a matter to reconcile them, especially as both are ultimately derived from the perceived lack of material culture dating to the 27th Dynasty. In the former case, this absence is construed as being a result of the weak and ephemeral nature of Achaemenid rule, a rule that consequently had little or no lasting impact on the Egyptians (e.g., Johnson 1994). For example, in the realm of statuary the apparent absence of any Achaemenid influence on Egyptian art demonstrates the weakness of Achaemenid rule, as well as the general imperviousness of Egyptian culture to foreign intrusions. In the latter case, absence indicates oppression, such as the suppression and destruction of temples and the imposition of crippling tribute obligations (e.g., Sternberg-el Hotabi 2000). Once again, statuary is illustrative, since the lack of individual pieces dated to this period is often considered evidence for artistic stagnation resulting from economic decline and a general sense of malaise on the part of the Egyptians.

That there are two mostly contrary interpretations for the same body of evidence demonstrates clearly the difficulties of studying this period. The main challenge is the perceived shortage of archaeological material dating to the 27th Dynasty, which, as we have already seen, informs both of the prevailing views of the period. This shortage is problematic not only because limited data make interpretation more difficult, but also because this shortage results not from the lack of recovered archaeological and textual evidence but from disciplinary biases. In an important essay David Aston (1999) has shown that, with respect to funerary assemblages, the absence of material of 27th Dynasty date must be a consequence of research practices, specifically the practice of only assigning a tomb or object a 27th Dynasty date if compelled to do so by epigraphic evidence; everything else, Aston argues, is assigned by default either to the 26th or to the 30th Dynasty, to wit, the periods of native Egyptian rule. In other words, there are more specific chronological criteria demanded for dating something to the 27th Dynasty than to any other period, and if an object does not meet any of these criteria it is given an earlier or later date without comment or justification.

Aston does not speculate as to the origin of this practice, but it is

not hard to see how implicit notions about Achaemenid imperialism have permeated the study of the Late Period to such an extent that it affects even object chronologies. It is thus inadequate merely to assemble a corpus of material dating to the period of Achaemenid rule. It is also necessary to examine the historiographical and epistemological foundations of the archaeology of the Late Period as a whole and of the Achaemenid Empire in particular, since these too can dramatically affect the creation of such a corpus, as well as its interpretation.

The goal of this book is to resolve the paradox of Achaemenid Egypt by means of a study of the material culture of this period. Unlike textual sources for this period, which have a long history of scholarship going back to Georges Posener's (1936) classic study *La premiere domination perse en Égypte*, the archaeology of the period of Achaemenid rule has received comparatively little attention. Moreover, significant progress has been made in the study of the Demotic and Aramaic sources for this period (e.g., Agut-Labordère 2017; Schütze 2017), such as the publication of the *Textbook of Aramaic Documents from Ancient Egypt* (Porten and Yardeni 1986–99). Archaeology, however, has not matched this progress, no doubt in part because of the difficulties of dating individual objects and types, and of using vastly different kinds of material culture to address a single question.

But archaeology is equally critical to our understanding of this important period. Archaeological remains are not limited to Upper Egypt the way most Demotic and Aramaic papyri are, and they are produced by people from all walks of life, not just those who appear in the documentary record. Also, archaeology provides a means of accessing the decisions made by individuals and groups about the objects they chose to use in the course of their lives and in preparation for their deaths. Because these choices were made within a broader social context, what Pierre Bourdieu (1990, 52–65) calls the *habitus*, they can be usefully parsed and analysed with a view towards reconstructing some part of that context. Finally, an archaeological approach facilitates comparison both with those other satrapies of the empire that have now themselves been subject to some degree of archaeological investigation, and to other premodern empires known by their material remains.

This book has three main objectives:

1. To examine the intellectual foundations of our knowledge of the archaeology of the 27th Dynasty. This is an essential precursor to any study of Achaemenid rule in Egypt, since modern preconceptions

about the nature of Achaemenid imperialism have clearly played a role in both the formation of the corpus of material culture dating to this period and the interpretation of it. By examining these preconceptions it becomes possible to distinguish between the products of ancient agency and those of modern scholarship.

2. To assemble a corpus of visual and material records emanating from Egypt whose dates can be plausibly or definitely placed in the 27th Dynasty, on the reasonable assumption that this corpus is broadly illustrative of further material which cannot be dated so securely.

3. To use this corpus to characterise the nature and impact of Achaemenid rule in Egypt in order to test the widely held assumptions of the ephemerality or harshness of Achaemenid rule. This is not a straightforward proposition, for the simple reason that narratives of this period of Egyptian history are permeated by the prejudices of ancient authors and modern scholars alike. These prejudices have not only coloured the formation of the bodies of evidence conventionally used to study this period, but also influenced the methods and approaches used to interpret this same evidence. Furthermore, the tendency to view Persians and Egyptians as discrete and physically separated groups whose identities, tastes and attitudes were always homogeneous oversimplifies a much more complex reality. Imperialism creates winners and losers, but an individual's ethnic or cultural origin does not necessarily predict the nature of his or her experiences with the empire. Rather, in assessing the evidence for Achaemenid rule in Egypt it is essential to recognise the full range of potential responses and experiences that could be had there.

ANCIENT AND MODERN VIEWS OF THE PERSIANS

The historiographic origins of the paradoxical approaches to Achaemenid rule in Egypt lie in the combination of modern and ancient views of Achaemenid imperialism, views in which that imperialism was seen through an orientalist lens. In the words of Edward Said (1978, 3), whose formulation of the concept remains central to postcolonial thought, orientalism is,

> The corporate institution for dealing with the Orient – dealing with it by making statements about it, authorizing views of it, describing it, by teaching it, settling it, ruling over it: in short, Orientalism as a Western style for dominating, restructuring, and having authority over the Orient.

In other words, orientalism refers to the practice of highlighting the differences between East and West in a manner that casts the latter as dynamic and civilised and the former as savage and immutable. Its advent, according to Said, coincided with European overseas colonialism in the eighteenth and nineteenth centuries. This historical link has been challenged, as have other specific aspects of his argument. Yet the basic notion of a direct relationship between orientalism and colonialism remains unassailable. To wit, the civilised nature of the West justified its domination of the East. The present study accepts as an important premise that orientalist prejudices continue to play a role in modern historiographic thought, not to mention public perceptions (Goody 2006).

To be sure, this orientalism is a modern social construct, resulting, as noted above, from the specific circumstances surrounding European colonialism. But Said (1978, 56–8) also identified a sort of proto-orientalism that existed in antiquity, beginning in the decades immediately after the Persian Wars (see further Colburn 2011, 95–8). The earliest clear incidence of this is in Aeschylus's *Persians*, first produced in 472 BC and staged often thereafter, in which the Persians are portrayed as slavish, decadent, emotional and effeminate in contrast to the free, rational and manly Greeks. It also occurs in many subsequent Greek texts, most notably the *Persica* of Ctesias, but also in such works as the epilogue to Xenophon's *Cyropaedia* (8.8), Aristotle's *Politics* (7.1327b 18–34) and the Hippocratic treatise *On Airs, Waters, and Places* (16), in which the 'mental flabbiness' and 'cowardice' of the Persians are attributed to climate and despotism. Moreover, the proto-orientalism of these texts is paralleled by depictions of Persians in Greek art (Miller 2011a). Along with the contrast between Greek and barbarian there is also an idea, already present in Herodotus, that following the heydays of Cyrus and Darius, the empire went into an irreversible decline brought on by the innate wantonness and decadence of the Persians. These prejudices became a part of panhellenic self-identity, and as a result they persisted in Greek thought, informing later authors such as Plutarch. Thus they permeate the Greek sources for Achaemenid history.

The biases espoused in the Greek sources have informed modern scholarship on the empire because, until comparatively recently, they were the main source of evidence for Achaemenid history (Colburn 2011, 96–7; McCaskie 2012). Early scholars of the empire, themselves operating in an orientalist milieu, found the prejudices in the Greek sources to be very much in line with their own views on the contrast between East and West. As Heleen Sancisi-Weerdenburg

(1987, 130) puts it, 'it is rather a case where two tendencies, the undefined but implicit "Orientalism" of the fourth century Greek literature and the prevalent mental attitudes of Europe-centrism in the 19th century mutually reinforce each other'. In this same period the Classics also played a role in the formation and validation of European colonialism by privileging the study of Greece and Rome, both of which engaged in colonisation and imperialism of various kinds, making them exemplars for contemporary states and individual actors (Vasunia 2003; Colburn 2011, 97–8). Nineteenth-century colonisers saw themselves as the cultural, political and even linguistic successors to the Greeks and Romans, and thus looked favourably on their own imperialism as well as that of their ancient antecedents. Early Egyptologists, also with strong roots in European colonialism, saw themselves similarly (Reid 2002). Although there was less of a sense of *translatio imperii* between ancient Egypt and the nineteenth-century empires, pioneering Egyptologists, who were invariably trained in the Classics, also internalised the Greek biases against the Persians. This created a double standard in which Egyptian imperialism, such as that of the New Kingdom, was looked upon favourably, whereas Achaemenid imperialism in Egypt was not.

This combination of ancient and modern orientalist prejudices has important ramifications for the understanding of Achaemenid Egypt. In particular the presuppositions that ensue from it have affected the manner in which the evidence for Achaemenid rule has been interpreted. Modern readings of Herodotus's account of Cambyses' activities in Egypt provide an illuminating instance of this. In brief, Herodotus reports that following his defeat of the forces of Psammetichus III, Cambyses committed a number of grievous acts of sacrilege including the mutilation of the corpse of Pharaoh Amasis (3.16), the slaying of an Apis bull along with several priests (3.27–9), and the murder of his own sister, whom he had also married (3.31–2). The first and third of these incidents cannot be independently verified, but the killing of the Apis bull and its subsequent secret burial by the surviving priests is challenged by the Egyptian evidence: a stela and an inscribed sarcophagus from the Serapeum at Saqqara record Cambyses' pious interment of an Apis bull with all due ceremony in 524 BC (Posener 1936, nos. 3–4; Kuhrt 2007, 122–4).

John Dillery (2005) has provided a compelling explanation for the dramatic divergence of the Greek literary testimony and the Egyptian epigraphic evidence. He points out that the Greek narrative has many features in common with an Egyptian literary motif, known to

modern scholars by the German term *Chaosbeschreibung*. He argues that in the century between Cambyses' invasion and Herodotus's visit the events of that invasion were assimilated to Egyptian myth in order to preserve the 'integrity of Egyptian civilization as a coherent system of meaning' from 'disintegration and cultural amnesia', a process identified by Jan Assmann (2002, 367–420) as characteristic of periods of foreign rule in Egypt.

This was the version of Cambyses' tenure in Egypt to which Herodotus had access, and he incorporated it into his broader narrative of the Persian Wars. This does not mean that Herodotus necessarily espoused proto-orientalist prejudices; his views of the Persians were considerably more nuanced than that. And according to Dillery's reading of the beginning of Book 3, there are Egyptian voices alongside Herodotus's in this passage. But Herodotus chose quite deliberately to include these events in his account of Cambyses because they served the purposes of his narrative agenda, purposes which modern scholars perhaps have yet to comprehend fully (e.g., Lateiner 1989, 163–84; Selden 1999; Bichler 2000, 209–12; Irwin forthcoming). More importantly, Herodotus's work was an instant classic, read widely in antiquity (Hornblower 2006) as well as by modern students and scholars. These readers had no frame of reference for contextualising what they had read other than their own ideas about the Orient, and certainly they were not familiar with the *Chaosbeschreibung* motif.

Thus Herodotus's description of the madness and impiety of Cambyses became a part of the general narrative of Achaemenid rule in Egypt. He appears in the Coptic Cambyses Romance and the Chronicle of John of Nikiu, both composed about a thousand years later, assimilated to the Biblical bogeyman Nebuchadnezzar as an archetypal villain (Lloyd 1994; Venticinque 2006). Modern scholars too, though not nearly so naive, are nevertheless susceptible to the temptation to portray Cambyses as a monster. For example, various scholars (e.g., Kienitz 1953, 55–9; Depuydt 1995; Devauchelle 1995a, 68–70; 1998; Jansen-Winkeln 2002, 314–15) have attempted to prove that Cambyses did in fact kill an Apis bull, usually by means of calendrical gymnastics that allow for the existence of a second bull during his reign, or adjustments to the regnal dating of stelae that would put the burial of this bull after Cambyses' death. Such attempts to 'confirm' Herodotus are symptomatic of the continuing difficulty of mitigating orientalist prejudices.

It is critically important not to downplay the violence and trauma of the invasion of Cambyses. Every invasion is violent and traumatic

in one way or another, and there is no reason to believe that the Persian invasion of Egypt was exceptional. But also we cannot simply repeat the prejudices of previous scholarship, which depict Achaemenid imperialism as extraordinarily despotic and cruel, on the pretence that this addresses postcolonial concerns about the harmful aspects of imperialism, as some scholars have done (e.g., Lincoln 2007; Harrison 2011).

It is also important to recognise that imperialism was not necessary for oppression to take place. In the Petition of Petiese, a lengthy Demotic narrative from el-Hiba, an elderly priest recounts the abuses he suffered at the hands of his fellow priests and the failure of the royal court at Memphis to intercede on his behalf (P. Ryl. Dem. 9; Vittmann 1998). The putative date of the document's composition is year nine of Darius (513 BC), a mere decade after the invasion of Cambyses, with the events it purports to describe taking place much earlier than this during the Saite Period of native Egyptian rule.

It is not at all clear that this document was intended to be a factual account. It has some anomalous features, such as the inclusion of hymns, but at the same time some of the individuals mentioned in the text are also referred to in the non-literary papyri from el-Hiba. Thus the Petition of Petiese at least refers to real people, if not to real events (Traunecker 2008). The ostensible purpose of the document's composition was to allow Petiese to once again petition the court at Memphis to redress his grievances, and by 513 this was a satrapal court with an Achaemenid governor in charge. It is unknown whether or not Petiese's petition was successful, or even whether or not it was ever made, but the implication here is that it was plausible for him to hope that the Achaemenid rulers of Egypt would help him where the native rulers had failed to do so. The Petition of Petiese demonstrates very effectively that foreign imperialism was not at all necessary to oppression or violence.

APPROACHES TO ACHAEMENID RULE IN EGYPT

The effects of these prejudices on the study of Achaemenid imperialism are numerous and sundry, and they vary from one region of the empire to another. In the case of Egypt, two of these effects are especially worthy of mention because of the role they have played in the historiography of the 27th Dynasty. The first of these is what Margaret Root (1991) has referred to as the 'politics of meagerness', namely the practice of highlighting and continually reinforcing the ostensible absence of the empire in the material record. The second is

the assumption that the vast territorial extent of the empire inhibited trans-regional social, political and cultural interaction, and, in the specific case of Egypt, facilitated its cultural isolation and impermeability. As is shown in the following discussions, neither of these ideas stands up to critical scrutiny, and the role of each in the formation of our understanding of this period requires reassessment.

The politics of meagreness

Perhaps the more palpable consequence of the prejudices outlined above is the tendency on the part of many scholars to emphasise the limited amount of evidence, both in physical objects and in intangibles such as names or titles, that can potentially inform studies of Achaemenid rule or presence in a given region of the empire. This tendency is itself informed by notions of the weakness and ephemerality of the empire's rule, which in turn affect the classification of material culture from various satrapies, usually by emphasising formal features that make reference to non-Achaemenid material culture traditions. For example, designating an object as 'Graeco-Persian' prioritises its apparently Greek characteristics, with the result that the object becomes evidence for unidirectional Greek cultural influence over, rather than complex engagement with, the Achaemenid Empire (Gates 2002). Such classifications result in a paucity of evidence for Achaemenid imperialism that then reifies the starting assumptions.

At the outset there is the simple problem of what is construed as evidence for Achaemenid presence or activity in a given region. As Sancisi-Weerdenburg (1990, 264) has pointed out:

> In looking for traces of the Persian empire, the search has so far been mostly confined to phenomena that betray an Iranian influence, to artefacts of a typical or a hybrid Iranian provenience, to changes in the titulary and in the onomastica derived from the Iranian vocabulary.

Such an approach, however, presupposes a direct relationship between imperialism and material culture, and though such relationships undoubtedly exist they are not so simplistic as 'Persian-looking objects' equalling 'Persians'. Rather, there is an enormous multitude of potential relationships between the individuals in a given area and an empire of which they are subjects, and some of these relationships affect decisions made about the acquisition, use and discard of objects. In the Achaemenid Empire in particular imperial ideology stressed the diversity and variety of the subject peoples, with the result that there was less overt pressure for those peoples to adopt

Persian material culture or practices (Colburn 2017). Thus, in order to assess properly the impact of Achaemenid imperialism, or to gauge how certain individuals experienced or interacted with that imperialism, we must consider all of the material produced or recovered in regions subject to Achaemenid rule, regardless of how 'Persian' it might appear to be (Colburn 2014a). By examining changes and shifts in material during the 27th Dynasty it is possible to see how Achaemenid rule may have impacted Egypt and the Egyptians, even if this impact did not necessarily result in objects (or names and titles) taking on an overtly Achaemenid aspect or tone.

There is actually a great deal of evidence available for studying Achaemenid rule in Egypt. Michel Wuttmann and Sylvie Marchand (2005) have compiled a gazetteer of some sixty sites that feature material potentially of 27th Dynasty date. Moreover, the quantity of evidence further increases when the material that has been uncritically dated to earlier or later periods is included. That much of this material does not exhibit any overt references to the Achaemenid Empire is a separate matter entirely. In some instances these references have simply not yet been identified or fully understood. Many objects have been reattributed to earlier or later periods on the basis of isolated examples or unproven assumptions. In other instances we must acknowledge that lack of explicit allusion to the imperial presence is itself a form of evidence for the experience of empire. There is no scarcity of evidence after all; the challenges are to identify it, and to develop a methodology that permits synthesis and comparison of highly disparate lines of evidence.

The obstacle of distance

The second consequence of ancient and modern biases against the Achaemenids relates to the understanding of the geographic dynamics of the empire. Specifically, the empire's huge area, often remarked upon by modern scholars, is seen as an impediment to its operation and interconnectivity. Egypt, on the western fringes of the empire, is considered especially remote from the centres of imperial power and activity at Persepolis, Susa and Ecbatana. Some 2,800 km of roads separated Persepolis from Memphis, and it is commonly assumed that this distance was inimical to cultural and political interaction and influence. While it is undoubtedly true that travel in antiquity was slow by the standards of the present day, the Achaemenid Empire created an infrastructure of movement that served to mitigate the problems posed by its vast territorial extent.

This infrastructure included both a network of roads that connected Persepolis and Susa with other cities of the empire, such as Bactra, Sardis and Memphis, and an administrative apparatus of caravanserais, watchmen and road maintenance that facilitated the movement of people, goods and ideas throughout the empire with a minimum of danger and inconvenience (Briant 2012; Colburn 2013). Of particular importance for Egypt was the road through the Sinai Peninsula connecting the eastern Nile Delta with the Levantine satrapy known as 'Across-the-River', which was presumably supplied with water by cisterns or other forms of storage along the way, as was the case during Cambyses' invasion (Graf 1994, 184–5; Cruz-Uribe 2003a, 17–24).

There was also a system of mounted couriers, known in the documents of the Persepolis Fortification Archive by the Elamite term *pirradazish*. These couriers provided high-speed communication for the Great King and other imperial officials in a manner akin to that of the Pony Express of recent American history. Changing horses at way stations permitted them to travel with the utmost speed, with the result that a message could reach Memphis from Persepolis in approximately twelve days (Colburn 2013, 46). This means that the Great King could in fact exercise a degree of direct control over affairs in Egypt without being physically present there. Furthermore, the communication systems enabled the king's immediate proxy, his satrap, to be absent from Egypt without losing oversight of activities there. Indeed the fifth-century satrap Arshama seems to have travelled back and forth between Egypt and Persia during his tenure, since some of the letters he wrote to his subordinates from the centre of the empire have survived (TADAE A6.3–13, D6.3–14; Tuplin and Ma 2013). The geographical distance separating Egypt from other parts of the empire was vast, but there were strong connections between them nevertheless. As the assiduous attempts to reconquer Egypt during the fourth century indicate, the Nile Valley was never far from the Great King's attention.

Egypt was also connected to the Achaemenid heartland by way of the sea route around the Arabian Peninsula and into the Persian Gulf. This route was facilitated by the construction of a canal through the Wadi Tumilat in the eastern Nile Delta during the reign of Darius I, connecting the Nile to the Red Sea (Posener 1938; Redmount 1995; Aubert 2004). It is often suggested for various reasons that this canal could not have served a practical purpose (Tuplin 1991). The wind regime in the Red Sea was such that in the northern third of the sea the prevailing winds were almost always northerly, making

it difficult to sail southward. Likewise, the canal was only open for a few months in the winter, but ships sailing for India had to leave the Red Sea by late spring or summer in order to make use of the monsoon winds (Cooper 2009, 205). These same ships would depart from India late in the calendar year, and by the time they returned to the Gulf of Suez the canal would be closed for the year. Finally, there is perhaps also an implicit notion that the Persians, being a Near Eastern people, were landlubbers. Herodotus (1.143.1), for example, states explicitly that the Persians were not ναυβάται (literally 'boat-goers'); this idea is furthered by the fact that Achaemenid naval operations in the Mediterranean were typically carried out by Greek or Phoenician fleets.

Despite these frequent statements to the contrary, there is a long history of movement by sea between the Arabian Peninsula and neighbouring regions, namely east Africa across the Red Sea to the west, and Mesopotamia and Iran across the Persian Gulf to the east, beginning at least as early as the sixth millennium BC (Boivin and Fuller 2009). Much of this seaborne movement was probably carried out on a small scale by *caboteurs*, moving small distances along the coast and thereby creating a chain of linked connections. But there was also a capacity for long-range movement. This was demonstrated effectively by the *Tigris*, the reed boat built by Thor Heyerdahl in 1978, which he sailed from Iraq to Pakistan, and then to the Red Sea (Heyerdahl 1981). Though the *Tigris*, which was at sea for five months, does not prove that such journeys were undertaken, it demonstrates at least that they were possible with the technology available in antiquity (see further Moorey 1998). This movement continued in later periods as well. Roman sea trade with India, as attested in the early first-century AD Greek sailing manual known as the *Periplus Maris Erythraei*, is well known (Sidebotham 2012); later still in the Middle Ages Arabs plied the waters of the Red Sea, Persian Gulf and Indian Ocean (Agius 2008).

Thus the objection that the canal could not have created a functional maritime link between Egypt and Persia is unsubstantiated. Certainly its intent seems to have been to create such a link. This much is stated bluntly in the trilingual cuneiform inscriptions on the stelae set up along the course of the canal, of which three now survive (Posener 1936, nos. 8–10). The accompanying hieroglyphic inscriptions are less well preserved, but seem to contain the same meaning, albeit presented in a distinctly Egyptian idiom (Lloyd 2007b, 99–107; Klotz 2015). Herodotus (4.44) also refers to a voyage undertaken by Scylax of Caryanda at the behest of Darius to

explore the sea route between the mouth of the Indus and the Red Sea coast of Egypt.

There is evidence as well for Achaemenid interest in the eastern terminus of this sea route in the Persian Gulf. Tablets from the Persepolis Fortification Archive refer to the movement of labour crews to and from the site of Taoce on the Bushehr Peninsula, where an Achaemenid royal residence was located; there are also references in Neo-Babylonian documents to the movement of workers, cattle and wooden beams to Taoce from Mesopotamia (Henkelman 2008). Archaeological surveys have identified an expansion in settlement on the Bushehr Peninsula during the Achaemenid Period, possibly on account of the construction of a major irrigation canal (Whitcomb 1987; Carter et al. 2006). There is also scattered textual and archaeological evidence for Achaemenid presence in and around the Persian Gulf, including on the island of Bahrain, suggesting perhaps the sea route was part of a larger southern maritime region of the empire (Potts 2010). Finally, Herodotus (3.93) includes the 'islands of the Ἐρυθρά θάλασσα' in the fourteenth satrapy; in later usage this term refers to the sea route from the Red Sea to India, in essence the northwestern portion of the Indian Ocean (Sidebotham 1986, 182–6). The implication is that Herodotus considered this sea route a part of the empire.

Egypt was linked to the rest of the empire by means of roads and sea routes and the infrastructure to exploit them effectively for the purposes of communication and transport. This means that what happened in Persepolis, Susa or even Bactra could potentially impact Egypt, and vice versa. The satrapy was an integral part of the empire, and the potential for cultural exchange and interaction must have existed there as much as in any other region.

The ethno-classe dominante

One of the main cumulative effects of the prejudices and preconceptions discussed above has been to confine the study of Achaemenid imperialism, in Egypt and throughout the empire, to certain models of limited or indirect interaction between the Persians and their subjects. It is of course entirely possible that the empire operated in a manner that deliberately curtailed direct intervention in local affairs or institutions, but such an assessment cannot be made based solely on the products of biased scholarship. Moreover, as Sancisi-Weerdenburg (1990) has rightly pointed out, it is difficult to envision how an empire that did not interfere at all with the territories under

its control could actually function. These preconceptions are embedded in historical and archaeological narratives of the empire, so that scholars studying Achaemenid rule regard approaches that favour local autonomy and non-interference as the best fit for the evidence. Studies of cultural interaction are similarly hamstrung by the effects of these old prejudices, leading to suggestions that, for example, the empire was characterised by 'cultural adjacency' (Tuplin 2009, 427) rather than interaction or exchange. This unsatisfying assessment is clearly an attempt to make sense of the apparent scarcity of evidence for Achaemenid presence or influence in various parts of the empire. But it still relies on a body of evidence whose creation is informed by the politics of meagreness.

Perhaps the most influential approach to Achaemenid rule in Egypt has been Pierre Briant's (1988a) model of a satrapy governed by what he termed the *ethno-classe dominante*. According to this model, the empire was ruled by a group of ethnic Persian aristocrats (that is, Persian by birth and descent rather than acculturation or self-identification) centred on the person of the Great King and the royal court. These Persians jealously maintained their own separate group identity, politically, culturally and linguistically, from the subjects of the empire. They restricted access to visual markers of their Persian identity, as well as to their bloodlines by refraining from intermarriage with locals. Egyptians were excluded from holding posts with any political power, being limited instead to religious ones.

The appeal of this model is clear: it explains both the apparent lack of Persian influence on Egyptian political or cultural institutions and how the Persians maintained control of Egypt for over a century. But when the trope of scarcity is removed, it loses much of its explanatory force. And as Briant (2017, 5) himself has recognised, there are now counterexamples to the model's main premises. First, intermarriage between Persians and Egyptians does seem to have taken place. The stela of Djedherbes (Cairo JE 98807; Mathieson et al. 1995), whose parents Tanofrether and Artam have Egyptian and Persian names respectively, is perhaps the best-known instance. Of course names do not equal ethnic or geographic origin, but even if this stela is dismissed as direct evidence for literal interbreeding, it still challenges the model of cultural exclusivity, since it represents an attempt to bridge two different cultural entities. And there are other examples of families with multiethnic names in Achaemenid Egypt, such as that of Wennefer, the 'Hyrcanian cavalryman' with an Egyptian name whose parents, Merega and Taweret, have Persian

and Egyptian names respectively (Smith and Martin 2009, no. 17), or Padihorakhbity, son of Isetreskhty and Pshrs, to name a few (Schott 1967; Vittmann 2011, 396).[2]

Second, there are several examples of people with Egyptian names holding important imperial administrative offices during the 27th Dynasty. Most famously, Udjahorresnet was variously chief physician, administrator of the palace, sealbearer of the King of Upper and Lower Egypt, and 'sole companion' of Cambyses and Darius. But there were other highly placed Egyptians as well (Huss 1997, 135–9), including Horwedja (*senti*, or finance minister), Ptahhotep (overseer of the treasury, and *kppš*, a Persian title that was reserved for the most eminent officials and administrators), Ahmose (general) and Khnemibre (the director of works responsible for the procurement of stone in the Wadi Hammamat). Egyptian titles do tend towards hyperbole, and it can be difficult to disentangle honours and sinecures from professional functions. But the *ethno-classe dominante* model requires that all of these examples be explained away as exceptions or instances of empty self-aggrandisement. This is paralleled elsewhere in the empire, where there are cases of apparent non-Persians, such as Ezra, Nehemiah, Themistocles, Datames and Belshunu, serving as governors, local rulers and imperial agents, comprising what has been called the 'international elite of the Achaemenid Empire' (Weinberg 1999). In the secondary literature these individuals are often called 'collaborators', which is an anachronistic and pejorative term, and it implies without basis that such instances were the exception rather than the rule.

These are two examples of weaknesses of the *ethno-classe dominante* as a model for the structure of Achaemenid rule in Egypt and as an explanation for the seemingly limited evidence for that rule. They do not invalidate Briant's approach altogether, but they call into question its rigid separation of the Persians from the subjects of their empire and generalisations about culture contact and exchange extrapolated from it. We are now in a position, based on an assiduous interrogation of visual and material evidence along with textual, to suggest a more flexible approach for understanding the possible range of experiences with the empire that could be had by its rulers and subjects, Persians and Egyptians alike.

[2] See also Smith and Martin 2009, no. 13, and the Aramaic examples in Lozachmeur 1998 and Porten 2003.

BEYOND PERSIANS AND EGYPTIANS

If we are to measure the impact of the empire's rule of Egypt, we need to do so in a manner that can accommodate the full gamut of that impact. In this respect, the field of Roman archaeology, especially the study of the processes of cultural contact and interaction in the provinces (often called 'Romanisation'), provides an illuminating methodological parallel. Older models in which a monolithic and superior Roman culture is either forced upon or willingly accepted by a subject population in place of its native, inferior one have long since given way to a range of more nuanced approaches that attempt to accommodate local variation and grant agency to individuals.

In particular David Mattingly (2011, 213–18), building on the postcolonial critiques of Edward Said, has argued that the impact of Roman rule is best understood in terms of 'discrepant experiences'. In other words, empire was experienced differently by everyone. For some, it led to disenfranchisement, loss of life or property, or oppression by economic or cultural institutions. For others, it created new opportunities by setting aside existing power structures and creating new connections to distant peoples and places which contributed to the flow of goods and ideas over longer distances than had been possible before. And this was true not only for those subject to empire, but also for those actively participating in it. As Mattingly (2011, 29) puts it, 'we need to break free from the tendency to see the colonial world as one of rulers and ruled (Romans and natives) and explore the full spectrum of discrepancy between these binary oppositions'.

This approach provides a promising means of assessing the nature and impact of Achaemenid rule in Egypt. The focus on discrepant experiences recognises the trauma inherent in any colonial situation while at the same time it rejects the categorisation of local subject peoples as undifferentiated blocks characterised by certain essentialised traits. It thus obviates the problem of orientalist prejudices colouring the interpretation of Achaemenid rule. The emphasis on experience also helps to move beyond the impasse created by the politics of meagreness, because it is necessary to consider all of the available evidence pertaining to an individual's experience in a given colonial setting, regardless of whether or not it betrays some explicit hint of Achaemenid presence or influence. So long as the date is reasonably certain, a context in which there is no discernible effect or impact of Achaemenid rule is as important and interesting as one in which the evidence for change is overwhelming (Sancisi-Weerdenburg 1990, 272–3; Colburn 2014a; 2017). Indeed, given

that it is necessary to deconstruct much of what is already known about the object typologies and chronologies of Late Period Egypt, an approach that treats individual cases rather than entire categories permits us to focus on what material can be firmly dated rather than getting stuck in circular arguments with material that cannot.

Of course identifying ancient individuals is not always possible. In Egypt there are certain forms of evidence that permit this readily, including statues, funerary monuments and papyri naming specific people. Funerary materials are especially useful because many Egyptians took great care to plan for their own afterlives by furnishing their own tombs and commissioning monuments well in advance. This means that such materials directly reflect the agency of the individuals they commemorate. In other instances the evidence permits investigation only at the level of institutions, communities and other groups of individuals. Yet this is still useful for studying experience. The priests of Apis in Memphis or the inhabitants of Ain Manawir in the Kharga Oasis are much more specific groups than 'Egyptians' or 'Persians', and taking each as its own unit of analysis still provides an important level of detail and avoids the use of misleading overarching categories.

There are two ways of studying experience in Achaemenid Egypt employed in this book. One is to look for structural continuities and discontinuities in the social, economic and institutional fabric of Egypt. The other main approach is focused on the construction of identity by individuals and communities, and the decisions about visual and material culture that result from it.

Structures of history

In a justifiably famous study of Mediterranean history, Fernand Braudel (1972, 20–1) identifies three registers of historical inquiry. One of these registers, in Braudel's words, consists of 'history, one might say, on the scale not of man, but of individual men... *l'histoire événementielle*, that is, the history of events'. There has been a great deal of scholarship, both on Egypt and on the Achaemenid Empire, focused on this register of historical inquiry. This scholarship has done the invaluable service of creating the framework of facts, events and chronologies that constitutes the current state of knowledge about Achaemenid Egypt. At the same time its focus on specific events limits its utility for studying experience on any broad scale. Accordingly, this book focuses primarily on Braudel's two other historical registers as a means of supplementing existing

data, and of putting disparate bodies of evidence in dialogue with each other.

The second of Braudel's registers concerns 'another history, this time with slow but perceptible rhythms ... one could call it social history, the history of groups and groupings'. This register consists of the institutions and communities that comprised Egypt's social and economic structures. Foremost among these was the office of pharaoh, the living incarnation of the god Horus and the primary conduit between the earthly and divine realms (Morris 2010b). The pharaoh was in essence the chief priest of every cult in every temple in Egypt, though for practical purposes many of his duties were devolved onto various priesthoods. One of his main responsibilities was the maintenance of *maat*, or cosmic balance, which was achieved through piety and good governance (Assmann 2001). The temples themselves, many of which endured for centuries, were also crucial institutions. They controlled a variety of important resources, ranging from farmland to access to the gods. The priests of these temples were an important segment of Egypt's social elite, and they served as living links to the past. And there were other groups as well, such as the nomes (the forty-plus districts into which Egypt was divided), the army or warrior class, and the various villages and communities that dotted the Egyptian landscape (Lloyd 1983, 299–315). These groups and institutions, and the interactions between them, determined much of the fabric of everyday life in Egypt. An imperial power such as the Achaemenid Empire certainly had the capacity to modify these groups, through changes to administration or the movement of people, and these changes could profoundly affect an individual's experience of Persian rule.

The last of Braudel's registers, often called the '*longue durée*', is 'a history whose passage is almost imperceptible, that of man in his relationship to the environment, a history in which all change is slow, a history of constant repetition, ever-recurring cycles'. In Egypt this definition immediately evokes the Nile flood, which, though neither consistent nor predictable, could always be relied upon to take place. Every year its waters were redirected into irrigation canals, and the combination of water and the silt left behind by it was largely responsible for Egypt's enormous agricultural fertility. To either side of the Nile was the low desert, where temples and tombs were built, away from precious cultivable land, where they could, at least in theory, stand unmolested for all eternity. Beyond that was the high desert, then as now mostly uninhabited, and not even considered part of Egypt proper by the Egyptians themselves. The ability

of the Persians, or indeed anyone, to effect changes on this register was limited, but not impossible. The canal dug by Darius connecting the Nile to the Red Sea has already been mentioned, and the introduction of the qanat to the Western Desert, as discussed further in Chapter 3, altered significantly the nature of agriculture there.

Moreover, in a country as ancient as Egypt, even at the time of Cambyses' invasion, the built landscape also figured into this register of history. The pyramid of Djoser at Saqqara, for example, had stood for over two thousand years when nearby Memphis became the capital of Achaemenid Egypt, and was an important and highly visible focal point for the Saqqara necropolis and the greater Memphis area as a whole. Such conceptual landscapes, comprising both physical features and longstanding edifices, played a crucial role in the formation and maintenance of Egyptian cultural memory, a concept discussed further below (Richards 1999). The alteration, neglect or enhancement of these conceptual landscapes by the imperial power could have a significant impact on an individual's experience of Achaemenid rule, ranging from almost total ignorance of it to the destruction of his or her worldview.

The social, economic and environmental structures that comprise both of these latter two historical registers essentially defined and constrained the parameters in which individual actors operated and made decisions. Changes to these structures resulting from Achaemenid rule in turn changed the range of options available to an individual, and thus affected the possible experiences that individual could have in a given context. Indeed, in many cases it is difficult or impossible to perceive the impact of Achaemenid rule on an individual, whereas changes, or the absence of change, to these structures are generally easier to detect, since their imprints on the material and textual records are more substantial. Thus they serve as a valuable instrument for examining discrepant experiences in Achaemenid Egypt.

Individual identities

Identity refers to how one conceives of oneself in relation to certain groups of people. Thus identities are typically either associative or differential, to wit, they serve to define an individual as part of a group, or as separate from it. These groups are oriented along certain parameters such as ethnicity, socioeconomic standing, geographic origin, political or religious affiliation, and are broadly and theoretically construed rather than formalised (Meskell 2001; Sen

2006, 18–39; Mac Sweeney 2009). In other words, they exist as part of the structure of a society but do not necessarily have formally defined memberships.

Moreover, the identity of a given individual is typically defined in relation to a wide array of such groups; for example, someone could simultaneously be a woman, a resident of Naukratis, of Samian parentage, Greek in terms of her native language and religious practice, Ionian in terms of her dialect and *ethne*, a merchant's daughter, a sailor's wife, a mother, an Egyptian by birth and residence, and not the sort of person who would normally make offerings to Hephaestus. This list could continue *ad infinitum*, but the point is that identity is multifaceted. Most of these facets are impossible to disentangle from each other, equally so for our hypothetical Naukratite herself as for the modern scholar studying her. In a colonial or imperial setting identity often prominently includes one's affiliation to or distance from the foreign group responsible for that imperialism. In this respect it is important to recognise as well that identity is sometimes actively constructed to achieve a certain purpose or effect, and sometimes it exists passively as the aggregate of one's notions of oneself at any given time (Jones 1997; Sen 2006, 18–39; Knapp and van Dommelen 2008).

Archaeologists can study identity because it is materialised through the decisions made by an individual about the objects he or she acquires and uses (Colburn 2014a, 781–2). Put simply, the creation and selection of an object consists of a series or set of decisions. These decisions pertain to a wide variety of the object's physical traits, including material, design, composition, size and so forth. Some of these choices relate directly to an object's material properties or physical function. A bowl, for example, requires one of a certain range of shapes in order to succeed as a bowl, and the artisan makes choices in the course of making the bowl in order to achieve a successful bowl shape. Other choices, however, are between functionally equivalent alternatives, and the artisan chooses between them on much less tangible grounds, such as tradition, habit, expectations as to how a certain sort of object should look, appropriateness to a given context or individual's identity, ideological goals and the like.

The specific reasons informing these decisions are not always clear to those making them. The artisan or consumer is not always able to say exactly why he selects one alternative over another, and indeed he may not always be aware he is making a choice at all. But all of these decisions, conscious or otherwise, are made in order to achieve what is perceived to be a desirable result. Sometimes a desirable

result means only that the object is appropriate to the identity of the consumer, however he or she conceives of it. But, assuming reasonable expectations, what leads to a desirable outcome is determined in large part by the broader circumstances and conditions current at the time and place of production (Baxandall 1985). This means that the examination of the identities of individuals can further our understanding of the social worlds in which they lived.

In the process of creating, Egyptian artisans and consumers drew on visual repertoires that included not only the established Egyptian canon but also foreign material culture traditions. As per the model outlined above, they elected to quote these various traditions when they believed it advantageous to do so. Sometimes these quotations were explicit and deliberate, and sometimes they were made unconsciously because the visual effect they produced was appropriate to the identity of the patron. In both cases, however, the advantage provided by these quotations was the reference they made to what we might call 'superordinate centres' of charismatic authority. The term is drawn from the work of Mary Helms (1993), who has argued that in many early and traditional societies, individuals and political entities derived their charismatic authority (both political and social) from connections (both real and imagined) to centres of social order. These centres were distinguished by their remoteness. Sometimes this remoteness was geographic; sometimes it was chronological or cosmological; and no distinction is made between these types of remoteness.

Many individuals in Achaemenid Egypt constructed their identities in reference to two major superordinate centres. One of these was the Great King and his court, and by extension the built and ideological environment of Persepolis itself. The other was what Jan Assmann (1995; 2011) refers to as the 'cultural memory' (that is, collective notions of the structure of social order based on bygone eras) of Egypt in the periods prior to Achaemenid rule. The inhabitants of the Egyptian satrapy defined themselves by association with or disassociation from these centres, depending on how they conceived of themselves and their worlds. These aspects of their identities were in turn reflected in their choices about material culture, including both representational art and utilitarian objects. Indeed, the practice in Egypt of creating representations of oneself, such as votive statues or tomb painting, to serve as eternal proxies meant that many individuals actually had occasion to consider what aspects of their identity were most important (Wendrich 2010). By parsing the references to these superordinate centres it is possible to determine how certain individuals in Egypt constructed their identities during

the period of Achaemenid rule. This in turn provides a sense of the broader social, cultural, political and religious environment in which these identities were made.

THE STRUCTURE OF THE PRESENT STUDY

This book examines the nature and impact of Achaemenid rule in Egypt in a holistic manner that eschews rigid divisions between Persian and Egyptian, conqueror and conquered, through the analysis and interpretation of a corpus of archaeological remains assembled here for that purpose. Chapters 2 and 3 focus on specific places: the city of Memphis, the political and administrative centre of the country, and the Kharga and Dakhla Oases in the Western Desert, a remote outpost of Egypt. These two locations alternatively provide urban and rural perspectives on the nature and experience of Achaemenid rule. Both also represent major concentrations of material from which conclusions may be drawn. In turn they provide a point of comparison for analysing more discrete items that cannot be contextualised so readily in time and space, but which may yet be important evidence for understanding this period in Egypt.

Chapter 2 focuses on Memphis and its associated necropoleis. This was the burial place of several Old Kingdom pharaohs, whose funerary monuments dominate the landscapes of Saqqara and Abusir nearby. It was also the capital of Egypt many times throughout its history, including during the Saite Period. This status was maintained under the Achaemenids, when it served as the seat of the Persian satrap. Thus Memphis remained an important place, both in the physical landscape of Egypt, and also in the cultural memory of the Egyptians themselves. At the same time it was also a great cosmopolis, one of the major cities of the eastern Mediterranean and the Near East, and as such it was a multilingual, multiethnic hub, to which many different people came for many different reasons. This variety is reflected in the material remains of the city.

Chapter 3 is concerned with the Kharga and Dakhla Oases, which form a single continuous depression in the Western Desert. The oases were an obscure region, considered by the Egyptians to be outside of Egypt proper. Although sparsely populated since the Old Kingdom, during the 27th Dynasty settlement in the oases expanded dramatically with the aid of the qanat, an irrigation technology that originated in southwestern Iran. This expansion of settlement served an imperial purpose, namely to link this important strategic location more closely to centres of imperial power in the Nile Valley. But,

as the Demotic ostraca from the temple of Osiris at Ain Manawir indicate, it also created a thriving local economy with ties to the Mediterranean and the production of cash crops, notably castor oil, for export. Once again, the empire's impact in the Western Desert produced varied consequences.

While Chapters 2 and 3 focus on two specific places, Chapters 4 to 6 address the experience of Achaemenid rule using three different categories of material culture, each of which provides a different perspective on the social and economic structures present in Egyptian society in this period and the decisions made by individuals in light of them. Chapter 4 considers the construction of individual identities and their representations in sculpture. The prevailing view has been that the 27th Dynasty was characterised by artistic poverty brought on by Achaemenid rule. A re-examination of the dating criteria used for Late Period sculpture demonstrates that this 'poverty' is very much a modern scholarly construct. It is important to recognise as well that the statuary and other such objects that survive into the present are not necessarily a representative sample of the artistic output of the entire Late Period.

Furthermore, those examples of Egyptian art that can unequivocally be assigned to the Achaemenid Period are illustrative of a wide range of approaches to and experiences with the empire. The manner in which people conceived of themselves and their broader places in society informed how they chose to represent themselves. For example, as is evident in their naophorous statues (Figs 4.16, 4.17) the high-ranking officials Horwedja and Ptahhotep had seemingly very different ideas about the empire: Ptahhotep identified with the international elite that served as its administrators, while Horwedja identified more with longstanding Egyptian cultural notions. Ethnicity was not a clear predictor either of one's relationship to the empire or of how each conceived of his identity. That said, the material presented in this chapter demonstrates the sheer range of potential reactions and experiences.

In contrast to the durable personal monuments discussed in Chapter 4, Chapter 5 considers how Achaemenid rule may have affected the decisions people made about identity on a daily basis, specifically regarding food and drink. Culinary practices are closely linked to cultural identity, and they also reinforce social hierarchies. So even minor changes in such practices can indicate potentially profound cultural shifts. The appearance in Egypt of three well-known types of Persian drinking vessels – the Achaemenid 'phiale', the 'rhyton', or drinking horn, and the Achaemenid deep bowl –

suggest that certain aspects of Persian dining practices were adopted in Egypt. Moreover, these vessels were associated with specific elements of Achaemenid social hierarchy: phialai and rhyta were given as gifts by the Great King to guests at the royal table, and thus signalled an exalted social statues, whereas Achaemenid bowls symbolised one's imperial identity, hence their appearance in the reliefs on the Persepolis Apadana, where they are carried by delegates from across the empire (Fig. 5.6). That these vessels were made and used in Egypt shows that certain people there defined their social status in reference to the empire, and not solely in Egyptian terms.

Chapter 6 considers economic impact, and changes to economic networks in Egypt. The integration of Egypt into the Achaemenid Empire included both the levying of tribute payments on Egypt and the connection of this land to a vast trade network facilitated by imperial infrastructure. The most palpable consequence of this integration was Egypt's newfound need for silver in order to make tribute payments. In previous periods the political economy of Egypt operated on a system of staple finance, with grain serving as the primary form of money. The Achaemenid Empire, however, had a comparatively modest need for grain, and Egypt accordingly had to find some way to convert staples into a durable and portable form of wealth. This was achieved by selling grain and other products to the Greeks. As a result Egypt acquired large quantities of Athenian tetradrachms, which became so prominent that by the end of the fifth century the tetradrachm appeared as a unit of account in Demotic and Aramaic documents, and was even imitated by the Egyptians. Indeed, the tetradrachm was so prevalent that during the Second Persian Period imitations of it were even issued in the names of the satraps Sabaces and Mazaces, and of Artaxerxes III himself (Fig. 6.2). In this respect Achaemenid rule played an important yet indirect role in setting Egypt on the road to monetisation, a process developed further by the Ptolemies.

It becomes abundantly clear that Achaemenid rule had a significant impact on Egypt. In some cases this impact was systemic and had long-term effects; in other cases the impact was experienced on an individual level, affecting how certain people conceived of themselves and their worlds, with some identifying with the empire and those who ruled it, and others experiencing no discernible disruption to their daily lives despite the presence of 'foreign' rulers. This new picture subverts the tired tropes of 27th Dynasty Egypt as being mercilessly oppressed by Achaemenid rule or entirely unaffected by it; the actual situation, as we shall see, was much more complex.

2. *Urban Experiences: Memphis*

> Behold, my heart has gone forth furtively and hastens to a place that it knows; it has gone downstream that it may see Memphis.
>
> Papyrus Anastasi IV

'THE BALANCE OF THE TWO LANDS'

After defeating the forces of Psammetichus III on the Pelusiac branch of the Nile, Cambyses proceeded upriver to Memphis and besieged the city; within ten days it was under Persian control (Hdt. 3.13; Cruz-Uribe 2003a, 30–3; Kahn 2007, 106). This was an important strategic move on the part of Cambyses, since Memphis was the administrative hub of Egypt, and whoever controlled it controlled access to the Nile Delta from the rest of Egypt and vice versa. Indeed, Memphis had been the political and administrative capital of Egypt many times over the years, beginning in the Old Kingdom (Trindade Lopes 2016). During the Third Intermediate and Late Periods, it was invariably the target of all foreign invasions of Egypt; when Memphis was captured, so too was Egypt (Kahn and Tammuz 2009). But it was of central importance to the Egyptians in cultural terms as well. This importance is evident in one of the city's ancient names: *Mekhat tawy*, meaning 'the balance of the Two Lands'. Another of its names, *Hikaptah*, 'the palace of the spirit of Ptah', is the source of the Greek name for the entire land of Egypt, indicating that at one point Memphis was synonymous with Egypt itself, at least as far as the Greeks were concerned (Smith 1974, 7–8; Zivie 1982, 24–6; Jeffreys 2001, 373). As this name indicates, Memphis was the home of Ptah, the demiurge god whom the Egyptians believed created the world. It was the location of pharaonic coronation ceremonies,

such as the 'circling of the walls' and the erection of the *djed* pillar (van Dijk 1986), and was where many pharaohs celebrated the *Sed* festival commemorating the stability and longevity of their reigns (Kees 1961, 148–50; Trindade Lopes 2016, 63–4).

The centrality of Memphis makes it an important and useful starting point for the study of Achaemenid rule in Egypt. During the 27th Dynasty it served as the seat of the satrap, the Great King's representative and proxy. Thus it was connected to a network of other imperial centres, Persepolis and Susa included, by means of roads, waterways and the messengers that travelled them. It was the site of an imperial garrison, and of a bureaucratic apparatus that served the needs of the empire as well as those of the satrapy. In addition to being besieged by Cambyses, it was attacked several times by Persian and Egyptian armies in the course of the fifth and fourth centuries BC. More than at any other place in Egypt, the period of Achaemenid rule is best represented by its material remains at Memphis. Indeed, the centrality of Memphis has made it, and its nearby mortuary landscapes, the subject of archaeological investigation from the earliest days of modern Egyptology, including by such formative figures as Auguste Mariette, Richard Lepsius and Flinders Petrie. Much of this fieldwork has been focused on the necropoleis, especially Saqqara, and much of it has been concerned primarily with earlier periods of Egyptian history. But the long history of research there has nevertheless turned up a significant quantity of material potentially relevant to the reconstruction of the Achaemenid Period landscape (as has the long history of looting and unregulated excavation there). And more recent work has begun to redress this imbalance more explicitly.

The combination of Memphis's importance to Egyptian cultural memory, its prominence as a locus of imperial activity, and its relative abundance of evidence make it an invaluable case study for assessing the nature and impact of Achaemenid rule. To that end this chapter has three main purposes:

1. To present an overview of Late Period Memphis. Although the city and its environs have been the subject of much scholarship and fieldwork, the results of these efforts are scattered across different publications and typically separated by dynasty. Given the comparatively modest portion of the city's remains that can be dated specifically to the Late Period, let alone to the 27th Dynasty, this has created a false impression of scarcity or meagreness during this period. By taking a *longue durée* perspective it becomes possible to correct this misconception by considering what buildings and monuments, some of which were constructed in earlier periods, and

some of which are only attested later, may have been standing and in active use during the Late Period. This reconstructed physical and conceptual landscape creates a backdrop for understanding the nature and impact of Achaemenid rule at Memphis and provides essential context for the material specifically of 27th Dynasty date.

2. To characterise the nature of the Achaemenid imperial presence in the city. This provides a basis for studying how the empire was experienced in Memphis, since that experience could vary considerably depending on the nature and extent of the empire's presence there. For example, this presence could be military or administrative, and it could be distributed across the city or confined to a single quarter. All of these factors affect the degree of contact an individual could have with the empire, and thereby influence that individual's experience of it.

3. To examine the experience of Achaemenid rule at Memphis, based on how it affected larger social structures (such as cultic institutions) and individuals. As we shall see, the empire strove to maintain existing structures of religious, political and administrative authority. At the same time Achaemenid rule meant different things to different people. The monuments, objects and papyri discussed in this chapter illustrate the range and variety of experiences had there.

This chapter, then, is a demonstration of the richness of the archaeological record for the study of Memphis in the 27th Dynasty, and of the range of experiences encountered by its inhabitants under Achaemenid rule. The evidence points to continuities with earlier periods, as well as to certain changes that must have resulted from Egypt's inclusion in the empire. Achaemenid rule was a prominent feature of life in fifth-century Memphis, but its overall effect was to add another dimension to the already complex web of social relations and cultural memory that existed there.

THE URBAN LANDSCAPE OF LATE PERIOD MEMPHIS

By the time of Cambyses' invasion Memphis was an ancient city. The earliest archaeological evidence for settlement at Memphis itself dates to the First Intermediate Period (c. 2160–2055 BC), but there are numerous tombs of Early Dynastic date (c. 3000–2686 BC) in the low desert to the west of Memphis, at Saqqara and Abusir, as well as on the eastern side of the Nile at Helwan and Heliopolis, implying that Memphis was already an important site at this early date (Jeffreys and Tavares 1994). The physical remnants of its

past greatness were visible all around, both in the city proper and especially in its necropoleis. This antiquity had already played a significant role in how the Kushite and Saite pharaohs represented themselves, and individual Egyptians, in the course of creating their own personal monuments, quoted ancient ones because of the strong attraction to the past (Morkot 2003; 2007). The reliefs of the pyramid temple of the 5th Dynasty pharaoh Sahure (c. 2487–2475 BC) at Abusir, for example, were extensively copied and reinterpreted by Late Period artisans (Baines 1973). The Egyptian past, or more specifically collective notions of that past, was an important source of charismatic authority in Memphis. At the same time, Memphis was the capital of a major kingdom with diplomatic and military relationships with various cities and empires throughout the Near East, the Mediterranean basin, and the African continent. As such it had connections to many places outside of Egypt, connections that people in Egypt could draw upon as sources of charismatic authority. The people of Late Period Memphis, even before the arrival of the Persians, had a wide array of cultural ideas and practices to make use of in the formation of their identities.

Despite its importance in all periods of ancient Egyptian history Memphis remains poorly understood archaeologically. Little of the ancient city remains today, and much of the large-scale excavation there has been at nearby desert sites, notably Saqqara. The main exception to this trend is the Egypt Exploration Society's survey of Memphis (begun in 1982), though its focus has been more on the reconstruction of the ancient environment than on the city's urban character (Jeffreys 2012). The excavations which have taken place in the city proper have been concerned mainly with earlier periods, and the practice of dating standing or excavated remains on the basis of epigraphic evidence, necessary because of the limitations of stratigraphy in the loose sand of the Egyptian desert, creates a decidedly erratic and incomplete picture. But even the sketchy description on the following pages makes it clear that Memphis was a vibrant city during the Late Period, including the 27th Dynasty. Indeed, the fact that it is so difficult to distinguish between monuments and materials of Saite, Persian and fourth-century date shows that there was no meaningful caesura in the city's history as a result of Achaemenid rule.

The remains of Memphis itself lie some 20 km south of Cairo near the modern town of Mit Rahina on the western side of the Nile. During the Old Kingdom the city was located on a riverine island between two branches of the Nile (Bunbury and Jeffreys

2011). Over time sand blown in from the Western Desert caused the western branch, which separated Memphis from Saqqara and Abusir, to diminish gradually in size until it became a stream. This stream was later turned into a canal known in the Ptolemaic Period as Phchet and today as the Bahr el Libeini. During the inundation the canal became a lake, and the city proper was protected from flooding by a series of dykes. By the Late Period the eastern branch of the Nile would have been the major one, serving to connect Upper Egypt with the Delta. Today it is approximately 1.5 km east of Mit Rahina, but in antiquity it ran right along the eastern edge of the city. Recent coring work undertaken as part of the Survey of Memphis indicates that a harbour (called 'Peru-nefer', meaning 'bon voyage') was located in the northern part of the city (Smith and Jeffreys 1986, 91–4; Jeffreys 2010, 163–6; Bunbury and Jeffreys 2011, 72–3), and an Aramaic document (TADAE C3.8; Bowman 1941) of fifth-century date seems to indicate Memphis's continuing role as a river port under Achaemenid rule.

The remains of the city proper are located on and around a series of artificially raised mounds, known in Arabic as *akwâm* (singular *kôm*), clustered around the modern village of Mit Rahina (Fig. 2.1). During the Late Period the major buildings were the Palace of Apries at Kom Tuman just northeast of Mit Rahina, and, nestled among several mounds to the southeast, the temple of Ptah. In addition to these there was doubtless a wealth of other buildings, structures, houses and neighbourhoods, some discernible through archaeological remains and others attested only in textual sources. These include other temples, dockyards and workshops, as well as foreign quarters and residential neighbours. These features cannot be dated precisely to the 27th Dynasty, but it is very likely most of them existed in one form or another during Persian rule.

Little is known about the houses of Late Period Memphis, as the early excavators often did not take much interest in later domestic structures in their zeal to uncover earlier majestic ones. Petrie (1909a, 11), in the course of clearing a temple built by Merenptah at Kom el-Qala to the east of the temple of Ptah, excavated a number of houses which he suggested were 'probably built during a few centuries before the Ptolemies' (Fig. 2.2). In the same area C. S. Fisher (1917, 277; see also Schulman 1988, 88) identified five separate residential strata atop the palace of Merenptah; the third of these he dated to the Late Period on the basis of an inscription naming Amasis, but unfortunately he never published a plan of them. The houses excavated by Petrie vary in size and layout, and most did not

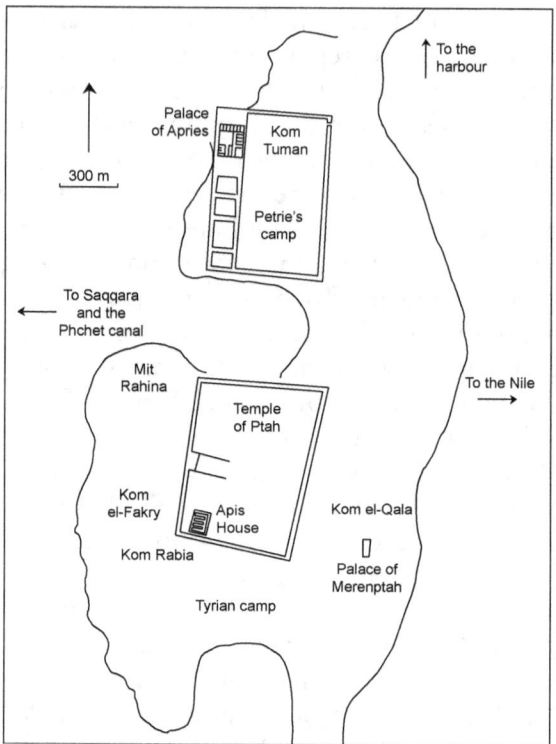

Fig. 2.1. Sketch map of ancient Memphis. Drawn by the author after Petrie (1909a, pl. 1).

survive well enough to provide a complete ground plan. The largest preserved rooms are about eight metres on their longest side; many of the smaller rooms are only four metres. The houses are roughly oriented to the temple of Merenptah, and though they do not form a regular grid at least one east–west street is visible on the plan that probably ran from the waterfront through the residential neighbourhood formerly dominated by the temple and palace of Merenptah, to the temple of Ptah in the centre of town. Presumably neighbourhoods like this were typical of Memphis in all periods.

During the New Kingdom, and perhaps later as well, these neighbourhoods were grouped into administrative districts, called the 'North District', the 'South District', the 'District of Ptah' and the 'District of Pharaoh, which is called the Fine District' (Kitchen 1991, 95–7). It is not clear what sections of the city comprised these districts, though some good guesses can be made. By the Late Period some of these districts would have overlapped with or been supplanted by the various foreign quarters, such the 'Syro-Persian' Quarter, the

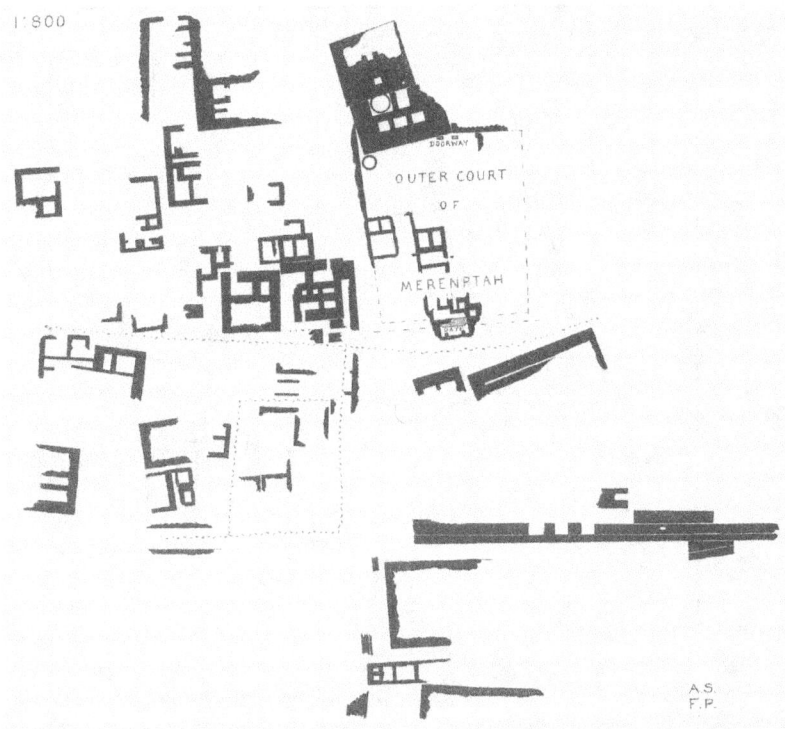

Fig. 2.2. Plan of the houses in the vicinity of the Palace of Merenptah. Image in the public domain from Petrie (1909a, pl. 27).

Carian Quarter and even the Greek Quarter. Although these groups are best attested in the Ptolemaic Period (Thompson 2012, 81–92), all of them were certainly present in Memphis during the Late Period as well (Smoláriková 2003; McAnally 2016; Colburn 2018a, 83–5). The implication is that there were discrete foreign populations settled in different parts of Memphis. Unfortunately, there are not enough published plans of Late Period houses to attempt to identify where each of these populations resided and under what conditions. There was also the 'Tyrian camp' referred to by Herodotus (2.112), which Petrie (1909a, 3–4) places south of the temple of Ptah (Castagna 1981; Lloyd 2007a, 322). This was probably the site of a garrison or mercenary colony, since the word used by Herodotus, στρᾰτόπεδον, normally refers to an armed encampment. Indeed, as a political centre Memphis must have had soldiers stationed there throughout its history, as well as an army of bureaucrats and administrators, not to mention the large population of craftsmen, slaves and farmers necessary to support such a capital. The city's population in the Late Period

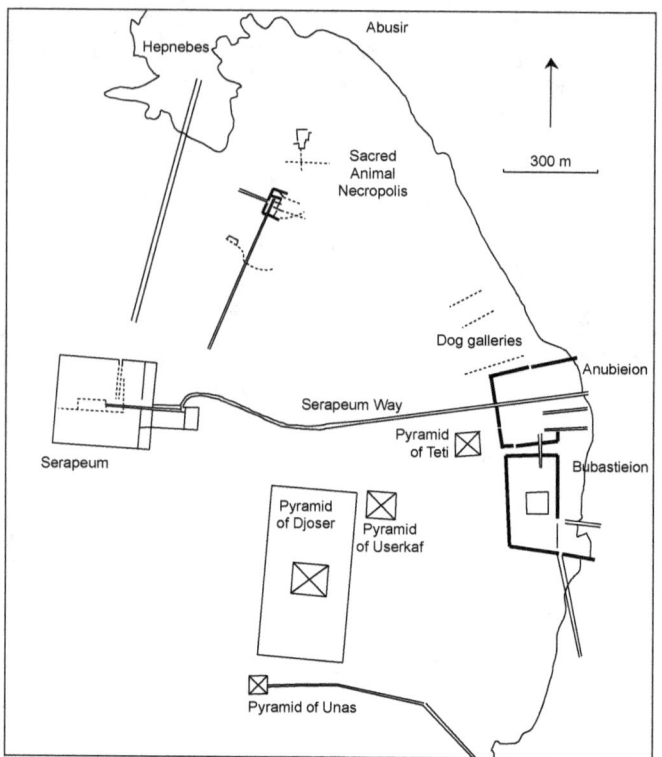

Fig. 2.3. Map of Saqqara. Drawn by the author after Thompson (2012, fig. 4).

has been estimated at 20,000–40,000, on the basis of the total population of Egypt as determined by its available arable land in antiquity (Hassan 1993, 563). This estimate is a deliberately conservative one, and even so Memphis was one of the larger cities in the Achaemenid Empire.[1]

Memphis, however, was not just a city of the living; across the Bahr el Libeini to the west in the low desert lay the necropoleis at Saqqara and Abusir (Fig. 2.3). While these were not residential areas in the same manner as at Memphis itself, they were very much an important part of the conceptual landscape of ancient Memphis. Moreover, the various sacred animal catacombs and royal and private monuments employed large numbers of priests, workers and other specialists. In other words, Saqqara and Abusir were cities of the dead, but they were also inhabited and frequented by many living

[1] For example, Boiy 2004, 229–34, puts the population of late Achaemenid Babylon at c. 50,000, and Colburn, forthcoming a, estimates that the population of Persepolis in c. 493 BC was at least 16,000 people.

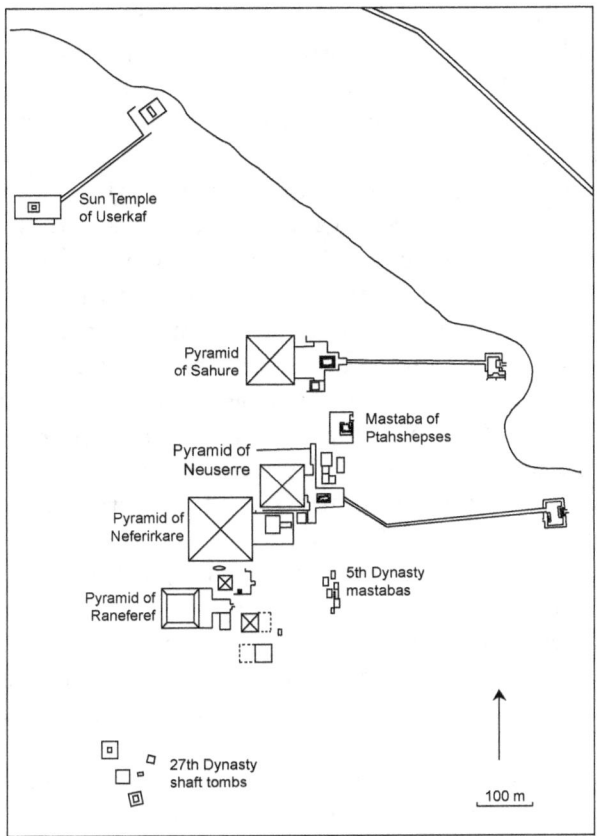

Fig. 2.4. Map of Abusir. Drawn by the author after Bareš (1999, fig. 1).

people. As such they were an essential part of the urban landscape of Memphis during the Late Period.

Saqqara was already a major locus for burial for private individuals in the Early Dynastic Period (c. 3000–2686 BC), and beginning in the 3rd Dynasty (c. 2686–2125 BC) the pharaohs began to erect their tombs there, starting with the step pyramid of Djoser, which dominates Saqqara to this day (Jeffreys and Tavares 1994, 147–51; Tavares 1999). Abusir (Fig. 2.4), whose name is an Arabic rendering of *Per-Wesir* (Egyptian for 'house of Osiris'), was a necropolis as early as the 3rd Dynasty, and several 5th Dynasty pharaohs built their pyramids there (Verner 2017). During the New Kingdom many high-ranking private individuals built their tombs at Saqqara and Abusir, both because of the cosmological attraction of the ancient monuments there and because these monuments provided a ready source of building materials. These tombs ranged from simple,

single-room chapels to miniature temples, imitating the great mortuary temples built by contemporary pharaohs at Thebes.

Saqqara and Abusir continued their roles as major necropoleis during the Late Period as well. There are several shaft tombs clustered around the pyramids of Djoser and Unas, some of which were on top of and dug into an Old Kingdom mastaba (Stammers 2009, 103–9, 115, 118–25, 128; Ziegler 2013). These tombs each contained multiple wooden coffins, and the presence of Aramaic papyri is strongly suggestive of a fifth-century date for these burials. There are several more such shaft tombs to the south of the Unas causeway as well. At Abusir a handful of shaft tombs have been found in the area immediately to the south of the pyramids of Raneferef and Neferirkara, including the tomb of Udjahorresnet (Bareš 1999; Bareš and Smoláriková 2008; 2011; Stammers 2009, 111–14; Coppens and Smoláriková 2009; Smoláriková 2015; Verner 2017, 315–70). Persian Period activity is also confirmed by the presence of Aramaic and Phoenician graffiti on the tombs there, in both the Late Period shafts and the Old Kingdom pyramids. These graffiti were probably made either by people involved in the construction and provisioning of the shaft tombs, or by visitors to the necropolis seeking inspiration and building materials for their own tombs (Dušek and Mynářová 2013).

Alongside these shaft tombs, there were also more modest burials, such as those in a cemetery near the precinct of Anubis at Saqqara consisting of small graves each containing only a few objects (Giddy 1992). Further such burials are implied by the various funerary stelae found in secondary contexts or otherwise attributed to Saqqara and Abusir. Some of these stelae are inscribed in Carian or Greek (Masson 1978; Gallo and Masson 1993; Höckmann 2001; Adiego 2007, 34–79) but it is impossible to say whether they were from discrete cemeteries associated with these communities, or if they were interspersed among the other monuments of the necropolis. Finally, there was also significant reuse of older tomb structures, such as Old Kingdom mastabas, in this period. Such reuse is attested primarily by the so-called 'embalmers' caches' of ceramic vessels found in various places around Saqqara. These caches contain vessels of Late Period date, but most of them were discovered in the course of excavating New Kingdom tombs (Aston and Aston 2010). Their exact purpose remains obscure, but they provide indisputable evidence for activity in the necropolis during the Late Period.

By the time of Cambyses' invasion Saqqara had also become a veritable 'mummified zoo' of sacred animals (Ray 1978, 151): in

addition to the Apis bull, the incarnation of Ptah, god of Memphis, there were ibises and baboons (both associated with Thoth), hawks (associated with Horus), dogs (associated with Anubis), cats (associated with Bastet), rams, lions and snakes (Nicholson 2005). The mummified corpses of most of these sacred animals were housed in vast catacombs attached to temple complexes, clustered around the step pyramid of Djoser. Most of these temples are best known in their Ptolemaic iterations, but they were clearly in use in earlier periods as well.

The most famous of these burial complexes is the Serapeum on the western side of Saqqara, the burial place of the Apis bulls and therefore the funerary equivalent of the temple of Ptah in Memphis. The Serapeum featured a massive enclosure wall that housed cult places for a number of different gods in various guises (of which nothing now remains), but its best known feature is the catacombs containing the corpses of the Apis bulls (Mariette 1882; Dodson 2001; 2005; Jurman 2010; Marković 2017, 152–3). The bulls were entombed in sarcophagi within the vaulted chambers of the catacombs; many of these burials were commemorated by stelae set up by pharaohs or noted in personal votives dedicated by individual pilgrims and worshippers seeking to consult the god (Vercoutter 1962; Malinine et al. 1968; Devauchelle 1994a; 1994b; 2000). Above ground, both within the enclosure walls and outside of them, the Serapeum, like the other sacred animal temples at Saqqara, was also a town of sorts, housing the administration of the Apis cult and including residences for the priests and shops and inns catering to pilgrims (Thompson 2012, 144–76).

In addition to the Serapeum, the sacred precincts of Anubis (the 'Anubieion' in Greek) and Bastet ('Bubasteion'), where dogs and cats respectively were buried, were located on the east side of Saqqara near the Phchet canal (Jeffreys and Smith 1988; Zivie and Lichtenberg 2005). To the north was a district known as 'Hepnebes', where the ibis, baboon, hawk and Mother of Apis catacombs, and their associated temples, were located. These are collectively known as the Sacred Animal Necropolis (Martin 1981; Davies and Smith 2005; Nicholson 2005; Davies 2006; Smith et al. 2006). As many as eight temples were built on a terrace abutting the cliffs into which the animal catacombs were dug. Much of the datable material recovered from these temples and catacombs is of Ptolemaic date, but there is epigraphic evidence showing that the cult of the Mother of Apis was already in operation by the late sixth century BC (Smith 1972; Davies 2009). The Demotic and Aramaic papyri found at

North Saqqara further support this dating (Segal 1983; Smith and Tait 1983; Smith and Martin 2009).

The reconstruction of the greater Memphis area presented here indicates the extent and character of the city and its necropoleis during the Late Period. For the purposes of studying the period of Achaemenid rule more particularly, it is important for two reasons especially. First, it demonstrates the range of structures and institutions that were potentially part of the 27th Dynasty urban landscape. Those features definitely known from either earlier or later periods, such as the temple of Ptah, very probably existed in the 27th Dynasty as well. Other features, such as the graves found near the Anubieion or near the pyramids of Djoser and Unas, cannot be dated precisely, and thus could as likely belong to the Persian Period as to the Saite Period or the fourth century. The tendency of scholars to fixate on the era in which a given building or residential quarter was first constructed or attested obscures the real likelihood that many of them endured across multiple time periods.

Second, even before the advent of Achaemenid rule Memphis was clearly a large and important city, home to some major political and cultural institutions, such as the Palace of Apries and the Serapeum. It was in essence a repository of Egyptian cultural memory. But it was also already a cosmopolis, home to many foreign populations and connected to many places outside of Egypt through social, military and economic ties of various kinds. The integration of Egypt into the Achaemenid Empire created new connections. Some, such as the garrisoning of soldiers in Memphis, directly served imperial purposes; others were created as responses to or results of that imperialism. In both cases the creation and maintenance of these connections had material consequences, some of which remain visible today in the archaeological and textual records derived from Memphis. The rest of this chapter attempts to identify those connections based on the available evidence. This provides a means of gauging both the nature of Achaemenid rule in Egypt, namely by considering how the Persians engaged with the Egyptians and their various institutions, and the impact of that imperialism, namely by showing how certain Egyptians (as well as immigrants to Egypt) engaged with the empire.

THE PALACE OF APRIES

In seeking an imperial presence at Memphis, the first place to look is the Palace of Apries (Fig. 2.5), so-named by Petrie (1909a, 4) on account of a cartouche naming Apries on a limestone column

Fig. 2.5. Plan of the Palace of Apries, Memphis. Image in the public domain from Petrie (1909b, pl. 1).

discovered at Kom Tuman. Other than this cartouche, however, there is no evidence that the palace was built specifically by Apries, but it was probably constructed by one of the Saite pharaohs. This is because by the Late Period the palace of Merenptah (located at Kom el-Qala to the southeast), which had served as the royal palace in Memphis during the New Kingdom, had become a residential neighbourhood. The Palace of Apries sits in the northwestern corner of a large enclosure identified by Petrie as a military camp, mostly on the grounds of its proximity to the palace and its seemingly imposing nature (Jeffreys 1985, 41–3; Leclère 2008, 65–6). Recent excavations there support a Late Period date for this structure, as many of the datable finds belong to this general period. These include a few sherds of at least one Athenian red figure ceramic vessel, made sometime between about 530 BC and the end of the fifth century (Trindade Lopes and Fonseca Braga 2011). A series of smaller enclosures immediately to the south of the palace has been interpreted as the remains of a monumental ramp or causeway leading up to the main entrance from the south (Kemp 1977, 107), the direction of the city centre.

The palace was the political and military centre of Memphis throughout the entire Late Period, including during the 27th Dynasty. Its remains have degraded badly since Petrie's excavations between 1907 and 1914 (Kemp 1977), so the description given here, based primarily on Petrie's reports, also attempts to reconstruct this important, and now essentially nonexistent, building (Petrie 1909b, 1–5; see further Kemp 1977; Kaiser 1987, 132–7; Nielsen 1999, 27–31, 244–6; Leclère 2008, 66–9; Smoláriková 2008, 55–65). It was roughly rectangular in shape, with its long sides, approximately 120 metres in length, on the east and west; the shorter sides, on the north and south, were approximately 100 metres across. The palace was built of mudbrick with stone facing on the walls and stone lintels, columns and flooring. The main entrance was at the south side of the building, where it met the monumental causeway leading from the centre of town. The southern wall of the palace was protected by a fosse or moat, presumably crossed by a bridge, or even a drawbridge.

The entrance opened onto a wide hallway, some eight metres across, dubbed 'Old Broadway' by Petrie. This hallway led into the 'Great Court' (also Petrie's term), after passing on the right a small room (called a kitchen by Petrie and a guardroom by Kaiser, the latter being more likely). The Great Court was a large, square room, about 30 metres on a side, which must originally have had columns,

though the exact arrangement (peristyle or hypostyle) is unclear from the few dislocated remnants found by Petrie. A rectangular monolithic stone cist was sunk into the floor of the room almost exactly in its centre; Petrie suggested that it may have served as a secure storage place for a throne, though it may simply be intrusive. The room's size and centrality suggest that it may have served as an audience chamber or reception room where the pharaoh or the satrap, in lieu of the Great King himself, held court.

Two small suites of rooms were also accessible from the Great Court, one from the south side of the room (towards the front of the palace), and one from the north. The southern suite consisted of a single room and several corridors with thick walls, interpreted as the base of a tower, and perhaps also as a stairwell leading to the upper floor of the palace. To the rear of the Great Court were three smaller rooms. One of them, called the 'work-shop', contained bronze scrap in the form of broken nails; the other two apparently yielded no finds. Beyond these rooms the rear of the palace had already ceased to exist in Petrie's day. He recovered two column capitals there and identified two north–south oriented walls to either side; accordingly he identified this area as a peristyle reception hall, perhaps an open air one.

The other main section of the palace consisted of another wide hallway running roughly parallel to Old Broadway, about 10 metres to the east of it. Petrie dubbed this 'New Broadway', in the belief that it represented a renovation supplanting Old Broadway as the main ingress into the palace. It is not at all clear, however, whether or not it provided access to the Great Court, since by his own admission Petrie was ill the day the southeastern corner of the Great Court was cleared and was unable to ascertain the precise relationship of these two features. It may just as well be the case that this was a second entrance providing access to an administrative or private area (as per Kaiser's reconstruction). Indeed, the eastern side of the palace consisted of several suites of smaller rooms suggestive of such purposes. One of these rooms at the back of the palace contained scale armour, discussed further below. There may well have been more such rooms on the western side of the palace, as coring in this area carried out in 1989 has indicated that the palace's foundations extended further west than Petrie initially believed (Giddy et al. 1990, 12).

A small amount of the palace's decorative programme has survived in the form of several disjointed monumental relief blocks (Figs 2.6, 2.7) discovered by Petrie (1909b, 5–11; Kaiser 1987; Bagh 2011, 36–43) at the front of the building in a secondary context.

Fig. 2.6. Drawing of scenes from the pylon, Palace of Apries, Memphis. Image in the public domain from Petrie (1909b, pl. 9).

These blocks, which are now dispersed in museums throughout the world, were once part of a doorway or freestanding pylon. They seem to represent the pharaoh performing in various religious capacities, including the *Sed* festival, as well as in other rites that are more obscure.[2] Their depiction follows similar such representations from monuments of the Old and Middle Kingdoms at Saqqara and Abusir, to such an extent that Petrie originally attributed the reliefs to the 12th Dynasty. However, their proximity to the palace and the smooth facial features of the pharaoh are consistent with a Late

[2] The *Sed* festival celebrated the continuing rule of the pharaoh (Hornung and Staehelin 2006). It normally took place during his thirtieth jubilee, and then every three years thereafter.

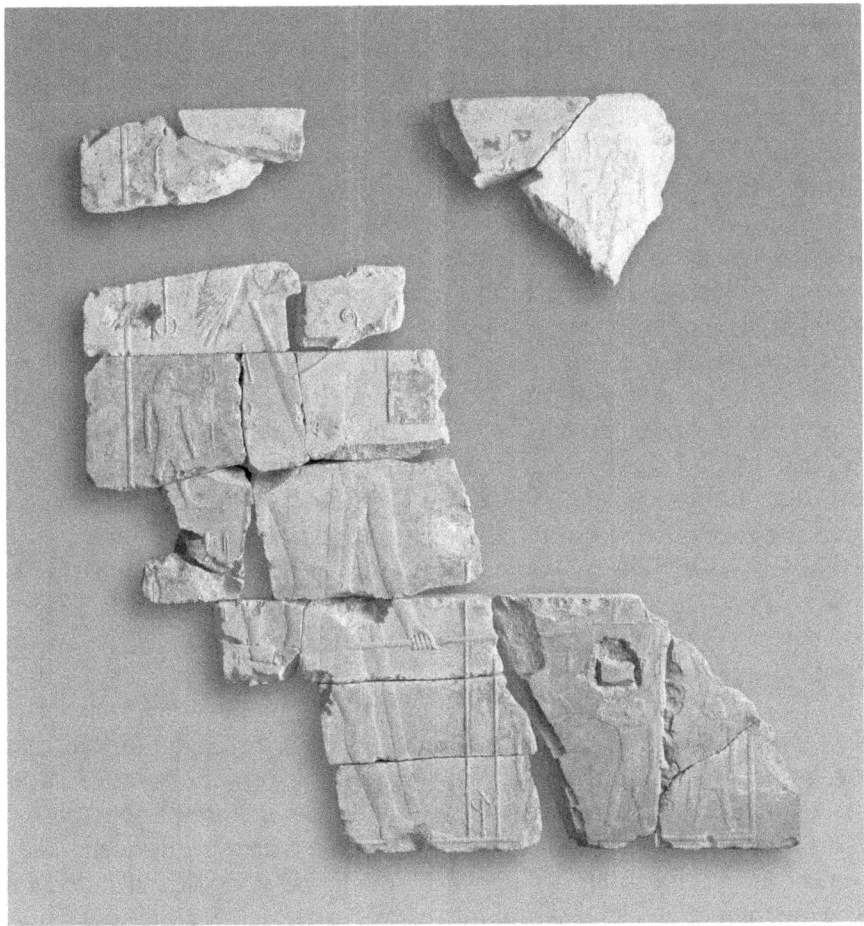

Fig. 2.7. Reliefs from the pylon of the Palace of Apries, Memphis, c. 6th–5th century BC. Limestone; H. 222 cm; W. 208 cm; D. 11.5 cm. New York, Metropolitan Museum of Art 09.183.1a1–23. Image in the public domain.

Period date (Morkot 2003, 85). It is especially interesting to note that among the hieroglyphic inscriptions on these blocks the cartouches are empty. Empty cartouches also occur in temple reliefs in the Ptolemaic and Roman Periods, where they are understood to refer to kingship generally rather than to a specific pharaoh (Spieser 2010, 6). Thus this façade should not be regarded as being unfinished; rather it seems that the empty cartouches mark the royal function of the building.

The Palace of Apries was clearly a major feature of the landscape of Late Period Memphis. At least from the reign of Apries onwards it was the primary locus of political power in the city. Furthermore,

according to Herodotus (2.154.3), Amasis moved Greek mercenaries from their camps in the Delta to Memphis as a safeguard against his Egyptian rivals. Indeed, the Palace of Apries is also easily construed as a fortress as well as a palace (Smoláriková 2003). It continued to serve these political and military functions under Achaemenid rule. It is also widely believed that the palace served as the seat of the satrap of Egypt, and there is some archaeological evidence to support this view. Petrie (1909b, 11–12; Petrie et al. 1910, 41–2) reported finding several objects indicating 27th Dynasty usage. These include a sculptural fragment of a cartouche, which (although bearing no carved text) preserves the beginning of Cambyses' name in paint, a fragment of limestone with an Aramaic graffito reading 'on the first of Ab, year 2 of Artaxerxes' (TADAE D12.2; Petrie 1909b, 12–13, pl. 13; Lemaire 1987, 52–5), fourteen bilingual wooden tags with Aramaic notations on one side and Demotic on the other, forty-seven bullae bearing impressions of seals (a good number of which clearly resonate with Achaemenid glyptic) and military equipment in the form of bronze and iron scale armour and some arrowheads. All this material bespeaks an Achaemenid imperial presence in the palace and raises interesting issues.

The cartouche, which Petrie identifies as having once been part of a statue, might just as well have been a fragment of the palace's furnishings. Either way, it is notable given the relative rarity of occurrences of Cambyses' name in Egypt. It may be that despite Cambyses' only brief tenure in Egypt the palace underwent some redecoration in order to properly recognise the current pharaoh during his reign. The Aramaic graffito (Fig. 2.8) consists of two identical texts, one roughly incised and the other written in ink. According to Petrie (1909b, 12) the incised text is a copy of the ink one, though he provides no explanation for this judgement. It might have been made by a craftsman during repair work or renovation done to the palace during the course of the fifth century. However, it is also possible that it represents some form of scribal practice. A. E. Cowley (in Petrie 1909b, 12–13) remarks that 'the inked writing does not seem to have been done by a person who was really familiar with the character. It looks as if he had tried to imitate the writing of a document dated in the reign of Artaxerxes II.' This date (19 August 403 BC) is supported by the graffito's palaeography (Lemaire 1987, 54). The implication of Cowley's assessment is that someone unfamiliar with Aramaic was learning how to reproduce date formulas. If so we may have evidence for an Egyptian scribe (or indeed any non-native Aramaic speaker) receiving training as part

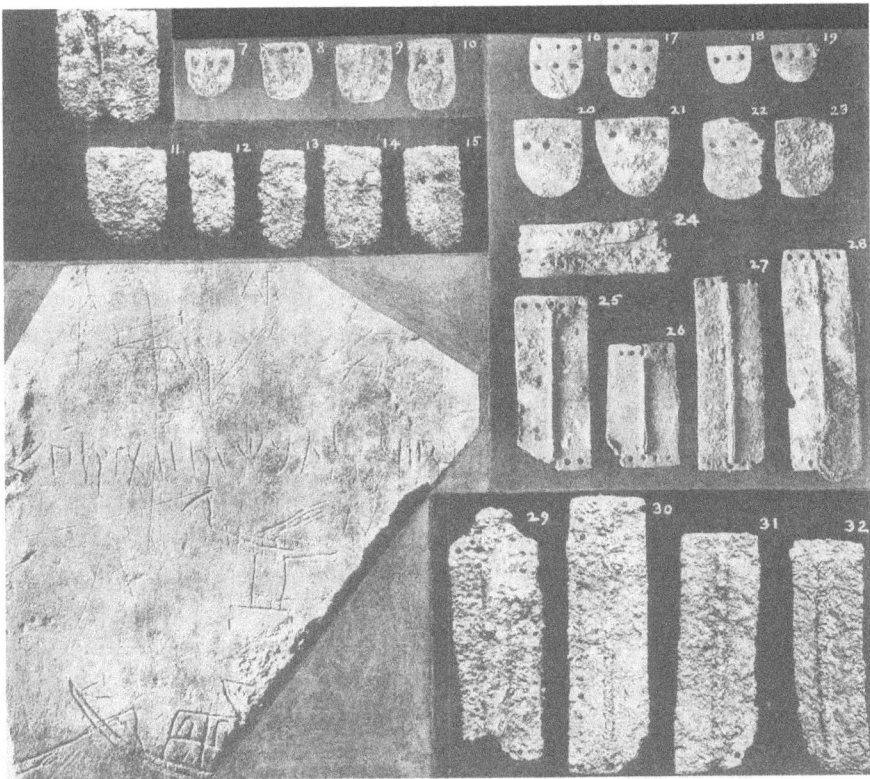

Fig. 2.8. Aramaic graffito and bronze and iron armour scales from the Palace of Apries, Memphis. Image in the public domain from Petrie (1909b, pl. 16).

of working for the satrapal administration in the Palace of Apries. The limestone fragment also features incised doodles of an ibis and a boat (Lemaire 1987, pl. 3), further suggesting the idea that it was a practice writing surface of some kind.

The other objects found in the palace attest to two important aspects of Achaemenid rule at Memphis, namely the empire's military presence in the city, and the nature of the imperial administration there. These aspects are both examined in detail below.

Military presence

The scale armour was discovered in a back room of the palace (on the east side of New Broadway), and the metal arrowheads by the moat at the front of the palace (Petrie 1909b, 13; Petrie et al. 1910, 41; Knobel et al. 1911, pl. 20). Petrie attributed the scale armour (Fig. 2.8) to the Achaemenids on the basis of a passage in Herodotus

(7.61.1) describing the Persians in Xerxes' army as wearing armour 'looking like the scales of a fish'. This description cannot, however, be taken at face value. Elsewhere Herodotus seems to contradict himself, stating in one passage that Persian infantry wore no armour (9.62.3, 9.63.2), and in another that they wore the 'Egyptian cuirass' (1.135.1), probably made of linen, in battle (Charles 2012). Despite the inconsistencies of his testimony on this matter, Herodotus's characterisation of Persian scale armour at 7.61.1 does find reinforcement from the Achaemenid heartland. Similar scale armour to that recovered from Memphis (specifically the metal scales themselves) has been found at Pasargadae (Stronach 1978, 181; Muscarella 1988, 212) and Persepolis (Schmidt 1957, 100). Although this armour is somewhat generic, it definitely does not reflect the traditional Egyptian or Greek panoplies (de Backer 2012). Thus its appearance at the Palace of Apries most probably reflects the presence of soldiers equipped with gear linked to Achaemenid imperial usage. The arrowheads (Fig. 2.9) are typologically more varied, but among them are several trilobate examples which again have close parallels in finds from Pasargadae (Stronach 1978, 180–1; Muscarella 1988,

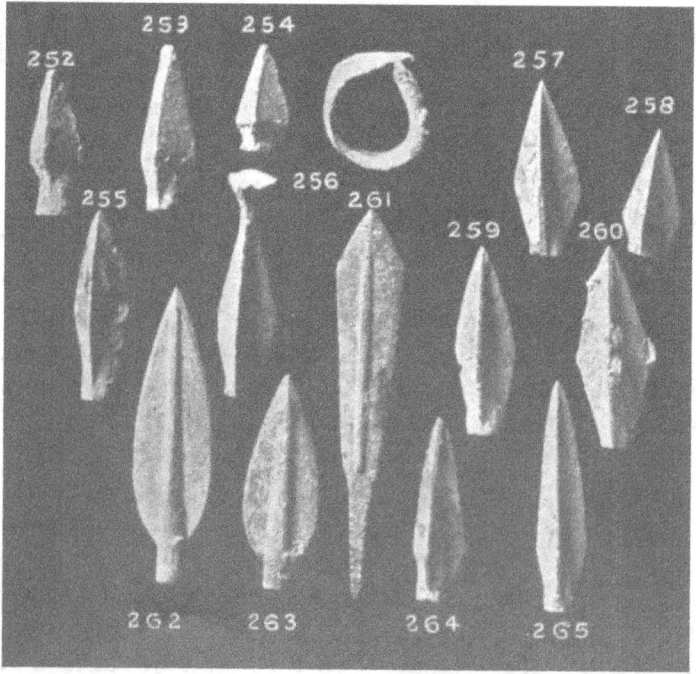

Fig. 2.9. Arrowheads from the Palace of Apries, Memphis. Image in the public domain from Knobel et al. (1911, pl. 20).

212–13), Persepolis (Schmidt 1957, 99) and Susa (Ghirshman 1954, 31–2), as well as from the Persian Period cemetery at Deve Hüyük in Syria (Moorey 1980a, 64–6). This evidence suggests that trilobate arrowheads were the standard equipment for bowmen in the Achaemenid imperial forces.

We cannot be certain of the ethnic origins of those who wore this armour or used these arrows found in Memphis. But Herodotus's description of Xerxes' army suggests that there was considerable variation in equipment among the contingents from different parts of the empire. The representations of delegates from the subject lands of the empire depicted on the façades of the Apadana at Persepolis show men dressed in distinctive garments and bearing a variety of weapons, including shields, swords, daggers, spears, bows and battle-axes (Schmidt 1953, 85–90; 1970, 145–58; Root 2011, 433–40). To the extent that they reflect actual military accoutrements of distinct peoples of the empire, these reliefs reaffirm Herodotus. As discussed above, Petrie identified the large enclosure to the southeast of the palace as a military camp (admittedly on textual rather than archaeological grounds). If this identification is correct it stands to reason this was where the garrison was stationed.

The palace itself may have doubled as a fortress. Its architecture resembles that of Achaemenid Period forts from other parts of the empire, such as at Ashdod in Palestine (Tal 2005, 80–1). This is not to suggest that the palace was actually constructed as a fort by the Persians, though it is possible there were renovations to that effect made in the fifth century. But according to Herodotus (2.154), Amasis had brought Greek mercenaries from the Nile Delta to Memphis in order to protect him from his Egyptian enemies, and the palace became a fortified garrison as a result, before the arrival of the Persians (Smoláriková 2003). The evidence presented here suggests that the palace continued to function as such under Achaemenid rule, though the 'Tyrian camp' to the south of the temple of Ptah was potentially another locus of military activity in Memphis.

It may even be possible to gauge the size of the Persian garrison. Herodotus (3.91.1), in his list of the satrapies of the empire and the tribute paid by each, adds the detail that the Egyptians provided 120,000 measures of grain per year for the support of the Memphis garrison. In theory this should be a useful basis for a population estimate. Unfortunately, it is not actually clear what unit of dry measure he is referring to in this passage. Previous estimates of the size of this garrison have been suggested based on Herodotus's figure using the Attic *medimnos* (Hignett 1963, 41 n. 5; Ray 1988,

269).[3] Another possibility, which has not been considered before, is the *artaba*, a Persian measure introduced to Egypt in the 27th Dynasty and retained in subsequent periods (Vleeming 1981). This is an attractive alternative, because the Memphis garrison's rations were most likely measured in *artabai*, and Herodotus's source for this information probably reflected the use of this measure.

Two sizes of *artaba* are known from the Ptolemaic Period: one consisting of 40 *choinikes* (hereinafter χ), and one consisting of 30 χ (Depauw 1997, 166–7). The 40 χ *artaba* is a modified, half-sized version of the *ḥ3r*, an older Egyptian unit of dry measure, whereas the 30 χ *artaba* derives from a Persian measure attested in both the Persepolis Fortification Archive (Elamite *irtiba*) and the Aramaic documents from Egypt (*'rdb*) (Vittmann 2004, 137–8; Tavernier 2007, 449–50). Presumably the Persian administration in Memphis would have used this 30 χ *artaba*. The Ptolemaic *choinix* equals about 1 litre, making this *artaba* approximately 30 litres. This amount is supported both by the known quantities of the constituent parts of the *artaba* as specified in the Persepolis Fortification Archive, and by inscribed cosmetic jars from Persepolis (Schmidt 1957, 108–9) and Egypt (Ritner 1996) respectively that are labelled with the amounts they hold (Vleeming 1981, 542–3; Chauveau 2018). Thus, if the 120,000 measures of grain Herodotus refers to are in fact *artabai*, and if they are *artabai* of 30 χ, the Memphis garrison received 3.6 million litres of grain per annum.

This figure can be used to determine the size of the garrison. According to Herodotus (7.187.1) soldiers in Xerxes' army received 1 χ per day in grain, which is very similar to the grain issued to workers in the Fortification Archive (Tuplin 2018, 103 n. 21). Based on this ration the Memphis garrison consisted of no more than 9,863 men, but this number should be lowered to accommodate the higher amounts typically received by ranking officials as wages. Assuming that one third of the garrison received on average double wages (an assumption based on a wage calculation problem in the Rhind Mathematical Papyrus; see Kemp 2006, 176–9), the entire troop presence would not have exceeded 7,397 men. The fodder necessary for animals would also lower this calculation of the garrison's total human population, if their fodder was included in Herodotus's figure. Families, if present, were, however, probably not supported

[3] Ray is not explicit about whether or not his calculations are based on the *medimnos*, but I can find no other logical basis for his estimate. Herodotus simply uses the word σῖτος in the genitive.

by official rations, and therefore would not affect the population estimate. Taking all of these factors into consideration, an estimate of some 7,000 men in the garrison is reasonable.

A reference in the Aramaic papyri from Saqqara to the 'fields of the garrison' suggests that these soldiers might have been assigned plots of land (Segal 1983, no. 31; Wesselius 1984). Through the yield of these plots they would have been expected to enhance their official food allocation, as was the case at Elephantine. If so, it might be possible to suggest a higher figure. This, however, is unnecessary. Based on the model provided by the Persepolis Fortification Archive, the grain supplied to the members of the garrison at Memphis should be regarded as wages rather than rations; in essence they were paid only while on active duty. Otherwise they had usufruct of these fields, and presumably rented them out, using the proceeds to support their families and to improve their own social and economic standings within their communities (Dusinberre 2013, 85–93). This interpretation is supported by another Aramaic papyrus from Saqqara which indicates that the fields were taxed (TADAE B8.10; Segal 1983, no. 16). And one of the primary means for the pharaoh to exploit the agricultural wealth of Egypt was to assign farmland to soldiers in lieu of issuing rations (Hdt. 2.168; Lloyd 1983, 309–10; Fischer-Bovet 2013). The Great King utilised a similar system in Babylonia, where land was categorised as 'bow land', 'horse land' or 'chariot land' depending on what type of soldiers were farming it (Jursa 2009; 2011).

The actual composition of this garrison was no doubt quite varied. Herodotus notes that the garrison was comprised of the Persians and their allies or auxiliaries (ἐπίκουροι in Greek). A Demotic letter found at Saqqara (EES S.H5–DP 269 + 284), dated on palaeographic grounds and the addressee's seemingly Persian name to the fifth or fourth century BC, is addressed to the 'chief of the army' (Smith and Kuhrt 1982; Schmitt 1985; Tavernier 2007, 253). This is probably a reference to the garrison commander rather than the overall commander of Persian military forces in Egypt, since this latter role was generally assumed by the satrap himself. Of course, the commander's Persian name does not mean the commander was Persian by birth, though it does suggest an affinity with the Persians. Another Demotic papyrus from Saqqara (EES S.H5–DP 419) refers to a 'garrison commander' whose name, '*Tḥmtrpm*', may be Persian (Smith and Martin 2009, 49–51). It is likely that many of the soldiers stationed in Egypt were drawn from throughout the empire. Some may have been Phoenicians, as suggested by the name of the 'Tyrian camp' mentioned by Herodotus (2.112). And it is well known that the empire employed

Jews as soldiers in Egypt, most notably in Elephantine but also in the Delta (Kaplan 2003, 7–8). Foreign communities in Egypt had already provided soldiers to the Saite pharaohs before the Persian conquest, and it is clear that they continued to do so under Achaemenid rule.

One final object worth considering in the context of the military function of the Palace of Apries is the sling bullet discovered by Petrie (1909b, 11) inscribed with the name of Khababash in Demotic. Khababash is now generally understood to have led a partially successful revolt against Achaemenid rule during the Second Persian Period (Burstein 2000; Wojciechowska 2016, 19–20, 75–9). Sling bullets inscribed in Greek, which are more common and better known than Egyptian examples, usually feature an exclamation such as 'victory' or 'take that', or the name of the ruler or city who provided the bullet (Guarducci 1969, 516–24). So while very little is known about the circumstances, events or extent of his revolt, this bullet raises the intriguing possibility that the palace was assaulted by Khababash's forces. If the palace served the same functions during the Second Persian Period as it had in the fifth century, it is not surprising that Khababash attacked this locus of pharaonic authority and military might. It is worth noting as well that there were several coups and deposition of rulers during the tumultuous years of the fourth century in Egypt. Khababash's revolt, though aimed at Achaemenid rule, fits this pattern of political instability. So his attack on the Palace of Apries would have been inspired at least as much by its association with generic pharaonic power as with any manifestation of Achaemenid imperial authority.

Administration

The evidence from the Palace of Apries for the imperial administration in Memphis consists of clay sealings and wooden tags. According to Petrie (Petrie et al. 1910, 41) all fourteen of the tags and thirty-nine of the sealings constituted 'the sweepings of an office that had existed in the upper part of the building', implying that they had all been found together in a secondary context. Both the tags and the sealings were transported to the Ashmolean Museum and subsequently lost during the Second World War, with the result that they now only exist in the form of Petrie's initial publication of them (Garrison and Root 2001, 35–6).[4]

[4] Two of the tags, Petrie's C and H, remained in Cairo, but their whereabouts are currently unknown. One sealing from the palace, MPS 46, is currently in the collection of the Petrie Museum at University College, London (UC58385).

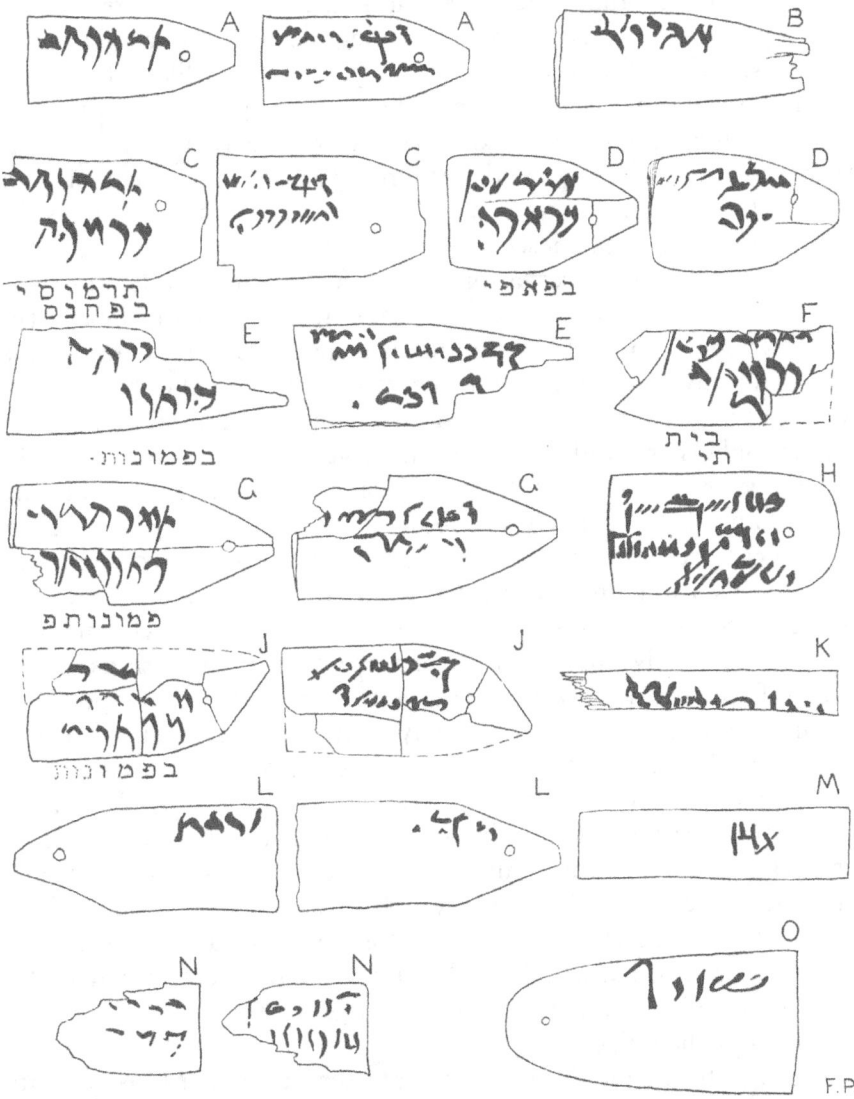

Fig. 2.10. Drawings of the wooden tags from the Palace of Apries, Memphis, with Aramaic and Demotic inscriptions. Image in the public domain from Petrie et al. (1910, pl. 34).

The tags (Fig. 2.10) consist of thin strips of wood that taper at one end and have holes for tying them to other things. The largest of them are approximately 7 cm in length and 3 cm across, but there is little uniformity among them in terms of size and shape. Each has an inscription written in black ink, with Demotic on one side and

Aramaic on the other. The inscriptions are very poorly preserved, to the point that most of them are illegible in the published photographs, but on the basis of their lengths it seems likely that each contained the same information in both languages. They appear to contain dates (some names of months can be read), and on the Aramaic sides of tags A and C there appears to be the word for 'beans'. In the Demotic on C and F Vittmann (2009, 106) reads the Egyptian names 'Tremenese' and 'Tefnakhte'.

Given their poor preservation it is difficult to make much of these tags. They bear some physical resemblance to mummy labels, the small wooden dockets containing the name and parentage of a deceased individual, and in some cases information about where the body was to be shipped or a religious formula. Demotic (and Greek) mummy labels are well known in the Ptolemaic and Roman Periods, and a few Aramaic ones, both wooden and ceramic, have been found at Elephantine (Lozachmeur 2006, nos. E1–5) and Saqqara (TADAE D17.1–5; Porten and Gee 2001, 270–1). The use of wooden tags, however, was not limited exclusively to mummies; they were also used to label other items and as a medium for writing accounts and receipts, especially during the Ptolemaic and Roman Periods (Worp 2012). Though it is possible the tags from the Palace of Apries are mummy labels, it is far more likely that they were administrative documents instead, especially if the reading of the Aramaic word for 'beans' is correct. The clay Aramaic tablets in the Persepolis Fortification Archive (similarly written in ink) exhibit a comparable terseness, often featuring only a date or a single word (Azzoni and Dusinberre 2014, 1–2). Moreover, the use of wood as a writing surface for administrative texts written in Aramaic is attested in Bactria as well (Henkelman and Folmer 2016). Certainly, it is difficult to conceive of a reason why mummy labels would be purposefully kept at the palace.

In the Achaemenid Empire Aramaic served as a means of communication between regions where different languages were in use, including Egypt. This is usefully illustrated by the letters of Arshama, the satrap of Egypt in the second half of the fifth century (TADAE A6.3–13, D6.3–14; Driver 1957; Tuplin and Ma 2013). These parchment letters, now in the Bodleian Library in Oxford, are without provenance, but they were purchased as a lot along with the leather sack holding them and sealed clay bullae clearly part of the assemblage (Allen 2013). It can be deduced from their content that the letters were written at a time when Arshama was absent from Egypt. In them he communicates with his subordinates in Egypt on a variety

of topics, including the management of his own estates in Egypt, the restoration of land grants following an insurrection, and troop discipline. One of them, TADAE A6.9, is a document authorising his subordinate Nakhthor to draw rations on a trip from somewhere in Mesopotamia or Iran to Egypt. All of these letters are written in Aramaic, and the implication is that in Egypt, as well as along the road through northern Mesopotamia and the Levant, there were individuals capable of reading this language.

The use of Aramaic on the wooden tags suggests this was also true of the Palace of Apries. Furthermore, the combination of Aramaic and Demotic shows that these tags were meant to be intelligible in both local Egyptian and larger Achaemenid imperial contexts. This reinforces the impression that Achaemenid administration in Egypt was bilingual in nature, a view supported by parallel cases from elsewhere in the empire. For example, both Aramaic and Elamite were used at Persepolis on the tablets of the Fortification Archive; indeed, many of the Elamite tablets (inscribed in cuneiform with a stylus) feature Aramaic glosses written in ink.

This bilingual character is evident in the sealings as well. Petrie found thirty-nine of these sealings (MPS 1–39) in the same context as the wooden tags discussed above, and five more (MPS 42, 46, 47, 50 and A1) in other contexts in the course of excavating the palace (Figs 2.11, 2.12, 2.13).[5] According to his report, the backs of MPS 1–39 indicated they were from 'parcels' rather than papyri. Presumably this means that the reverses bore impressions of strings, but not the crosshatching characteristic of papyri. Unfortunately, Petrie published no photographs of their reverses. It is clear, however, that MPS 46 (the sole surviving bulla) was once affixed to a papyrus. Whether the entire assemblage of Memphis sealings was once attached to parcels or documents, or a mix of both, they are certainly remnants of an administrative operation.

To assess what role these sealings played in the administration of the satrapy it is important to characterise how sealed bullae operated more generally within the social and administrative traditions of Egypt. Sealings were normally attached to five different categories of object: bags, boxes, papyri, pegs (usually as part of a door) and jars; they were also sometimes not attached to anything (Smith 2018;

[5] For the sake of clarity and ease of reference Petrie's numbering is retained here, designated with the siglum 'MPS' (for 'Memphis Palace Seal'). The numbering is discontinuous because Petrie included other sealings not explicitly from the palace in his publication, and MPS A1 is so labelled because it was published separately from the others, in Petrie 1909b, pl. 15.

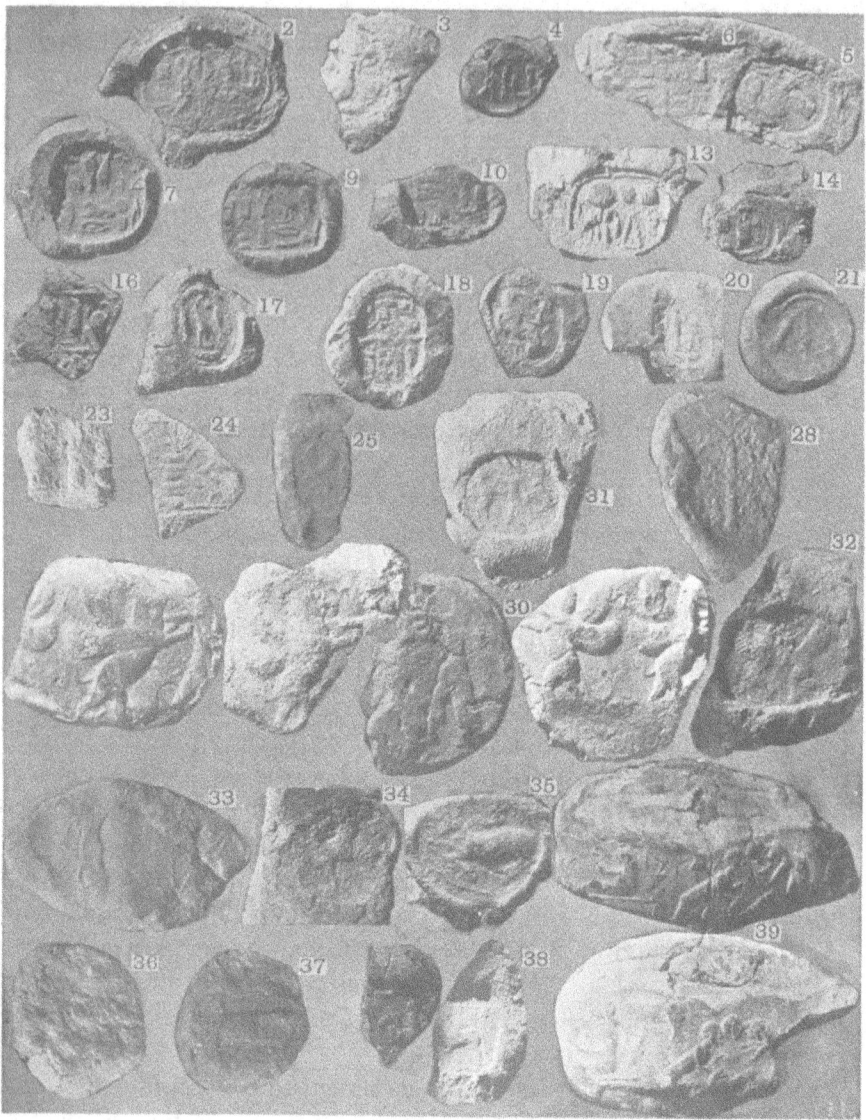

Fig. 2.11. Bullae from the Palace of Apries, Memphis, featuring seal impressions. Image in the public domain from Petrie et al. (1910, pl. 35).

Wegner 2018). Papyrus documents of all kinds were normally folded and trussed with string upon which clay was superimposed to form bullae, which were then impressed with seals (Porten 1979; Vandorpe 1996). In general, sealings served two purposes. First, as on clay tablets, they certified that the people who sealed the document were present for the transaction or agreement it recorded; this especially

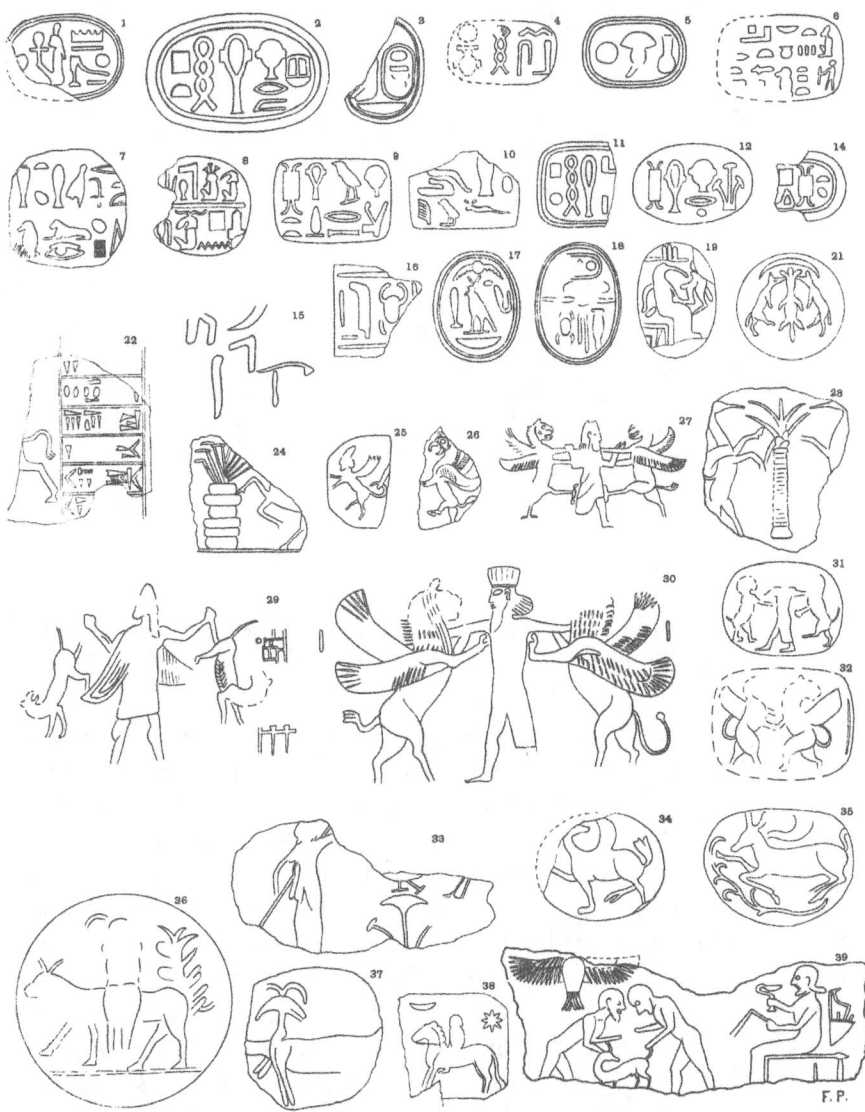

Fig. 2.12. Drawings of seal impressions as preserved on the bullae from the Palace of Apries, Memphis. Image in the public domain from Petrie et al. (1910, pl. 36).

applies to contracts and receipts. Second, as with the clay 'envelopes' sometimes used to encase Mesopotamian cuneiform tablets, the act of sealing folded documents prevented tampering by ensuring that no one accessed the text directly once it had been written.

The reason for sealing of bags, boxes, jars and pegs is much less straightforward, and there is significant disagreement amongst

Fig. 2.13. Additional sealings from the Palace of Apries, Memphis. Images in the public domain from Petrie et al. (1910, pl. 37) and Petrie (1909b, pl. 15).

Egyptologists on this matter. It is frequently argued that such sealings controlled access to the contents of specific rooms and containers (e.g., Wegner 2018). In other words, only individuals of certain ranks had the authority to break certain sealings. It has also been suggested that sealings served an accounting function. For instance, when they were removed from a container or door they may have been stored and then counted in order to keep track of how much of a given commodity was used in a given period and by whom (Smith 2018). These approaches are not mutually exclusive, and in either case it is likely that sealings were retained after their removal for the purposes of record keeping. Finally, they may also have served as tokens of some kind, which permitted the bearer access to certain places or which were redeemable for certain goods.

When the Persians entered Egypt, they encountered a longstanding legacy of seal usage. At the same time, they brought with them their own traditions of sealing, built upon millennia of development within greater Mesopotamia and Elam. Seals and sealing were clearly of great importance in the administration of the entire Achaemenid Empire. This is best seen at Persepolis in the tablets from the Fortification Archive, as well as in other archives and corpora of sealings from elsewhere in the empire (Root 2008; Garrison 2017a; 2017b, 15–116).

In the Fortification Archive approximately 86 per cent of the Elamite tablets are sealed, as are nearly all of the Aramaic and uninscribed documents. The purpose of sealing varied depending on the administrative context. In the case of 'Q texts', for example, which record the issuance of travel rations, the seals of the supplier and the recipient of the goods were normally impressed on the tablet, certifying that both were present for the transaction. In 'T texts', which are letters containing instructions to subordinates, the person issuing the orders sealed the document to authenticate the instructions being given. Given the eschewal of fingernails and other seal surrogates, it seems that most participants in the administrative apparatus from which the Fortification Archive resulted needed to have seals.

A similar pattern of sealing is discernible in the bullae from Daskyleion in Hellespontine Phrygia, the site of a satrapal court (Kaptan 2002). Most of the over 400 bullae were attached to papyri, though some appear to have been affixed to parchment instead, indicating in both cases their use for sealing documents rather than containers or doors. In this respect their function was probably comparable to that of sealing tablets at Persepolis. The same is also true of the handful of bullae preserved in the Elephantine Aramaic papyri (Sayce and Cowley 1906, 45, 47; Sachau 1911, 111; Cooney 1953a). On the whole, the Elephantine papyri relate to personal affairs rather than governmental activities, but some documents clearly do derive from the imperial administration (Briant 2002, 448–50). And they also further support the possibility that the Memphis sealings were attached to papyri.

It is worth mentioning as well that the parchment letters in the Arshama correspondence were contained in a leather bag along with eight bullae (Driver 1957, 3–4; Allen 2013), of which seven bear an impression of the inscribed cylinder seal of Arshama himself (Wu 2014, 228–9, 245–6, 265–6, 273, 289, pls. 4a–b). This seal is now known to have been an heirloom when Arshama used it in the fifth century BC (Garrison forthcoming). It was originally commissioned and used by his eponymous grandfather, the son of Darius the Great and his royal wife Irtashduna (Artystone in Herodotus), and it appears on the tablets of the Persepolis Fortification Archive, which date to between 509 and 493. Memphis is not explicitly mentioned in the extant Arshama letters. But during his long tenure as satrap Arshama must have sent similar letters on parchment to his subordinates there, and he would have sealed them to certify his authority. The other bulla in the bag bears the impression of a stamp seal with a linear design that is poorly preserved and thus difficult to interpret

(Kaptan forthcoming). Further study is required to understand how the combination of bullae and parchment letters (some of which appear not to have been opened in antiquity) in this bag fit into the larger administrative apparatus of Achaemenid Egypt. But it may be that this bag and its contents, including the bullae, were being archived as part of the normal course of imperial business. The sealings from the Palace of Apries were perhaps retained for filing in a similar manner.

Petrie's characterisation of most of the sealings as being from parcels suggests that they were once attached to bags or boxes. Jars or pegs or would have resulted in more distinctive and unusual shapes, on which Petrie would probably have commented. One would also like to think that he would have recognised the imprint of papyrus (though he apparently missed it on MPS 46). If we accept Petrie's assessment at face value, we need to consider what these sealings of parcels were doing in the palace. One distinct possibility is that these sealings, especially MPS 1–39, all from a single context, were associated with the movement of commodities into the palace, or access to them within the palace. The sealings were then retained in order to be tallied or otherwise documented.

Another possibility, and a more likely one, is that some, if not all, of the sealings were indeed attached to documents, specifically parchment documents like the Arshama correspondence. Parchment would create a similar imprint on a bulla to that of a leather bag or 'parcel' as Petrie put it. This very plausible option would attest to imperial communication at the highest level between authorities in Egypt and those elsewhere in the empire, including the royal courts in the Achaemenid heartland. Hides for production of parchment are referenced in Persepolis texts (PF 58–77; Hallock 1969, 97–102), and it is clear that some of the tablets in the Fortification archive must have been attached by string to longer documents written in Aramaic on parchment rolls. The mix of parchment and papyrus documents attested at Daskyleion through the evidence of the reverses of the bullae in that archive suggests, moreover, that the co-existence of parchment documents, endemic to western Asia, and papyrus ones, as per Egyptian scribal traditions, is to be expected in Achaemenid Memphis.

Whether from containers or letters (or a mix of both), the sealed bullae from the Palace of Apries are the product of an imperial bureaucracy. That the Great King remained in regular contact with officials throughout is made abundantly clear by the frequent references in the Persepolis Fortification Archive to people going to and

coming from the king, often bearing sealed documents (Colburn 2013). And the empire's road infrastructure was undoubtedly designed to facilitate this communication. The provisioning of the satrapal headquarters was necessarily another important imperial activity. In this connection it is interesting to note that the sealed bullae found in the Persepolis Treasury also appear to have been originally affixed to parchment or papyrus documents (Cameron 1948, 26–9; Schmidt 1957, 5–7, pls. 2, 4–14). Many of the clay tablets from the Treasury refer to the disbursement of rations and wages, and it is not difficult to conceive of the Memphis bullae operating in some comparable manner. In this imperial bureaucracy seals served as proxies for individuals who were personally responsible for overseeing and directing operations at all levels, from provisioning up to making policy. In many instances seals also served as proxies for individuals who were witnesses to and participants in the recorded transactions and agreements.

What information can be gleaned from the Memphis bullae is summarised in Table 2.1. It must be emphasised at the outset that Petrie published only extremely poor photos of some of them, and only sketchy line drawings of others. These images are now the only means of studying the seals that produced these impressions. The meagre documentation makes commentary on the visual content of these sealings very difficult, and commentary on their styles of carving next to impossible. Nevertheless, they provide an invaluable window onto the social environment of the satrapal administration based at the palace. This environment was one in which traditional Egyptian glyptic types co-existed alongside the broader complement of western Asiatic glyptic types that blossomed under the aegis of Achaemenid rule, creating an expansive array of motifs and styles carved on both stamp and cylinder seals.

The MPS numbers refer to seals rather than individual impressions, since Petrie gave MPS 39 and MPS 50 single numbers but noted each was impressed multiple times on individual bullae. In many cases the edges of an image are not preserved in the impression, meaning it is sometimes impossible to be sure what type of seal (stamp or cylinder) created the impression. Scarabs, although technically a type of stamp seal, are identified separately here because of their distinctive shape and special significance in Egyptian thought. The translations of the inscriptions are taken from Petrie's publication, except where noted.

These seals exhibit a variety of formal features, some of which are clearly intelligible in an Egyptian cultural context. At least eleven of

Table 2.1 Sealings from the Palace of Apries, Memphis.

MPS no.	Type	Description of image	Inscription
1	Scarab	Cartouche	'Sety' (= Sety I)
2	Scarab	Hieroglyphic inscription	'Ptah protect Heremheb'
3	Scarab	Kneeling figure (?)	'Men-kheper-ra' (= Necho I?)
4	Uncertain	Hieroglyphic inscription	'the health of Apries'
5	Scarab	Cartouche	'Apries'
6	Uncertain	Hieroglyphic inscription	'Pedu-neit-nebt-Senu', plus a reference to Thoth
7	Uncertain	Hieroglyphic inscription	'the servant of Bast, Hezer-suten-apt, son of Tahuti-ar-maat', son of Pedu
8	Uncertain	Hieroglyphic inscription	'prophet of Hapi, Thoth, and Khnumu, Pen-Amen'
9	Uncertain	Hieroglyphic inscription	'Neit protect Uza-ran-her-desher'
10	Uncertain	Hieroglyphic inscription	'Zed-bast-auf'
11	Scarab	Hieroglyphic inscription	'Ptah protect Pedu'
12	Uncertain	Hieroglyphic inscription	'Neith protect Hor-kkebt'
13	Scarab	Hieroglyphic inscription	'Ra-mes son of Pedu'
14	Scarab	Hieroglyphic inscription	'Pedu-neit'
15	Uncertain	Aramaic inscription (?)	Too poorly preserved for a reading
16	Uncertain	Hieroglyphic inscription	'Maat-kheper' (probably part of a throne name of Ramesses X; von Beckerath 1999, 174–5)
17	Scarab	Hieroglyphic inscription	'servant of Horus'
18	Scarab	Hieroglyphic inscription	Too poorly preserved for a reading
19	Scarab	Thoth seated with another figure, possibly an ape	None
20	Scarab	King before Ptah	None
21	Stamp	Figural hieroglyphic inscription	'Aahmes' (i.e. Amasis)
22	Cylinder	Creature; Old Persian cuneiform inscription in panel	'Darius' (SD²a)

No.	Type	Description	Reading
23	Cylinder	Old Persian (?) cuneiform inscription in panel	Too poorly preserved for a reading
24	Cylinder	Palm tree; rampant creature	None
25	Stamp	Rampant human-headed winged creature grasped by the tail by another figure	None
26	Uncertain	Rampant griffin	None
27	Uncertain	Hero grasping two rampant griffins by the neck	None
28	Uncertain	Palm tree; two rampant bird-headed creatures	None
29	Uncertain	Hero grasping two creatures (lions?) by the tail; cuneiform in right terminal field	Too poorly preserved for a reading
30	Uncertain	Hero grasping two winged lion creatures by the neck	None
31	Stamp	Hero grasping two creatures (lions) by the neck	None
32	Stamp	Combat between two winged lion creatures	None
33	Uncertain	Hero and a bird (or two) perched on a lotus	None
34	Stamp	Griffin moving left and looking back to the right	None
35	Stamp	Stag	None
36	Uncertain	Bull with rider (?)	None
37	Uncertain	Goat moving left and looking back to the right (?)	None
38	Stamp	Rider with crescent moon and star in upper terminal fields	None
39	Cylinder	Two male figures standing over a goat; in right terminal field is a seated male figure holding whip (or stemmed cup) and flail with bow and quiver of arrows behind him; winged disc (?) in upper terminal field	None
42	Stamp	Hieroglyphic inscription	'servant of Neit, Er-shenu-un-nofer son of Zed-bast-u-ankh'
46	Cylinder	Human-headed bird creature with scorpion's tail and additional bull head and foreleg drawing a bow; winged hero (?) grasping a griffin by the hind leg; lotus border	None
47	Uncertain	Hieroglyphic inscription	'Ra-nefer-ab' (Psammetichus II)
50	Stamp	Man emerging from a snake or dragon	None
A1	Stamp (?)	Hero grasping winged bird-headed creature	None

them appear to be scarabs (or scaraboids), on the basis of the ovoid shapes of the contours of their impressions. The scarab, specifically a stamp seal in the shape of a scarab beetle, had a long history of use in Egypt, in large part because of the symbolic importance of the scarab beetle within an Egyptian religious context (Ward 1994). Two of these scarabs also feature images of Egyptian gods: Ptah, the chief god of Memphis (MPS 20), and Thoth, god of wisdom to whom the ibis and the baboon, two of the animals entombed at Saqqara, were sacred (MPS 19). Twenty of the seals feature hieroglyphic inscriptions, many of which are personal names (sometimes as part of an invocation of a god, such as MPS 11: 'Ptah protect Pedu'). Six of these inscriptions name pharaohs: MPS 1 (Sety I), MPS 4 and MPS 5 (Apries), MPS 16 (Ramesses X), MPS 21 (Amasis) and MPS 47 (Psammetichus II). Additionally, MPS 3 names Necho I, who, while not pharaoh, was the father of Psammetichus I and the local ruler of Sais. It is quite probable that many of these seals were antiques, manufactured during the reigns of the rulers they name. They may have been handed down over generations as heirlooms, though this is less likely for MPS 1 and MPS 16, which name New Kingdom pharaohs and are therefore removed from the 27th Dynasty by at least six centuries; probably these two were plundered from tombs. It is also worth considering that when a pharaoh died he became a god, and thus objects naming pharaohs could continue to be made long after that pharaoh's death in connection with his mortuary cult. This is especially notable in the case of Amenhotep I, whose worship remained particularly active in the Theban necropolis for hundreds of years after his death c. 1504 BC (Ward 1994, 189; Hollender 2009).

Others seals attested in the Memphis corpus are seemingly products of Achaemenid glyptic workshops. At least two seals, MPS 22 and MPS 23, feature Old Persian inscriptions. According to Petrie both have the same inscription, which has been read as 'Darius', and it may be that these impressions were made by a single seal (Schmitt 1981, 33–4). At a minimum, then, the bullae attest to at least one royal name seal used in connection with the Memphis administration. This important category of seal occurs at Persepolis in the Fortification and Treasury Archives, as well as at Daskyleion. Based upon the contextual information provided by the Persepolis tablets regarding the use of these seals by specific personages, Mark Garrison (2014, 82–4) has recently argued that these seals were given by Darius I as gifts to high-ranking, non-royal bureaucrats and administrators as a means of integrating them into his still fresh regime.

Another seal, MPS 15, features a fragmentary Aramaic inscription. Unfortunately, it is not preserved well enough to be read. Aramaic was frequently the language of choice for elite Persians whose seals are known from the Fortification Archive. The seal of Arshama is one example; the seals of Parnakka (PFS 9* and 16*), the chief administrator at Persepolis and the uncle (or cousin) of Darius, also both feature Aramaic inscriptions (Garrison and Root 2001, cat. nos. 22, 288; Colburn 2014a, 788–91).

Several of the Memphis seals, both stamps and cylinders, draw on a comparable iconographic repertoire to those in the Persepolis Fortification Archive. Four (MPS 27, 29–31; possibly also MPS 25) feature the heroic encounter motif, which experienced a distinctive upsurge in prominence around 500 BC, especially in the context of Persepolitan glyptic (Garrison and Root 2001; Garrison 2010). Indeed, the resonance of this imagery was widespread, extending, for example, to Sardis (Dusinberre 1997; 2003, 158–71) and Daskyleion (Kaptan 2002, 55–73) in the western reaches of the empire. Three of these heroic encounter seals from Memphis (MPS 27, MPS 29, MPS 30) have heroes with long hair and beards, which are uncommon in Egyptian representations (save for depictions of foreigners). Three seals (MPS 27, MPS 30, MPS 31) feature the 'Assyrian garment', a robe worn wrapped around the body over a short undergarment often with the front leg exposed; again, these are frequent attributes of the heroes that appear on the Persepolis seals (Garrison and Root 2001, 505, 514–16). Also, the winged creatures that appear on MPS 25–30, 32, 34 and 46 have numerous close parallels at Persepolis.

One of these seals, MPS 25, is a heroic encounter seal that exhibits the telltale octagonal contour characteristic of the class of seals known as pyramidal stamp seals, a significant number of which are attested in the Fortification Archive (Root 1998). Emerging out of Late Babylonian glyptic tradition, this stamp seal shape gains new life in the Achaemenid Empire, deployed not only for images of Babylonian-type worship scenes (where it originates) but also for images of very diverse types, styles and representational motifs including the heroic encounter (e.g., PFS 1463s; Garrison and Root 2001, cat. no. 231). It also occurs at Sardis, Gordion, Daskyleion and here at Memphis, among other places throughout the empire.

The seals attested at the Palace of Apries thus make reference to at least two different glyptic traditions: the Egyptian tradition of hieroglyphic inscriptions and scarabs, and the broad corpus of Achaemenid visual and inscriptional motifs, especially the heroic encounter. In his initial publication of the sealings, Petrie (Petrie et

al. 1910, 42–3) also identified several of the seals (MPS 33–9 and MPS 50) as Greek. This uncritical identification reflects a deeper methodological issue, namely the assumption that the ethnic context of an object can be read from cultural referents made by its motif, iconography or style (Gates 2002). In other words, that these seals looked Greek to Petrie says more about the intellectual climate of Petrie's day than it does about where or by whom these seals were made, or who owned and used them. In this case it is entirely possible that these seals were made or used by Greeks (as Petrie would have it). There was, after all, a permanent community of Greeks residing in Memphis by the late sixth century BC (Colburn 2018a, 83–5). The seals preserved in the Persepolis Fortification and Treasury Archives demonstrate the wide range of motifs and styles that the seal carvers of Persepolis were capable of creating, and it is at least equally plausible that some of the seals identified by Petrie as being Greek were produced at Persepolis.

Likewise, the context of a seal's production does not guarantee the ethnic identity or geographic origin of its owner. For example, the seals inscribed with names of Egyptian pharaohs (MPS 1, MPS 3–5, MPS 16, MPS 21, MPS 47) make obvious reference to Egyptian cultural memory and have special importance in Egyptian religious and historical contexts. But the names Psammetichus, Necho and Amasis all occur in various capacities at Persepolis as well. Fragments of eight stone objects (probably tableware) bearing cartouches naming these pharaohs were found in the Treasury, as was part of a statue base inscribed with a cartouche of Necho (Schmidt 1957, 68, 83). Nicholas Cahill (1985) has argued that gifts to the royal court from throughout the empire were stored in the Treasury. The stone vessels (and the statue fragment as well) should be included among these gifts, either as diplomatic gifts dating to before Cambyses' invasion, or as ceremonial gifts given by the Egyptians as an act of imperial participation. In either case these cartouches may have made these vessels suitable as gifts to a king, and they also attest to a familiarity with or interest in the Saite pharaohs at Persepolis.

This interest also occurs in the form of a cylinder seal, PFUTS 136* (Fig. 2.14), known from nine impressions on uninscribed tablets from the Fortification Archive, which features a cartouche of Amasis topped with ostrich feathers (Garrison and Ritner 2010, 28–33, 47–9). The imagery of the seal draws on motifs well known in the Fortification Archive, especially the heroic encounter and the use of the Assyrian garment, albeit with some deviations. Nonetheless, it does seem to be a product of a Persepolitan glyptic workshop.

Fig. 2.14. Composite line drawing from impressions of PFUTS 136* (drawing by M. B. Garrison). Courtesy of the Persepolis Seal Project and the Persepolis Fortification Archive Project, the Oriental Institute of the University of Chicago.

Since it is known only from impressions on uninscribed tablets it is impossible to date it precisely, but it is unnecessary to assume this seal was carved while Amasis was still alive; the stone vessels from the Treasury attest to interest in the Saite pharaohs at a time when they were all long dead.

Three other seals of Achaemenid date also feature hieroglyphic inscriptions naming Saite pharaohs. One of these, a cylinder seal with the name of Amasis, is now in the British Museum (ME 89585; Merrillees 2005, no. 56; Giovino 2006, 105–7). It has no known provenance, but its motif (the heroic encounter) and its formal features (especially the hero wearing the Achaemenid court robe) make it a likely product of a Persepolitan workshop. The inscription on this seal is not enclosed by a cartouche, and the implication is that it refers to the seal owner's name, rather than the pharaoh; Amasis (or 'Ahmose') is a fairly common name in Egypt between the Middle Kingdom and the end of the Ptolemaic Period (Ranke 1935, 12). If the seal was indeed produced at Persepolis, it may be that Egyptian name-writing conventions were ignored or not understood. There is also a cylinder seal with a cartouche naming Apries that was once in the collection of the Comte de Caylus but is now lost (Giovino 2006, 110–12). The seal is known from a drawing published by de Caylus in 1761, and features a heroic encounter involving an apparently clean-shaven hero wearing the Achaemenid court garb. The cartouche is part of a larger inscription giving a basiliphoric name meaning 'Apries is one protected by Ptah' (Garrison and Ritner 2010, 48–9); this may be the name of the seal's original owner.

The third seal, MPS 21, is known only from its impression preserved

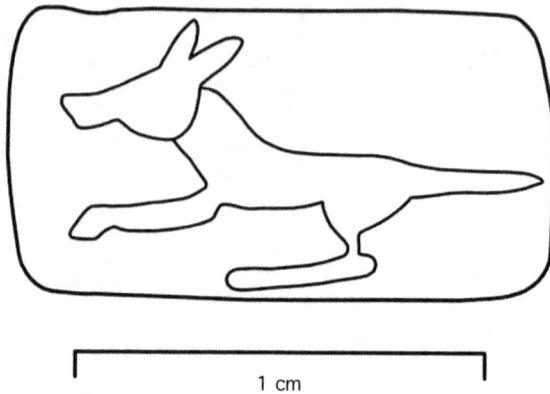

Fig. 2.15. Composite line drawing from impressions of PFATS 184s (drawing by E. R. M. Dusinberre). Courtesy of the Persepolis Fortification Archive Project, the Oriental Institute of the University of Chicago.

on one of the Memphis bullae. It is a circular stamp seal featuring a lunette (the sign *iʿḥ*) over two foxes flanking a splayed fox pelt (*ms*), spelling *iʿḥ-ms* ('Amasis'). The presence or absence of a cartouche is unclear in this case, since the edge of the seal essentially encloses the image. The normal hieroglyph for *ms* consists of three stylised fox pelts tied together at the top; the full-bodied foxes depicted on this seal are unknown in Egyptian art. They are, however, paralleled by seals attested at Persepolis and Daskyleion. The Aramaic tablets from the Persepolis Fortification Archive preserve impressions of a seal, PFATS 184s (Fig. 2.15), that features a full-bodied fox running to the left (Dusinberre forthcoming). Similarly, a seal impressed on the bullae from Daskyleion, DS 79, shows a horseman riding to the left with a hand upraised, and a fox running to the right (Kaptan 2002, 101–2).

This seal was produced by an artisan working outside of normal Egyptian epigraphic and glyptic conventions for a patron adequately familiar with hieroglyphics to specify and appreciate this inscription. This familiarity could result equally from a knowledge of Egyptian or from exposure to this name at Persepolis through the objects discussed above. This patron could have been an Egyptian, perhaps one named Amasis, who commissioned this foreign-looking seal because he did not construct his personal identity solely in Egyptian terms and desired to invoke the prestige of his affiliation with court circles. Or he could instead have been a non-Egyptian familiar with the hieroglyphs for Amasis who wished to demonstrate a knowledge of or connection to this important satrapy. It is even possible that he

was a Persian whose name was Amasis, such as the general named by Herodotus (4.167.1) as the leader of the expedition dispatched by Aryandas to attack Barca in Libya (Colburn forthcoming b). The fact that an impression of this seal ended up in the Palace of Apries in Memphis leaves open all three possibilities and illustrates further the kind of interaction that took place in the visual culture of the empire.

Indeed, there is more than just the co-existence of different visual repertoires among the seals revealed by the Memphis bullae. There is also clear evidence for the combination of elements drawn from these repertoires on the part of certain individuals. This is best illustrated by MPS 46. The single impression of this seal preserves two scenes. The composition of one figure, a winged human holding a griffin upside down by its hind leg, occurs in the seals of the Persepolis Fortification Archive, such as PFS 1* and PFS 684 (Garrison and Root 2001, nos. 182–3). This figure wears the Persian court robe, represented by vertical bands on either side of the torso, another feature frequently attested in the Fortification Archive, especially in connection with the 'Court Style', which is more properly a suite of iconographic and stylistic features than it is a style of carving in the strictest sense (Garrison 1991, 13–20; Garrison and Root 2001, 18–19, 515–16). In this respect the seal is very much at home at Persepolis, where it would probably have been owned and used by an elite member of the local bureaucracy and royal court.

The other figure is a composite creature drawing a bow. This creature has the body of a fish, the legs and tail of a bird, a scorpion's stinger, the head and torso of a man and the head and foreleg of a bull extending from the front of the bird's body; the creature also wears a dentate crown. Composite archers of this sort also occur at Persepolis, and the combination of bird and scorpion in particular appears in PFS 78 and PFS 118 (Garrison 2000, 136–40). The fish body, however, most evident in the tail fin, is very unusual in Achaemenid glyptic. Its closest parallel is in Urartian art of the ninth to seventh centuries BC, where composite creatures combining the features of birds and fish, as well as those of other animals and humans, are depicted in metalwork, especially bronze belts (Eichler 1984, 41–2). The significance of these composite creatures remains unclear, as does their appeal for an Achaemenid audience. Yet the occurrence of this combination of animal features on a sealing from Memphis would suggest not only that this aspect of Urartian art had survived into the Achaemenid Empire, but also that the empire had disseminated it far outside the Urartian heartland in what is today eastern Turkey.

MPS 46 also features a very particular motif going back ultimately to an Egyptian origin: the lotus and bud border preserved at both the top and bottom of the image. Individual lotus flowers held by court personages including the king are a significant iconographical element in the relief sculptures of Persepolis. But repeating bands of lotuses and buds do not occur on any seals from the Persepolis Fortification or Treasury corpora. The only representation of such a border from Persepolis is on a fragment of a glass vessel found in the Treasury (Schmidt 1957, 92, pl. 66.2). It does, however, occur on one glazed tile pattern of Achaemenid date from Susa (Louvre Sb 3336; Harper et al. 1992, no. 158), although here the lotus alternates with a palmette rather than a bud (Fig. 2.16). Despite the abundant reworking of Egyptian architectural decorations on the architecture of Persepolis we do not so far have any vestige of the motif deployed there in a monumental capacity.

The lotus-and-bud motif has a long history in Egypt and thence

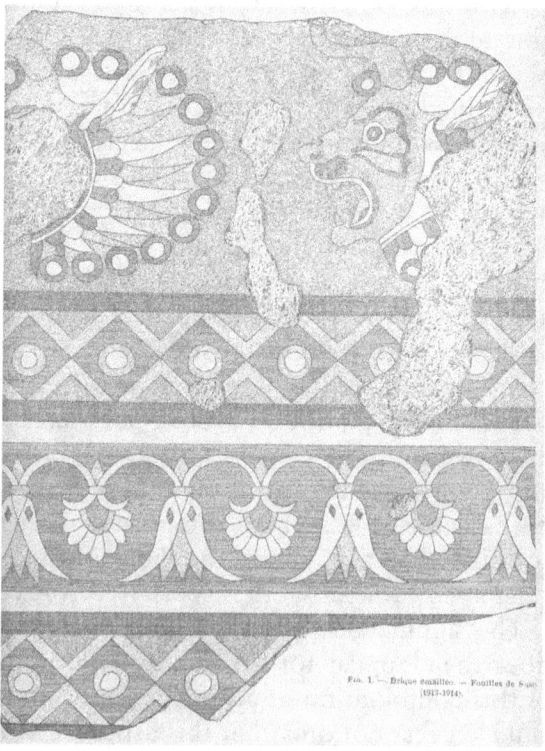

Fig. 2.16. Glazed tile from Susa, Iran, 6th–5th century BC. Siliceous brick; H. 36 cm; W. 31 cm. Paris, Louvre Sb 3336. Image in the public domain from Toscanne (1916, fig. 1).

to northern Mesopotamia (Barnett 1957, 99–101; Rawson 1984, 203–4, 210–12; Colburn 2014b, 111–13). In Egypt, where it must have originated, it first occurs during the New Kingdom. At el-Amarna it is found as a border on wall paintings in the Great Palace and the North Riverside Palace, and it also appears on the walls of private tombs. In the Third Intermediate Period it occurs on various items found in the royal necropolis of Tanis, and on anthropoid sarcophagi as a decorative element, usually as one of several bands of designs framing the face. All of these uses persist into the Late Period.

At some point during the New Kingdom the lotus-and-bud motif was adopted in Phoenicia, where it is best attested on the sarcophagus of Ahiram, king of Byblos, dating perhaps to c. 1000 BC. It then appears on a number of the carved ivories excavated at the Assyrian capital of Nimrud. These prestige ivories, which were inlays for royal furniture and accoutrements, span the ninth to the seventh centuries BC. The motif also appears on some of the ivories found at Arslan Tash, Samaria and Khorsabad, which date to roughly the same period, and on a relief orthostat from the north gate at Karatepe in Cilicia. It even occurs in metalwork, as indicated by the fragments of several bronze *korai* discovered at Olympia which were made of reused bronze repoussé friezes of north Syrian origin, including friezes of alternating lotuses and buds. Finally, it occurs in Neo-Assyrian palaces as a border on both carved stone pavement slabs at Nimrud and Khorsabad and painted murals at Khorsabad, Til Barsip, Nimrud, Nineveh and Dur-Katlimmu. In most of its Levantine and Mesopotamian iterations the lotus buds were represented as cones, reflecting the appearance of the white lotus when its blossom closed at night. A limestone plaque from Susa (Louvre Sb 43), dating to the Neo-Elamite Period (c. eighth–seventh centuries BC), has a border of closed lotus blossoms that closely resemble the Neo-Assyrian examples; moreover, in the commentary on the plaque Oscar White Muscarella (in Harper et al. 1992, 201–2) observes that while the carving belongs to an Elamite tradition the iconography of the image owes much to Neo-Assyrian art.

On the basis of this brief review it is possible to reconstruct the transmission of the lotus-and-bud motif from New Kingdom Egypt, where its use in funerary contexts derived from its symbolic rebirth every morning, to northern Mesopotamia, where it had become part of an international visual *koine* by the eighth century BC. This latter iteration is most probably the context in which it was adopted in the Achaemenid Empire. This is best seen on Seal 100 from Gordion (Fig.

Fig. 2.17. Drawing of the impression of Seal 100 from Gordion. Courtesy of the Penn Museum Gordion Archive, drawing by Elspeth Dusinberre.

2.17), excavated in 1952. This agate cylinder seal (2.4 cm in height) features a worship scene that draws heavily on Achaemenid imperial and religious iconography to represent symbolically the cosmic balance and harmony maintained by the Great King (Dusinberre 2008). The lotus-and-bud border plays into this representation by echoing the lotus blossoms held by the worshippers; at the same time it makes reference to visual traditions of the early first millennium, implying the seal owner's knowledge of and connections to these important sources of charismatic authority. Put differently, the seal cutter had a wide array of options for the border imagery, and the selection of the lotus-and-bud was a result of this motif's appropriateness to the identity of the patron who commissioned it.

A similar process is likely to have informed the design and execution of MPS 46, with the added possibility that the appropriateness of the motif was determined by the seal owner's connections to Egypt through his role in the imperial administration. The motif may even have been selected deliberately as an attempt to engender some solidarity with the owner's Egyptian colleagues, for whom it was still quite familiar. Alternatively, a native of Egypt could have commissioned this seal because it was appropriate to his identity as an official of the Achaemenid Empire, and he chose to include this border as a nod to his homeland. Regardless, the currency of the lotus-and-bud at Gordion and Memphis attests to the international and multicultural social environment that existed in these two geographically disparate cities under Achaemenid rule.

The occurrence of seals operating within both Egyptian and

Achaemenid glyptic milieus does not necessarily indicate that this office was staffed by Egyptians and Persians, though this is quite possible. Rather, it is evidence that this office (and indeed the palace as a whole) was part of a larger administrative system whose employees considered either Achaemenid imperial imagery or Egyptian cultural memory, or both, appropriate to their individual identities. In this respect it must have been very much like the administration in the Persepolis region itself. As noted above, the seals preserved on the tablets of the Fortification Archive allude to a wide variety of cultural referents, both in their visual quotation of other artistic traditions and in the languages attested in the seal inscriptions and on the tablets themselves, including Elamite, Aramaic, Old Persian, Babylonian Akkadian, Greek, Phrygian and Egyptian hieroglyphics (Root 1997; Tavernier 2008). Indeed, the wooden tags from the Palace of Apries (Fig. 2.10), with their Aramaic and Demotic texts, parallel this multilingual and multicultural administrative environment. The administration of Achaemenid Egypt seems, based on the glyptic evidence, to have been an open social environment, and not one that required its participants to identify solely with the empire. Nor is it necessary to suppose that this situation was unique to Memphis; the handful of bullae preserved from the Elephantine Aramaic papyri demonstrate the same diversity of images as those from the Palace of Apries (Cooney 1953a).

Continuity and change

There is distinctive evidence for an Achaemenid imperial presence at the Palace of Apries, consisting of both a military garrison and an administrative apparatus. Both of these were multicultural operations, and thus contributed to the cosmopolitan social environment of Memphis. The estimated garrison of 7,000 men was certainly a significant presence; for comparison, this was equivalent to just over half of the Roman military strength in all of Egypt during the second and third centuries AD (Alston 1995, 31–2). The Achaemenid forces here and elsewhere in Egypt were drawn from around the empire. But a large military presence comprised primarily of foreign soldiers was nothing new in Memphis (Smoláriková 2003). Indeed, according to Herodotus (2.154.3), Pharaoh Amasis (reigned 570–526 BC) had installed his Greek and Carian mercenaries there as his personal guard, so the presence of non-Egyptian soldiers at the palace during the 27th Dynasty hardly represents a change at all. Likewise, Egyptian bureaucrats will have found themselves working

and communicating with Persians and other foreigners in the course of their duties at the palace. The evidence for bilingual protocols at the palace suggests that the empire's administrative apparatus was grafted onto the existing system rather than supplanting it entirely. On the whole, the Achaemenid imperial presence at the palace was unmistakable, but at the same time it was couched in terms already familiar to the residents of Memphis.

The deliberateness of this continuity is further implied by the anonymous royal reliefs associated with the palace (Figs 2.6, 2.7). These reliefs were originally part of a freestanding pylon or doorway, presumably at the main entrance to the palace, though they may instead have been located inside (Petrie 1909b, 5–11; Kaiser 1987; Bagh 2011, 36–43). In either case these reliefs, which draw heavily on earlier royal monuments (many of which were still standing in the Late Period), depict the pharaoh enacting certain religious festivals central to his function as king and mediator between the divine and earthly realms. As noted earlier in this chapter, these reliefs have empty cartouches which were never inscribed with the king's name. This absence inhibits precise dating of these reliefs; on current evidence they could equally be a product of the 27th Dynasty or the 26th, especially since a pylon could have been built subsequent to the palace's construction. Also as already noted, during the Ptolemaic and Roman Periods empty cartouches signified the generalised concept of kingship (Spieser 2010, 6). Their occurrence on these reliefs is one of their earliest, and it most likely prefigures their later usage.

It is interesting to note that the empty cartouche is congruent with the Achaemenid practice, evident at Persepolis as well as in imperial coin types, of representing the Great King generically, as a statement of dynastic stability and continuity, rather than depicting individual rulers idiosyncratically (Root 1979, 92–3, 99, 117, 171). The blank cartouches can be understood as operating along the same lines. This is by no means a definitive argument in favour of a 27th Dynasty date for the reliefs from the Palace of Apries, but the parallel with Achaemenid representations of the king does provide an intriguing (if not compelling) explanation for this otherwise curious phenomenon. And regardless of the date of the creation of the reliefs, it is probable that the Persians interpreted the empty cartouches in light of their own representational practices, which is perhaps why specific royal names were never added to them. Moreover, the citation of earlier royal monuments, especially those depicting the pharaoh carrying out his religious duties, would have served to reinforce the

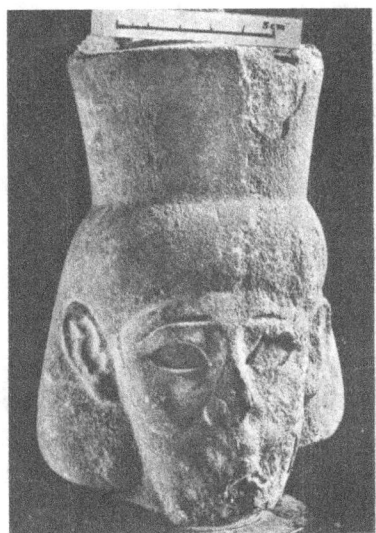
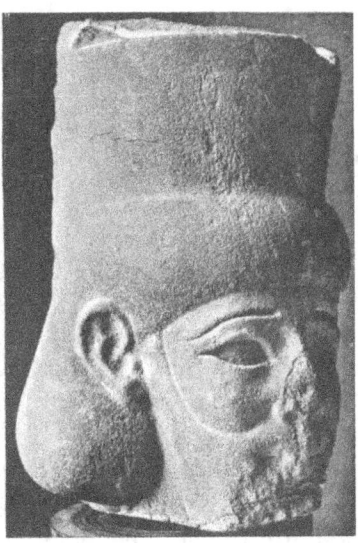

Fig. 2.18. Head from a statuette of a Persian king, c. 5th century BC. Greywacke; H. 17 cm. Strasbourg, Institut d'Égyptologie, Université de Strasbourg inv. 1604. Image in the public domain from Spiegelberg (1909a, pl. 16).

Great King's assumption of these duties as pharaoh. A visitor to the palace, on seeing these reliefs, would see a king doing his job in the same manner as he had always done it.

It is equally telling that there is no evidence for the erection of monumental images of the Great King at the Palace of Apries, or indeed anywhere in Memphis, in a manner that drew explicitly on Achaemenid imperial iconography. The only putative images of the Great King from Memphis are a handful of small stone and terracotta heads (Traunecker 1995; Rehm 2005 [2006], 497). The largest of these (Fig. 2.18), now in Strasbourg (Institut d'Égyptologie, Université de Strasbourg, inv. 1604), is a mere 17 cm high (Spiegelberg 1909a, 33), and the complete statue of which it was once a part was probably no more than one metre in height. These images are far from monumental, and one is even a fragment of a bowl decorated in high relief. They are personal effects rather than official royal representations. It is entirely possible they were owned by administrators or imperial officials posted to the palace, but there is no way of determining this for certain. These objects were purchased rather than excavated, so they lack clear provenance and cannot even be dated securely. The only known representations of the king at the palace itself are the reliefs of the generic Late Period pharaoh referred to above.

Likewise, there was seemingly no attempt made on the part of the Great King or his satrap to replace the Palace of Apries with a structure built along the lines of the palaces at Persepolis, Pasargadae or Susa. The existing palace was seemingly adequate to the needs of the imperial administration, and its deliberate reuse by the Achaemenids was a means of tapping into existing power structures and, in the case of Egypt, an important source of charismatic authority that served to legitimise imperial rule there. In this respect the Palace of Apries was comparable to other administrative structures across the empire, such as the columned hall at Altıntepe in the Armenian satrapy, which were similarly taken over intact and integrated into the empire's administrative apparatus (Dusinberre 2013, 59–60; Khatchadourian 2016, 141–50).

The seals from the palace, as preserved in the bullae unearthed by Petrie's excavations, indicate an atmosphere of inclusion and participation. The variety of images and motifs, drawing on both Achaemenid imperial imagery and Egyptian cultural memory, that appear on these seals attest to an open social environment characterising administrative and social life there. There was no compulsion or expectation for the Memphis administrators to construct their identities, as represented in their choice of seals, primarily in Achaemenid terms. Rather, those who wished to use exclusively Egyptian imagery were seemingly welcome to do so. In fact, in the absence of accompanying texts, there is no way of knowing who actually used the Egyptian-type seals. Furthermore, some of the owners of these seals may well have been from other parts of the empire. Likewise, some of the seals that drew mainly on Achaemenid imperial imagery may have been owned by natives of Egypt who identified themselves not just as Egyptians, but also as members of the international elite who governed the empire. The imperial presence at the Palace of Apries undoubtedly created conditions in which cultural interaction was an important factor of daily business. It provided for a wide range of experiences, both for Egyptians living under Achaemenid rule, and for people from throughout the empire who came to Egypt on imperial business.

THE CULT OF APIS

The cult of Apis provides a particularly informative case study for examining the impact and nature of Achaemenid rule in Memphis. The Apis bull was the animal incarnation of Ptah, the demiurge of Memphis and one of the most important gods in Egypt. The

remains of the temple of Ptah lie just east of the modern village of Mit Rahina in a large depression known as the 'Birka' (Arabic for 'lake'), in essence placing it in downtown Memphis (Jeffreys 1985, 33–8; Kitchen 1991, 87–92; Leclère 2008, 53–5, 61–3). Although little remains of the temple itself, it is abundantly clear that it was one of the largest and most central structures in Memphis during the Late Period. Both physically and cosmologically, Ptah loomed large in Memphis, and by extension so did Apis.

Despite the limited archaeological evidence, the continued operation of the Ptah temple in the period of Achaemenid rule is evident from textual sources. Several high priests of Ptah from the 27th Dynasty are known from stelae from the Serapeum at Saqqara, indicating that the cult of Ptah was still in operation and supporting priestly functions (Vittmann 2009, 89–91). This much is also suggested by a curious passage in Herodotus (2.110) recounting an abortive attempt by Darius to dedicate a statue of himself in the temple. After describing the exploits and achievements of Sesostris (a semi-legendry amalgamation of two Middle Kingdom pharaohs) Herodotus says that Darius wished to dedicate a statue of himself but was refused permission to do so by a priest. The reason given for the refusal was that Darius's exploits had not surpassed those of Sesostris; specifically, Sesostris had conquered the Scythians, but Darius had not.[6] The specificity of the achievement gap between these two rulers suggests that Sesostris' exploits were designed explicitly to exceed Darius's own, leading to the conclusion that Herodotus's story reflects a fictitious account that was invented and disseminated as an act of resistance against Achaemenid rule by certain priests of Ptah (Moyer 2011, 72–4). Indeed, subsequent versions of the exploits of Sesostris include the conquest of Arabia and even India, added no doubt in order to surpass the exploits of Alexander. Thus, although the incident probably did not take place as Herodotus describes, his awareness of the tradition points to an active priesthood in the fifth century BC, with whom he was in contact.

We are much better informed about the cult of the Apis bull. As noted above, Apis was the animal incarnation of Ptah, and their cults were certainly intertwined, to the extent that the House of Apis, where the bull lived during his lifetime and was prepared for

[6] Presumably the European Scythians are meant here, since at 2.103 Herodotus describes a successful campaign of Sesostris against them, while at 4.131–42 he narrates Darius's retreat before the same Scythians. Darius also launched an expedition against the Saka Tigraxauda ('the Scythians who wear the pointed hat'), which he presents as a clear success in the Bisitun Inscription (DB §74–5). See Cameron 1943, 311.

burial following his death, was located in the southwest corner of the sacred precinct of Ptah (Dimick 1958; Anthes 1959, 75–9; Jones 1990; Leclère 2008, 63–5; Marković 2016). Hieroglyphic stelae from Saqqara make reference to 'Windows of Appearances' used by the Apis bull and his mother to make public appearances (Smith 1974, 10; Jurman 2010), and according to Strabo (17.31), writing in the late first century BC,

> They set Apis loose at a certain hour, particularly that he may be shown to foreigners; for although people can see him through the window in the sanctuary, they wish to see him outside also; but when he has finished a short bout of skipping in the court they take him back again to his familiar stall. (trans. H. L. Jones)

The temple, which seems to have been an open-air structure, consisted of at least four long, narrow enclosures running parallel to each other along an east–west axis and connected by small openings, all atop a large mudbrick platform. The Late Period date of the Apis House is suggested by the stone lion beds featuring cartouches of Amasis and Necho II, as well as by a hoard of thirteen imitation Athenian coins found mixed in with the bricks of the platform along its northern side (Jones and Jones 1988, 105–10).

Not much is known about the workings of the Apis cult itself, save for the interment of the mummified bulls at the Serapeum and some details about the bulls' distinctive colouring (Dodson 2005, 72–91; Marković 2017). But it is of special relevance to the study of Achaemenid imperialism in Egypt because of Herodotus's account (3.27–9) of the murder of an Apis bull at the hands of Cambyses. The historiography and intellectual underpinnings of the interpretation of this passage have already been discussed in Chapter 1. Here it suffices to present the evidence for Cambyses' participation in, or at least endorsement of, the burial of the Apis bull (specifically Apis 27.1/XLII).[7]

This evidence consists of a sarcophagus and a stela from the Serapeum featuring inscriptions of Cambyses as pharaoh. These hieroglyphic texts make unequivocal reference to the interment of this bull (Posener 1936, nos. 3–4; Devauchelle 1994a, 102–3; Kuhrt 2007, 122–4; Sternberg-el Hotabi 2017, 101–2, 106). The sarcophagus's inscription is illustrative of their general content:

[7] The convention for numbering Apis bulls is as follows. The Arabic numerals indicate the dynasty during which the bull was interred, followed by that bull's order within that dynasty; e.g., Apis 27.1 is the first attested bull buried during the 27th Dynasty. The Roman numerals are those assigned by Mariette 1882, 114–202.

The Horus Smatowy, King of Upper and Lower Egypt, Mesutire, son of Re, Cambyses – may he live forever! He has made a fine monument for his father Apis-Osiris with a great granite sarcophagus, dedicated by the King of Upper and Lower Egypt, Mesutire, son of Re, Cambyses – may he live forever, in perpetuity and prosperity, full of health and joy, appearing as King of Upper and Lower Egypt eternally. (trans. Kuhrt 2007, 124)

This text presents Cambyses entirely in an Egyptian royal context, and it implies that the burial of the Apis bull took place with Cambyses' full knowledge and participation, not, as Herodotus says, as a clandestine act performed by the priesthood in opposition to the will of the new Persian ruler. Moreover, the stela (Louvre IM 4133) glosses this textual content with a visual depiction of Cambyses as the pharaoh kneeling before Apis, reinforcing visually the statements of royal piety and reverence that occur in the inscriptions (Fig. 2.19). In short, from the available Egyptian primary sources there is nothing out of the ordinary about the burial of this Apis bull, except perhaps that Cambyses may even have attended it in person. This honour was not afforded to any subsequent Apis bull during Achaemenid rule, since it was the only such funeral known to have occurred when an Achaemenid Great King was present anywhere in Egypt.

Subsequent Achaemenid kings did, however, maintain support for

Fig. 2.19. Detail of a stela from the Serapeum at Saqqara depicting Cambyses before the Apis bull, 524 BC. Limestone; H. 66 cm; W. 44 cm. Paris, Louvre IM 4133. Drawing by the author after Kuhrt (2007, fig. 4.3).

this cult. Funerals of Apis bulls are attested in the Serapeum during the reigns of Darius I and II, and the pharaoh's ostensible participation in the funeral was always indicated in the appropriate inscriptions, even if he was himself absent from Egypt (Devauchelle 1994a, 103–6, 109–14; Dodson 2001, 31–2; 2005, 84–6; Sternberg-el Hotabi 2017, 56–66, 103–6). The absence of burials dating to the reigns of Xerxes and Artaxerxes I is probably due to an accident of preservation rather than to any abrupt shift in royal policy. The Serapeum was an active cult site, and therefore prone to post-depositional processes resulting from a multitude of procedures and rituals, all of which could have contributed to the destruction or dislocation of funerary materials. For example, during the reign of Amasis a number of earlier stelae were buried under the floor in the process of the interment of Apis 26.6/XLI (Devauchelle 1994a, 102).

There is evidence that further renovations of the tomb galleries in the Serapeum took place under the reign of Darius I. These renovations, particularly the creation of two new entrances to the galleries, are mentioned on a biographic inscription on another Serapeum stela, where they are explicitly identified as resulting from the king's prerogative (Louvre IM 4039; Vercoutter 1962, 70–7; Dodson 2001, 31; Marković 2017, 152–3). One of these entrances was considerably wider than its predecessors and thus facilitated the interment of much larger sarcophagi than had been possible previously, and indeed the size of the stone sarcophagi only increased during the fifth century, showing if anything that the cult was not only going strong under Achaemenid rule, but had also attracted special royal attention.

The burials of the Mother of Apis in the catacombs of the Sacred Animal Necropolis at North Saqqara are also suggestive of the continuity of the cult of Apis throughout the 27th Dynasty. Strictly speaking the Mother of Apis was a bovine incarnation of Isis, and it is unclear what formal relationship existed between her cult and that of Apis proper. But there are at least seven Mother of Apis funerals attested in the stelae excavated at the Sacred Animal Necropolis dating to the fifth century (Smith 1972; Smith et al. 2011). This epigraphic evidence shows that there was no disruption in cult practices here as a result of Achaemenid rule. Indeed, the evidence we have suggests that the cult flourished along traditional lines.

The endurance, and indeed the prosperity, of the cult of Apis are also discernible from the House of Apis in Memphis (Fig. 2.20). During the course of a single excavation season in 1941 a large (54.5 cm in diameter and 31.5 cm tall) stone basin was found there,

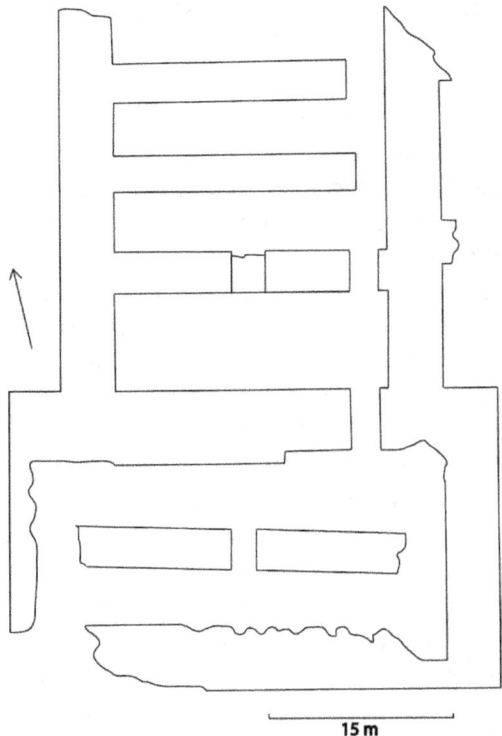

Fig. 2.20. Plan of the House of Apis, Memphis. Drawn by the author after Anthes (1959, pl. 41).

bearing an incised hieroglyphic inscription reading 'King of Upper and Lower Egypt, Darius, beloved of the living Apis', followed by 'year 34' and '72 *hnw*' (Cairo JE 86754; Lucas 1943; El Amir 1948, 52). The 34th year of Darius I was 484 BC, which coincides with the date of the burial of Apis 27.4/XLIII. The likelihood is that this basin was provided on that particular occasion, presumably to be used in the process of embalming the Apis bull. Its addition to the temple's ritual equipment as an item worthy of pharaonic dedication demonstrates active royal engagement with the cult.

The Late Period expansion of the House of Apis is potentially even more informative about Achaemenid imperial interaction with the cult. The temple was built on two uneven terraces. Although there is epigraphic evidence for activity at the southern terrace during the 25th and 26th Dynasties, the higher northern terrace seems to be a later addition. The excavators dated this addition to the reign of Nectanebo II (360–343 BC) on three grounds (Jones 1990). First, a stela from Saqqara dating to the second year of

Nectanebo (358 BC) makes reference to the inauguration of a new 'place of Apis' (Spiegelberg 1909b, 89–93; Porter and Moss 1981, 779). Second, as already noted a hoard of thirteen imitation Athenian coins was found below floor level, and has been interpreted as a foundation deposit (Jones and Jones 1988, 107–10). Third, the ceramic material in the fill beneath the floor dates primarily to the fifth century, implying the north terrace was built sometime after that.

None of these three lines of evidence provides unequivocal grounds for the date of the construction of the northern terrace. The stela from the Serapeum does refer to the 'building of the Place of Apis' being ordered by Nectanebo, but there are no in situ remains at the site bearing cartouches of this pharaoh, and it is impossible to determine the extent of the building activity to which this stela refers. Likewise, the usefulness of coins for dating purposes is not straightforward by any means, especially when it is unclear why the coins in question were deposited (Lockyear 2012). As is discussed further in Chapter 6, these coins from below floor level in the addition to the House of Apis most likely belong to the fourth century BC, though they could have been minted as early as c. 410 BC. It is also unlikely that these coins constitute a foundation deposit. None of the other temple foundation deposits datable to the fourth century contains coins, and there are no other examples of coins being used in this manner in Egypt until the reign of Ptolemy X (107–88 BC; Weinstein 1973, 297–308, 343–50, 391–2). This coin hoard was presumably hidden for some reason, making it intrusive in the architectural stratigraphy of the Apis House and therefore indicative only of the temple being in existence prior to its deposition. Certainly the hoard does not compel a fourth-century date for the building activity. Lastly, the ceramic evidence is not definitive either, as shown by an excerpt from the brief ceramics report (French and Jones 1993, 21):

> The repertoire is very restricted, consisting almost entirely of red-slip jars of a few related forms probably to be placed in the earlier or middle years of the 5th century B.C., before the appearance of the full range of Persian forms. Thus the foundation compartments could have been filled and sealed by pavements at any time after this date.

The ceramics indicate that the renovations occurred sometime after the mid-fifth century, but not necessarily in the fourth. So it is quite possible that the Apis House was rebuilt with its northern addition under Achaemenid rule, perhaps in association with the funeral of the Apis bull that took place in year 11 of the reign of Darius II (413 BC). None of the evidence requires a fourth-century date.

The maintenance of the cult of Apis by means of the customary pharaonic involvement in the funerary rites served to maintain the Great King's royal status in Egypt, especially as the satrap's seat and power base was located in the cult's home town of Memphis. Outside of Herodotus's account of Cambyses' slaughter of an Apis bull there is no indication that this cult was mistreated under Achaemenid rule, or that it suffered any neglect. Indeed, the Egyptian primary evidence directly contradicts Herodotus in certain key aspects, and his version of events needs to be considered in the wider context of the Egyptian literature of the time (Dillery 2005). In all, the impression is one of business as usual. The priestly institutions remained operational, the rituals concerning the interments of the Apis bull and the Mother of Apis continued, and the names of the Achaemenid pharaohs were placed on dedications and ritual equipment, indicating that the financial and cultural infrastructures of the cults of Ptah and Apis remained intact.

INDIVIDUAL EXPERIENCES

In addition to affecting the institutions discussed in the preceding sections, Achaemenid rule in Memphis was also experienced by individuals. These individuals had varying degrees of participation in that rule, with some coming to Egypt explicitly for that purpose, some native Egyptians becoming closely or loosely associated with the new regime by necessity or inclination, and others leading lives that were affected only indirectly and perhaps in many cases without any sense of discernible change. This section addresses some cases of individual experience by considering two types of material: tomb monuments from Saqqara and Abusir, and personal names preserved in Aramaic and Demotic papyri (primarily from Saqqara). Both of these provide access to major decisions made by individuals in the context of the empire, namely decisions about preparations for the afterlife and the names given to their children. As with institutions, the experiences of individuals seem to have varied considerably, and though there are few funerary and onomastic phenomena that belong solely to the 27th Dynasty, certain trends and changes are nevertheless discernible that shed light on social conditions at the satrapal capital.

Tombs and other funerary monuments

The extensive necropolis of Memphis has already been described earlier in this chapter. As noted above, it was in use for private

burials in the Early Dynastic Period (c. 3000–2686 BC), and continued to be so through the Ptolemaic and Roman Periods and beyond. Tombs dating to the Late Period are scattered throughout this mortuary landscape. Identifying them, and especially those that belong specifically to the 27th Dynasty, is difficult, however, in large part because many of the features of these tombs (in terms of both form and burial practice) occur as early as the Saite Period and continue to occur into the fourth century, if not later (Aston 1999).

Thus there are few reliable criteria for assigning a given Late Period tomb to any particular dynasty. Prosopography remains one of the best means of dating, especially as the Serapeum stelae preserve a large corpus of names and dates that can be checked against those that appear in tomb inscriptions. Cartouches containing royal names, however, are not necessarily good indicators of a tomb's date. In the tomb of Udjahorresnet at Abusir, for example, the foundation deposits featured objects bearing cartouches of Amasis (Bareš 1996), even though it is well established on the basis of his statue in the Vatican that he died during the reign of Darius I. Moreover, as noted earlier in this chapter, many dead kings were worshipped and venerated long after their deaths; accordingly, objects inscribed with these names could remain in use until well after the king they name had died.

Another potential criterion is the presence of Aramaic papyri. The earliest Aramaic papyrus from Egypt, TADAE A1.1, dates to c. 604 BC. But the next earliest document of secure date, TADAE B1.1, dates to 515 BC, and the rest of the Aramaic papyri from Egypt are datable mainly to the fifth century BC (with a few to the fourth), on the basis of regnal dates and palaeography (Vittmann 2003, 88). So the presence of an Aramaic document in a tomb is a reasonable (though not foolproof) indicator of a 27th Dynasty date. There are also certain grave goods, such as ceramics, which can potentially help to narrow down a tomb's date, assuming the types are known well enough to be dated precisely.

In the absence of any of these definitive dating criteria, tombs are frequently attributed to the 26th or 30th Dynasties by default (Aston 1999), creating an appearance of scarcity which, if accepted uncritically, undermines any attempt to use mortuary evidence to study Achaemenid Memphis. A clear example of this is Campbell's Tomb, a large shaft tomb at Giza typically assigned to the 26th Dynasty (Porter and Moss 1981, 290–1; El-Sadeek 1984, 126–32; Zivie-Coche 1991, 283–5; Stammers 2009, 28–9, 110, 160–1). The burial in the main shaft cannot be dated to any specific dynasty. The individual in this burial, Pakap, has the basilophorous 'beautiful

name' of 'Wahibreemakhet', which contains the name of Pharaoh Apries ('Wahibra' in Egyptian). The 'beautiful name', a translation of the Egyptian term *rn nfr*, is one of the two names most Egyptians had; often it was an abbreviation of the other, 'major' name, and may have functioned like a first name or nickname (Vittmann 2013a, 3). Herman de Meulenaere (1966, 27–30) argues this name could only have been granted to Pakap by Apries himself during his reign. But there are many examples of basilophorous names referring to kings who were long dead (Vittmann 2009, 96–7; 2013b, 6), so this name does not supply a firm dating criterion. However, one of the secondary burials in the tomb was that of Ptahhotep, a courtier and administrator who rose to prominence in the later reign of Darius I (he is discussed further in Chapter 4). He must have died after 490 BC, and this is the only ironclad date for the entire tomb structure. Though it is possible that Pakap died prior to Achaemenid rule, or at least that he began building his tomb before 526, there is no actual evidence whatsoever mandating the attribution of Campbell's Tomb to the 26th Dynasty rather than the 27th.

Saqqara was still an important locus of burial in the 27th Dynasty. Although many installations of the Persian Period await discovery or have not been distinguished from the larger category of the Late Period tombs that have been excavated, there are tantalising glimpses of what may be there. The shaft tomb N1 at Saqqara, for example, contains Aramaic papyri that strongly suggest a fifth-century date. The fourteen ceramic coffins with Aramaic inscriptions (as well as five Aramaic mummy tags) found during the course of the excavation of the pyramid of Khendjer (also at Saqqara) are also very likely to belong to this period (Porten and Gee 2001, 270–3; Ziegler 2013, 362). The continued use or reuse of existing tombs during the 27th Dynasty is also attested here. For example, the tomb of Bakenrenef at Saqqara, located near the causeway of the pyramid of Unas, was built in the reign of Psammetichus I (c. 664–610 BC), but a number of galleries were added to it during the fifth century, and there were repairs and additions made during the fourth century and into the Ptolemaic Period (El Naggar 1978, 52–5; Bresciani et al. 1983, 32–9; Stammers 2009, 121–5). At least three individuals, all named Horiraa, were interred in the tomb over the course of the fifth century. It is not clear what relationship, if any, they had to Bakenrenef; the possibility of a family tomb being reused over multiple generations seems reasonable. At any rate, this is a useful illustration of how 27th Dynasty burials can be obscured by their close proximity to material that can be clearly dated to other periods.

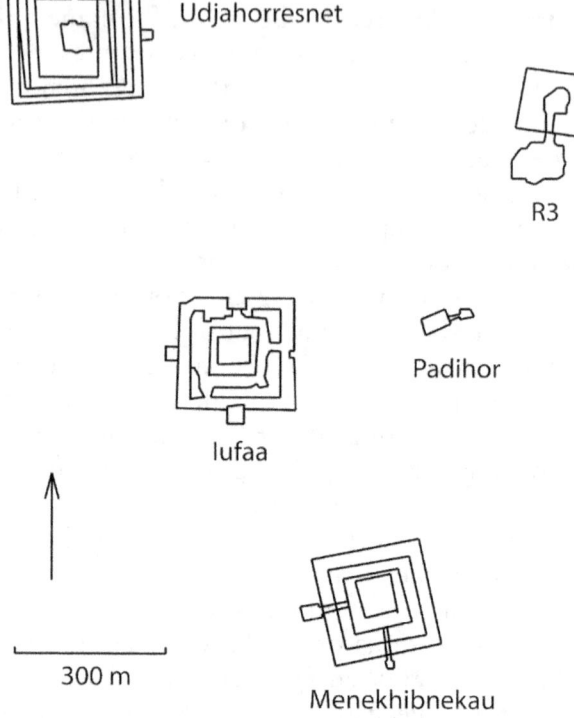

Fig. 2.21. Plan of the shaft tombs at Abusir. Drawn by the author after Coppens and Smoláriková (2009, fig. 1).

Perhaps the best-dated and most thoroughly investigated tombs of 27th Dynasty date are the five 'Saite–Persian' shaft tombs at Abusir (Fig. 2.21). One of these tombs is that of Udjahorresnet (Bareš 1999; Smoláriková 2015; Verner 2017, 321–8), a high-ranking courtier during the reigns of Cambyses and Darius I (discussed further in Chapter 4). Based on Demotic graffiti found on blocks from the tomb, it appears that construction had already begun during the reign of Amasis (Bareš 2002). But, as Udjahorresnet did not die until the reign of Darius, his tomb is nonetheless an important monument for the study of the early phases of Achaemenid rule in Egypt. The other four tombs are seemingly contemporary with Udjahorresnet's, since they all have consistent orientations and were constructed on a grid plan of sorts (Bareš 2007). The tombs of Iufaa and Menekhibnekau, as well as tomb R3, all contained Greek and Egyptian ceramics of late sixth- and early fifth-century date (Bareš et al. 2003, 153–4; Bareš and Smoláriková 2008, 165–75; 2011, 62, 314–16; Coppens and Smoláriková 2009, 98–104). The tomb of Menekhibnekau also

contained a Phoenician storage jar with four inscriptions, three in Phoenician and one in Aramaic, datable on palaeographic grounds to the same time period (Dušek and Mynářová 2011), and a *menat* (a type of necklace associated with the goddess Hathor) inscribed with a cartouche of Amasis, providing a terminus post quem for this tomb.

It is impossible to say how typical these five tombs were of 27th Dynasty burials more generally. But there is no reason to assume they were the only tombs of their kind and scale dating to this period, and it is likely they are representative of a larger corpus of Memphite tombs. That no other tombs of this date have yet been found at Abusir may well result from the necropolis shifting to more modest burials within a few decades (Bareš 2009; Bareš and Smoláriková 2011, 69–71). The tombs of Udjahorresnet and his contemporaries are all shaft tombs, consisting of deep central shafts with burial chambers at the bottom, though among them there is a degree of variation within this general type. All of the five tombs also feature one or two secondary shafts which presumably provided access to the burial chamber once the main shaft had been filled; they may also have had symbolic importance. For the most part the superstructures of these tombs have not survived, probably on account of looting in the late Roman Period. The shafts were surrounded by enclosure walls, and sometimes also by square trenches. Tomb R3 also had a small, sunken courtyard on its south side, outside of the enclosure wall (Coppens and Smoláriková 2009, 86–7; Stammers 2009, 114). The tomb of Iufaa contained five interments other than Iufaa himself, all of whom, on the basis of their skeletal remains, appear to have been related to him (Bareš and Smoláriková 2008, 253–81). The other tombs contained only single burials.

Shaft tombs of this type are unique to the Late Period in the area around Memphis, appearing at least as early as the reign of Psammetichus II (595–589 BC) and disappearing by the end of the fifth century (Bareš 1999, 21–9; Gestermann 2006; Stammers 2009, 26–39). The five tombs discussed here are architecturally indistinguishable from Saite examples. The orientation of the burials varies somewhat: the burial chamber in the tomb of Menekhibnekau is oriented on a north–south axis, whereas the burial chamber in the tomb of Iufaa is oriented on an east–west axis in accordance with normal practice in Egypt from the New Kingdom onwards. But this variability occurs in the orientation of some Saite burials at Saqqara as well. The implication is that in the Late Period the orientation could be based on more than just cardinal direction (Stammers

2009, 31). At Saqqara and Abusir the abundance of older royal monuments had two important effects on the tombs constructed during the Late Period, including the 27th Dynasty. First, physical space in the necropolis was limited, which occasionally required tombs to have unusual structures in order to fit into small spaces. Second, there were many sources of cultural memory embedded in this landscape that had a great potential to affect how all Late Period burials were oriented.

The tombs that have so far been securely attributed specifically to the Persian Period share other features with most Late Period tombs. This is particularly notable in terms of their inscriptional content. There is a great deal of variety in the actual selection and disposition of the various funerary texts inscribed on the walls of the tombs. These texts include spells from the Pyramid Texts, the Coffin Texts and the Book of the Dead, as well as formulas addressed to Osiris and Ptah-Sokar (Bareš 2006a). When compared to the inscriptions on tombs of Saite date there is nothing unusual about these choices of funerary texts; indeed, the texts inscribed on the walls of the tomb of Iufaa even closely parallel those in the tombs of Bakenrenef, Amentefnakht and Padineith (Stammers 2009, 65).

The titles held by Udjahorresnet, Iufaa and Menekhibnekau are similarly consonant with those that occur elsewhere in the Memphis necropolis.[8] For example, Udjahorresnet's titles, as given in his tomb, include 'Chief Physician of Upper and Lower Egypt', 'Overseer of the Scribes of the Great Prison', 'Prince', 'Mayor', 'Chancellor of the King of Lower Egypt', 'Sole Companion' and 'Director of the Palace', all of which appear in other Late Period tombs (Stammers 2009, 152–70). The same is true of the titles of Iufaa and Menekhibnekau. The fact that the repertoire of titles does not change significantly from the Saite to the Persian Period suggests that there was no major shift in the social standing of the individuals buried in the more prominent private tombs at Saqqara and Abusir, nor that burial forms that had previously been restricted to certain classes of people had now become more widely available (Bareš 2006b).

Finally, the location of these five tombs at Abusir, somewhat removed from the loci of burial and cultic activity at Saqqara, conforms to the pre-Persian pattern of clustering tombs around earlier monuments, in this case the pyramids of the 4th and 5th Dynasties. Moreover, it has been pointed out that their placement would have made them visible from the Palace of Apries, which, as discussed

[8] R3 and the tomb of Padihor have only a few inscriptions, which do not include titles.

above, was an important centre of administrative and imperial activity during the Late Period (Stammers 2009, 19–22).

In large part, then, there is nothing about these 27th Dynasty tombs that distinguishes them from their Saite predecessors. Even Udjahorresnet, whose participation in Achaemenid rule in Egypt is well known, and who identified himself with the empire's elite in other contexts, does not make any reference to this aspect of his social and professional biography in the form or contents of his tomb. In other words, his distinguished situation within the imperial administration did not necessitate that for his burial he defer either in form or in ritual practice to the cultural norms of the Persians. None of these tombs has any feature that is specific to the 27th Dynasty, and this is significant for our understanding of Achaemenid Memphis for a number of reasons.

First, these tombs, many of which are of significant size, clearly demonstrate that the advent of Achaemenid rule did not necessarily create a social or economic environment in which such tombs could no longer be built. It does appear that the tomb of Udjahorresnet was already under construction in the reign of Amasis (Bareš 1999, 79–86), though it was not used until his death in the 510s BC (Spalinger 1986, 823). It may be that one or more of the other four tombs was also already under construction prior to Cambyses' invasion, but in no case did a severe economic downturn (or other major social change that would have affected burial practice on a wide scale) occur to prevent these tombs from being completed, furnished and used.

Second, the tomb of Udjahorresnet suggests that the lack of visual quotations of Achaemenid material culture was due to personal choice. On his statue now in the Vatican Udjahorresnet makes visual reference to his connections with the Achaemenid imperial elite; the absence of such references in the design and decoration of his tomb must be the result of his deliberate decision not to include them. This decision was not the result of a lack of cultural interaction in the context of Achaemenid Memphis. Udjahorresnet especially, whose career took him to the Great King's court and back, was undoubtedly exposed to a wide variety of cultural, religious and funerary traditions in its course.

Third, these tombs, some of which clearly belonged to individuals of decidedly elite status (Bareš 2006b), illustrate one of the many possible reactions to Achaemenid rule in Egypt. In Egypt people undertook preparations for their own burials well in advance, and accordingly had direct control over the design, construction and

decoration of their tombs and funerary monuments (Baines and Lacovara 2002). The decisions they made in the process of creating these tombs were informed by a variety of factors, including the prevailing social and cultural environment of the time. Thus for these individuals Achaemenid rule did not force them to change how they thought of the afterlife, or what they considered appropriate or necessary to include in the design and contents of their tombs.

But this is not, however, the only reaction to Achaemenid rule visible among the funerary monuments of Memphis. For example, there are funerary representations, now spatially removed from the tombs with which they were once associated, that show a different attitude. One of these (see Fig. 4.15), now in Berlin (Ägyptisches Museum 23721), was purchased by F. W. von Bissing at Mit Rahina and is said to come from the area of Memphis (von Bissing 1930; Vittmann 2003, 151).[9] Though often referred to as such, it is not a stela per se, since it is wider than it is tall and seems to have been cut away from a larger relief of some kind. The scene depicts a male figure laid out on his back on a funeral couch flanked by mourners, some of whom are pulling out their hair while others place dust on their heads. The deceased has a long beard and wears a sleeved garment. The figure's clothes and beard, the attitude of some of the mourners, and even the horse that appears in the upper left corner all point to non-Egyptian norms. Although the portrayal of the body, laid out on its back on a bier, is a frequent image on Egyptian funerary monuments, normally the body would be mummified rather than shown wearing clothing as it is on this relief.

No epigraphic material is preserved from the original monument, so it is impossible to say whom it commemorated. But it is significant that within the context of the Memphite necropolis (with its ancient royal tombs and contemporary monumental ones) this individual elected to make reference to a wider assortment of cultural practices than could be represented by traditional Egyptian imagery alone. In particular, his beard and the riding costume he wears reflect Persian culture, as does the inclusion of his horse in the scene. The acts of mourning depicted are more difficult to pin down, but they seem to reflect a combination of Egyptian (placing dust on one's head) and non-Egyptian (pulling out one's hair) practices. This individual, regardless of his station in life or place of origin, sought to identify

[9] Both this relief and the stela of Djedherbes are examined in further detail in Chapter 4, where the authenticity of the former is discussed (on which see Muscarella 2003; Wasmuth 2017c, 116–18).

himself in part with the Achaemenid Empire in death, while still being buried and commemorated in an Egyptian setting.

Another example of the integration of foreign elements into an Egyptian funerary monument is the stela of Djedherbes from Saqqara (Cairo JE 98807; Mathieson et al. 1995; Wasmuth 2017c) (see Fig. 4.14). The stela is a distinctly Egyptian form of funerary monument that features a distinctly Egyptian scene, namely the embalming of the deceased in the presence of Anubis. But it also includes in its lower register a seated figure who clearly evokes Achaemenid imperial iconography. The seated figure, who is bearded, wears a long, sleeved garment akin to the Persian 'court garb' depicted in the reliefs from Persepolis (Root 1979, *passim*; 2011, 426–33; Stronach 2011). The identity of this figure is unclear, because the scene in this register seems to combine different Egyptian funerary motifs; suggestions include the Great King, Djedherbes himself, or Djedherbes' father (Mathieson et al. 1995, 38; Wasmuth 2017c, 106–11). According to the stela's inscription, Djedherbes' father had a Persian name, while Djedherbes and his mother had Egyptian ones. These names need not indicate the ethnic origins of his family, but they do point to the multicultural environment of Djedherbes' upbringing. This multiculturalism in turn informed his choice of funerary monument. He could have commissioned a monument that drew exclusively on one set of cultural practices. Instead he opted for a visual effect that expressed the complexity both of his relationship to the Achaemenid Empire and of the larger social environment in Memphis in which he made the decisions about his tomb.

Names in the Saqqara papyri

Another body of evidence informing this study of how different individuals experienced the Achaemenid Empire is provided by the papyri from the Sacred Animal Necropolis at North Saqqara. Most of the papyri probably originated in Memphis proper, since only a small number pertain to the administration of the animal cults themselves or to relevant religious matters. Indeed, a great number of the papyri of Late Period date excavated at Saqqara are similarly decontextualised, probably because they were intended to be reused as mummy cartonnage, for humans or animals. Approximately 750 Demotic and 200 Aramaic papyri were found in the fill of the northern enclosure, in the central temple enclosure, and in surface contexts in the southern dependencies of the temple complex (Smith and Martin 2009, 23). The deposition of these papyri has been dated

to the third century BC based on the architectural stratigraphy of the site (Smith et al. 2006, 119–22). The composition dates of the Demotic documents seem in general, however, to belong to the fifth and fourth centuries on the basis of the few identifiable regnal dates preserved on them. The Aramaic papyri probably all date to the fifth century, since the use of this language in Egypt was significantly reduced after 400 BC (Smith and Martin 2009, 23). Those papyri that are intelligible seem to consist of reports, letters and contracts, to wit normal business documents generated by individuals and larger administrative entities, including perhaps the Achaemenid imperial administration.

Despite the generally poor condition of these papyri, the efforts of the papyrologists working on them have yielded important results. A full examination of these results and their implications for the understanding of the administration, prosopography and economic life of Late Period Memphis is beyond the scope of this study, and is best left to the appropriate specialists. For the purposes of this discussion, the personal names that occur in these documents are, nevertheless, highly suggestive. At least twenty-seven names of possible Persian origin have been identified in the Aramaic texts (Zadok 1986). Likewise, a number of names that similarly appear to be of Persian origin have also been identified in the Demotic papyri (Huyse 1992; Smith 1992; Tavernier 2002; Smith and Martin 2009, *passim*). Some of these foreign-named individuals, such as the 'chief of the army' mentioned earlier in this chapter, are very likely to be foreigners who came to Egypt either on imperial business, or on business of their own that required them to travel across the empire. For most of them, however, there is no way of determining ethnic or geographic origin on the basis of the names alone.

For example, in the Demotic legal document EES S.H5–DP 174 (Smith and Martin 2009, no. 13) we find one Bagaya, who has a Persian name, and whose mother, Tahesis, has an Egyptian name. From this document alone we cannot tell where Bagaya or his parents were born, what languages they spoke at home, or whether they considered themselves Egyptian or Persian, or both. But we can say with certainty that his family made use of both Egyptian and non-Egyptian names. The combination of Egyptian and non-Egyptian names within a single family is also widely attested in the Aramaic papyri from the rest of Egypt, Elephantine especially, with Persian names being distinctly popular (Porten 2003).

The occurrence of non-Egyptian names, and Persian names especially, on some of these papyri from Saqqara results both from the

introduction of new names by foreign individuals and from parents of various ethnic backgrounds selecting these names for their children; some may also have been assumed by adults for social or political effect. The reasons informing such choices are varied, in Egypt as in all societies, with habit, familial tradition (especially papponymy) and religious concerns all potentially playing a role (Vittmann 2013a; 2013b). But despite this individual variability it is nevertheless a sound assumption that the names chosen for children by their parents were considered suitable and in some cases distinctly advantageous. This assumption is borne out by research into modern name-giving, which finds that 'many parents, whether they realize it or not, like the sound of names that sound "successful"' (Levitt and Dubner 2005, 179–204), even if those names do not necessarily derive from the cultural or linguistic traditions to which the parents themselves belong. In other words, the names parents give their children are aspirational, and this is the case in Egypt as well. An obvious example is provided by the Egyptian name *Ḏd-Ptḥ-jw.f-ʿnḫ*, meaning 'Ptah said, he will live'. The name implies that the parents consulted an oracle of Ptah in regard to the birth of their child, but regardless of whether they did or not, the choice of this name reflects parental anxiety concerning infant mortality (Ranke 1926, 734–5; Vittmann 2013b, 2). The selection of names was often less explicitly referential than this, and what was construed as a successful name varied considerably according to the family's circumstances, with a variety of factors affecting the actual choice. But except in rare instances the naming of a child spoke, deliberately or unconsciously, to the parents' hopes for that child.

The presence of non-Egyptian names in these papyri suggests that they had joined the repertoire of 'successful' names in Egypt. No doubt many of these were given to the children of foreign individuals, but as we have already seen this was not always the case. Some Egyptians found that certain foreigners, Persians included, were worthy of emulation on account of their apparent success, however such success was judged. This represents a distinct change from earlier periods, when foreigners, though tolerated, were treated in ideological terms as agents of chaos and destruction. This perception of success may have to do with the connections these foreigners had to other parts of the empire, which provided economic advantages and access to sources of charismatic authority, and perhaps also with the fact that many of them had come to Egypt on imperial business and were thus taking advantage of certain opportunities provided by Achaemenid rule.

Not all Egyptians reacted in this inclusive manner. For example, throughout the first millennium BC names referring to the defeat of an enemy by a divine power were popular in Egypt, and it has been suggested that the employment of these names (called *noms imprécatoires* by modern scholars) was an act of resistance against foreign rulers by some Egyptians (Guentch-Ogloeuff 1941; Vittmann 2013a, 7–8). Others simply continued traditions of papponymy and using family names. Some individuals took on second names. This is attested directly in one interesting case of a hieroglyphic graffito of an imperial official from the Wadi Hammamat dating to 450 BC (Posener 1936, no. 33; Vittmann 2004, 164; Tavernier 2007, 117). The official has a Persian name, Ariyavrata, but the inscription specifies further that Ariyavrata was also called Djeho, which is clearly an Egyptian name. Such double names are much better attested in the Ptolemaic and Roman Periods in Egypt, where they appear to have been deployed selectively depending on the social or political context in which an individual was operating at a given time (Clarysse 1985). This no doubt applies to some of the names that appear in the Saqqara papyri as well, and it helps us to understand the social implications of the naming practices discernible in these documents.

The onomastic evidence provided by these papyri parallels the archaeological evidence provided by the funerary monuments discussed above. While it is certainly the case that many people in Egypt carried on as before, experiencing little if any effect of Achaemenid rule in terms of how they conceived of themselves and their relationships to the wider world, others experienced it in significant ways, significant enough that it changed how they prepared for the afterlife and how they named their children.

DISCREPANT EXPERIENCES AT ACHAEMENID MEMPHIS

The picture of Achaemenid Memphis presented in this chapter is incomplete, due to the vagaries of archaeological preservation, lack of interest on the part of scholars until comparatively recently, and modern destruction of the site resulting from human activities (e.g., Kemp 1977, 102; Jeffreys 2012). Nevertheless, what remains is illustrative of both the imperial presence in the city and the range of experiences had by its inhabitants during the 27th Dynasty. The imperial presence, centred on the Palace of Apries, must have been distinctive, as there was a sizeable garrison quartered in the city, and the palace had become part of the larger imperial administrative

apparatus. That said, the soldiers that comprised this garrison would have been drawn from throughout the empire, and the administrators would have included Egyptians whose positions in existing institutions made them de facto imperial agents. Indeed, the sealings from the Palace of Apries suggest that this administration, like that attested in the Persepolis Fortification Archive, fostered a social environment in which people could draw on a wide variety of cultural motifs in order to represent themselves.

It is interesting that one of the key features of the imperial presence at Memphis, the satrapal court, is largely invisible archaeologically. The reason for this invisibility was the satrap's seamless insertion into the existing Egyptian bureaucracy and power structure, including his use of the Saite pharaoh's palace. This insertion was no doubt facilitated by individuals like those buried at Abusir, whose titles, already mentioned above, such as 'Director of the Palace', 'Chancellor of the King of Lower Egypt', 'Writer of Memoranda', 'Scribe of the Royal Documents' and 'Director of the Palaces of the Red Crown', imply their involvement in the court (Stammers 2009, 156–8). Since the Great King was rarely present in Egypt in person, these individuals were most likely involved principally in the activities and operation of the satrapal court. This example is suggestive of the difficulty in identifying imperial presence at Memphis when it was expressed primarily in Egyptian terms, and the material given here should be considered as representing a minimum of the overall imperial presence in this city.

There is also a range of experiences attested at Achaemenid Memphis. For some people and institutions the presence of the empire, as articulated above, ensured continuity rather than change. The cult of the Apis bull provides the best evidence for this sort of experience on the part of a singularly Egyptian institution. The interment of the bulls at the Serapeum continued, using ever larger coffins, and the rebuilding of the House of Apis attributed to the fourth century could just as easily have taken place in the fifth. The imperial support for the cult was part of the Great King's responsibility as pharaoh to maintain *maat*, or cosmic order, and in the Persian Period this responsibility was clearly undertaken with gusto. Similarly, the shaft tombs at Abusir exhibit clear continuities with Saite tombs, even though the titles of these individuals as recorded in their tombs imply their involvement in the satrapal court at high levels. One of them, Udjahorresnet, even claims elsewhere to have been personally summoned to the court of Darius. The implication of this continuity is that service to the empire did not compel one to

identify with it. Indeed, as mentioned above, this same conclusion can be drawn from the vestiges of the imperial administration in Memphis, namely sealings from the Palace of Apries.

At the same time, Achaemenid rule clearly loomed large for certain other individuals. This is most readily discernible from the names that occur in Demotic and Aramaic papyri alike, which show a marked increase in the number of names borrowed from Old Persian. It is not any great number to be sure, and some of these people so named were definitely transplants from elsewhere in the empire. But especially given the mixtures of names from different languages that occur within single families, it appears that some residents of Memphis saw themselves as denizens of the empire, and named their children accordingly.

The variable, even contradictory, findings presented here emphasise that Achaemenid rule in Memphis did not at all create a uniform experience. Rather, everyone had his or her own experience with the empire, informed by a wide variety of factors. These discrepant experiences occurred against a backdrop of an imperial presence that was simultaneously vigorous and open, thus permitting the range of responses seen here. In other words, the very nature of Achaemenid imperialism at Memphis facilitated the continued employment of Egyptian cultural memory as a major source of charismatic authority, while at the same time it added another source of such authority, namely connections to the empire. People drew on either or both of these sources as they saw fit.

The material discussed in this chapter and the conclusions drawn from it provide a useful starting point for understanding objects from elsewhere in Egypt, many of which are of putative or uncertain provenance, and for addressing other bodies of evidence which are less plentiful or consist of specific types of material. The next chapter contextualises Memphis by considering the experience of the empire in a rural setting, namely the Kharga and Dakhla Oases in Egypt's Western Desert.

3. Rural Experiences: The Western Desert

> There is a certain kind of banishment, as to an island, in the province of Egypt: banishment to the Oasis.
>
> Ulpian of Tyre, *On the Duties of Proconsul*

THE PROBLEM OF THE DESERT

After securing the Nile Valley, Cambyses turned his attention to the Western Desert. According to Herodotus (3.26), he dispatched a force of 50,000 men from Thebes, which, after marching for seven days, arrived at a city called 'Oasis'(ἐς Ὄασιν πόλιν). Herodotus says the objective of the expedition was to subdue the 'Ammonians', who are usually understood to be the inhabitants of the Siwa Oasis to the north, but given the allotted time this expedition must have reached Kharga instead (Osing 1998, 1447–8; Cruz-Uribe 2003a, 35–7). Herodotus goes on to say that the expedition was buried in a sandstorm, but this statement need not be taken literally. As discussed in Chapter 1, Herodotus's narrative of Cambyses' activities probably stems from an attempt on the part of the Egyptians to preserve the integrity of Egyptian cultural memory, which in Herodotus's interpretation results in the depiction of Cambyses as a madman. Indeed, this story of Cambyses' doomed expedition corresponds closely to the traditional Egyptian view of the desert as remote, desolate and dangerous (Morris 2010a).

The Kharga and Dakhla Oases, which lay some 500 km south of Memphis, were only sparsely populated and intermittently settled during the pharaonic period of Egyptian history. Although they had been officially administered since the Old Kingdom by governors appointed by the pharaoh and visited by caravans, police patrols

and various other expeditions, the Egyptians viewed the oases as a place apart from Egypt. In the Roman Period this view was made explicit in papyri from the oases, which refer to the Nile Valley as 'Egypt' (Bingen 1998, 290), implying that the oases were beyond the borders of Egyptian civilisation. Their remoteness is emphasised by numerous ancient authors as well, who refer to the oases as islands; as Strabo (17.5) put it, 'the Egyptians call "oases" the inhabited districts which are surrounded by large deserts, like islands in the open sea' (trans. H. L. Jones).

The question for the Persians was how to deal with the problem presented by the geographic and cultural remoteness of the desert. Cities, such as Memphis, had longstanding power structures, which the Persians could either dismantle or appropriate. Rural hinterlands, of which the Kharga and Dakhla Oases are extreme examples, had no such structures, so the Persians had to develop a different strategy for implementing Achaemenid rule there. In the oases, they addressed this problem by bringing the necessities of Egyptian civilisation, especially water and temples, to the desert. This in turn permitted the creation or expansion of the sort of institutions they used to make Egypt part of the Achaemenid Empire.

The Kharga and Dakhla Oases of the Western Desert provide an invaluable opportunity to examine how the Persians integrated remote and rural hinterlands into the satrapy of Egypt, and how the inhabitants of those hinterlands may have experienced that integration. This chapter first considers the geographical and historical setting of the oases, including earlier Egyptian approaches to them. Next it examines the evidence for qanat irrigation and temple construction, as these are the main archaeological features of the oases in this period. It concludes with a brief discussion of the impact of Achaemenid rule in the Western Desert on those who experienced it.[1]

THE GEOGRAPHICAL AND HISTORICAL SETTING OF THE OASES

The Kharga and Dakhla Oases form a single large depression in the high desert (Fig. 3.1). Together they comprise the largest oasis in Egypt's Western Desert; in the Ptolemaic and Roman Periods they were often known collectively as the 'Great Oasis'. In earlier periods, by the New Kingdom at least, they were known by the term *wḥ3.t rsy.t*, meaning 'southern oasis', distinguishing them from the

[1] This chapter expands significantly on the argument made in Colburn 2018b.

Rural Experiences: The Western Desert

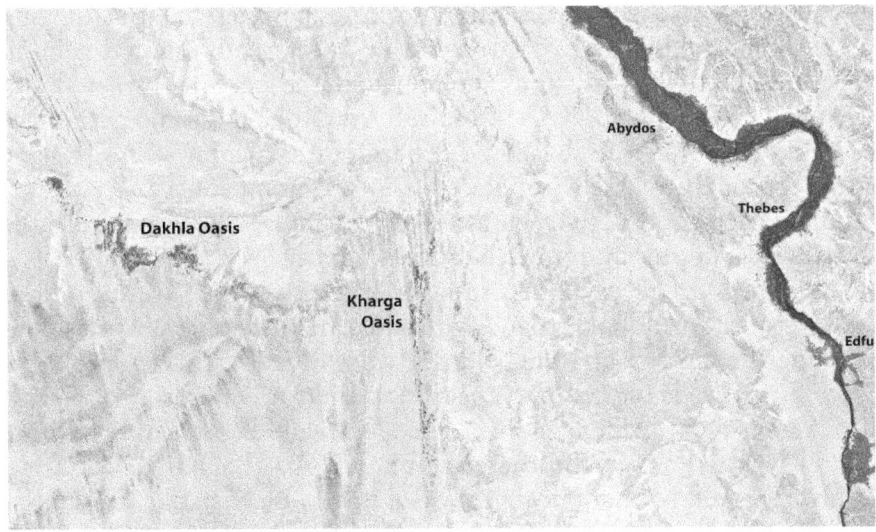

Fig. 3.1. Satellite image of the Kharga and Dakhla Oases in 2019. Image © Google, ORION-ME, with place names added by the author.

Bahariya, Farafra and Siwa Oases to the north (Giddy 1987, 39–40). Kharga, lying some 200 km west of the Nile Valley, is approximately 185 km north to south, and between 20 and 80 km east to west. To the west, separated from Kharga by a broad ridge, is Dakhla, which extends some 75 km further to the northwest, with a width of between 10 and 20 km.

The oases were connected to the Nile Valley by means of several overland routes across the desert that cut through the steep northern and eastern scarp (Giddy 1987, 6–13; Darnell and Darnell 2013; Rossi and Ikram 2013). To the west the Abu Ballas trail led to Gilf Kebir and ultimately the Kufra Oasis in Libya (Förster 2013). To the south the oases were connected to the Darb al Arbein ('Road of Forty Days') caravan route, which penetrated deep into the Sudan. Although there is little evidence for the use of the Darb al Arbein in antiquity (Roe 2005–6), the Amduat, an Egyptian funerary text of New Kingdom date, seems to reflect some knowledge of the geography and climate of the Chad Basin in central Africa (Schneider 2010), suggesting this route was in use as early as the second millennium BC.

There is evidence for human occupation of the oases as early as the Upper Palaeolithic, some 40,000 years ago (McDonald 1999; Wiseman 1999). Over the course of the fifth millennium BC, however, the eastern Sahara became increasingly arid. This caused

the springs in the oases to dry up, and necessitated the digging of artesian wells. After about 3500 BC the already limited rainfall ceased almost entirely, and settlement in the oases contracted significantly (Kuper 2006). As a result, during the pharaonic period the oases were never densely settled. Kharga in particular seems to have been especially sparsely populated (Caton-Thompson 1952, 45–53). Some agricultural activity is attested at Umm Mawagir during the Middle Kingdom, and at Gebel Ghuweida nearby during the New Kingdom (Darnell et al. 2013, 6–7). These two sites are located at the western terminus of the Girga road, one of the main routes connecting the oasis to the Thebaid in the Nile Valley, so they probably served the needs of passing expeditions and caravans.

There is more evidence for settlement in Dakhla, probably because water was more plentiful there than in Kharga (Bagnall 2004, 262). During the Old Kingdom there was a governor based at Balat, who may have been responsible for the entire Western Desert (Pantalacci 2013). Two temples are attested in the oasis as well, at Mut el-Kharab and Amheida (Kaper 2009; 2012). The former was founded in the New Kingdom, and the latter during the 23rd Dynasty, and both continued to operate into the Late Period. Both were presumably also associated with settlements. On the whole, however, Egyptian activity in the Western Desert after the Old Kingdom seems to have been focused more on expeditions, trade and procurement of raw materials than on settlement and agriculture (Darnell 2013).

Textual evidence from the Nile Valley suggests that the Egyptians regarded the oases as distant and desolate, far from the reliable waters of the Nile. This view is expressed poignantly in Papyrus Pushkin 127 (Caminos 1977), a hieratic literary letter dating to the Third Intermediate Period describing the travails of a priest named Wermai. It paints a grim picture of life in the Western Desert:

> Mark you, I am sick at heart; for a month I have been kept away from grain. I and those who are with me ache with hunger. The people among whom I am, their well-to-do are few; the Nile is stopped, and their land in darkness. They cannot escape from dire affliction. (trans. Caminos 1977, 71)

As it is a work of literature this account may not be entirely accurate. It does suggest how the Egyptians may have viewed the oasis, however. Contemporary documents show that the Great Oasis served as a place of exile in this period. In particular, the so-called 'Banishment Stela' from Karnak (Louvre C. 256; Ritner 2009, 124–9) records how during the 21st Dynasty the Theban high priest Menkheperra pardoned and recalled the 'quarrelsome servants ... who are in the

oasis in which people are confined'. These 'quarrelsome servants' were probably Theban priests who had been exiled in the course of political turmoil at the end of the New Kingdom. There are few such textual references to the oases during the 26th Dynasty (Klotz 2013, 903–5), but it stands to reason that the negative view of the oasis persisted down into the Late Period.

With the advent of Achaemenid rule the Western Desert became a base for rebels against the Persians. The earliest of these was Petubaste IV, whose cartouche appears on blocks from a gateway at the temple at Amheida in the Dakhla Oasis (Kaper 2015).[2] Petubaste is generally thought to have revolted in the period of unrest after Cambyses' death in 522 (Yoyotte 1972; Wijnsma 2018), though the discovery of his cartouche at Amheida has raised the possibility that Cambyses' expedition against the 'Ammonians', whatever its outcome, was actually directed at him. Regardless of the date of his revolt, Petubaste's base seems to have been in Dakhla, since these blocks are the clearest evidence for his activity in any specific location.[3] A few decades later another rebel, Inarus (Kahn 2008), is attested in the southern Kharga Oasis. A Demotic ostracon from Ain Manawir uses his name (without a cartouche) in a dating formula on a contract (Chauveau 2004; Winnicki 2006). Inarus's power base was in the Delta, and the use of his name in this manner in the Kharga Oasis suggests he had gained some sort of foothold in the Western Desert. Yet the lack of a cartouche suggests his rule was not fully recognised there, or at least that there was some uncertainty about what was happening.

Most likely Petubaste and Inarus were using the oases of the Western Desert as an alternative route to the Nile. A thousand years earlier, during the Second Intermediate Period (c. 1650–1550 BC), the besieged king of the Hyksos, Apep, sent a messenger through the Western Desert to Kerma to try to convince the Kushites to attack Pharaoh Kamose's forces from the rear. Kamose, however, intercepted the messenger in the Bahariya Oasis, and then secured the oasis to prevent this from happening again (Kuhlmann 2002; Simpson 2003, 345–50). As discussed in the previous chapter, during Achaemenid

[2] Petubaste IV has only recently been distinguished from Petubaste III.

[3] A Demotic document found by Petrie at Maidum (P. Ashmolean 1984.87; Petrie et al. 1910, 43 no. 43; Vittmann 2015) bears the impression of a seal naming Petubaste. The document refers to the allotment of land in the Herakleopolite nome, south of Memphis, raising the possibility that Petubaste controlled this region. However, as discussed in Chapter 2, seals naming deceased kings (or pretenders) continued to be used in Egypt long after the king in question had died, and on its own this document cannot be taken as evidence for Petubaste's control of any part of the Nile Valley.

rule Memphis, located at the apex of the Nile Delta, was a well-guarded imperial stronghold. The oases of the Western Desert were perhaps the only means for either rebel to bypass the capital and gain access to southern Egypt.

The importance of Kharga and Dakhla for maintaining control of Egypt is clear. Following Cambyses' expedition, the Persians seemingly adopted a new approach to the oases, one that emphasised their integration into the Egyptian cultural and political sphere instead of military domination. They introduced an irrigation technology, the qanat, which facilitated agriculture on a level that was previously impossible, leading even to the cultivation of cash crops. They founded several temples, including the major temple of Amun at Hibis. The combination of temples and irrigation suggests the establishment of new settlements or the enhancement and development of existing ones. And all of this was apparently achieved without the construction of fortresses to defend these new installations. The Persians' approach was not to fortify the oasis so much as to populate it. This served to bring the oases into the imperial fold. It is important not to overstate the ramifications of this shift, but it nevertheless represents an important departure from earlier approaches to controlling and exploiting the Western Desert.

IRRIGATION

The development of irrigation in the Kharga and Dakhla Oases during the 27th Dynasty is attested primarily by the introduction of the 'qanat', an irrigation technology closely associated with Iran. 'Qanat' (often pluralised as 'qanats') is an Arabic term for an underground channel connecting a source of water with a cistern some distance away (Fig. 3.2). Once the water source and destination were determined and the qanat's overall course plotted, a series of vertical shafts were dug down from the surface, and then horizontal galleries

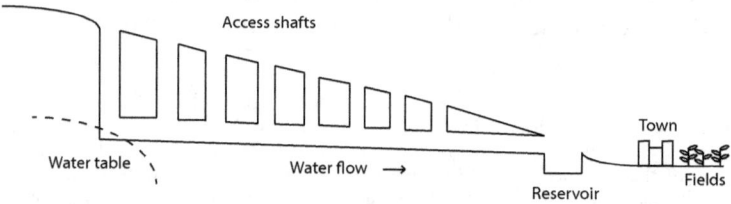

Fig. 3.2. Schematic drawing of a qanat. Drawn by the author after Wilson (2006, fig. 18.2).

were dug between them at an incline (Goblot 1979, 30–6; Stiros 2006, 1059; De Planhol 2011, 565–9; Boucharlat 2017, 280–2). In the finished qanat the water flowed from the source to the cistern, from which it was redirected into surface channels or drawn with containers. Qanats are especially valuable for supplying water in arid environments, for agriculture as well as for consumption, and they are used in many regions of the Old World and New, where they are known by various names (e.g., *karez, khettara, falaj, foggara*).

The presence of qanats in the Western Desert has been known since the nineteenth century. Frédéric Cailliaud (1826, 152–5, 163–4, 178–80), who visited the Dakhla Oasis in 1820, noted them at several sites. Nearly a century later H. J. Llewellyn Beadnell (1909, 167–85) described a number of them in the northern Kharga Oasis, providing not only a discussion of their condition and functionality, but also some interesting ethnographic data about the effort necessary for their cleaning and maintenance. Yet despite these early accounts, qanats have only recently been subject to systematic study, and then in only two parts of Kharga: Ain Manawir in the south and in the vicinity of Ain Gib and Qasr el-Sumayra and along the Darb Ain Amur in the north. These qanats are likely to represent only a fraction of those that once existed in the oases. In addition to those described anecdotally by travellers such as Cailliaud and Beadnell, more qanats have been discovered in the eastern Dakhla Oasis in the Wadi el-Gemal, for example (Abd el-Rahman 2011, 13).[4] Many more must remain as yet unrecognised, as without regular maintenance they are apt to become filled with windblown sand, causing them to become difficult to locate and identify.

Ain Manawir is one of five hill sites (the best known of which is Dush, ancient Kysis) in the Baris basin at the southern end of the Kharga Oasis. The site includes a mudbrick temple dedicated to Osiris and two groups of houses (Wuttmann et al. 1996, 393–402; Grimal 1997, 340–2; Willeitner 2003, 46–8). Several hundred Demotic ostraca were excavated as well, both from a building adjoining the southern wall of the temple and from some of the houses (Chauveau 1996; 2001; 2005; 2008; 2011; Wuttmann et al. 1996, 408–14; 1998, 442–4; Agut-Labordère 2018a). These ostraca are significant not only for their dates, which range mostly from 445 to 390 BC, but also for their content, much of which pertains to the

[4] It is worth noting as well that there are qanats in the Bahairya and Frafara Oases (de Angeli 2013). They are associated with sites of Roman date, though, as discussed further below, this does not provide definitive evidence for the date of their initial construction.

sale and management of water rights. The excavators also identified twenty-two qanats dug into the northern and eastern slopes of the hill and feeding agricultural fields below (Wuttmann et al. 1996, 440–7; 1998, 398–421; 2000; Wuttmann 2001; Gonon 2005; Colburn 2018b, 92–3). They are spaced fairly evenly at intervals of between 150 and 200 m on the north slope, and less regularly on the east. Their overall lengths range between about 200 and 350 m.

In addition to those at Ain Manawir, qanats have also been identified at the other four hill sites nearby: Ain Boreq, Ain Ziyada, Dikura and Dush (Bousquet 1996, 179–91, 195–202). Dush, where at least three separate qanats have been found, is the only one of these sites to have been explored systematically. Most of the remains from the site date to the Roman Period; however, as discussed further below in the next section, radiocarbon dates and references to Dush in the ostraca from Ain Manawir indicate that it was first occupied during the 27th Dynasty (Reddé 2004, 186). The qanats there presumably date to this period as well, since they would have been needed to facilitate agriculture. Some of the other qanats in the area may also originate in this same period, though it is difficult to distinguish between qanats of Achaemenid and Roman origin, especially since the earlier qanats were reused in later periods, sometimes with modifications. Indeed, variations in form and construction technique imply that these qanats were dug and maintained over a long period of time (Bousquet 1996, 192–3).

In the northern Kharga Oasis qanats have been documented so far near two forts, Ain Gib and Qasr el-Sumayra, and at two settlements, Ain Lebekha and Umm el-Dabadib. Ain Gib and Qasr el-Sumayra are located along the main route from Kharga to Assiut in the Nile Valley. Three separate qanat systems have been identified in the vicinity of these forts, each no less than 400 m from each other and supplying different areas (Schacht 2003; Ikram and Rossi 2004, 84–6). These qanats are quite long, between 7 and 11.5 km. Ain Lebekha and Umm el-Dabadib are both south of these forts, situated along the Darb Ain Amur, the main route from Kharga to the Dakhla Oasis. Four different qanats have been mapped at Ain Lebekha, watering three separate areas of cultivation (Rossi and Ikram 2010, 238–9). The longest of these qanats is about 500 m. Finally, seven qanats have been identified at Umm el-Dabadib, extending all together over 14 km in length and featuring approximately 640 vertical shafts (Rossi 2000, 348–52; Rossi and Ikram 2006, 301–2). All of these sites have been dated to between the first and fourth centuries AD, primarily on the basis of ceramic surface

finds from each. But this indicates the main period of use, and does not necessarily mean that the qanats themselves originated at the same time, especially as they are intrinsically difficult to date. Indeed, there is at least one shaft grave at Umm el-Dabadib, a form typical of Late Period funerary architecture, and also pottery of unknown date which probably predates the Roman Period (Rossi and Ikram 2006, 296, 300). Accordingly, earlier dates for these sites, and for the qanats, are certainly possible.

The qanats of Ain Manawir clearly date to the period of Achaemenid rule. As noted above, the Demotic ostraca recovered there refer to the leasing of water rights for fixed periods of time in exchange for percentages of the harvest, and they even seem to refer to qanats in particular (Chauveau 1996, 41–2; 2001; 2005, 160–1; Agut-Labordère 2018a). These ostraca mention regnal years, and thus can be assigned to the period between 483 and 370 BC, though the earliest extant water contract dates to 443 (Chauveau 2008, 521; Agut-Labordère 2018a, 361). The qanats must belong to this same period. This date is also supported by the fact that one of the houses at Ain Manawir was built over the spoil heaps resulting from the construction of a qanat. The ostraca found in this house date to between 436 and 388 BC, so the qanat in question must have been dug prior to this, sometime in the mid-fifth century (Grimal 1999, 486). The other qanats in the oasis cannot be dated so firmly. Their locations in the vicinity of Roman Period sites may suggest a later date for their origin. However, qanats were frequently reused in later periods. For example, when Beadnell visited Umm el-Dabadib in 1905 one of the ancient qanats had been cleared in order to supply water to the modern village (Beadnell 1909, 171–2). Thus, there is nothing that compels a Roman date for the initial construction of these qanats, and it is entirely possible that these later forts and settlements were established in places where water was already accessible.

The origin and spread of qanat technology

Qanats are closely associated with both the Achaemenid Empire and modern Iran. According to one estimate, in AD 2000 there were some 40,000 qanats in Iran, of which some 25,000 were still in operation, making Iran one of the most prominent users of this form of hydraulic technology (Kheirabadi 2000, 94; de Planhol 2011, 578–83). This prominence, which is unmatched anywhere else in the world, informs the association of qanats with the empire, as

does a passage in Polybius (10.28) describing a qanat system in Media and dating its origin to the time of the Achaemenids (Briant 2001). The traditional view of the spread of this technology is that it was first invented in Urartu (which controlled parts of what is now northwestern Iran) during the first half of the first millennium BC, was inherited subsequently by the Achaemenids, and then spread by them throughout their empire (English 1968; Goblot 1979, 67–71; de Planhol 2011, 573–8). In recent years the geographic origin of the qanat has become open to debate, and this in turn has undermined the model of its dissemination throughout the Near East by way of Achaemenid rule. These are in fact separate (albeit closely related) issues. Therefore it is worth revisiting the subject here because of its importance for understanding the significance the qanats in the Kharga Oasis.

Several potential origins for the qanat have been proposed or implied. As noted above, the traditional view is that they first appeared in the kingdom of Urartu. The basis for this argument is Sargon II's 'Letter to the Gods', a report of his campaign of 714 BC against Urartu in which he describes the water system around the city of Ulhu (Goblot 1979, 67–9). This description includes references to water channels which have been interpreted as tunnels or shafts. This interpretation was furthered by the existence of ancient qanats in eastern Anatolia in an area once subject to Urartian rule. However, this interpretation has been challenged on both lexical and archaeological grounds (Çifçi and Greaves 2013, 200). The Akkadian word in the Letter to the Gods which had been interpreted as referring to a qanat (*išqillatu*) is now understood to mean 'pebble', and the entire passage seems to refer in fact to canals rather than qanats. Likewise, the qanats that have been discovered in eastern Anatolia bear no relation to Urartian settlement patterns, making it likely they are of later date, and thus not the earliest known qanats.

Qanats of presumably pre-Achaemenid date have been found in both northern Mesopotamia and the Oman Peninsula. Nearly 7,500 vertical shafts have been identified in the plain of Erbil (ancient Arbela) in Iraq using satellite imagery, and recent fieldwork suggests they were dug following the breakdown of Assyrian state power in the seventh century BC (Ur et al. 2013). If so, this provides evidence for pre-Achaemenid qanat use in northern Mesopotamia, and raises the possibility that the technology originated there. The qanats in Oman occur at several Iron Age sites, including in the al Ain Oasis, and at Bida bint Saud, al-Thuqaibah, al-Madam and Maysar (Magee 2005; Boucharlat 2017, 282–7). These sites are datable by their

ceramic remains to the period 1000–600 BC (Iron Age II). These qanats, or *aflaj* as they are known in Oman, predate the formation of the Achaemenid Empire, but given the broad dating of them it is impossible to say by how much.

While these qanats in Mesopotamia and Oman demonstrate their existence outside of Iran prior to the establishment of the Achaemenid Empire, there is also evidence for qanats in Iran itself, as early as the second millennium BC. A survey carried out in the Deh Luran plain in western Iran in 1969 identified a form of qanat associated with sites dating to c. 1600–1300 BC (Neely 2010). Unlike typical qanats, these drew on rivers, specifically the River Dawairij, rather than a subterranean source, and in some cases they fed surface canals. But they still feature the telltale vertical shafts that are a hallmark of the Iranian qanat in its fully developed form. Additionally, a typical qanat system at Miam near Dasht-e Bayaz, some 60 km east of Ferdows in northeastern Iran, has now been dated using optically stimulated luminescence (OSL). The results suggest that these qanats were dug at least 3,300 years ago, also during the second millennium BC (Fattahi 2015). Further research is needed to fully understand the archaeological context for these qanats, but this date makes them, along with the examples from the Deh Luran plain, the earliest known examples of this technology in the Near East. Arguably these qanats are the precursors to those in Mesopotamia and Oman, since the Elamites had extensive contacts with both regions (Potts 2006; Radner 2013), though the possibility remains that they were developed independently in one or more of these places.

There are also suggestions that qanats were in use in Egypt prior to the Persian conquest. Qanats in the Bahariya Oasis have been attributed both to the New Kingdom and to the 26th Dynasty. The New Kingdom date is derived from a reference in the Great Harris Papyrus to Ramesses III making 'vineyards without limit' in the oases of the Western Desert (Gosline 1990, 27–8). There is, however, neither any reference to qanats in the passage, nor any allusion to irrigation at all. The 26th Dynasty date derives from a tomb mentioned briefly by Ahmed Fakhry, but never published in any detail. According to Fakhry (1942, 83) the tomb was constructed in such a way as to avoid an existing qanat, and therefore postdated it. He attributed the tomb to the Saite Period without specifying his reasons for doing so. No doubt this is another example of the common practice of dating Late Period tombs to the 26th Dynasty in the absence of definitive evidence (Aston 1999). Thus the evidence it offers is not at all definite. Finally, a Demotic ostracon from

Ain Manawir has a regnal date of Amasis (specifically 528 BC). This has been taken to indicate that the settlement there was established prior to the Persian Period, and since the settlement relied on qanats for irrigation and drinking water, these too must date to the 26th Dynasty (Cruz-Uribe 2003b, 539–40). This ostracon, however, is clearly an outlier. Most of the ostraca from Ain Manawir date to the second half of the fifth century or early fourth century (Chauveau 2001, 137; 2005, 158). So it is hardly evidence of Saite Period settlement. Moreover, the text on this earliest ostracon refers to a marriage contract and makes no reference whatsoever to water management. It is of no use as an indicator of the pre-existence of qanats in Egypt during the 26th Dynasty. Accordingly, there is no sound evidence for the construction of qanats in Egypt prior to Achaemenid rule there.

Thus the earliest known qanats are indeed found in Iran, in a region not far from what was later to become the Achaemenid heartland. It is of course entirely possible that the qanat was invented independently in different times and places, but the expertise necessary to construct them makes this scenario less probable. In the absence of modern measuring instruments it would have been necessary for those responsible for their initial construction and upkeep to have access to an extensive store of geodetic knowledge (Stiros 2006). This knowledge could be built up over a long period of time through experience and trial and error, but it could also be supplied more swiftly and easily by an outside expert familiar with the technology. Thus the simplest explanation for the spread of qanat technology is that it did disseminate in large part from Iran.

There is good evidence as well that the qanat first spread to the southern Levant during Achaemenid rule. Qanats in the Negev can be dated to this period on the basis of ceramic remains found around and within them (Evenari et al. 1982, 178). Similarly, the qanats in al-ʿUlā Oasis in northwest Arabia can be dated to the fifth and fourth centuries BC based on the Dadanitic inscriptions associated with them (Scagliarini 2001–2). Both of these regions were subject to some degree of Achaemenid control (Graf 1990), and the appearance of qanats must be a result of this. To the west the Garamantes in Libya also made use of qanats (Wilson 2006), beginning at the earliest in the fourth or third century BC, as indicated by radiocarbon dates of seeds recovered from the earliest stratigraphic layers at Garama (Old Jarma), their capital city (Mattingly et al. 2002, 13–14). Since Garama must have relied on qanat irrigation, it stands to reason that the city's earliest phases coincide roughly with the introduction

of qanat technology to the region. Most likely it was transmitted westward along the Abu Ballas trail or the more northerly caravan route described by Herodotus (4.181–5; Liverani 2000) that linked Egypt with Libya and with points further west. It is even possible that hydrological engineers brought qanat technology to Libya as a result of the revolts that ended Achaemenid rule in Egypt in the late fourth century (Colburn 2018b, 109 n. 2).

At any rate, the fifth-century date of the qanats of the Kharga Oasis fits this pattern of westward diffusion contemporary with the Achaemenid Empire, and there is no evidence for their use anywhere in Africa before this period. The likelihood then is that the empire fostered or facilitated the spread of this irrigation technology.

Irrigation and empire

The link between the state (in this case, the Achaemenid Empire) and irrigation in antiquity has been the subject of a significant and distinctive body of scholarship. Of particular note is Karl Wittfogel's *Oriental Despotism* (1957), which advanced the ambitious 'hydraulic hypothesis' linking the control of irrigation to the creation of state bureaucracies that controlled economic resources. While impressive, this hypothesis has been much criticised because the causality posited by Wittfogel is not supported in many Near Eastern cases where irrigation infrastructures appear to predate state formation. The most notable refutation of the hydraulic hypothesis in an Egyptian context was by Karl Butzer (1976), who emphasised the small scale and local character of irrigation in the Nile Valley. Much of this local management, where it appears in documentary sources anyway, was carried out by temples. For example, in Papyrus Reinhardt, a tenth-century BC register of the arable land administered by the domain of Amun, there are references to a temple official with the title 'Water-Chief', presumably an official responsible for the allocation of water from canals under the temple's control (Vleeming 1993, 56–7). This sort of control is similarly attested in the Demotic ostraca from Ain Manawir, referred to above, where irrigation is under the administrative remit of the local temple of Osiris. As with farmland, the pharaoh delegated control of irrigation to local institutions such as temples in exchange for the ability to draw on local resources and manpower as needed (Manning 2002; Colburn 2018c, 73–6).

But this is not to say there was no pharaonic involvement in irrigation. Certainly large-scale projects such as the development of the Fayum during the Middle Kingdom were royal undertakings.

Furthermore, recent research on Near Eastern landscapes using the results of field surveys and declassified satellite photography supports one aspect of Wittfogel's hydraulic hypothesis, that large terrestrial empires promoted the spread of irrigation technologies (Wilkinson and Rayne 2010). This conclusion is based on the apparent coincidence of extensive irrigation works with periods of political centralisation in the Near East. In other words, empires deliberately introduced irrigation technologies to existing cultivatable regions in order to intensify agricultural production, and to sparsely populated ones to permit colonisation.

During the period of Achaemenid rule, for instance, a section of the Tigris valley west of Samarra (in the area of modern Dujail, Iraq) became densely populated for the first time with the aid of a newly constructed network of canals (Adams 1972). Such colonisation was undoubtedly a product of imperial impetus (perhaps continuing an effort begun under the Neo-Babylonian kings), but this does not necessarily imply that the canals themselves were managed by a centralised bureaucracy. On the contrary, local management of water resources seems to have been the normal practice in the Achaemenid Empire, where this management was fostered and supported by the Great King, even while no attempt was made at creating centralised control or interfering with existing local systems (Briant 1994).

This pattern of imperial involvement and local control fits the material from the Western Desert. The introduction of the qanat, and probably also the initial construction of the irrigation systems, was undertaken by imperial officials and paid for out of imperial coffers. According to one estimate it took at least five years to dig a single qanat in the oasis (Bousquet and Robin 1999, 32–3), and Beadnell (1909, 171) reports that cleaning of a qanat at Umm el-Dabadib in 1905 required the efforts of seventy to eighty men 'working throughout the hot season'. If these figures are accurate and representative, qanat construction would have required a significant outlay of time and effort, too much it seems for private individuals to undertake on their own.

Rather, expert engineers would have been brought in from elsewhere in the empire to plan and supervise the work, and also to train local residents to maintain the qanats. It is true that hydrological conditions in the Western Desert of Egypt, especially the vast Nubian Sandstone Aquifer, were different from those in Iran, and qanat technology had to be adapted to these conditions. This process of adaptation may well account for the seemingly irregular character of the qanats which has been observed at Ain Manawir (Gonon 2005;

Boucharlat 2017, 289). Once construction was complete, the Great King in his role as pharaoh assigned the water rights to temples such as the temple of Osiris in Ain Manawir. These temples then took over the management of the qanats. It may well be that, as in the case of Dujail mentioned earlier, the empire deliberately sought to populate the Kharga Oasis, using the qanat technology precisely to achieve this end.

TEMPLES

Although there is a long history of religious activity in Egypt's Western Desert, the physical infrastructure of this activity, including shrines, kiosks, grottos and graffiti, suggests it primarily took place on a small scale (Darnell 2007a, 46–8). During the 27th Dynasty, however, there is a clear shift towards larger structures. No fewer than four temples – three in Kharga and one in Dakhla – can be firmly attributed to the period of Achaemenid rule, and two more at Dush in the southern Kharga Oasis very likely belong to this period as well. Additionally, some of the later temples in the oases, dating to the Ptolemaic and Roman Periods (Cruz-Uribe 1999; Willeitner 2003, 22–53; Bagnall 2004, 251–62), could have been constructed originally in the 27th Dynasty or replaced earlier temples. For example, geophysical survey has revealed that the Ptolemaic temple at Qasr el-Zayyan, 27 km south of Hibis, was built over an earlier structure (Kamei et al. 2002; Atya et al. 2005). Without the benefit of excavation is it impossible to say what it was or when it was built, but its plan is consistent with that of a temple, raising the possibility that the Ptolemaic temple supplanted an Achaemenid one (Klotz 2009, 19–20). Similarly, the temple at Ain Amur, situated along one of the main routes from Kharga to Dakhla, is generally regarded as Roman (Winlock 1936, 48–51; Fakhry 1941; Willeinter 2003, 53), but there is no definitive evidence for the date of its construction or use, other than some Coptic graffiti. Both of these examples illustrate the possibility that there are other temples of 27th Dynasty date in the oases that are as yet unrecognised as such.

Ain Manawir

As discussed above, Ain Manawir was the site of a settlement in the southern Kharga Oasis established during the 27th Dynasty with the aid of multiple qanat systems that provided irrigation. Like the settlement, the temple (Fig. 3.3) seems to have been a new foundation.

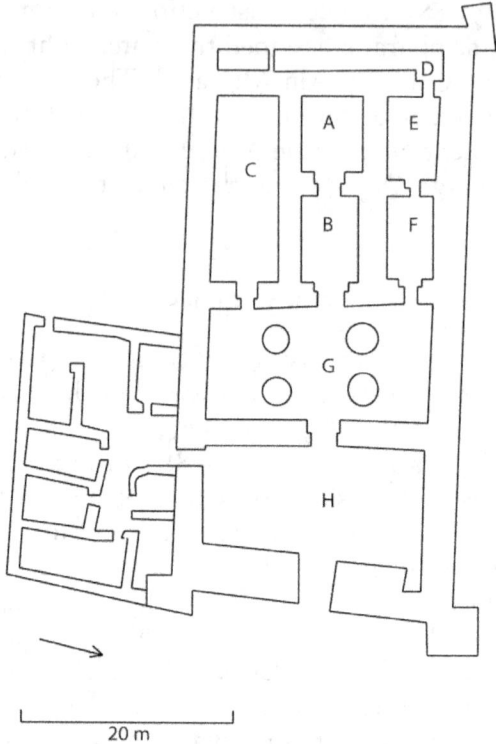

Fig. 3.3. Plan of the temple of Osiris at Ain Manawir, with adjoining building. Drawn by the author after Wuttmann et al. (1996, fig. 4).

It consists of a large structure (approximately 60 by 18 m), made of stone and mudbrick, facing east (Wuttmann et al. 1996, 393–402; Willeitner 2003, 46–8; Colburn 2018b, 95–6). It includes a forecourt (H), a hypostyle hall (G), the main sanctuary (A), a barque chapel (B), and two other chapels (E and F). The sanctuary and barque chapel were originally paved with stone, and the walls are decorated with red ochre. They feature painted images of a large ankh, two squatting falcon-headed gods identified as Horus or Re-Harakhte and Khons, and as many as three more gods who are too poorly preserved to be identified. The walls of the barque chapel feature images of three human-headed gods who are also too poorly preserved for identification. The decorations of both of these rooms are painted in red, black, white and yellow. Four bronze statuettes of Osiris were recovered from these two rooms as well (Wuttmann et al. 1996, 431–3; Wuttmann et al. 2007).

The two other chapels (rooms E and F) are on the north side of the sanctuary and barque chapel, and neither has any surviving decora-

tion. Seventy-two bronze statuettes of Osiris were found in room E, along with six Demotic ostraca, and 173 statuettes of Osiris were found in room F, as well as a few of other gods, some more ostraca and the remains of a small wooden naos (Wuttmann et al. 2007). Chapel F also featured fragments of sarcophagi below floor level, indicating the possibility of human burials there. The excavators suggest that these burials may actually predate the temple itself, or that the cavity in which they were found was a pre-existing feature over which the temple was built (Wuttmann et al. 1996, 396–8). A corridor (D), or other narrow room, runs along the back of the temple, in which were found another Osiris figurine and twenty Demotic ostraca. On the south side of the main sanctuary and barque chapel is a large room (C), the purpose of which remains unclear. A large amount of pottery was found there, along with yet another Osiris statuette and some more Demotic ostraca. Both C and D have some signs of decoration preserved on their walls, mostly red, white and black paint. In front of the hypostyle hall is a forecourt.

Abutting the temple to the south is another, smaller building where approximately one third of the Demotic ostraca found at Ain Manawir were discovered (Wuttmann et al. 1996, 402–7). On account of this, and its proximity to the temple, it has been suggested that this building was the office of the temple scribe (Chauveau 1996, 34–5). Although some of these ostraca do bear texts referring to temple business, the majority of them are contracts that are not explicitly related to temple affairs. However, the temple scribe probably also served as the village scribe, so this suggestion is quite plausible, especially as the temple was also the administrative hub of Ain Manawir. As noted above, these ostraca range in date from 483 to 370 BC, providing a sound indication of when the temple was in operation (Chauveau 2008, 521).

Based on references in the ostraca it is clear that the temple at Ain Manawir was dedicated to Osiris. There are frequent references to him, and the phrase 'domain of Osiris' appears as well (Wuttmann et al. 1996, 401–2). This conclusion is also reinforced by the large number of Osiris statuettes found throughout the temple. The ostraca provide a glimpse into the temple's activities. For example, there is a reference to a *lesonis* priest named Hor, son of Horteb, and to a person named Unamheb, who is apparently involved in temple services of some kind (Chauveau 2001, 140–1; 2008, 521). The temple was also involved in the sale and leasing of agricultural fields. Full publication of these ostraca will permit a fuller understanding of the temple's activities, but based on information currently available

there is nothing striking or out of the ordinary here for an Egyptian temple at any period.

Dush

At Dush (ancient Kysis), some 5 km east of Ain Manawir, there are two small temples that were in use during the Roman Period but which may well have been built during the 27th Dynasty. One of these temples, measuring about 20 m in length, is made of sandstone, and features a forecourt, hypostyle hall, and four small rooms at the back. It sits within a larger mudbrick enclosure. The other temple is made of mudbrick. Both are in poor states of preservation. The sandstone temple was dedicated to Osiris, and the Demotic ostraca from Ain Manawir make reference to 'Isis who is in Kysis', suggesting that the brick temple may have been dedicated to her (Chauveau 1996, 38–9).

Much of the material from Dush dates to the Roman Period, and the sandstone temple has inscriptions spanning the reigns of Domitian to Antoninus Pius. Yet there are several factors pointing to an earlier date of construction (Reddé 2004, 172–3, 180). First, radiocarbon dates were obtained from the enclosure and the mudbrick temple. The sample from the enclosure dates to 450–350 BC, and the sample from the mudbrick temple to 423–179 BC. Second, Kysis is mentioned in the Demotic ostraca from Ain Manawir, suggesting the settlement, and therefore its temples, had also been established sometime during the fifth century BC. Indeed, as noted above these ostraca refer specifically to Isis of Kysis, implying the presence of a temple in this period. Third, as discussed earlier, there are qanats at Dush, which may have been dug under Achaemenid rule when this technology was first brought to the oasis and deployed nearby at Ain Manawir. None of these factors proves definitively that these two temples were built in the 27th Dynasty, but there is a strong possibility that they were.

Qasr el-Ghuweida

Between Dush and Hibis, at the site of Qasr el-Ghuweida (known in antiquity as Perwesekh), there is a small sandstone temple (Fig. 3.4), approximately 19 by 10 m, surrounded by the remains of a once imposing mudbrick fortress (Willeitner 2003, 41–4; Darnell 2007b; 2010, 104–7; Darnell et al. 2013; Colburn 2018b, 96–7). The temple has a forecourt (A), a hypostyle hall (B) with four

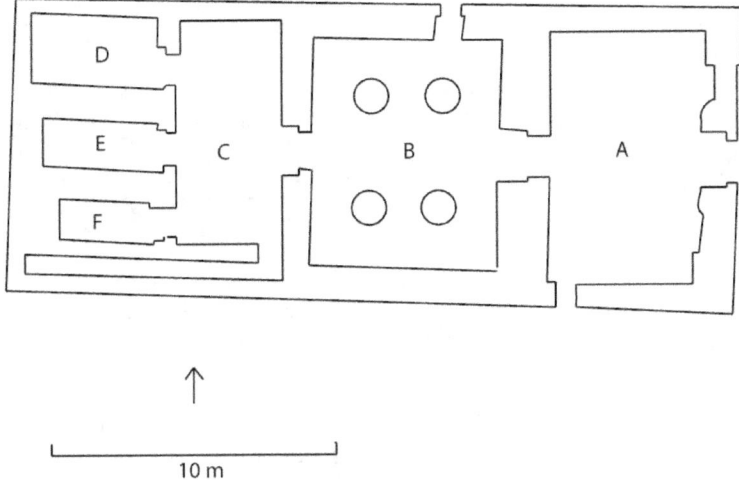

Fig. 3.4. Plan of the temple at Qasr el-Ghuweida. Drawn by the author after Darnell et al. (2013, fig. 2).

columns, a vestibule (C), and three rooms at the back, oriented east to west (D–F). The middle of these three rooms (E) was decorated with raised relief on the west wall and painted plaster on the north and south walls, and is thus thought to be the temple's main sanctuary. The relief on the west wall depicts the pharaoh facing left and presenting the goddess Maat to the Theban triad of Amun, Mut and Khons. On the north wall the king stands before Amun-Re, Mut, Khons, Min and Isis, and on the south he makes offerings to Amun-Re, Mut, Khons, Geb and Nut. No other part of the temple preserves any decoration.

In the past the original construction of this temple was dated to the Saite Period (or earlier), with the forecourt regarded as an addition by Ptolemy III (Porter and Moss 1952, 291–3; Arnold 1999, 88–9; Cruz-Uribe 1999, 407). However, the earliest datable material from the temple is two cartouches of Darius I: one painted on the north wall of the main sanctuary, and the other in raised relief on the west wall (Darnell 2007b, 30). This latter cartouche accompanies the carved decorations on this wall, so the king before the Theban triad must be Darius. The main sanctuary is slightly askew to the rest of the temple, suggesting it was built first as a freestanding shrine prior to Achaemenid rule, and the rest of the temple was subsequently constructed around it (Darnell 2007b, 31–2). If so, it seems that the Persians expanded an existing shrine into a full temple sometime during the reign of Darius. The fort itself may also date to

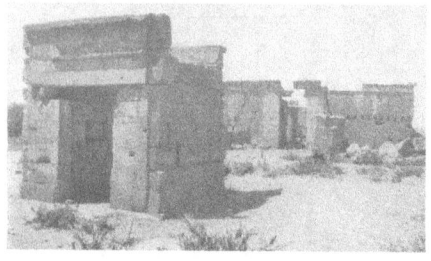 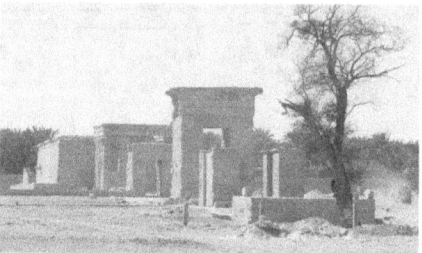

Fig. 3.5. **Left:** The Hibis temple in 1908. Image in the public domain from Winlock (1909, fig. 2). **Right:** The Hibis temple in 2012. Photograph by T. Landvatter, and reproduced by permission.

the Persian Period (Morkot 1996, 84–6), but there is at present no firm evidence for the date of its construction or use.

Hibis

The largest, best known and best preserved temple in the Western Desert is the temple of Amun in Hibis, just north of the modern town of Kharga (Fig. 3.5). The ancient town of Hibis (meaning 'town of the plough'), which has not been studied in any detail, was located within a large patch of cultivable land, perhaps nearly a square kilometre in area (Winlock 1941, 1–4, pl. 29). Part of this town was seemingly taken up by a seasonal lake, and the remains of an ancient quay were still extant in the early twentieth century. The temple itself is situated about 100 m west of the lake on a high point in the centre of town, with a processional way lined with sphinxes linking them (Winlock 1941, 34–8). A monumental gateway and a freestanding pylon were added later, probably in the late Ptolemaic or early Roman Period, since in AD 49 the Roman governor of the oasis inscribed the first of many public notices on the pylon.

The earliest part of the temple (Fig. 3.6) is the western half, a rectangular structure approximately 19 by 28 m (Winlock 1941, 7–19; Colburn 2018b, 97–102). It is comprised of a porch (M) with four columns, a forecourt consisting of a hypostyle hall (B) also with four columns, a small main sanctuary (A) at the rear, and several small rooms off the hypostyle hall, as well as two staircases leading to an upper level. The upper level featured several small decorated chapels, a larger open-air area and a staircase (E) providing access to the roof of the hypostyle hall and forecourt. Additionally, under the southwest corner of the temple there are two crypts, accessible

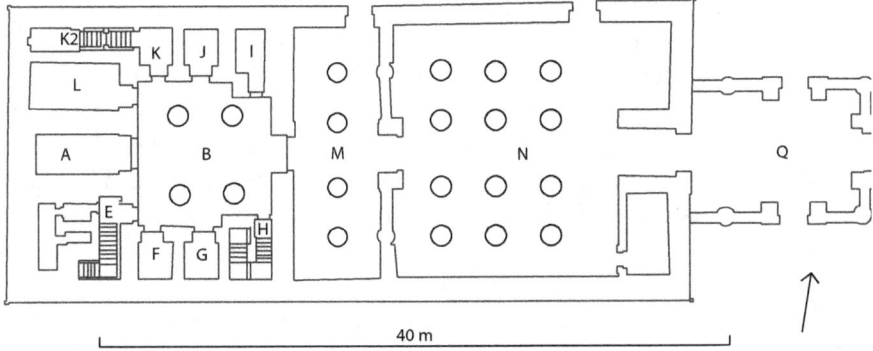

Fig. 3.6. Plan of the ground floor of the Hibis temple. Drawn by the author after Davies (1953, pl. 1).

via trapdoor. The east side of the forecourt is walled off with a set of four engaged columns with a doorway in the middle; this was the main façade of the earliest phase of the temple.

Later a large hypostyle hall (N) containing twelve columns was added to the east side of the temple (Winlock 1941, 20–6). Winlock attributed this addition to the period between 391 and 378 BC, on the reasonable assumption that it predated the later eastward extension of the temple in the 30th Dynasty, and the unexplained assumption that it must have been built after the end of Achaemenid rule. In fact there is no reason this hypostyle hall could not have been built sometime in the fifth century rather than in the fourth. Nectanebo I and II added a portico (Q) to the front of the temple, and an enclosure wall was built around the temple in this period as well; this wall was replaced with a larger one during the early Ptolemaic Period (Winlock 1941, 26–36).

The date of the Hibis temple's construction has been subject to some debate. Winlock (1941, 7–9) attributed the earliest phase of construction to Darius I, whose name appears many times on the walls of the western portion of the temple (Lippert 2016; Sternberg-el Hotabi 2017, 108–9; Wasmuth 2017a, 225–6). It is worth noting that Winlock dismissed Darius II as the temple's founder because he believed that conditions in Egypt were too turbulent during Darius's reign for a project of this scale (Wasmuth 2017a, 227–9). In fact, this purported turbulence is largely a modern scholarly construct, and the dates of the reign of Darius II (423–405 BC) are more consistent with the dates on the Demotic ostraca from Ain Manawir than those of Darius I. But Darius I's throne name also appears in the Hibis temple's inscriptions. Thus, while it is possible that Darius II

adopted the throne name of his eponymous predecessor, Darius I is still generally believed to be responsible for the temple.

Since Winlock's day several scholars, beginning with Eugene Cruz-Uribe (1986, 164–5; 1987, 225–30; 2008), have sought to attribute the temple's establishment to Psammetichus II (see also Arnold 1999, 88–9; Lloyd 2007b, 107–10; 2014, 191). The basis for this argument is a single instance of the Horus name of Psammetichus, *mnḫ-ib*, which occurs in the forecourt (B), a supposed change in the style of carving in certain parts of temple, which Cruz-Uribe takes as evidence for an additional building phase, and blocks which may have come from an earlier building, over which the Hibis temple was built. He thus suggests that Darius I replaced the cartouches of Psammetichus with his own, thereby usurping the temple.

But this evidence is not conclusive by any means, and there are other explanations for it. First, while *mnḫ-ib* was indeed Psammetichus's Horus name, Darius may also have used it. Pharaohs often reused royal names, especially in order to legitimise their reigns (Kahl 2002), and Darius may well have taken Psammetichius's Horus name for himself (Wasmuth 2017a, 226–7).[5] Also, none of the cartouches of Darius in the temple, including some tiny ones, shows any evidence of having been recut or repainted (Ismail 2009, 21–2). Second, a change in carving style need not result from two distinct building phases. Although it is clear that work on the temple took place over a long period of time, the decorative programme of the oldest part is unified and coherent, strongly suggesting it was conceived of and designed as a single monument rather than piecemeal (Ismail 2009, 22–4; Lippert 2016). Third, while it is entirely possible that the Hibis temple was built on the remains of an earlier building, there is nothing to indicate that this was a temple. Finally, the establishment of a temple of this size implies the presence of a significant settlement as well. Such a settlement would require irrigation, so if the qanats discussed in the previous section were indeed introduced into the Kharga Oasis during the 27th Dynasty, the Hibis temple would most likely date to this period as well. Certainly it would be curious and unprecedented to build a large temple in a sparsely inhabited wilderness.

On account of its comparatively good condition, the temple's decorative and epigraphic programmes are reasonably well documented and studied. While a full description of the reliefs and inscriptions is beyond the scope of this chapter, an overview is presented here

[5] I owe this suggestion to David Klotz (personal communication, 2013).

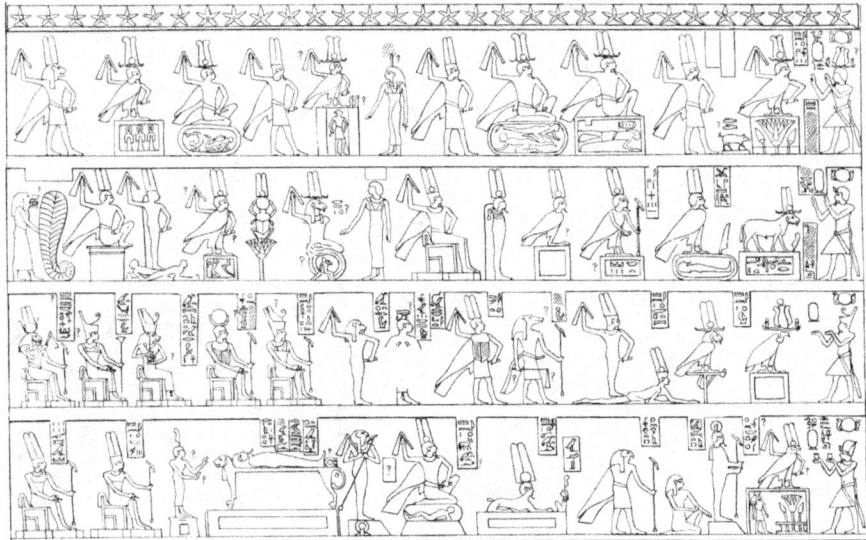

Fig. 3.7. Line drawing of reliefs from the west wall of sanctuary (A) in the Hibis temple, depicting Darius as pharaoh making offerings to various Egyptian gods. From Davies (1953, pl. 2). Image © the Metropolitan Museum of Art. Reproduced by permission of the Metropolitan Museum of Art.

because of the temple's prominence and importance in the oasis, and its close association with the Great King. The temple is decorated with reliefs on both its exterior and interior walls. Most of these reliefs display images of King Darius as pharaoh making offerings to various gods. Foremost among these gods are Amun (both Amun of Hibis and Amun of Karnak), Mut, Khons, Osiris and Horus, though there are many others who appear less frequently.

The sanctuary of the temple (A) bears some 700 representations of different gods from throughout Egypt (Fig. 3.7), executed in high relief (Davies 1953, 3–14, pls. 2–6; Cruz-Uribe 1988, 1–44). Adjacent to the sanctuary, room L features a large image of Darius enthroned wearing the double crown (Fig. 3.8); below him is the classic image of the 'Uniting of the Two Lands' (Davies 1953, 22–3, pl. 26; Cruz-Uribe 1988, 109–12), representing the unity of Upper and Lower Egypt (Goedicke 1985). Most of the rest of the carved decoration is in shallow sunken relief, much of which still preserves traces of paint. Certain of the rooms in the temple, namely K1 and K2, and the second floor chapels E1, E2, H1 and H2, give special attention to Osiris in their reliefs and inscriptions (Davies 1953, 18–22, pls. 15–16, 19–20, 22–5; Osing 1986a; Cruz-Uribe 1988, 74–9, 85–91, 93–104; Ismail 2009, 151–311; Wasmuth 2017a, 230).

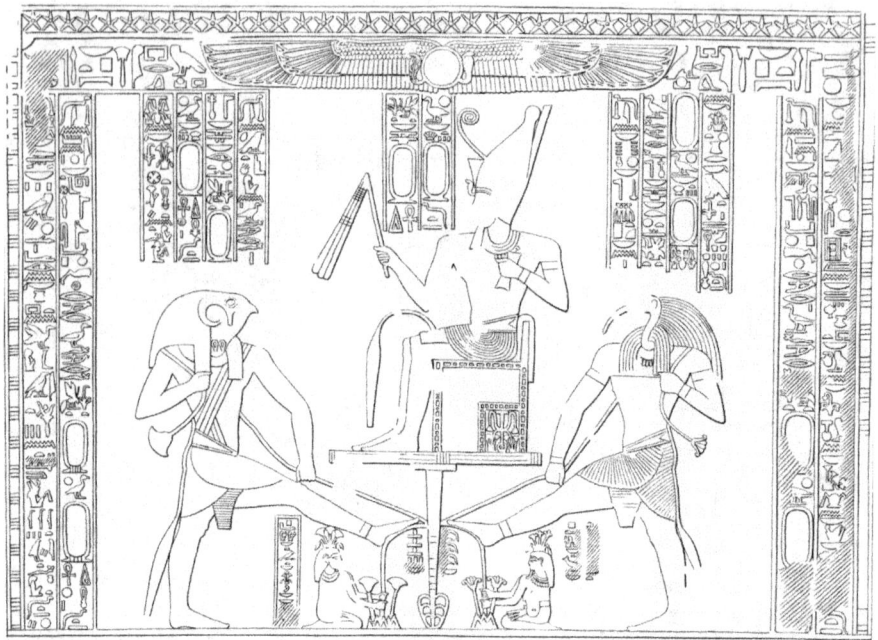

Fig. 3.8. Line drawing of reliefs from the west wall of room L in the Hibis temple, depicting Darius as pharaoh enthroned over the 'Uniting of the Two Lands'. From Davies (1953, pl. 26). Image © the Metropolitan Museum of Art. Reproduced by permission of the Metropolitan Museum of Art.

The forecourt (M) has several images of Darius making offerings to gods, including one where he is in a papyrus stand picking flowers for Amun-Min (Davies 1953, 23–7, pls. 28–38; Cruz-Uribe 1988, 112–45; Sternberg-el Hotabi 2006; Wasmuth 2017a, 230–2). This room also includes five hymns to Amun-Re (Klotz 2006), and an inscription over the door into the forecourt (B) announcing Darius's dedication of the temple to Amun (Drioton 1940, 360–77).

There are a number of curious or noteworthy features of this temple that contribute to our understanding of the role it played in the Kharga Oasis under Achaemenid rule. First, Darius is depicted wearing various Egyptian crowns and other pharaonic regalia. Unlike the statue of Darius found in Susa (see Fig. 4.7), but originally made for a temple in Egypt, there are no renderings in the Hibis temple that depict him in Persian court garb. There are, in fact, no visual references to his personal status as a foreign ruler, much less a specifically Persian one. Rather, he is represented entirely in Egyptian terms; his rounded facial features and double chin (Fig. 3.9) are reminiscent of Saite royal images (Myśliwiec 1988, 74–5).

Fig. 3.9. Relief of Darius as pharaoh from the forecourt of the Hibis temple. Photograph by the NYU Excavations at Amheida Staff, 'Hibis, Temple Decorations (IV)', Ancient World Image Bank (New York: Institute for the Study of the Ancient World, 2009–), reproduced under a Creative Commons licence (CC BY 2.0).

There are only two instances in which aspects of the temple's representational programme or its complementary texts make reference to Darius's status as a non-Egyptian pharaoh. One allusion appears on the northern end of the original front façade of the temple (the exterior wall of room M that would later became the western interior wall of room N). This wall features an unusual relief (Fig. 3.10) of a winged god with a falcon's head and tail wearing the double crown and spearing a serpent representing the demon Apep (Davies 1953, 27–8, pls. 42–3; Cruz-Uribe 1988, 147; Myśliwiec 2000, 140–2; Wasmuth 2017a, 235–9). While the depicted features of this god would suggest Horus, the accompanying inscription identifies him as Seth, the slayer of Osiris, on whom Horus took vengeance. Indeed, in the oases Seth was usually depicted with a falcon head (Osing 1985).

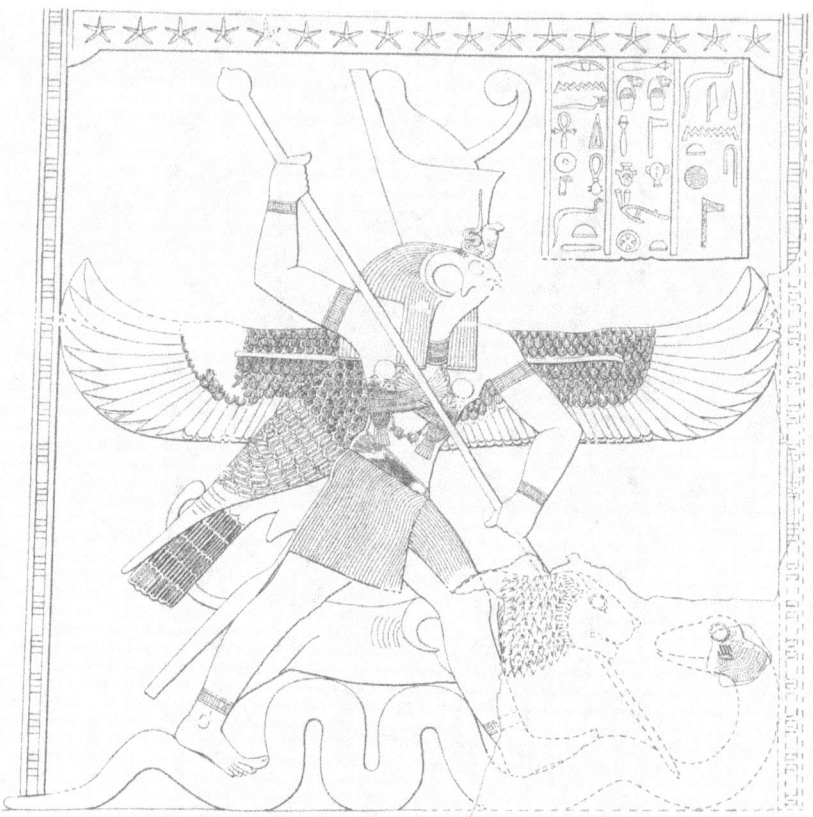

Fig. 3.10. Line drawing of reliefs from the forecourt of the Hibis temple, depicting Seth slaying Apep. From Davies (1953, pl. 42). Image © the Metropolitan Museum of Art. Reproduced by permission of the Metropolitan Museum of Art.

Although Seth was primarily regarded as a transgressive or disruptive figure, his slaying of Apep, an enemy of Re, was his main positive role in Egyptian religious thought, and is attested variously in visual and textual media (Te Velde 1967, 99–108). At the same time, since at least the New Kingdom, Seth was typically also identified with foreigners such as the Hyksos (Te Velde 1967, 109–51). This association was usually intended as a negative one. But the prominent inclusion of Seth, the foreigner, in the decorative programme of the Hibis temple in his most positive guise may in fact be a reference to the foreign king who commissioned the temple. If so, this image of Seth is an example of how Achaemenid rule was recast in terms of Egyptian cosmology, as a means of fitting contemporary political realities into an Egyptian worldview (Wasmuth 2017a, 235–9).

The second allusion makes explicit reference to Darius as a foreign

ruler. The end of the cryptographic inscription carved on the north side of the doorway leading into the forecourt reads 'there is not another sovereign like Pharaoh, king of Egypt, Lord of the Two Lands, Darius, great ruler of all the rulers and of all foreign lands' (trans. Cruz-Uribe 1988, 114). The title 'great ruler of all the rulers and of all foreign lands' is not a normal Egyptian royal title, and is paralleled only in the hieroglyphic inscription on the famous statue of Darius from Susa (Kuhrt 2007, 478–9). Yet it closely resembles one of the Great King's more common epithets, 'king of kings', in verbal rhetoric from Persia.

It is important to recognise here that the cryptographic nature of this inscription makes for many uncertainties in the readings of the various hieroglyphs. Cryptographic writing made use of the fact that hieroglyphics could potentially represent images, sounds and words. A scribe could manipulate the appearance of a text by either modifying the hieroglyphic signs to make them more pictorially and visually stimulating, or using signs to represent sounds instead of words and thus spell phonetically. The closest parallel for the use of cryptographic writing at Hibis is the practice on the part of some New Kingdom pharaohs of having their names and titles written cryptographically on temple walls in order to achieve an ornamental visual effect (Drioton 1940; Darnell 2004, 17–21). In this case the inclusion of a foreign title may have been permissible because the inscription was cryptographic. Regardless, this is an interesting example of a pharaonic representational strategy being used to communicate Darius's status as Great King of the Achaemenid Empire.

The ideology of ecumenical world-order that is a hallmark of Achaemenid texts and images is alluded to in the Hibis temple in other ways as well. The hieroglyphic bandeau inscription on the exterior wall of the temple is a building inscription indicating the sources of certain construction materials (Davies 1953, pls. 44–5; Cruz-Uribe 1988, 148–51). A very similar inscription, though less well preserved, occurs inside the sanctuary of the temple at Qasr el-Ghuweida (Darnell et al. 2013, 14–16). Both inscriptions refer to "š-wood from the Western Desert' and 'Asiatic copper'; additionally, the inscription from Hibis refers to 'white stone of Meska', and it is likely that the inscription from Qasr el-Ghuweida originally did as well. 'Meska' is probably a local limestone quarry in the Kharga Oasis, and the term "š-wood from the Western Desert' is understood to mean Libyan juniper.

Thus the inscription makes reference to local stone, copper from a region to the east of Egypt, and wood from a region to the west,

one which had only recently been added to the empire (Darnell et al. 2013, 16–20). In this respect it alludes to the entire geographic remit of Darius's rule, albeit from a decidedly Egypto-centric perspective. It even resembles the more famous 'Foundation Charter' from Susa (DSf; Kuhrt 2007, 492–5), a trilingual cuneiform inscription that similarly lists all of the various sources of building material from around the empire used to build Darius's palace at Susa, including a local source of stone (in this case a village in Elam). The foundation charter is clearly not a literal record of the process of construction; rather it demonstrates the wide range of peoples and resources on which Darius could draw as Great King (Root 2010, 178–86). The inscriptions from Hibis and Qasr el-Ghuweida are in the same vein. While it is entirely plausible that wood was brought in from Libya, Egypt had ample supplies of copper. But the point of the inscription was to place the temple in the broader context of a network of imperial power that crossed Egypt's geographic borders. In terms of its rhetorical intent it follows a tradition of Achaemenid imperial inscriptions.

Finally, the peculiarities of the temple's sanctuary (A) may provide some key evidence as to the role played by the temple, the town of Hibis and the Kharga Oasis more generally during the 27th Dynasty. In this small room, less than 5 m on its longest side, there are approximately 700 representations of gods, cult statues of gods, and perhaps priests as well (Davies 1953, 3–14, pls. 2–6; Cruz-Uribe 1988, 1–44). In general they are grouped geographically, and even though some obscure local deities are included there are notable omissions as well (Cruz-Uribe 1988, 192–8; Osing 1990, 763–7; Sternberg-el Hotabi 1994; Kessler 2003). The west wall features mainly the gods of the Theban area, with particular emphasis on the Theban triad of Amun, Mut and Khons. The south wall has gods from Upper Egypt, including Philae, Kom Ombo, Nekhen and Abydos, as well as gods from the Hermopolite nome. The north wall focuses on Herakleopolis, Memphis, Heliopolis, Leontopolis, the Fayum and perhaps even Sebennytos. Much of the Delta region, however, is excluded.

One proposed explanation for this decorative scheme is that the gods shown in the sanctuary represent a list of those cults that were officially supported by the state (Cruz-Uribe 1988, 196–8). This explanation is based in large part on the absence of Neith, the main goddess of Sais in the Nile Delta, from the temple's sanctuary. Neith was closely associated with the pharaohs of the 26th Dynasty, and the biographical inscription of Udjahorresnet, as given on his

naophorous statue, is often cited as evidence for Persian curtailment of her cult. But, according to this inscription, Udjahorresnet 'caused his majesty to recognise the greatness of Sais', and,

> [He] asked the majesty of the King of Upper and Lower Egypt, Cambyses, on account of all the foreigners who had set themselves down in the temple of Neith, that they should be expelled therefrom in order to cause that the temple of Neith should be once more in all its splendour as it had been earlier. (trans. Kuhrt 2007, 118)

He goes on to say how Cambyses acceded to his request and describes all the other acts of piety Cambyses performed for Neith. There is no mention of Cambyses shutting down the temple, nor any indication that its operation was curtailed by Cambyses or Darius (Serrano Delgado 2004). There is no evidence to support this strictly political explanation of the sanctuary's reliefs.

Instead, these reliefs should be regarded as 'cult-topographical' in nature, in that they essentially catalogued deities and cult practices across Egypt (Sternberg-el Hotabi 1994; Kessler 2003). Cult-topographical reliefs and inscriptions are a well-known feature of Ptolemaic and Roman Period temples, such as the temple of Horus at Edfu. These temples are generally thought of as codifying Egyptian religious knowledge in order to preserve Egyptian identity and culture in times of foreign influence or domination (Assmann 1992). As such they not only functioned as the house of a single specific god, but also housed much of the Egyptian pantheon, including even the rituals performed by priests in order to maintain the cosmic integrity of Egypt (Finnestad 1997). In essence, they were repositories of Egyptian religion. The decoration of the sanctuary of the Hibis temple seems to perform a similar function; as one scholar puts it, at Hibis 'the naos was, in effect, conceived of as a microcosmos wherein the gods of Egypt were gathered' (Zivie-Coche 2008, 8). In this respect the Hibis temple prefigures the 'pan-Egyptian' temples of later periods.

Amheida

There is also evidence for the construction of a temple at Amheida (ancient Trimithis) in the Dakhla Oasis during the 27th Dynasty. Amheida was the site of a significant urban centre during the Roman Period, and its temple, which was situated on a hill in the middle of town, was constructed using spolia from earlier structures. Among these spolia was discovered a block bearing part of a cartouche

of Darius, along with part of a carved relief of the goddess Meret (Kaper 2012, 171–2; Bagnall et al. 2015, 53–4). Other, similar relief fragments featuring Thoth, Mut, Nephthys, Hathor and Neferhotep were found as well, suggesting that a one-room temple to Thoth was built there during the reign of Darius. Another cartouche of Darius, stamped on a fragment of a ceramic vessel, was found in the temple area. A small animal necropolis, seemingly of Late Period date, was also identified in the vicinity of the temple (Bagnall et al. 2015, 57–60). About forty-five fragments of bronze statuettes of Osiris, reminiscent of those excavated at Ain Manawir, were discovered in this necropolis.

Cartouches of Necho II, Psammetichus II and Amasis appear on blocks at the site of the Amheida temple, indicating that Darius's temple was not the earliest one built there (Kaper 2012, 169–71; Bagnall et al. 2015, 46–53). Some of the blocks from this earlier temple appear to have been reused in the time of Darius, but it is difficult to say whether Darius demolished the temple altogether, or enhanced it with the addition of a room or freestanding shrine. As discussed earlier in this chapter, cartouches of Petubaste IV, a pretender against Cambyses, were found at Amheida on blocks from a gateway which was presumably also part of the earlier temple (Kaper 2015, 127–34). This may explain Darius's interest in Amheida: it had been Petubaste's base of operations. Accordingly Darius built his own temple structure there, as part of his efforts to control this remote region of the Western Desert and integrate it more closely into the Egyptian satrapy.

The Great King as temple builder

As with the qanats discussed earlier, these temples must have been constructed on the orders of the Great King. In Egypt all temple construction was the exclusive responsibility of the pharaoh (Morris 2010b, 214). Being a divine figure himself, he was uniquely suited to mediate between the human and divine realms, and he therefore served as the chief priest of every temple and cult throughout Egypt. In practice, he had to delegate the majority of these duties to subordinates, since he could not be everywhere at once, and accordingly the Egyptians had rituals and practices that facilitated the substitution of another priest for the pharaoh. This delegation extended to temple construction as well. This is perhaps best exemplified in the text of the Berlin Leather Roll (P. Berlin 3029; Osing 1992, 109–19), usually thought to be a New Kingdom copy of a Middle Kingdom

royal inscription (Piccato 1997). In this text, King Senusret I (reigned c. 1956–1911 BC) decrees the construction of a temple of Atum and then appoints an official to oversee the work:

> The king himself said: 'Royal Seal-bearer, Sole Friend, Overseer of the two Gold-houses and two Silver-houses, and Master of the Secrets of the Two Crowns, it is your counsel which causes to be made all the works which my person has desired to exist. You are the master of them, he who shall do as I wish ... Make the place whose creation is desired! Decree the workmen to work according to what you have ordained!' (trans. Parkinson 1991, 42)

Two aspects of this text are of particular interest here. First, the official is explicitly charged with designing the temple. This may imply he is an architect, but it seems more likely that he was responsible for conceptualising the temple, in consultation with various religious experts, architects and designers, as well as with the king himself. Indeed, the official's titles suggest he is a high-ranking courtier, in essence a functional extension of the king himself. Second, despite the delegation of royal authority, the king is nevertheless the primary agent in this enterprise; the official is not even named. So temple construction required royal action, but everything else could be handled by a subordinate. In the Berlin Leather Roll, after the king enjoins his chosen official to 'decree the workmen to work according to what you have ordained' (trans. Parkinson 1991, 42) he participates in the foundation ritual itself on the site of the future temple. No mention is made of his involvement in planning or design. And as discussed above, the king's presence was not necessarily required for this step either, since the Egyptians had procedures for replacing the king on specific occasions.

This means that the Achaemenid Great King could establish temples without actually setting foot in Egypt, let alone being present at the site of the temple itself. Rather, as described in the Berlin Leather Roll, the king could delegate this task to a trusted courtier, who would in turn consult with the relevant experts to design the architecture, decoration and religious content of the temple. This was probably accomplished through the satrap, who performed many of the pharaoh's duties on behalf of the Great King, though the king could also dispatch subordinates directly from Persia. Such is the case of Udjahorresnet, who, according to his autobiographical inscription, was sent by Darius from Elam 'to set to rights the House of Life' in Sais (trans. Kuhrt 2007, 119). The 'House of Life' is usually understood to be a temple entity charged with maintaining and promoting all forms of cultic knowledge (Eyre 2013, 311–15).

While this is not the same as founding a new temple, it nevertheless illustrates how the Great King could perform pharaonic duties relating to temples, including founding them, without necessarily being in Egypt. Indeed, inscriptions on both the Ghuweida and Hibis temples explicitly name Darius as their founder (Davies 1953, pls. 44–5; Cruz-Uribe 1988, 148–51; Darnell et al. 2013, 14–16). The other temples in the Western Desert may well have been similarly inscribed at one point, but the inscriptions have not survived. The extent to which Darius was involved in the planning or design of these temples cannot be ascertained, but it is certainly evident that they were built at his command to serve the empire's goals.

THE PIONEERS OF THE WESTERN DESERT

The introduction of the qanat and the construction of new temples in the oases served the empire's goals by linking the Western Desert more closely to the rest of Egypt. By bringing the necessities of settled life to the oases, namely irrigation and religion, it became possible to bring people there as well. This in turn made the desert less remote and less dangerous, and the new and expanded settlements became the basis for imperial rule in the oases. For example, temples not only administered the disbursement of water rights, but, as is discussed further in Chapter 6, they were also used by the satrap of Egypt to generate silver for tribute payments. Furthermore, direct satrapal oversight of temples is attested in the so-called 'Pherendates correspondence', a dossier of Demotic letters relating to the appointment of priests at the temple of Khnum at Elephantine (Fried 2004, 80–6; Müller 2016, 234–8). The expansion of religious infrastructure in the desert was thus also an expansion of Achaemenid control there.

In order for these measures to have any effect, it was necessary for people to move to the Western Desert. How this movement was achieved is unknown. It is equally possible that people were deported to the oases, or that they were given incentives to move to the new settlements in the desert; possibly a range of strategies was employed. That these settlers were Egyptian is suggested by the Demotic ostraca from Ain Manawir, which only mention individuals with Egyptian names (Chauveau 2005, 159). The temples, however, may provide a further clue as to the origins of these settlers.

As noted above, the Hibis temple was dedicated to Amun, and in its decorations the Theban triad of Amun, Mut and Khons receives special attention. Moreover, Amun of Karnak (as opposed to Amun

of Hibis) is addressed specifically in three of the six hymns inscribed on the walls of the forecourt (M; see Fig. 3.6). These hymns were all imported from Thebes and were actually carved on the walls of the Karnak temple there (Klotz 2006, 11; Sternberg-el Hotabi 2017, 113–15). Amun of Karnak is also depicted in the Hibis temple, for example on the walls of the forecourt (B; Davies 1953, pls. 7–8, 11–13). The prevalence of Theban cults may indicate that the priests of the Hibis temple were actually brought originally from Thebes (Klotz 2006, 8–9). And there were other imported gods as well. An obscure god, Merimutef of $Ḥ'y.t$, modern Manqabad, near Assiut, appears at the Hibis temple, suggesting links with Assiut (Osing 1986b, 80–1). The Theban triad likewise plays a significant role at Qasr el-Ghuweida, as do Min and Isis of Akhmim and Geb and Nut of Coptos, both in Upper Egypt (Darnell et al. 2013, 12–13). The religious knowledge used to found temples in the Western Desert seems to have originated largely in Upper Egypt, and it is likely that the priests appointed to staff these temples did too.

The selection of the approximately 700 gods depicted in the sanctuary (A) of the Hibis temple (Fig. 3.7) may also similarly reflect the geographic origins of the oases' settlers, which could explain why Upper Egypt is especially well represented while the Nile Delta is absent altogether. The scale of this movement is impossible to gauge, but it is unlikely to have been so great as to have had a significant demographic impact on Upper Egypt. According to one estimate, during the Late Period the population of Thebes alone was between 20,000 and 40,000 people (Hassan 1993, 563), whereas the 1882 census of the entire Western Desert (the first of its kind) put that population at just over 30,000 (Butzer 1976, 97). Even with the benefit of qanats and temples, the population of the oases in antiquity can only have been a fraction of this number.

In moving people from the Nile Valley to the Western Desert, whether through deportation or the promise of new opportunities, the Persians forged new connections and strengthened existing links between Kharga and Dakhla and the rest of Egypt. The oases' new settlers surely maintained contact with friends and family back in the Nile Valley through letters and even visits. During this period, the desert roads that connected the oases to the Nile were littered with fragments of *sigha*-pots, a type of flask used to transport water (Darnell 2000; Marchand 2000). There are also Demotic graffiti of 27th Dynasty date at the entrance to the Darb Rayayna, one of the routes to the Kharga Oasis west of Armant (Di Cerbo and Jasnow 1996). Both of these lines of evidence point to the presence of heavy

traffic along these roads during the period of Achaemenid rule. There are even references in the ostraca from Ain Manawir to dromedaries (Agut-Labordère 2018b, 182), suggesting that the Persians facilitated the introduction of the dromedary to the Western Desert. Perhaps this measure was part of their efforts to better ingrate the oases into the Egyptian satrapy, as dromedaries were much better suited to the rigours of traversing the high desert than horses or donkeys.

The new connections created by the empire had consequences for the people involved, and it remains to consider how the development of the Kharga and Dakhla Oases affected the experience of Achaemenid rule in the Western Desert. The best evidence comes from Ain Manawir, where in addition to grain (emmer wheat and hulled barley), olives and castor beans are attested as well (Newton et al. 2006; Agut-Labordère and Newton 2013; Newton et al. 2013; Agut-Labordère 2016). Olive pits were recovered there in the course of excavation, and castor beans occur in a number of the Demotic ostraca. Both of these crops were used to make oil, and as such were cash crops rather than staples. Castor oil was not even a foodstuff; references to it in the Elephantine papyri indicate that it was used primarily as lamp fuel and for anointment (Grelot 1964). Some of the oil used in Elephantine may well have comes from the Kharga Oasis. This is a clear indication that the agricultural activity in the oases was operating at a much higher level than mere subsistence, a level made possible by the deployment and assiduous maintenance of qanats.

Furthermore, the Demotic ostraca from Ain Manawir also contain references to 'staters of Ionia', usually understood to mean Athenian tetradrachms (Chauveau 2000; Agut-Labordère 2014; Colburn 2018b, 105–6). The full significance of these references is discussed in detail in Chapter 6; here it suffices to note that they indicate that Ain Manawir was a part of a larger trade network extending beyond Egypt itself. That coined money had penetrated this far south and was being used alongside traditional Egyptian units of weight is telling of the high volume of traffic between the oasis and the eastern Mediterranean, where the Athenian tetradrachm was the bullion coin par excellence. It is impossible to say whether or not anyone got rich from this trade in oil, but certainly it is a far cry from the grim picture of life in the oasis painted in the late New Kingdom Papyrus Pushkin 127 quoted earlier in this chapter.

Finally, three ceramic 'Achaemenid bowls' have been recovered at Ain Manawir. Two were found in a building adjoining the temple of Osiris, and a third with painted surface decoration was found in

an unspecified context (Wuttmann et al. 1996, 417–18 [Groupe 1, nos. 15–16]; Marchand 2002, 260 fig. 11; Colburn 2018b, 106–7). As articulated in greater detail in Chapter 5, these bowls appear in the reliefs on the Persepolis Apadana, where they symbolise the fundamental unity of the peoples of the empire. Versions of them made in a variety of materials have been found across the empire, including Egypt, and they are associated with a shared 'imperial' identity among the various subject peoples. Certain people at Ain Manawir must have regarded these bowls as appropriate to their identities. These people may even have thought of themselves as part of the empire, in addition to the other facets of their identities. And this phenomenon was not limited to the Kharga Oasis; another Achaemenid bowl was found in the Dakhla Oasis at Ain Tirghi in a burial originally attributed to the Roman Period (Hope 1981, 237, pl. 23; Patten 2000, 55), but since reassigned to the fifth century BC (Miller 1997, 136 n. 7). At both sites it seems that the empire played some role in how certain people constructed their identities.

These bowls are an important reminder that the implementation of Achaemenid rule in the Western Desert could not have been accomplished without some local participation. While it is certainly true that the Persians could easily have deported a large population to the oases, the fact that the settlements not only survived, but even prospered, suggests that at least some of the desert's new residents embraced their roles in the imperial project in the oases. The Achaemenid bowls, with their implied imperial identities, provide further confirmation of this.

INTEGRATING THE HINTERLAND

The Persians addressed the problems presented by the Western Desert by making it part of Egypt in a way it had not been before. While in previous periods interest in the desert had primarily taken the form of expeditions, caravans and military excursions, the Persians instead brought infrastructure, both agricultural and religious, to the Kharga and Dakhla Oases. This allowed settlement in the oases on a previously unknown scale, and the creation of the sort of institutions, such as villages and temples, on which Achaemenid rule could be built. In the process, life in the Western Desert was changed in notable ways. It is clear that some agricultural success was achieved in the oases with cash crops such as olives and castor beans. Furthermore, the extensive assortment of gods represented in the Hibis temple and the use of the Athenian tetradrachm show that the oases came to

participate in religious, economic and social networks that extended to the Nile Valley and beyond. Some of the oases' new residents even adopted certain aspects of an imperial identity. Others no doubt regarded their situation as tantamount to exile. But the Kharga and Dakhla Oases unquestionably had stronger ties to the rest of Egypt than had existed before, as a direct consequence of Achaemenid rule.

Although the oases of the Western Desert are exceptional in some respects, they are nevertheless illustrative of the ways in which Achaemenid rule could be implemented in a rural hinterland. As in Memphis, existing Egyptian institutions played a significant role, but in this case they had to be imported from elsewhere, with the help of Persian irrigation technology. In other rural areas of Egypt such measures were unnecessary, making Achaemenid rule difficult to identify archaeologically in most places. At Elkab in Upper Egypt, for example, a foundation deposit of ceramics seemingly from Susa, along with cartouches naming Darius (probably Darius II) on the temple walls (Capart 1940), suggests that the temple there was refounded or enlarged by the Persians. This royal interest in Elkab may well have been part of a larger effort to integrate southern Egypt into the empire by using its temples. Similar efforts by the Persians in other rural areas of Egypt may well have left fewer traces than this.

These two chapters on Memphis and the Western Desert have explored the impact of Achaemenid rule on an urban centre and a rural hinterland respectively. In both cases the impact of the empire, and the experience of it on the part of individuals and institutions, was not monolithic. Rather, it was varied and complex, defying easy generalisation. Memphis and the Kharga and Dakhla Oases also offer the two greatest concentrations of archaeological material and related evidence that can be securely dated to the 27th Dynasty. In this respect they provide an invaluable baseline for the studies to follow in the next three chapters, where the material evidence is often not as clearly fixed in time and space.

4. Representation and Identity

> The practical limitations on our knowledge of the past are not inherent in the nature of the archaeological record; the limitations lie in our methodological naïveté, in our lack of principles determining the relevance of archaeological remains to propositions regarding processes and events of the past.
>
> Lewis Binford

EGYPTIAN ART AND ACHAEMENID RULE

The previous two chapters examined the impact of Achaemenid rule on two specific places in Egypt: Memphis and the Kharga and Dakhla Oases. This chapter considers the same topic, but this time in specific reference to the experiences of individuals. Imperialism was experienced differently by everybody, and although these discrepant experiences can be studied profitably in aggregate (and often one has no choice but to do so), it is important where possible also to consider discrete individuals, as a counterweight to more generalising approaches. The differences in people's experiences with, reactions to and participation in empire result from a wide variety of factors, many of which are beyond recovery today. It is instructive to observe how two individuals who would otherwise be lumped together may have had very different experiences, or at the very least may have conceived of themselves and their roles in the broader social order in different ways. Although any one individual's experience is not necessarily representative of the experiences of a large category of people, these individual cases are indicative of a significant range of interactions with and relationships to the Achaemenid Empire, and illustrative of the sorts of impact the empire could and did have on Egypt.

One of the best ways to study individuals in Egypt is to examine how they themselves presented their identities in given contexts. As discussed in Chapter 1, identity is a construct, one that is multifaceted and constantly created and recreated through the decisions made by individuals. Fortunately for the archaeologist, identities become materialised and fossilised when these decisions relate to the creation of monuments or other objects that served as proxies for people. By parsing the visual features of these monuments we can effectively reconstruct some of these decisions and the identities that informed them. To that end this chapter examines several objects that were created to serve as proxies for specific individuals, with a view to determining how these individuals fabricated identities in the context of Achaemenid rule in Egypt.

Traditionally the study of the artistic output of an Achaemenid satrapy is hampered by what Margaret Root (1991) has called 'the politics of meagerness'. As discussed in Chapter 1, this refers to a vicious cycle wherein preconceptions of the weak and ephemeral nature of Achaemenid rule fuel assumptions about the scarcity of material produced in a given region, and this scarcity in turn affects how objects are classified, in terms of both their date and the cultural vectors most responsible for their creation. Since Root's initial articulation of this problem there has been much progress, particularly the recognition that unidirectional artistic influence is not the only way in which art and empire interact (e.g., Khatchadourian 2012; Colburn 2014a). In Egypt, however, there is still a persistent notion that this period was characterised by artistic poverty as a direct result of Achaemenid rule (e.g., Sternberg-el Hotabi 2000, 156–7; 2002, 117–18; 2016, 37–42). This view is best illustrated in a 1997 article on Late Period art:

> But there was a marked reduction of building activity and work in sculptural ateliers. The invasion of the Persians must have caused major disruptions in the lives of the Egyptians. It seems inconceivable that sculptural ateliers were operating normally, if at all, after this traumatic event. The extreme rarity of sculpture safely datable to this period attests to the logic of this conclusion. (Josephson 1997, 10)

The circularity of this argument is readily apparent. Assuming, as the article's author does, that Achaemenid rule was disruptive and oppressive, it stands to reason that sculpture workshops would have had less business and therefore less output, justifying in turn the all too common practice of dating Late Period statues to the Saite Period or the fourth century unless compelled to do otherwise by epigraphic evidence. This in turn leads to very few statues with 27th

Dynasty dates, which ultimately confirms the original premise about the nature of Achaemenid rule.

Its logical failings aside, the premise causes severe problems for the study of the art of this period. First, there is the practical problem of dating material to the 27th Dynasty. The criteria that have been employed for this activity are too imprecise, and therefore demand reconsideration. Second, and more importantly, this notion of artistic poverty was entrenched in narratives of the 27th Dynasty for the entire twentieth century, if not earlier, and it dominates any assessment of the nature of Achaemenid imperialism in Egypt. This poverty is not, however, a result of Achaemenid imperialism, but rather of modern scholarship. Egyptologists and other scholars brought their own assumptions about the Persians, informed by both Greek prejudices and modern orientalist ones, to their own work, and this has in turn shaped the art historical record for the period in question (Reid 2002, 139–212; Colburn 2011, 94–8). Thus before embarking on a study of individuals in Achaemenid Egypt it is necessary to re-examine the intellectual underpinnings of the study of Late Period art. As will be shown, many of the statues normally dated to the 26th or 30th Dynasties actually cannot be dated with any precision whatsoever, and thus there must be unrecognisable statues of 27th Dynasty date hidden among them.

This chapter, then, has two main purposes. The first is to challenge the artistic poverty of the 27th Dynasty by considering the historiography of this trope, and the means by which categories of Late Period art (especially statues) have been assembled and dated. Analysis of the process by which the corpus of Late Period material was formed, and especially the factors that affected the survival of certain statues and statue types, reveals that the collections which served as the foundation of the modern study of Egyptian statuary were derived in large part from the objects imported to Italy by the Romans. Thus Roman taste and Roman needs have had disproportionate influence on the formation of the corpus of Late Period statues.

The second purpose of this chapter is to present a series of case studies of individuals as viewed through sculptural representations. The creation of these representations was informed by a combination of how people conceived of themselves and the broader social, cultural, political and religious contexts out of which these self-conceptions emerged. Thus these representations are a valuable source of evidence for how individuals experienced Achaemenid rule in Egypt. The cases studied below show that these experiences were variable, and did not seem to divide predictably along ethnic lines.

THE ARTISTIC POVERTY OF ACHAEMENID EGYPT

The artistic poverty of Achaemenid Egypt can be traced back to the earliest studies of Late Period statuary. The first modern treatment of this topic is Käthe Bosse's *Die menschliche Figur in der Rundplastik der ägyptischen Spätzeit von der XXII. bis zur XXX. Dynastie*, published in 1936. In this book Bosse catalogued 224 statues of the 22nd to 30th Dynasties, of which she attributed six to the 27th Dynasty (Bosse 1936, nos. 19, 20, 89–91, 125). Her criteria for these attributions are unusual garments and epigraphy and prosopography; she does not assign anything to this period without one or the other of these features. Yet the apparent specificity of these criteria is in contradiction to the uncertainty of most of her other dates, for one finds statue after statue dated as 'wohl 26. Dynastie' without further comment or any clear justification for the attribution. In other words, without positive evidence compelling a 27th Dynasty date, she defaults to the 26th. Indeed, in her introduction she readily admits just how difficult it is to assign dates to many of these statues (Bosse 1936, 9). And despite this chronological uncertainty, she uses these flawed data to conclude that under Achaemenid rule there was a 'decay' in the art ('einen Verfall der Kunst'; Bosse 1936, 92). The uncertainty of her dates is ignored because the conclusion was what she expected from the outset.

Bosse's study illustrates how the trope of artistic poverty in the Persian Period arose. Bosse only dates statues to the 27th Dynasty on the basis of two criteria; in the absence of either of them, she defaults to a 26th Dynasty date. This leads to an unbalanced corpus, in which far more objects are attributed to the 26th Dynasty than to the Persian Period. This imbalance is then interpreted in negative terms (e.g., 'Verfall'), on the assumption that it is representative of the entire corpus of Late Period sculpture.

Subsequent scholarship has generally followed the pattern set by Bosse. The main exception to this trend was the work of Bernard Bothmer, who beginning in 1950 compiled the Corpus of Late Egyptian Sculpture, with the objective of cataloguing the Egyptian statuary of the period from 750 BC to AD 100. Bothmer identified approximately fifty statues of Persian date. His precise dating criteria are difficult to pin down, because they are only articulated in the entries to his exhibition catalogue *Egyptian Sculpture of the Late Period* (Bothmer 1960). In general he seems to have grouped statues according to shared formal features and then assumed that

the statues in the various groups were all contemporaneous. The formal features most used by Bothmer to attribute individual statues to the 27th Dynasty include the presence of the so-called 'Persian gesture' and 'Persian garment', the appearance of realism or aspects of portraiture instead of youthful idealisation, and the shape of the dorsal pillar.

Although Bothmer was optimistic that more Persian Period statuary would be identified with future research, in later decades much scholarly energy has been dedicated to redating material from the 27th Dynasty to earlier or later periods (e.g., de Meulenaere 1983; Leahy 1984a; 1988; Shubert 1989; Josephson 1997). Usually this was done either on epigraphic grounds, or by reassigning Bothmer's groups to earlier or later periods. This was not necessarily a deliberate attempt to remove material from the 27th Dynasty in order to propagate ideas about the artistic poverty of the time; rather these revisions are probably reactions to the frailties of Bothmer's chronology. But the subsequent studies have not improved on his methods, and, as the quotation from one such revisionist article given earlier in this chapter demonstrates, these studies were still informed by assumptions about the nature of Achaemenid imperialism and its impact on the artistic output of Egypt. Indeed, a handbook published as recently as 2016 features a section entitled 'Stagnation der Kunstproduction in Ägypten' (Sternberg-el Hotabi 2016, 37).

The study of Late Period sculpture has not changed fundamentally since Bosse's day. Although the dating criteria for Persian Period material have been expanded, the methodology remains the same, as does the assumption that the resulting corpus is a representative sample of Late Period sculpture. These are the main factors underlying the artistic poverty trope, and as is shown in the following pages none of them holds up to critical scrutiny.

Dating criteria

Overall, with the exception of certain forms of epigraphic evidence, the dating criteria for Persian Period sculpture are less secure than is normally recognised. These criteria include the presence of the so-called 'Persian gesture' and 'Persian garment', realistic rather than idealised depictions and the tapering of the dorsal pillar at the top. In some cases there are clear instances of these criteria conflicting with each other. In other cases a criterion is methodologically unsound because it is based on unspoken and unproven assumptions. Since these assumptions themselves are informed by preconceived notions

of Achaemenid imperialism that are open to serious challenge, the approach to dating Late Period material typically becomes bound up in circular arguments. In the following pages each of these criteria is reviewed and its shortcomings articulated. As will be shown, on the whole there are very few reasons to exclude a given statue from a 27th Dynasty date, and the corpus of representations dating to this period is certainly much larger than current approaches admit.

Inscriptions

The most reliable criterion for dating Egyptian statuary of the Late Period is the presence of an inscription that makes clear reference either to a pharaoh or to a person whose prosopography is sufficiently well known that the piece can be dated accordingly (Bothmer 1960, x; Leahy 1988, 32–44; Wasmuth 2017b, 243–4). This is not always a straightforward matter, especially as cartouches bearing royal names are frequently erased from statues, usually as acts of *damnatio memoriae*. In the case of private individuals usually the best scenario is that the name of the statue's dedicator, or that of a member of his family, occurs in the Serapeum stelae from Saqqara. However, dates derived from prosopography are not necessarily certain, since it is often impossible to determine whether or not two individuals with the same name are in fact the same person. Titles can help resolve such ambiguities of identity, but because they tend to be generic and widespread in Egypt, they too must be used cautiously.

The 'Persian gesture'

The 'Persian gesture' refers to the placement of one hand across the wrist or back of the other hand, while holding both hands in front of the body (Fig. 4.1). Its identification as a distinctively Persian gesture is based primarily on two factors: its frequent and strategic appearance in reliefs at Persepolis, and its contrasting rarity in Egyptian art before the Persian Period. In addition to Persepolis, where it appears prominently on the Apadana and is made by various courtiers in the presence of the king (Fig. 4.2), the gesture has a long history in Mesopotamian and Elamite representational traditions (Root 1979, 272–6, pls. 17–19, 22). In Mesopotamia it first occurs in the Ur III Period (c. 2112–2004 BC), especially in representations of Gudea of Lagash, where it was used for 'a contextually specific type of servant–master relationship between either man and god or minor

Representation and Identity 137

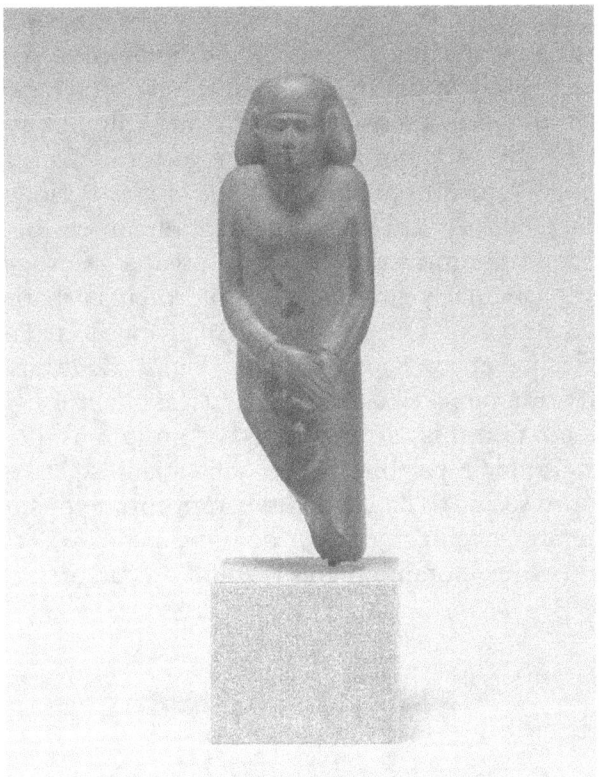

Fig. 4.1. Statue exhibiting the 'Persian gesture', c. 500–450 BC. Greywacke; H. 28 cm. Baltimore, Walters Art Museum 22.208. Reproduced under a Creative Commons licence (CC0 1.0).

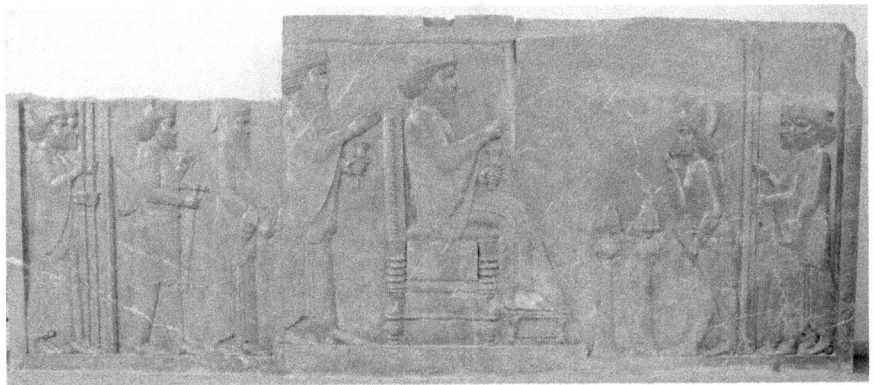

Fig. 4.2. Relief of the Great King enthroned receiving an official, Persepolis, Iran, c. 520–480 BC. Excavated from the Persepolis Treasury; originally the central panel of the eastern façade of the Apadana. Tehran, National Museum of Iran. Image © Jona Lendering and reproduced by permission.

deity and greater divinity' (Root 1979, 273). In this respect it had a distinctly different meaning from the more common pose in which the hands were clasped tightly together. It seems the hand-over-wrist gesture was an aspect of courtly behaviour which was applied by analogy to the divine realm as well. The gesture then appears again in quantity in Elam during the Middle Elamite Period of the thirteenth century BC, perhaps not coincidentally an era of widespread international communication between greater Mesopotamia and Egypt. One particularly notable example of it is in the near life-sized bronze statue of Queen Napir-Asu from Susa (Paris, Louvre Sb 2731; Harper et al. 1992, no. 83) (Fig. 4.3). Its use continues into the Neo-Elamite Period in the first few centuries of the first millennium BC, and this in turn served as an important contributor to the iconographic repertoire of the Achaemenids. At Persepolis the Persian gesture seems to have been the appropriate posture for one's hands in the presence of royalty or divinity, as this was the apparent meaning of its Mesopotamian and Elamite precursors.

Fig. 4.3. Statue of Queen Napir-Asu, c. 1340–1300 BC, from Susa, Iran. Bronze and copper; H. 129 cm. Paris, Louvre, Sb 2731. Image in the public domain from Lampre (1905, pl. 15).

The long history of the Persian gesture in Mesopotamia and Elam and its deployment in the programme of visual rhetoric at Persepolis make its association with the Achaemenid Empire reasonably clear. Yet despite the clarity of this association, its utility as a dating criterion is still limited, because there are a handful of instances of this gesture in Egyptian art that predate Achaemenid rule. The earliest of these occurrences is on a lapis lazuli figurine excavated at Hierakonpolis, and thus probably of Protodynastic date, c. 3200–3000 BC (Oxford, Ashmolean Museum AN1896-1908 E.1057, 1057a; Eaton-Krauss 2011, 187–8). It remains an open question, however, whether this figurine is an Egyptian product or, as Edith Porada (1980) has proposed, was carved somewhere in Iran. It thus provides no clear evidence either way as to the gesture's origin. Of the remaining examples, three are statues of Amenhotep III (reigned 1390–1352 BC; Bothmer 1960, 84), suggesting a special interest in this gesture on the part of this pharaoh, perhaps a result of his diplomatic relations with Mesopotamian powers (Kitchen 1998). The gesture's association with the Persians is also called into question by its occurrence in the Ptolemaic and Roman Periods as well (e.g., de Wit 1964; Laurent 1984, 140–2), though admittedly many of these later instances are similarly difficult to date precisely. Thus, although the association of the Persian gesture with the Achaemenid court is a sound premise, the appearance of the gesture as the sole dating criterion for a given object is not. In conjunction with other criteria, however, the gesture could still be used to propose a tentative 27th Dynasty date.

Since the Persian gesture is associated with the Achaemenid Empire it is worth considering the reason why someone would choose to be represented for all eternity making it. The typical explanation is that it was a symbol of subservience to and collaboration with the Achaemenid rulers of Egypt (Schulman 1981, 107–8). But it is unlikely that the Egyptians who chose to be represented in this matter conceived of it in these terms. Rather, the inclusion of the Persian gesture in one's monument was a means of highlighting one's connection to the centre of the social order, whether this centre was perceived to be at the satrapal court in Memphis or in Persia. To some extent Bothmer hints at this same explanation in his comment on one statue exhibiting this gesture: 'The pose is one that must have struck the Egyptians as typically foreign, and the man who had this sculpture made for himself ... must have wished to adopt something exotic (and probably fashionable) in his gesture' (Bothmer 1960, 84).

The relatively limited number of examples of this gesture suggests

not the small number of people who 'collaborated' with the Persians, but rather what must have been a largely widespread view that the centre of the social order remained firmly within an Egyptian context, regardless of the political developments of the sixth and fifth centuries. The exact connections made by patrons who commissioned statues of themselves displaying the Persian gesture remain unclear and are perhaps not the most significant feature of the choice. What matters in the context of this discussion is that the gesture was perceived by certain patrons as a positive statement and that these patrons wanted to have it associated with their monuments for all eternity.

The 'Persian garment'

A certain wraparound robe and sleeved jacket appearing in statuary and relief of the Late Period have been identified as explicitly Persian in nature; typically they are referred to as the 'Persian jacket' or the 'Persian garment'. The robe extends from the armpits to the ankles. It seems to comprise a single rectangular sheet wrapped tightly around the body starting at the front, going around the back, and then overlapping at the front again where it is tucked in (Bothmer 1960, 75–6; Wasmuth 2017b, 246). This is represented worn over a jacket with fitted sleeves that sometimes flare from the elbow. This combination is typically worn over a round-necked undergarment.

The association of this garment with the Achaemenid Empire is based on the similarities between it and the 'court robe' worn by many of the figures depicted on the Apadana reliefs (and elsewhere) at Persepolis (Fig. 4.2), and by the guards from Susa shown in glazed brick (Root 2011, 426–33; Stronach 2011).[1] It also occurs on seals and other imagery deployed all over the empire, including on some of the sealings from the Palace of Apries in Memphis (see Figs 2.11, 2.12, 2.13). Darius is depicted wearing similar clothing in the famous statue made in Egypt but excavated at Susa (see Fig. 4.7). Though there is some resemblance between the Persepolitan court robe and the wraparound robe and jacket combination from Egypt, the match is not an exact one. It has been suggested that the Persian court robe actually consisted of a single article of clothing rather than a combination of tunic and robe as in the Egyptian cases (Beck 1972). It also typically features a belt, which is absent from the Egyptian examples

[1] For examples of the court robe at Persepolis see Schmidt 1953, pls. 22–6, 50–2, 57–9, 63, 65–71, 75–6, and at Susa see Harper et al. 1992, nos. 155–6; Daucé 2013, 312–14.

(save for the statue of Darius). The formal resemblance between the Egyptian 'Persian garment' and Achaemenid court robe is thus more evocative than it is precise.

The chief difficulty with using the 'Persian garment' as a dating criterion is that it is attested in at least two instances prior to the Persian Period. One of these is a stela commemorating a man named Wahibra which features a niche decorated with carved relief (Edinburgh 1956.134; Bothmer 1960, no. 66). The stela is dated to the reign of Amasis on the basis of two other monuments of Wahibra, a naophorous statue (Cairo CG 672) and another stela (British Museum 1427), both of which are clearly datable by means of cartouches of Amasis (Bresciani 1967; El-Sayed 1975, 61–93, 219–20). The stela depicts Wahibra and his father Padihorresnet standing side by side looking out at the viewer. The figure of Wahibra, on the right, is better preserved than that of his father. He wears a long garment that extends from the level of his armpits as far down as the figure is preserved (seemingly all the way to his feet). The garment has two folds visible at the top, one tucked in to the top of the garment itself and the other hanging down over it. Wahibra also wears a sleeved jacket or tunic with an unclear neckline tucked into the long garment. Padihorresnet appears to be dressed similarly, though the details of his costume are difficult to discern. The second such instance of the 'Persian garment' is a kneeling naophorous statue of Somtutefnekhet (Cairo 27/11/58/8), which is datable to the reign of Amasis by means of a partially erased cartouche, and can be further narrowed down by a reference to year 39, which is 530 BC (Bresciani 1967). Somtutefnekht is also depicted wearing both a long garment extending from his armpits to his ankles with two folds at the top and a sleeved V-neck tunic tucked into it.

These are the only two depictions of the Persian garment featuring both the long robe and the sleeved tunic that date unequivocally to the Saite Period. There are various other statues and monuments which have been adduced in the past as evidence of the Persian garment's use in earlier periods (Colburn 2014b, 221–2). None of these objects, however, can be assigned unequivocally to the Saite Period; they thus create a false impression of the garment's prevalence prior to the invasion of Cambyses. Other personal monuments feature the robe without the jacket, and thus are not examples of the 'Persian garment' per se. At least two of these monuments are clearly datable on epigraphic grounds to the early and mid-sixth century BC, and thus may provide some useful evidence for the development of the 'Persian garment'.

The first of these monuments is a squat, basalt stela dedicated by a private individual named Necho (British Museum EA511; de Meulenaere 1983). A large niche in the stela features reliefs depicting two male figures, presumably Necho and his brother Nekhthorheb. These figures both wear long robes that extend from the mid-waist to the mid-calf. Both also have small knobs at the top of the robe, off centre; these are usually interpreted as the rolls of cloth that normally occur on the Persian garment. There are no sleeves readily visible on either figure, so these garments are essentially long kilts, albeit with the addition of rolls of cloth tucked into the top. This stela is dated to the early sixth century on the basis of the identification of Nekhthorheb with an eponymous individual, known from two statues and some inscribed objects, who was active under Psammetichus II (Posener 1951; El-Sayed 1975, 225–7; de Meulenaere 1983). This identification is based on a comparison of the titles of this Nekhthorheb, as listed on his own monuments, and those of Necho's brother, as listed on this stela; they have five in common. It is thus likely that these two people named Nekhthorheb were one and the same, though the personal name and the titles are too common to permit of certainty, especially in the absence of patronyms or surnames. So although this early sixth-century date is far from secure, it is at least probable.

The other monument is a naophorous statue of a man named Peftuaneith, which must have originally been dedicated at Abydos (Louvre A 93; Leahy 1984a; Spencer 2010, 455 figs 5–7). Peftuaneith wears a long garment extending from his armpits to his ankles with two stylised rolls of cloth at the front of the chest; these rolls, which are simply cylinders, seem to take the place of the folds that occur on the belted, wide-sleeved Persian garment. Like Necho and Nekthorheb, Peftuaneith does not wear a sleeved tunic. The statue is dated based on a cartouche of Amasis (Leahy 1984a). The date can be further narrowed down to the beginning of Amasis' reign, the mid-sixth century BC, because the reconstruction of Peftuaneith's career from the inscription on this statue (Lichtheim 1980, 33–6) and another in the British Museum (EA83; Heise 2007, 225–8) indicates that he was active under both Apries and Amasis, in whose service he worked to renovate several temple structures at Abydos (Leahy 1984a; Klotz 2010, 128–35). Since he was already at the height of his career under Apries, it stands to reason he was of mature age by the time Amasis came to power, and thus his statue is unlikely to date later than mid-century.

These two monuments of Necho and Peftuaneith show that by

the early sixth century BC a variation on the long Egyptian kilt had become popular. In the later sixth century this garment was combined with a long-sleeved tunic or shirt that covered the shoulders and chest entirely and was worn underneath the long kilt. This combination of clothing became especially prevalent during the period of Achaemenid rule, most likely on account of the resemblance it bore to the Persian court robe. So the 'Persian garment' is perhaps better described as the 'Persianising' garment, since it seems to represent a negotiation between a traditional Egyptian garment and the general look of the Achaemenid court robe.

Despite its uncertainty as a dating criterion, the 'Persian garment' is an enormously useful index of how certain Egyptians constructed their personal identities and conceived of themselves and their roles in the broader social order during the late sixth and fifth centuries BC, as is demonstrated further in the case studies.

Realism

Although rarely presented as a definitive dating criterion, the association of 'realistic' Egyptian statue heads with the period of Achaemenid rule is presented by many scholars as a matter of course (e.g., Bothmer 1960, 71–2, 78–9, 81–3; Barocas 1974; Shubert 1989). The association, however, is based on implicit and unproven assumptions about the nature of Achaemenid rule, Egyptian reactions to it, and the factors and reasons informing the creation and purposes of Egyptian art. This assumption is easily demonstrated by a statement in a standard handbook on Egyptian art: 'The melancholic introspection, already apparent in Saite times, became more pronounced in the resigned expressions with which the faces of the statues of this time gaze out into their troubled world' (Aldred 1980, 233). In other words, Achaemenid rule made the Egyptians sad, and this sadness was reflected in the creation of their statues. Obviously there are manifold methodological problems with this sort of approach, and only a few are examined here.

First, there is the problem of what is meant by 'realism'. The term implies accurate physical likenesses of the individuals who commissioned the statues, but in the context of Egyptian art it really refers to any departure from the more common idealising youthful visage. Such departures are not necessarily likenesses, since idealised representations of the human face can take a variety of forms depending on the social and cultural contexts of their deployment. The sculptures of republican Rome, for instance, are characterised

by a form of idealisation known as 'verism' that emphasises careworn and aged physiognomies over youthful ones in an effort to demonstrate the republican virtues of *gravitas* and *auctoritas* in the statesmen they represent (Tanner 2000). Similar examples of non-youthful idealised representation are known from earlier periods in Egypt, with the statues of the Middle Kingdom pharaoh Senusret III being perhaps the best known. The criteria used to identify such 'realism' are highly subjective, as demonstrated, for example, by one particularly amusing case in which a museum curator put his own clothes on a cast of an Old Kingdom bust, declaring 'one is struck by the modernity of the face, which might be met with any day in the street' (Dunham 1943, 10).

Second, implicit here is the assumption that artistic phenomena map closely onto political changes, and that such phenomena only occur in discrete chronological groups. While political conditions are indeed one of the many factors that affect artistic production, they are only one of many, and to assign them disproportionate influence during a single time period is methodologically unsound. Discernible trends and changes do occur in Egyptian statuary, but they do not necessarily affect the entire artistic output of a given time period. And it is worth noting that the dates of many of the individual pieces often assigned to the 27th Dynasty on the grounds of their apparent realism have been challenged, albeit not always with good reason (Barocas 1974; Shubert 1989).

Third, these approaches that link realism to Achaemenid rule assume that these images are simply reflections of the lived realities of their dedicators; they discount any purposeful manipulation of reality to achieve a certain goal or effect. Thus they ignore the potential that visual representations have to participate actively in, modify and create cultural and social processes rather than to merely result from them. The visual appearance of an object is the result of a series of decisions made by its creators (including both artist and patron). While these decisions are certainly informed by the social, cultural and political contexts in which they are made, it does not follow that art is necessarily a simple and regularised reflection of these contexts (Tanner 2000).

Dorsal pillar shape

Bothmer (1960, 79) cites the shape of the top termination of a statue's dorsal pillar as a chronological indicator, arguing that terminations in the shape of a truncated triangle or trapezium (Fig. 4.4)

Fig. 4.4. Naophorous statue with a trapezoidal dorsal pillar, 5th–4th century BC. Greywacke; H. 46.6 cm; W. 11 cm; D. 16.9 cm. New York: Metropolitan Museum of Art, 25.2.10. Image in the public domain.

do not occur on any statue dated on epigraphic grounds to the 26th Dynasty. On this basis he proposes that statues with this feature must date to the 27th Dynasty or later. Though this may well be the case, he goes on to argue that the shape of the dorsal pillar had a practical purpose rather than any symbolic meaning: he suggests it served to make the dorsal pillar less obvious on statues of individuals represented with bald heads instead of bag wigs. Bald heads do seem to become more common over time in the Late Period, and the tapered pillar associated with them becomes more common as well, but there is simply no indication of any causal link between Achaemenid imperialism in Egypt and changes in dorsal pillar shape.

As this review has shown, the criteria used for assigning statues and other objects to the Saite or Achaemenid Periods are not as reliable as much previous scholarship would suggest. Of all these criteria, only clear references in a statue's inscription to kings and individuals known from other, better-dated contexts are sound indicators of date. Otherwise there is no reliable means of assigning a given Late Period statue to one dynasty or another, and therefore no reason to exclude so much material from the period of Achaemenid rule. That said, issues revealed by discussion of the 'Persian gesture' and the 'Persian garment' inform our understanding of representation and identity in Egyptian statuary of the Persian Period. These are important visual cues related to the application of certain other Persianising features such as Iranian torques or bracelets, as will be discussed in specific cases later in this chapter.

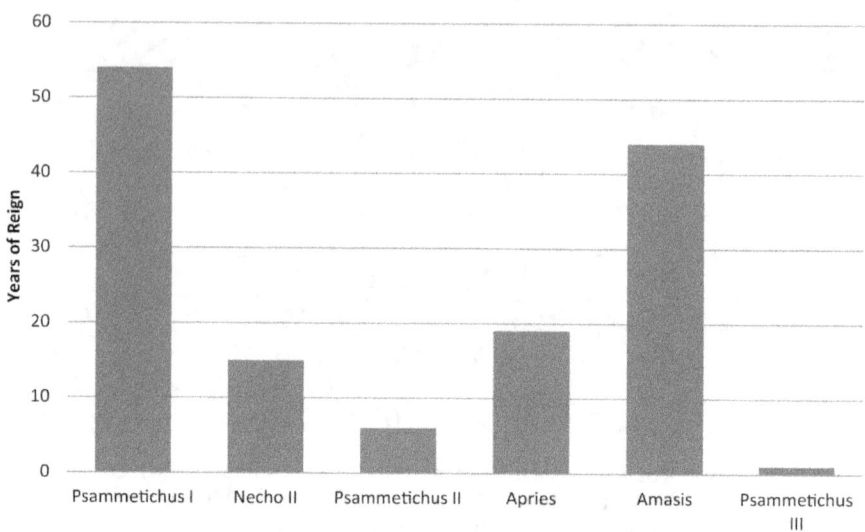

Fig. 4.5. Graph showing duration in years of each Late Period pharaoh, based on the chronology in Lloyd (2010, xxxviii–xxxix).

Formation processes of the art historical record

The second major factor that has contributed to the notion of artistic poverty in the period of Achaemenid rule is the assumption that the visual record of Egyptian art as it exists today is a representative sample of all the art produced in a certain medium during a certain period within a certain region. This assumption, which is not limited to Egyptian archaeology by any means, is a variant of the so-called 'Pompeii premise' (Schiffer 1985). It ignores 'formation processes', that is, the factors, both natural and man-made, that act on and affect material objects between the time of their creation and the present day. Such factors do not act equally on all material from all times and places. This much is demonstrated easily by a brief consideration of Saite royal sculpture. The Saite kings with the longest reigns, Psammetichus I and Amasis, ruled fifty-four and forty-four years respectively, with Apries a distant third at nineteen years (Fig. 4.5). Yet the extant quantity of their statuary as catalogued by Leahy (1984b) does not reflect these long reigns (Fig. 4.6).[2] *Damnatio memoriae* is often suggested as a contributing factor in this uneven-

[2] In this graph I have endeavoured to eliminate statues dated solely on stylistic grounds, especially in light of the criticism of dating criteria expressed in the previous section. This is why I have not used the more extensive list in Myśliwiec 1988, 46–51, since unlike Leahy he is not explicit about how his material is dated.

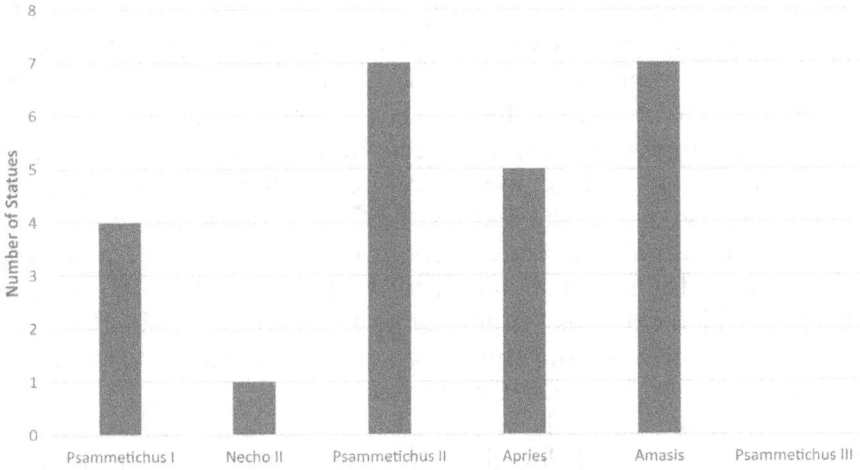

Fig. 4.6. Graph showing number of statues datable to various Saite pharaohs, based on Leahy (1984b)

ness of distribution (Leahy 1984b, 71–2), but on the whole it is very difficult to reconcile the surviving statues of the Saite pharaohs with our normative exceptions. Clearly it is worthwhile to consider how the corpus of Late Period sculpture was created, and how human activity especially has affected its creation.

The most thorough and detailed study of archaeological formation processes is Michael Schiffer's *Formation Processes of the Archaeological Record*, published in 1987. Schiffer considers a much broader range of objects than just statues, but he provides a framework for approaching the specific problem of what we might call the 'art historical record'. In general, formation processes belong to two categories: cultural and natural processes (or 'C-transforms' and 'N-transforms' in Schiffer's terms). Egypt's natural processes are quite straightforward. The two main natural forces that could contribute to the formation, and indeed the destruction, of stone statues are wind and water. Save for exceptional cases neither of these would normally affect statues set up in temples, where most Late Period statues seem to have been placed. This leaves cultural processes, to wit human activity, as the main factor to have a major impact on the preservation of visual art in Egypt's archaeological record. The following discussions seeks to illustrate via a few relevant examples the tortuous routes taken by some statues from the point of their creation to modern museums.

The inscriptions on most Late Period statues imply that their dedicators intended them to stand in the temple forever, though in reality

this rarely happened. Some temples, such as the Karnak temple, certainly did operate for very long periods. Assuming steady or even diminishing numbers of statues added every year, such temples eventually ran out of space. The priests then had to bury old statues within the temple precinct, since removing them entirely or defacing them would have dire consequences for their deceased dedicators and might also invoke the god's wrath. This is the standard explanation for the Karnak Cachette, a deposit of over 800 stone statues and other objects found in the courtyard in front of the Seventh Pylon at Karnak, which contains statues dating from the New Kingdom into the Ptolemaic Period and thus represents the accumulated statuary of seven or eight centuries (Colburn 2016, 229).

This is, however, the least dramatic sort of C-transform, causing the least amount of dislocation from the statue's original point of deposition. Other human actions, especially defacement and appropriation, could have a much greater impact. Defacement for high-status political reasons certainly did occur, as the various erased cartouches of Amasis mentioned in the previous section demonstrate. But defacement and destruction could happen for other reasons too (Colburn 2016, 229–30). The narrator of the Petition of Petiese accuses the priests in the temple of Amun in Teudjoy of throwing two statues of his grandfather into the Nile, as part of their feud with his family. The Petition is an admittedly singular document, but it is not too difficult to imagine this sort of local strife leading to the destruction of statues, and in a manner that is difficult to model or predict. Other factors could also contribute to the destruction of statues, and in Egypt the iconoclastic tendencies of more zealous Christians in the fourth and fifth centuries AD no doubt account for the destruction (and removal) of many Late Period statues. Finally, by the Ptolemaic, Roman and Late Antique Periods, many temples had ceased to operate as such, and had become residential or industrial zones instead. As a result, statues or other monuments could be reused as building materials or burned to produce quicklime.

Appropriation of statues, particularly their removal to some other location from the temple in which they were initially installed, also took place. Normally this was associated with invading armies intent on seizing plunder or appropriating the charismatic and religious authority of a defeated enemy (Winnicki 1994). But the centuries of Roman rule in Egypt also afforded ample opportunities for the removal of Egyptian statues (along with many other objects) to Rome and other places around the empire. A cursory glance at

the catalogues of Egyptian items collected by Roullet (1972) and Capriotti Vittozzi (2013) reveals an extraordinary variety of statues of gods, kings, private individuals, animals, obelisks and so forth found in Rome and elsewhere in Italy. This variety makes it difficult to identify any pattern in how, or criteria by which, objects were selected for export. And because these objects were imbued with new meaning according to the context of their reuse in Italy (and elsewhere around the Roman Empire), it seems that the main reason for their selection was their visibly Egyptian character, with condition, availability and the fame of the site from which they came also playing roles (Versluys 2010; Swetnam-Burland 2015, 28–33).

Certain statue types, however, were in demand in Rome for specific reasons. Statues of Ptolemaic queens were often understood to represent Isis, and in some cases they were actually used as such in sanctuaries. Indeed, statues of Isis sculpted in Italy were often modelled on statues of Ptolemaic queens, as seen in the case of a sculptural group from Hadrian's Villa that was part of a shrine to the deceased Antinous (Ashton 2010). The Romans may also have interpreted naophorous statues as images of priests; this much is suggested by a small basalt statue in the British Museum (EA24784; Malaise 2004, no. 27; Colburn 2016, 231) formerly in the possession of the Danish consul general Julius Loytved in Beirut. The worn and broken statue represents a standing male figure placing his arms around a figurine of Osiris. In addition to the inscribed dorsal pillar, which is lacunose, there are also inscriptions on the left side of the dorsal pillar reading *sacerdos Osirim ferens* in Latin and προφή[της] Ὄσειριν κώμ[α]ζω[ν] in Greek, both of which translate simply as 'priest bearing Osiris'.

The statue's condition makes it extremely difficult to assess its date. The latest known firmly datable naophorous statue (dated by a cartouche) is a product of the reign of Augustus (de Meulenaere 2009, 228), so this statue is likely to be Ptolemaic in date. The inscriptions, however, date on palaeographic grounds to the second or third century AD (Malaise 2004, 74 n. 17; Bricault 2005, 505). The contents of these inscriptions suggest that they were added as labels to identify the statue's form. The Roman interpretation of naophorous statues as representations of priests led to their use as décor for Roman sanctuaries of Isis or Serapis (Roullet 1972, 111; Malaise 2004). The roles played by these two types of Egyptian statues in Roman religion may well have created special demand for them, more so than other Egyptian art, and therefore led to disproportionate importation of these types to Italy (and other places in the Roman Empire).

The sites in Egypt from which these statues came were not necessarily evenly distributed (Colburn 2016, 231–3). The provenances of many of the objects taken to Rome cannot now be ascertained, but Heliopolis and Sais seem to have been favoured sites for the procurement of Egyptian objects by the Romans. It is not at all difficult to imagine why Sais may have been a popular source for statues: its proximity to Alexandria would have made it convenient for seaborne merchants bound for Italy, and Sais's relative obscurity and unimportance in the Roman Period probably also made it simpler for merchants, and anyone else, to remove statues from the temple there. This is in distinct contrast to Memphis, which, as discussed in Chapter 2, was the seat of the satrap during Achaemenid rule, and continued to be one of the major cities of Egypt into Late Antiquity. It was finally surpassed by Cairo, and in the late twelfth century it was mined for building materials by Salah ad-Din for the construction of the Cairo citadel. Indeed, Roullet's (1972, 112–13) catalogue only contains a single item from Memphis.

The survival of statues that were removed to Italy depended on yet another set of human activities, usefully illustrated by the well-known naophorous statue of Udjahorresnet (Fig. 4.18). According to its lengthy biographical inscription (Lichtheim 1980, 36–41; Kuhrt 2007, 117–22) this statue was originally dedicated in the temple of Neith at Sais in the 510s BC (Spalinger 1986, 823), where it probably remained until it was taken to Italy sometime during the Roman Period. It is generally thought to have been taken to Hadrian's Villa at Tibur (modern Tivoli, near Rome), where it was most likely used to decorate one of the Egyptian-themed areas of the villa, such as the pool complex known as Canopus (presumably intended to recall the Egyptian coastal town of the same name), or the shrine to Hadrian's lover Antinous, who drowned in the Nile (Colburn 2016, 233). If the statue was taken directly to Tivoli, this suggests it was removed from Egypt in the second century AD, possibly even during the fateful imperial visit to Egypt. But it is also possible that it came to Italy earlier, perhaps for use in a temple of Isis or Serapis.

There is no evidence for imperial use of Hadrian's Villa after the reign of Caracalla (AD 198–217), and in time the villa, along with its contents, became subject to looting, reoccupation and repurposing, all destructive processes (Colburn 2016, 233). For example, part of a lime kiln was discovered in one of the buildings, suggesting that much of the villa's stone, including statuary, was burned to produce quicklime. Likewise, spolia from the villa were used to construct various buildings in Tivoli, such as the twelfth-century churches of San Stefano and San

Pietro, and the sixteenth-century villa of Ippolito d'Este, Cardinal of Ferrara. It was not until 1461 that Flavio Biondo identified the remains of Hadrian's Villa, on the basis of the description in the *Historia Augusta* (26.5). This identification made the site a popular hunting ground for ancient works of art, Egyptian as well as Greek and Roman. Pirro Ligorio famously excavated the villa on behalf of the Cardinal of Ferrara in the sixteenth century, and throughout the seventeenth and early eighteenth centuries the Bulgarini family, who owned portions of the site, gave concessions to various other excavators.

One of these excavators presumably found the statue of Udjahorresnet, since in 1783 it was published in Carlo Fea's Italian edition of Winckelmann's *Geschichte der Kunst des Altertums* (Winckelmann 1783, pl. 8), and it was acquired by the Museo Egiziano Gregoriano the same year (Pietrangeli 1951; Colburn 2016, 233–4). In the nineteenth century, following the decipherment of hieroglyphics, the statue gained added interest on account of its lengthy and well-preserved inscription, which garnered particular attention (e.g., de Rougé 1851) on account of its references to figures known from Herodotus, such as Amasis, Cambyses and Darius. This assured its prominence at the beginning of the twentieth century when scholars such as Bosse began their work on Late Period statuary.

This partially speculative history of the statue of Udjahorresnet provides an example of one of the many paths an Egyptian statue could take from the temple where it was dedicated to the modern museum collection where it becomes part of the art historical record. It should be clear that happenstance plays a significant role in the preservation of statuary, and that certain factors such as the Roman need for objects to adorn temples of Isis and Serapis, as well as early modern interest in relating Egyptian hieroglyphic inscriptions to classical historical narratives, contributed to the survival of some statues over others. Indeed, it is quite likely that most of the statues that were not taken to Italy and other imperial locales during the Roman Period either ended up in caches such as that at Karnak or were destroyed altogether. Of those statues taken to Italy, many were from Sais, leading to a disproportionate rate of survival among statues of 26th Dynasty date.

The art historical record of the Late Period does not provide a representative sample of all the art produced in Egypt between 664 and 332 BC. Rather, a wide variety of human processes and actions have shaped it over two and a half millennia. This means that one cannot simply assume that patterns discernible in this record are necessarily a direct result of conditions in Achaemenid Egypt.

Artistic poverty in Achaemenid Egypt: a summary

Our modern narrative of the artistic poverty of the 27th Dynasty results from a variety of factors both ancient and modern, but we are hard pressed to validate the idea that the nature of Achaemenid imperialism was among the causal factors involved in this perceived situation. Indeed, we are hard pressed to validate the narrative at all. Modern scholars seeking to bring order to a disparate corpus of material also brought with them the long-held assumptions of their disciplines, including especially Greek ideas about the Achaemenids. Likewise, the uneven nature of the Roman harvesting of Egyptian statuary has led to the prominence of certain places, periods and statue types over others, and the bounty of this harvest provides the foundation of much of the modern scholarship on Egyptian art. Finally, the false precision with which much Late Period statuary is dated also contributes to this narrative. In fact, much of the material traditionally assigned to the Saite Period or the fourth century BC could just as well belong to the Persian Period, and our general inability to distinguish among the statuary of these various periods is a result not of our own methodological failings, but of the sheer variety of experiences that must have existed in Achaemenid Egypt. Accordingly, there is little to be gained by further minute chronological adjustments to the corpus of Late Period art. Rather, to understand the impact of Achaemenid rule at the individual level we must look at some individuals, or at least at how they elected to represent themselves in certain significant contexts. This is the purpose of the case studies discussed below.

CASE STUDIES

The case studies that follow explore the range of experiences of Achaemenid rule in Egypt by examining representations of individuals. The variations in these representations result from the different ways in which individuals conceived of their identities within the context of Achaemenid Egypt. Some seem to have paid little heed to the empire in their choices as to how to represent themselves, whereas others made reference to superordinate centres outside of Egypt, such as Persepolis, as part their representations. This variety is suggestive of the potential gamut of experiences had by people in Egypt during this period, including Egyptians, foreigners (including ethnic Persians) and the children of mixed marriages. Of course, these cases are biased towards the people who could most afford the

services of sculptors and other artisans. It is also skewed towards men, representations of whom predominate in this sort of evidence. So it is important to recognise that the experiences discussed here are those of only a small subset of the population.

The statue of Darius from Susa

Perhaps the best-known representation of an individual created during the period of Achaemenid rule in Egypt is the statue of Darius I (Fig. 4.7) found at Susa on Christmas Eve 1972 by the Délégation archéologique française en Iran and now in the National Museum of Iran (Colburn 2014a, 784–8). Both the statue's trilingual cuneiform inscription (DSab) and the Egyptian greywacke from which it was carved attest to its creation in Egypt. Furthermore, the content of the hieroglyphic inscription (Kuhrt 2007, 477–9) is consistent with an Egyptian royal monument and makes frequent reference to the god Atum of Tjeku, another name for the town of Pithom (identified as modern Tell el-Maskhuta in the eastern Nile Delta), implying that the statue had been set up there originally in a temple of Atum (Bresciani 1998; Yoyotte 2013, 250–2, 256; Wasmuth 2017a, 102). Yet despite its unequivocally Egyptian origin, the inclusion of Achaemenid imperial iconography in the representation of Darius makes it clear that the statue was designed as an imperial monument as well as a local Egyptian one. Its creation must have involved high-ranking officials familiar with the expression of imperial ideology, as well as priests of Atum. The dual design of the statue is best explained by Pithom's location on Darius's Red Sea canal, an important nexus between Egypt and the Achaemenid heartland and thus a significant locus of imperial activity.

The date and circumstances of the statue's removal from Egypt to Persia remain subject to debate. But the statue's original setting at Pithom may help to explain it. According to the inscription on the Tell el-Maskhuta stela (Posener 1936, 50–63; Klotz 2015, 276–80; Wasmuth 2017a, 126–7), which features the best preserved of the hieroglyphic inscriptions on the stelae erected along the canal, Darius conceived of the idea of the canal while in his palace in Persia, for the purpose of moving goods and tribute by water from Egypt to Persia (Lloyd 2007b, 101–4). No reference is made to any statue in this inscription. But the transport to Susa of an Egyptian royal monument representing Darius as pharaoh would have been a very effective demonstration of the canal's successful completion and integrative potential. Whether this statue was the only one of its kind,

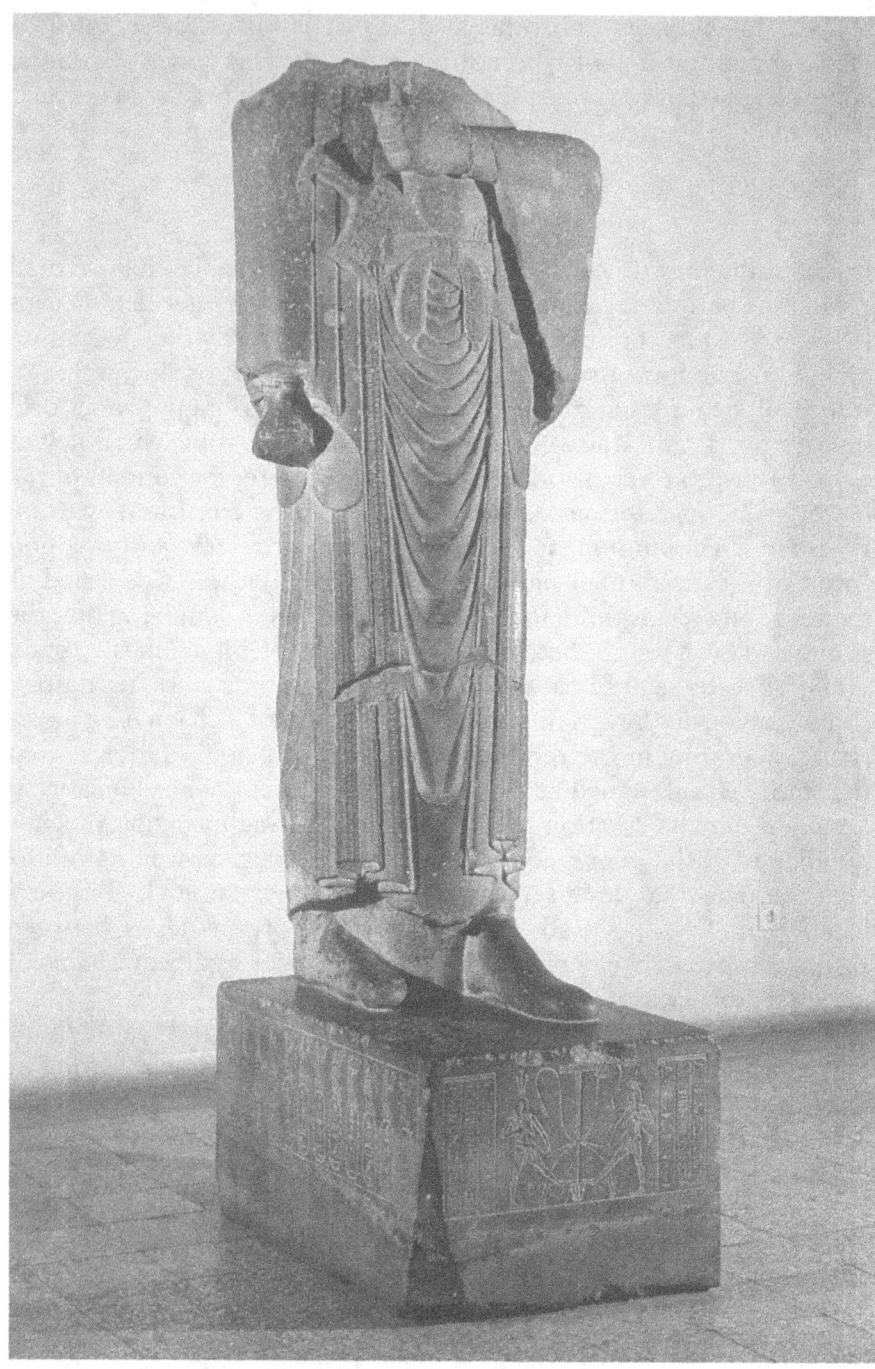

Fig. 4.7. Statue of Darius from Susa. Greywacke; H. 2.46 m. Tehran, National Museum of Iran 4112. Reproduced by permission of Jean Perrot and Rémy Boucharlat.

or if a duplicate of it remained in Pithom, is unknown, and to some extent irrelevant; certainly there is no reason to assume this statue was unique. Once in Susa it was integrated into the monumental gateway, where it became an important part of the palace's decorative programme (Razmjou 2002, 87–9). As such it was both a statement of Achaemenid imperial ideology generally and a monument to Achaemenid appropriation of Egyptian kingship in particular.

The statue is preserved up to its shoulders; originally it would have stood approximately 3 m high, making it well over life-size. It depicts Darius in a striding pose with his left foot further forward than his right. He holds his left arm horizontally across his chest and his right straight down at his side. He wears a full-length robe with flaring sleeves, gathered high on his waist with a belt; a dagger in a scabbard is tucked into the belt at the front. In his left hand he holds what seems to be the stem of a flower, the top of which is not preserved, and his right fist is filled with a cylinder, in keeping with Egyptian sculptural practice. At the back is a dorsal pillar that runs the entire preserved height of the statue. The cuboid base of the statue features incised decoration; at the front and back is a well-known Egyptian image, the 'Uniting of the Two Lands'. On each long side is a row of twelve kneeling figures representing personifications of a total of twenty-four peoples of the empire, including Persians (Roaf 1974; Yoyotte 2013, 262–9; Wasmuth 2017a, 156–86). The statue is inscribed with a trilingual cuneiform inscription (DSab) on the lower folds of Darius's garment; there are hieroglyphic inscriptions on the belt and lower folds of the garment, as well as on the top and sides of the base (Sternberg-el Hotabi 2017, 88–97; Wasmuth 2017a, 110–18, 121–2). No traces of the statue's head survive, but generally it is thought that it was largely consistent with the representations of the Great King at Persepolis and Naqš-e Rustam (Luschey 1983; Wasmuth 2017a, 118–20).

The statue of Darius quotes Egyptian artistic tradition in a number of features. Most distinctive is the representation of the 'Uniting of the Two Lands' on the base of the statue (Yoyotte 2013, 262–6; Colburn 2014a, 786). This image shows two fecundity figures representing Upper and Lower Egypt binding together a lotus and a papyrus plant (the two plants also representing Upper and Lower Egypt) with the hieroglyph for 'unite' in between them. This image goes back well into the Old Kingdom, and it is typically placed beneath the king, either below a cartouche containing his name, or on a throne or statue base (Goedicke 1985). Thus its inclusion on the statue of Darius is a straightforward appropriation of Egyptian iconography and of the royal ideology underlying it.

Fig. 4.8. Detail of the base of the statue of Darius from Susa. Image © Jona Lendering and reproduced by permission.

Similarly, the figures representing the subject peoples of the empire carved on the base of the statue (Fig. 4.8) have distinctive Egyptian antecedents in the depiction of foreign prisoners of war (Roaf 1974, 75–6; Root 1979, 138–47; Calmeyer 1991; Colburn 2014a, 786; Wasmuth 2017a, 156–62). Prisoners are identifiable as such because of their non-Egyptian attributes, especially their beards and clothing, and because their ethnonyms are written in studded cartouches representing city walls. Since the Predynastic Period they had been depicted kneeling and bound, and placed in a location where they were either beneath the king, or in some cases actually trodden upon by him (Ritner 1993, 113–36). The placement of the subject peoples on the base of Darius's statue, and therefore below the king, where they are effectively trampled by him, is consistent with Egyptian iconography, as are their kneeling pose and the cartouches that accompany them. The connection the statue makes with traditional Egyptian renditions of kingship is also reinforced by the hieroglyphic inscriptions, which praise Darius as pharaoh and frequently invoke the Egyptian god Atum (Kuhrt 2007, 478–9; Yoyotte 2013, 260–2).

Other aspects of the statue are also clearly borrowed from the Egyptian visual repertoire (Wasmuth 2017a, 105–6). As noted above, Darius's right fist is filled by a stone cylinder. This is a common feature of Egyptian statuary, and it has been interpreted variously as a shortened staff, a roll of linen or simply a convention for represent-

ing an empty hand. Likewise, the striding pose of the statue, with the left foot in front of the right, and with the stone in between them left in place, is also a regular feature of Egyptian statuary in particular. Finally, the inclusion of a dorsal pillar is a consistent feature of Egyptian sculpture in the round.

The statue of Darius, then, draws heavily on Egyptian representations of kingship in order to present Darius as a royal figure in Egypt. At the same time it also utilises visual references to Mesopotamian and Iranian art to nuance this presentation and adapt it to fit Achaemenid imperial ideology. For example, Darius is depicted wearing the Persian court robe and carrying an Elamite dagger; both are accoutrements of the Persians on the Persepolis reliefs and part of Darius's representation of himself as a 'Persian man', as alluded to in the statue's cuneiform inscription and referenced in the art of the empire in various media (Root 1979; 2011).

The figures representing the subject peoples on the base of the statue have also been adapted to better fit Achaemenid imperial ideology. The figures hold their arms up in front of them, with their open palms facing upward. This is in sharp contrast to the usual depiction of prisoners, whose arms are always bound behind their backs. Rather, in Egyptian art this pose is used to represent carrying or support, and the spatial relationship between the subject peoples and the figure of Darius implies that they are supporting the king (Roaf 1974, 77; Root 1979, 149; Colburn 2014a, 787). This imagery has close analogies at Persepolis and in the façades of the royal tombs at Naqš-e Rustam (Schmidt 1953, 116–20, 134–7; 1970, 77–118; Garrison 2017b, 391–403). There the king is depicted on a platform supported by rows of subject peoples in the atlas pose with their arms raised and their palms facing upward.

The atlas pose has a long history in Mesopotamian and Elamite art, where it usually denotes a divine context. Its use at Persepolis and Naqš-e Rustam to support the king is a means of representing the relationship between the king and the people of the empire, that is, it reinforces the king's amalgamation of political and religious authority with the support of his subjects (Root 1979, 131–61; Garrison 2011, 43–7). This notion is furthered by the inclusion of Persians among the subjects of the empire, at Persepolis and Naqš-e Rustam, as well as on the statue of Darius, which, visually at least, puts the Persians on a par with everyone else rather than emphasising their superiority (Roaf 1974, 94–8; Yoyotte 2013, 273–4). Finally, the trilingual cuneiform inscription on the statue (written in Old Persian, Elamite and Akkadian) is a feature of Darius's ideological

programme and served as a linguistic epitome of the empire's ecumenical nature (Finn 2011).

The statue of Darius was intelligible in two different contexts. In an Egyptian context it was a statement of Darius's role and legitimacy as pharaoh. In the context of the imperial court it communicated Darius's ideological programme in which he cast himself as a Persian heroic figure, who straddled the earthly and cosmic realms with the support and participation of all the peoples of his empire. Moreover, at Susa the Egyptian visual references made in the statue contributed to the notion of the universality of the empire, and in Egypt the adaptation of the Mesopotamian and Egyptian atlas pose to the Egyptian prisoner motif contributed to the notion that Achaemenid rule was different from other forms of imperialism, emphasising cooperation over domination. The selection of the specific assortment of visual elements that comprise the statue also provides a window onto how Darius and the others involved in its design and execution conceived of their larger world. The combination of Achaemenid and Egyptian features implies that the cultures that informed these different artistic traditions were the superordinate centres from which Darius drew his charismatic authority.

It is important to recognise as well that the statue was not unique in its role as a simultaneous Egyptian royal monument and marker of Achaemenid imperialism; the stelae which lined the Red Sea canal operated in a comparable manner. The four stelae were found respectively at Tell el-Maskhuta, at a site between Ismailiya and the Great Bitter Lake inexplicably called 'Serapeum' by the French, at Kabret, and at a location some 6 km north of Suez (Posener 1936, 48–87; 1938; Roaf 1974, 79–84; Redmount 1995, 127–8; Lloyd 2007b, 99–107; Klotz 2015, 276–80; Sternberg-el Hotabi 2017, 75–87; Wasmuth 2017a, 125–56). These huge stelae (over three metres tall and two metres wide) feature hieroglyphic and trilingual cuneiform texts in Elamite, Old Persian and Babylonian Akkadian, all of which make reference to Darius and the construction of the canal. The hieroglyphic texts are poorly preserved, but the most complete version, from the Tell el-Maskhuta stela, indicates that the text took the form of what is known to Egyptologists as a *Königsnovelle*, a genre of royal inscription with a long history in Egypt (Lloyd 2007b, 104). In such inscriptions the king conceives of an idea and then carries it through to completion in a manner unparalleled by any of his predecessors (Hofmann 2005). The cuneiform texts, although better preserved than the hieroglyphic (especially on the Kabret stela), are more curt. They refer in no uncertain terms

to Egypt's subjugation by the Persians and its integration into the empire:

> King Darius proclaims: I am a Persian; from Persia, I seized Egypt. I ordered this canal to be dug, from a river called Nile, which flows in Egypt, to the sea which goes to Persia. So this canal was dug as I had ordered, and ships went from Egypt through this canal to Persia, as was my desire. (DZc; Kuhrt 2007, 485–6)

Thus the inscriptions on the stelae, like the statue, were intelligible in both Egyptian and Achaemenid imperial contexts, and this is equally true of their visual aspects as well. The Tell el-Maskhuta stela (Fig. 4.9) features the vault of heaven hieroglyph and a winged disk in the lunette. Below that appears the 'Uniting of the Two Lands' scene, with a cartouche containing the name of Darius above the plants being bound together. The texts on either side of the scene confer blessings on Darius. Below this is a row of subject peoples with their ethnonyms enclosed in studded cartouches and with their hands upraised, as on the base of the statue of Darius. The main text of the stela is flanked by *wah* sceptres, symbols of power often carried by Egyptian gods. The cuneiform side as preserved on the Kabret stela (Fig. 4.10) also features the vault of heaven hieroglyph and a winged disk in the lunette, but this time the winged disk has a feathered tail and tendrils descending from it, in a manner in keeping with the representation of this motif in Achaemenid imperial monuments. Beneath this are mirror images of a man with a squared beard wearing a crenellated Persian crown and the Persian court robe. The stela is too poorly preserved to see exactly what the figures are doing. Each has one arm raised over a large central cartouche enclosing the name of Darius written in cuneiform rather than hieroglyphics. As on the Tell el-Maskhuta stela, the main trilingual cuneiform text is flanked by *wah* sceptres.

These stelae, like the statue, present Achaemenid imperial power in a local Egyptian idiom. There can be no doubt that these stelae made clear reference to Persepolis and to the empire, superordinate centres far outside of Egypt. At the same time they were not so alien that an Egyptian would mistake them for anything other than the work of the king. The overt reference to Achaemenid imperial iconography was especially appropriate to stelae erected along the canal connecting Egypt with Persia, and in certain respects the combination of Egyptian and Achaemenid motifs, imagery and language on these stelae represented this connection. So too did the statue of Darius, being a representation in an Egyptian manner of the Great King that may well have made the trip from Pithom to Susa by way

Fig. 4.9. Drawing of the Tell el-Maskhuta stela. Cairo JE 48855. Image in the public domain from Golénischeff (1890, pl. 8).

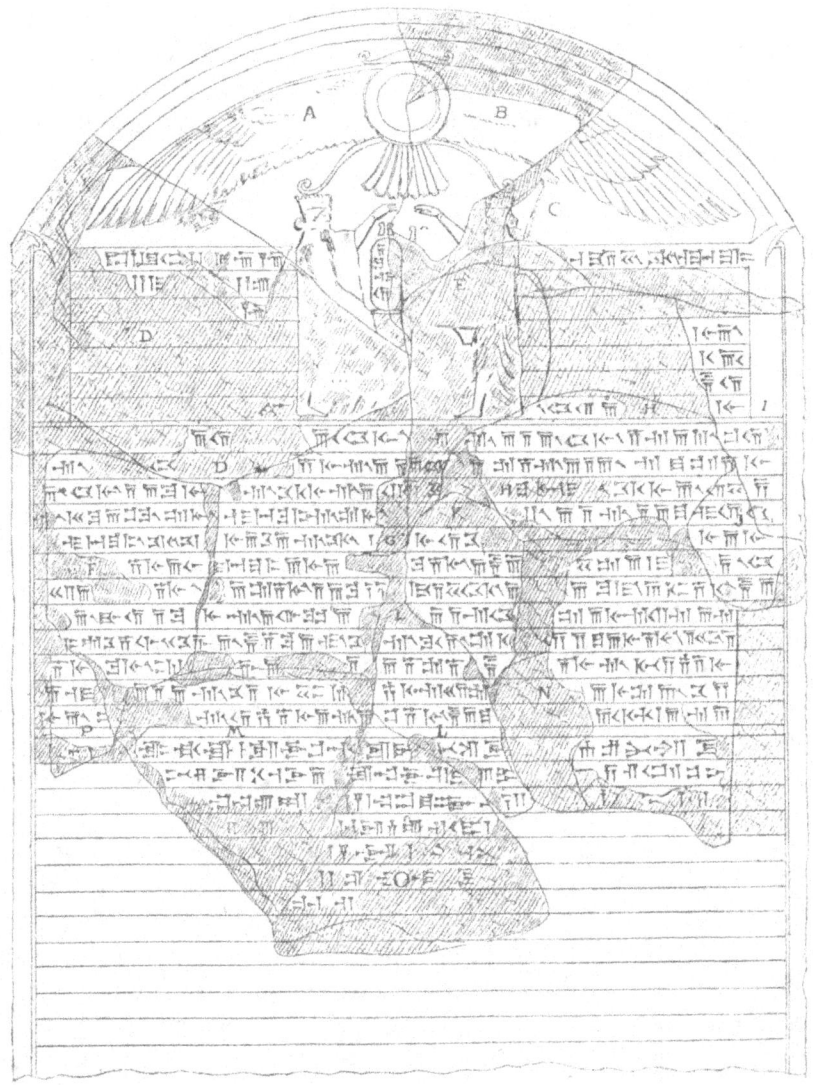

Fig. 4.10. Drawing of the Kabret stela. Image in the public domain from Ménant (1887, 145).

of the canal and the sea route around the Arabian Peninsula (Yoyotte 2013, 257–9).

Unlike the other cases discussed in this chapter, these monuments are imperial ones, conceived of and designed at the highest levels of the royal court in order to disseminate a specific idea. But because both the statue and the stelae were intended to address Egyptian audiences, their visual programmes speak to the social environment

that existed in Egypt. The same is true of the private objects and monument discussed in the rest of this chapter: the creators of these objects also sought to communicate specific ideas, mainly about how they conceived of their identities and their roles in the social order of Achaemenid Egypt.

Other royal images

The statue and the canal stelae are not the only images of Achaemenid pharaohs. There are undoubtedly others that are difficult, if not impossible, to identify firmly because they do not make overt references to any superordinate centre outside of Egypt and as a result, in the absence of inscriptional evidence, they tend to be assigned to earlier or later periods. Many of these representations are altogether impossible to date more precisely than to the Late Period (though this does not make them Saite by default). One tantalising example, a statue head in the Musée Jacquemart-André in Paris (MJAP-S 873; Perdu and Meffre 2012, no. 93), has the Horus name used by both Psammetichus II and Darius; thus the statue could arguably represent either of them. A few royal images can be attributed unequivocally to the 27th Dynasty on account of cartouches of Cambyses and Darius respectively, which serve to identify the pharaoh who is otherwise depicted generically. These include the reliefs of the Hibis temple in the Kharga Oasis (discussed in Chapter 3), the Serapeum stelae that show Cambyses and Darius before the deceased Apis bull (discussed briefly in Chapter 2), and two wooden shrines usually called 'naoi'.

One of these naoi, of unknown origin, is now in the British Museum (EA 37496; Razmjou 2005, no. 266; Lloyd 2014, 192). All that remains of it is the door (Fig. 4.11), which is richly ornamented with polychrome glass inlays depicting Darius before the enthroned god Anubis, with Isis, who is wearing cow horns, looking on, all below a winged disk. Darius wears an Egyptian kilt and the white crown of Upper Egypt as he makes his offering to Anubis. It is difficult to discern exactly what this offering is, since the image is poorly preserved, but it appears to be a figurine of some kind. Given the prominence of Anubis on this door, the naos probably once housed an image of that god. But with its lack of provenance and poor condition little more can be said about this door, other than that Achaemenid pharaohs could be depicted on personal votive monuments to a range of Egyptian gods.

The other naos (Fig. 4.12) is largely intact, reasonably well preserved, and comes from a controlled context (Mallawi Museum inv.

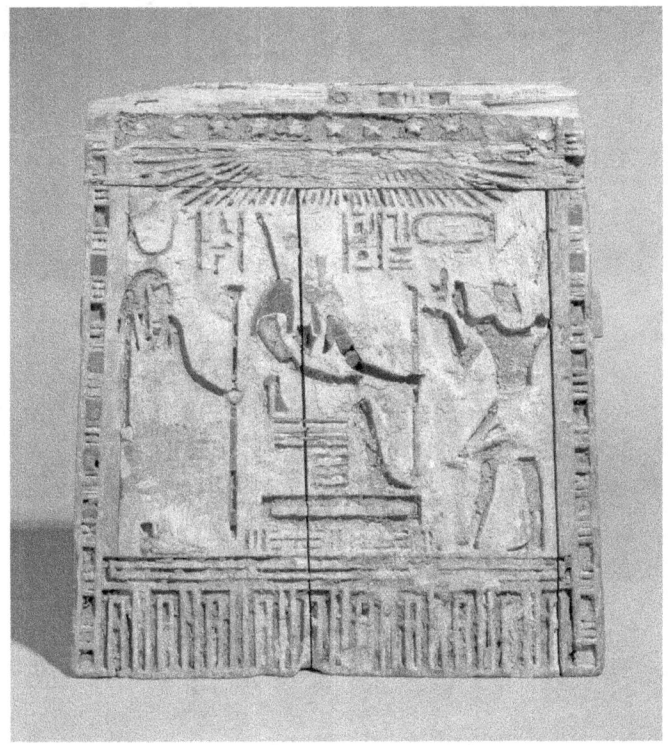

Fig. 4.11. Wooden naos door of Darius I, c. 522–486 BC. Wood and glass; H. 28 cm; W. 23.5 cm. London, British Museum EA37496. Reproduced by permission of the Trustees of the British Museum.

no. 200; Myśliwiec 1991; Mahran 2008; Sternberg-el Hotabi 2017, 98–100). It was discovered in 1945 during excavations of an ibis hypogeum at Tuna el-Gebel (Gabra 1945–6), the site of the necropolis of Hermopolis in Middle Egypt, along with a jar containing eight Aramaic papyri (TADAE A2.1–7, D1.1; Azzoni 2013, 122–8). These papyri do not feature dates, but their palaeography suggests a late sixth- or early fifth-century date (Naveh 1971). This is consistent with both the date of the naos itself (established by the cartouche of Darius I) and the pre-Ptolemaic dating of Gallery C, where the naos and the papyri were found, proposed by the modern excavators (Kessler and Nur el-Din 2005, 139–41).[3] These papyri consist

[3] Mahran (2008, 116) dates the naos to between 497 and 486 BC on the basis of the spelling of Darius's name, specifically the inclusion of a medial *h*, which, following Posener (1936, 161–3), she regards as a later development. Klotz (2008) has indeed shown that this variation is the result of better knowledge of Old Persian inflected endings on the part of Egyptian scribes, but this does not provide a firm date for the start of this spelling; it only means that a date late in the reign of Darius is more likely than an early one.

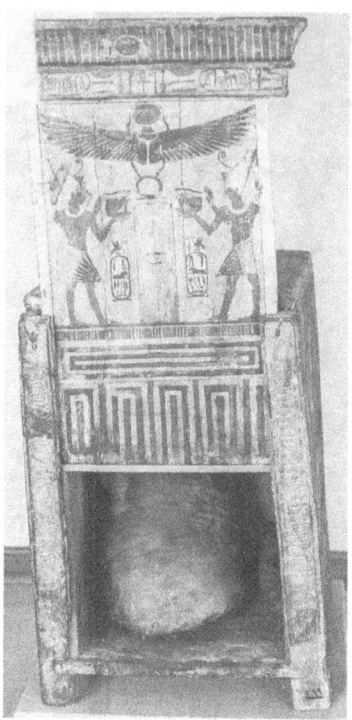

Fig. 4.12. Wooden naos of Darius I, c. 522–486 BC. Wood and glass; H. 41.5 cm; Base 35 × 28.5 cm. Mallawi Museum inv. no. 200. Image © Alain Guilleux and reproduced by permission.

of personal letters, probably written at Memphis and addressed to recipients in Luxor and Syene. Their presence in the hypogeum at Hermopolis was presumably the result of their having been set aside for use as mummy wrappings, reflecting the existence of a second-hand market in papyri for this purpose.

All of these factors point to the deposition of the naos in the hypogeum in a fifth-century context and not (as has been proposed by Myśliwiec 1991, 221; 2000, 144) in a Ptolemaic one. The naos does seem, however, to have been reused as a coffin for a baboon mummy. This type of naos was built for temporary use during religious festivals (Mahran 2008, 112), so there is nothing unusual about its reuse as a baboon coffin not long after it had served its original ritual purpose. Additionally, the presence of a baboon mummy in an ibis hypogeum is not especially curious either, since both animals were sacred to the god Thoth, the primary deity worshipped at Hermopolis; the burial complex at Tuna el-Gebel includes many burials of both animals.

The naos features painted and polychrome glass inlays on four sides. The sliding door at the front is topped with a cavetto cornice and depicts Darius twice in mirror image, presenting a *wedjat* eye to the god Re in the form a scarab beetle with outstretched wings holding up a sun disk. Darius, who is named both in the hieroglyphic inscription underneath the cornice and in the cartouches directly in front of him, wears the Egyptian kilt, a collar, and the double crown of Upper and Lower Egypt with a uraeus at the front. The inscription at the top reads 'May the good god live, the Lord of the Two Lands, Darius, may he live forever', a typical pious wish for the longevity of the king (Mahran 2008, 112). Darius also appears on the sides of the naos. The scene on both sides is largely the same: a mummiform falcon figure, identified in the inscription as 'Horus, protector of his father', sits on an open lotus and holds an ankh. He is flanked on either side by the goddess Nut, represented by a winged woman. Horus is also flanked by two small kneeling figures presenting a *wedjat* eye. These figures are not labelled, but they do wear the blue crown, suggesting that once again the king is represented here. That king would be Darius in a different guise. The back wall features the god Re in the form of a ram-headed mummiform figure sitting on a pedestal flanked by two winged cobras. Although there are no representations of the king on this side, the pious inscription from the front of the naos is repeated here.

The representations of Darius on this naos are entirely generic. Nothing distinguishes them visually from representations of earlier Egyptian kings in offering scenes (catalogued in Myśliwiec 1988, 46–66), including those of Amasis and the ephemeral pretender Petubaste IV on two similar wooden naoi (Yoyotte 1972, pl. 19). Moreover, Darius is depicted wearing the blue crown on the side panels, a crown especially favoured by the Saite pharaohs (Russmann 1995). There are no visual references to any superordinate centre outside of Egypt, no hints that Darius was anything other than an Egyptian pharaoh. This becomes all the more interesting in light of the distinct possibility that this naos was commissioned not by Darius himself, or by his satrap, but by a temple official at Hermopolis.

The usual assumption is that naoi bearing cartouches were commissioned by the rulers named on them. This was more probably the case with monumental stone naoi, which, on account of their size and material, were intended to be permanent fixtures in the temples where they were erected (Spencer 2006, 31–8). Such temple additions are a well-known royal prerogative. But it is unreasonable and unnecessary to assume that every wooden shrine like this one required royal or

satrapal initiative. Rather, it is more plausible to see this naos as a production of a local workshop in Hermopolis, created for use in a specific ritual. After the completion of the ritual it was reused for another ritual activity, namely the burial of a sacred baboon. Local production of such naoi is further supported by the many variations on the writing of Darius's name. In other words, scribes in various places had their own ways of writing the king's name (Cruz-Uribe 1992–3), and it was one of these variations, rather than a centrally composed one, that was supplied to the craftsman who built this particular naos. Darius's prominence on the naos was not a result of his direct involvement in the local cult. It was rather an indirect result of his royal status, since as pharaoh he was also the chief priest of every Egyptian cult and the intermediary between the Egyptian people and their gods (Morris 2010b, 213–14). His inclusion on this naos was standard procedure, not a political statement of any kind.

This naos, then, represents an instance in which certain Egyptians, in this case the priests responsible for its creation, assimilated a foreign ruler to their own notions of kingship. In fact, the naos implies that for certain Egyptians of high status (as the members of the Hermopolis priesthood surely must have been) there was no meaningful difference between the Achaemenid pharaohs and their Saite predecessors. Nor was this view necessarily limited to elites. A small limestone stela (Berlin, Ägyptisches Museum 7493) reportedly from the Fayum features an image of man named Pediusierpre worshipping the Horus falcon (Fig. 4.13). The accompanying hieroglyphic inscription clearly labels the falcon as 'the Good God, Lord of the Two Lands, Darius' (Burchardt 1911, 71–2; Lloyd 2014, 192–3). The carving of the stela is inexpert at best, and there are errors in the inscription, indicating that Pediusierpre was probably a person of modest means. Yet for him, worship of Darius in the guise of Horus was a matter of course, just as it was for the priests in Hermopolis.

This stela, along with the statue of Darius and the naoi discussed above, demonstrates the multiple ways in which Darius, and by extension other Great Kings, could be represented in Egypt. Although the variation depends in part on context, it suggests that there was no single view of Achaemenid rule in Egypt. Rather, there were multiple viewpoints, each informed by individual ideas and circumstances, and these viewpoints, like identity itself, were fluid. Furthermore, the generic representation of Darius on this naos shows that any unlabelled or unattributed image of a Late Period king could just as easily belong to the 27th Dynasty as to the 26th or the fourth century.

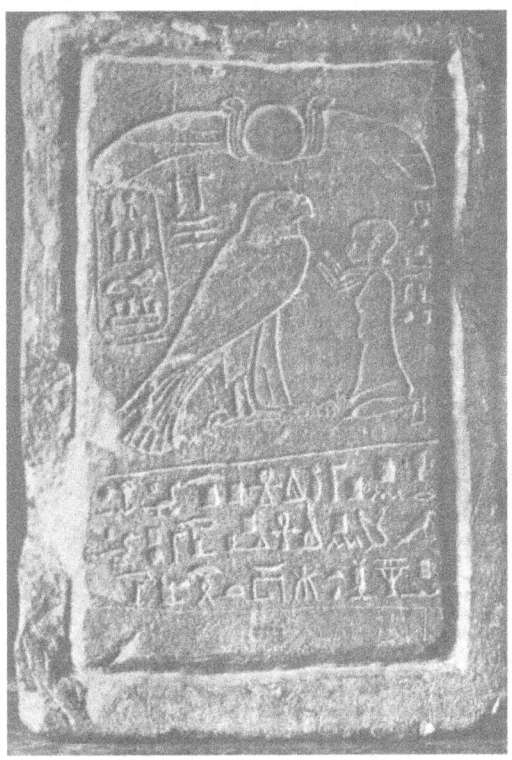

Fig. 4.13. Stela of Pediusierpre, c. 522–486 BC. Limestone; H. 29 cm; W. 19 cm. Berlin, Ägyptisches Museum 7493. Image in the public domain from Burchardt (1911, pl. 8.1).

Funerary reliefs

As pharaoh, Darius played a central role in both the political and the religious realm in Egypt, and the potential tension between these realms (political domination by foreigners versus the pharaoh's role in maintaining cosmic balance) was often resolved in favour of the latter, at least visually. This was the case for the Nubian pharaohs of the 25th Dynasty as well (Chimko 2003). For private individuals there were different tensions, between political, religious, cultural and social factors, and each person resolved these tensions in different ways depending on how he conceived of his identity in the appropriate context. Thus it is instructive to consider the representation of two non-royal private individuals who included images of apparent foreigners in their funerary monuments.

These monuments are two funerary stelae that were both mentioned in Chapter 2. One is the stela of Djedherbes (Cairo JE

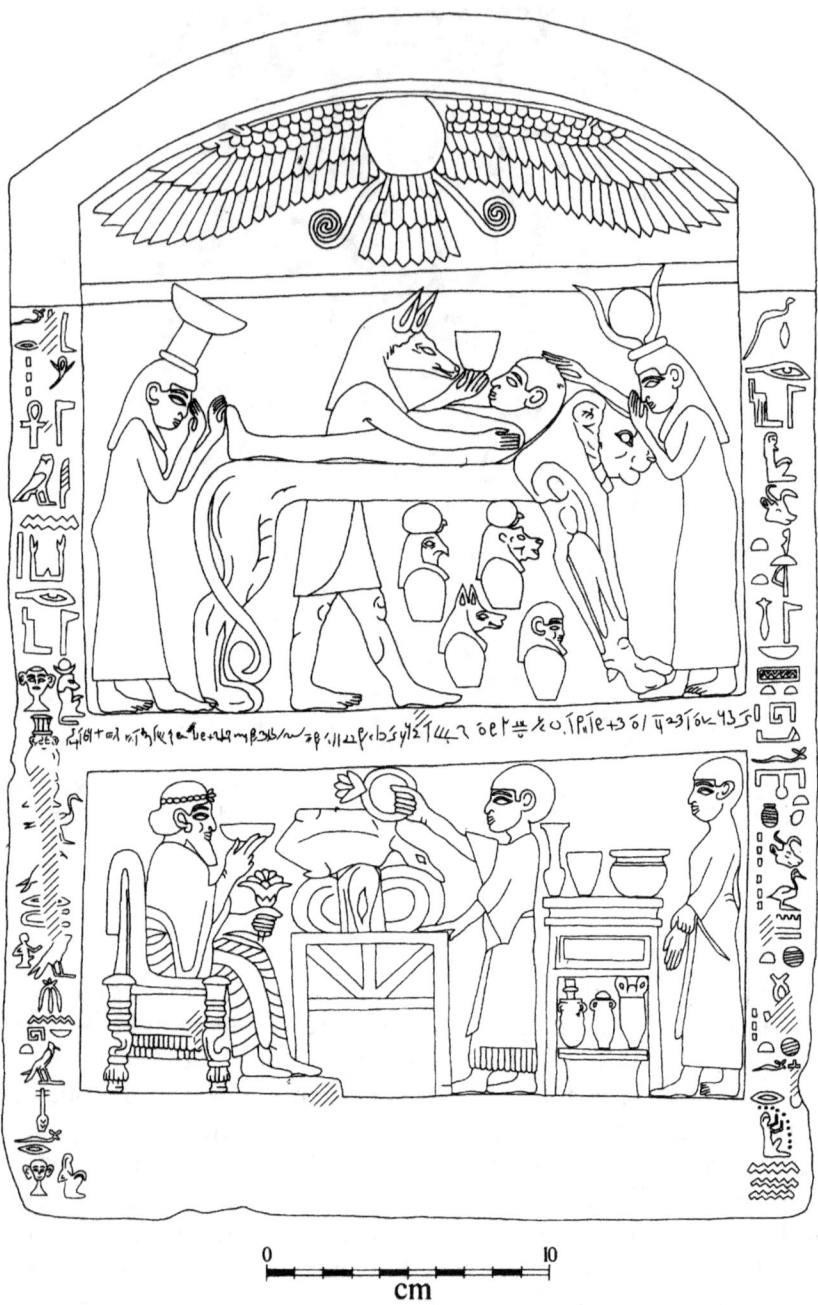

Fig. 4.14. Drawing of the stela of Djedherbes, excavated at Saqqara. Image © E. A. Bettles and reproduced by permission.

98807; Fig. 4.14), found in a secondary context at Saqqara in 1994 (Mathieson et al. 1995; Wasmuth 2017c). This stela is notable for a number of reasons, including its unusual decorative programme and the parentage of Djedherbes. According to the inscriptions his father had a Persian name (Artam), and his mother, like Djedherbes himself, had an Egyptian name (Tanofrether). Names do not necessarily indicate ethnic or racial origins, but, as discussed in Chapter 2, the names people give their children (or in some cases adopt for themselves) reflect their aspirations. The combination of the multicultural names in Djedherbes' family and the elements he chose to include in his funerary monument are indicative of the complexity of the social world in which he operated.

The stela has a rounded top and three registers of images. In the top register the lunette features a winged sun disk, typical of such monuments from Egypt, save that it has a feathered tail and two curled tendrils extending from beneath it. In the upper main register Djedherbes is depicted being embalmed by Anubis and mourned by Isis and Nephthys, a scene illustrating Spell 151 from the Book of the Dead. There are some stylistic features of this register that are unusual by Egyptian standards (and they are discussed further below), but on the whole its content and accoutrements are traditionally Egyptian.

In the lower register there is a presentation scene in which a standing figure makes an offering to an enthroned figure, seated before a lavishly supplied table of foodstuffs. Behind the offering figure is another table, this time laden with vessels. Another figure stands at the far right of the scene. There is some uncertainty as to who the figures in the lower register are meant to represent. The stela's excavators (Mathieson et al. 1995, 38–9) suggested tentatively that the enthroned figured could be Artam, Djedherbes' father. However, Margaret Miller (2011b, 125 n. 8) and Melanie Wasmuth (2017c, 106–11) have argued that it is Djedherbes himself. Wasmuth cites the numerous images of tomb owners seated before offering tables, ranging from the Old Kingdom to the New, while Miller notes that Egyptian funerary stelae can depict the deceased at various stages of life. Indeed, the enthroned figure is the most prominent one on the lower register, making this latter interpretation the most likely. The hieroglyphic inscription, which borders the registers on either side, invokes Osiris; the Demotic inscription, which runs horizontally between the two main registers, seems to be a laconic version of the hieroglyphic inscription (Mathieson et al. 1995, 33–7; Sternberg-el Hotabi 2017, 51–3; Wasmuth 2017c, 112–13).

While the upper scene appears wholly Egyptian in its ritual apparatus,

many of the details represented in the presentation scene below refer to other material culture traditions, especially to Achaemenid courtly arts. The enthroned figure wears the Persian court robe as depicted on the statue of Darius from Susa and on the seated Great King depicted on each of the two original central panels of the Apadana façades at Persepolis (see Fig. 4.2). This figure also has a long, rectangular royal Persian beard and a typical Persian haircut. He wears a circlet around his head, with a central flower at his forehead. Such a head ornament is worn by the two noble Persian attendants of Darius on the Bisitun relief (Root 2011, fig. 10). He holds a shallow drinking bowl on his fingertips in a manner known from other Near Eastern contexts and associated with Achaemenid banqueting practices (Miller 2011b). In his other hand he holds a lotus flower, which is reminiscent of the statue of Darius discussed above, and also occurs frequently at Persepolis. The lotus had deep symbolic meaning in Egypt, and its use in Achaemenid contexts reflects the interest on the part of Achaemenid royal planners in adapting key elements of the iconography from the satrapies of the empire.

The two standing individuals on the lower register look quite Egyptian. Along with their beardlessness and their close-shaved heads, they wear variations of the Egyptian 'Persian garment' discussed above. The figure on the left extends a circlet towards the enthroned individual. Though of exaggerated size, this item appears to be the lotus circlet worn by many women in New Kingdom tomb paintings (e.g., Tiradritti 2008, 214–15, 254). But it may also be intended to represent from a different perspective a headdress similar to the one worn by the seated person. The figure at the far right of the scene holds his hands down somewhat oddly in a way perhaps intended to depict the hand-over-wrist gesture of an attentive Persian courtier.

The throne is an impressive rendering of the elaborate Achaemenid throne type (see Fig. 4.2). The tables follow Syrian and Achaemenid examples, basically western Asiatic types. The funerary bier on which Djedherbes is laid out for mummification on the upper register takes the shape of a lion, a common motif in Egyptian funerary reliefs. But the modelled rendering of the lion's legs and head is reminiscent of carved representations of lions at Persepolis. Features of the stela's carving style also depart from Egyptian tradition, particularly in the robust relief modelling and in the breaking of the register boundaries by the crowns of Isis and Nephthys. This latter practice is otherwise unattested on Egyptian funerary stelae, but it does occur on Carian examples (Wasmuth 2017c, 98).

Djedherbes drew on a wide array of artistic and material traditions in the creation of this monument, which he is likely to have commissioned himself while he was still alive. Some of the result presumably reflects the identity and experience of the craftsman Djedherbes selected. On the basis of the carving and its resemblance to that of Carian funerary stelae Wasmuth (2017c, 114–15) argues that this stela was the product of a workshop that served primarily resident foreigners such as Carians and Phoenicians. Regardless, Djedherbes would have hired a craftsman to produce such a well-appointed stela quite intentionally and with at least some knowledge of his work. This choice, along with the inclusion of the scene on the lower register with its array of elements already discussed, emphatically suggests that Djedherbes saw some part of his identity as straddling Egyptian and Persian traditions. It is clear that he viewed his world as consisting of more than Egypt. Yet it is also clear that he operated within a distinctly Egyptian cultural and religious context. The scene in the upper register, an illustration of a spell from the Book of the Dead, as well as the form of the funerary stela itself are consistent with Egyptian funerary practice and religious belief, suggesting that Djedherbes had himself buried in the Egyptian manner with the full expectation of an afterlife as understood in Egyptian cosmology. In this respect Djedherbes, like Darius, represented himself in a manner intelligible in both an Egyptian and an Achaemenid context, since he considered both of these contexts of such great importance to his identity that he commissioned a funerary monument that accommodated them both.

The other monument is a section of a funerary relief allegedly from Memphis (Fig. 4.15), purchased by F. W. von Bissing in 1930 and now in Berlin (Ägyptisches Museum 23721; von Bissing 1930; Vittmann 2003, 151). The limestone relief measures 45 cm wide by 23 cm tall, and presumably once belonged to a larger monument. In the absence of a specific provenance and of any preserved inscription accompanying it, there is no way of determining what sort of monument it was. It might, for example, come from a tomb, or have been cut from a funerary stela. More importantly, Oscar White Muscarella (2003) has argued that its shape, crude carving and lack of provenance, and the seeming eclecticism of its references to non-Egyptian cultural traditions, all point to the relief being a modern forgery (see also Wasmuth 2017c, 116–18). Though this remains a possibility, the crude carving and eclecticism can also be interpreted as evidence for its genuineness, since to be convincing a forgery would adhere more closely to the established canon and exhibit high standards of craftsmanship, in order to appeal to early collectors and

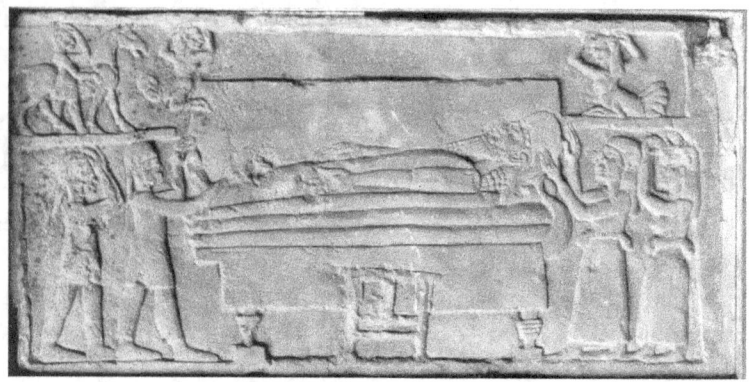

Fig. 4.15. Funerary relief. Limestone; H. 23 cm; W. 45 cm. Berlin, Ägyptisches Museum 23721. Image © Ägyptisches Museum und Papyrussammlung, Staatliche Museen zu Berlin. Reproduced under a Creative Commons licence (CC BY-NC-SA).

Egyptologists who were especially concerned with aesthetics and the acquisition of museum pieces.

The relief depicts a male figure laid out on his back on a funerary couch with a curved headboard and a small table in front of it. The man is not shown as a mummy, but rather as he would have appeared in life. He has a long beard and wears a sleeved garment and a rounded cap. His clothing resembles the Persian riding costume worn by many figures in the programme of Persepolis reliefs (Root 1979; forthcoming; Stronach 2011; see Fig. 4.2). He is flanked by mourners in grieving postures with upraised arms, two men wearing the riding costume on the left and two women with bared breasts and skirts on the right. The funerary couch is reminiscent of the couch on which Ashurbanipal lies on the famous banquet relief from Nineveh (Curtis 1996, 175–6).

In the upper register on the left two smaller mourners appear. One is clearly a male who leads a horse forward by its reigns with one hand while he raises the other to his brow. It is impossible to determine whether he wears an Egyptian kilt or the Persian riding costume, but he is clearly clean-shaven. The other figure is kneeling with torso turned frontal, both arms raised to the head. The sex of this figure is difficult to assess. On the right, another mourning figure appears in the form of a human female upper body with bared breasts and a lower body in the form of a bird. Her torso is also frontal, and she too raises both arms to her head.

The mourners in the relief exhibit a combination of Egyptian and non-Egyptian mourning practices. The female figure at the far right of

the scene and the male figure at the far left (as well as the male leading the horse at the upper left) are shown with their hands raised to their foreheads. This gesture represents the placement of dust on one's head, and has a long history in Egyptian funerary imagery, in both tomb reliefs and illustrated manuscripts of the Book of the Dead (e.g., Fazzini et al. 1989, no. 72; Taylor 2010, 82–103). The two frontal figures in the upper left and upper right of the scene, however, make slightly different gestures. These figures raise their hands to either side of their heads, in a manner most closely paralleled by Greek mourning practices, going back into the Bronze Age (Cavanagh and Mee 1995). It has no explicit precedent in Egyptian tradition; in its Greek context this gesture symbolises pulling out one's hair.

Interestingly, Herodotus (9.24) links the pulling out of hair as an act of mourning to the Persians (Petropoulou 2008, 19–22). In his description of the events following the death of the Achaemenid military commander Masistius during skirmishing shortly before the battle of Plataea in 479 BC, Herodotus makes explicit reference to the practice: 'They shaved off not only their own hair, but also that of their horses and their yoke-animals, and gave themselves over to unending lamentation ... so the Persians honoured Masistius on his death in their own fashion' (trans. R. Waterfield). The usual caveats must apply to using Herodotus to reconstruct Persian social practices, but his remark furthers the idea that pulling out hair is not a recognisable Egyptian mourning practice. And in this connection it is interesting as well that the horse on this relief is depicted without a mane, just as Herodotus describes.

The patron who commissioned this relief desired to be portrayed wearing the Persian riding costume and beard, laid out without the normal accoutrements of Egyptian funerary practice (as seen on the stela of Djedherbes, for example) and mourned in a manner seemingly alien to Egyptian custom. This provides no indication of his ethnic origins, but it does suggest how he conceived of his social position in life, namely as someone who seemingly operated in a military capacity (as a cavalryman) and would have been mourned by the Persians after his death. Muscarella (2003) has argued that the crude carving of the relief is inconsistent with the comparatively high status associated with such a person. But funerary monuments are usually aspirational rather than literal (Parker Pearson 2000, 72–94), so it cannot be determined from this relief what the deceased's social or economic standing actually was, only that he saw his role in the Achaemenid military apparatus as the central aspect of his identity. The relief's crudeness may result from the deceased's actual economic

standing, as it seems he could not afford something more refined. It is also impossible to say anything about the ethnic or geographic origins of the person represented on this relief, and the possibility remains that he may even have been Egyptian by birth. But it is clear that in death he wished to be depicted in a Persian manner.

These two stelae represent two different attempts by individuals at negotiating their places in the social order of Achaemenid Egypt, and to some extent of the empire more broadly. Much of the attention given to these individuals has focused on their ostensible foreignness, namely on their references in these monuments to superordinate centres outside of Egypt. However, both also emphasised their links to Egyptian cultural memory as integral parts of their identities, and it seems that these two individuals operated in a social and cultural context in which such dual identities were considered appropriate or even advantageous.

Horwedja and Ptahhotep

Thus far we have considered how the identities fashioned by individuals of varied status, as reflected in their representations of themselves, shed light on the broader social conditions in which these identities were constructed. But it is important to recognise that two different individuals operating in very similar such conditions could very well experience Achaemenid rule in very different ways, according to their own personalities, ideas and so forth. This is exemplified by the two statues examined in this section.

Both statues are of a type of unequivocal significance in an Egyptian cultural and religious setting: the naophorous statue. This statue type goes back to the New Kingdom, and it represents a uniquely Egyptian idea about the relationship between human and god (van Dijk 1983; Malaise 2004; de Meulenaere 2009). A human is depicted holding the god's shrine with a small figure of the god inside it, a protective act that assimilates the human to the god Shu, who tended the shrine of Atum and was therefore the archetypal Egyptian temple priest (Klotz 2014). Sometimes the shrine is absent, in which case the statue is called 'theophorous' ('god-bearing') rather than 'naophorous' ('shrine-bearing'), though the general meaning is seemingly the same. It is widely accepted that these statues were placed within temples, since their inscriptions are addressed to specific gods and also refer to offerings made to those gods by the individual represented. Thus these statues served as eternal proxies for their dedicators and markers of their piety. Their imagery must have

been selected and commissioned quite deliberately. Moreover, their placement in temples would have made them visible to members of that temple's priesthood, who would have been prominent members of the local community as well, and, perhaps more importantly, would have been able to read their inscriptions. The dedicators of these statues thus had to negotiate a balance between their personal religious concerns and their public personas, though of course these were not necessarily mutually exclusive.

The two statues considered here represent high-ranking officials of the time of Darius I. Both had titles indicating that they had responsibility for financial matters, and both of their statues preserve indications that they were dedicated in the temple of Ptah in Memphis (although they are both without clear provenance). The combination of these factors suggests that both men had positions at the satrapal court there. It is possible, even likely, that they knew each other. Yet, as their respective statues attest, despite both operating in largely identical social contexts each made different decisions concerning his self-representation. These two men conceived of their places in the broader social order of the empire in entirely different ways.

The first of these is the kneeling naophorous statue of Horwedja (Fig. 4.16), now in the Cleveland Museum of Art (1920.1978; Bothmer 1960, no. 61; Berman 1999, no. 316). The statue was purchased for the museum by Howard Carter from a dealer in Cairo, so its exact place of origin is unknown. However, the offering formula on the base addressed to Ptah-Sokar implies that the statue was dedicated in the temple of Ptah in Memphis (Bothmer 1960, 73). The date of the statue is probably in the reign of Darius I, because the same Horwedja is also known from an unpublished stela from the Serapeum dating to 519 BC (Louvre IM 4057; Porter and Moss 1981, 800). His titles are listed as 'Hereditary Prince, Count, Sealbearer of the King of Lower Egypt, Sole Companion' and, most significantly, *senti*. This last title is usually translated as 'finance minister' or 'planner', and its holder was apparently answerable to the king or satrap (Yoyotte 1989; Chauveau 2009, 127–9; Vittmann 2009, 100–2; Agut-Labordère 2017, 687).

Horwedja is depicted kneeling and holding a shrine of Ptah. He wears only a short pleated kilt, a garment that appears in Egyptian art as early as the 1st Dynasty and continues to occur well into the Roman Period (Vogelsang-Eastwood 1993, 53–64). It is worn by kings and commoners alike and is the quintessential male garment in ancient Egypt for most of its history. Horwedja also wears a bag wig and his face is idealised and youthful. In short, he makes no visual

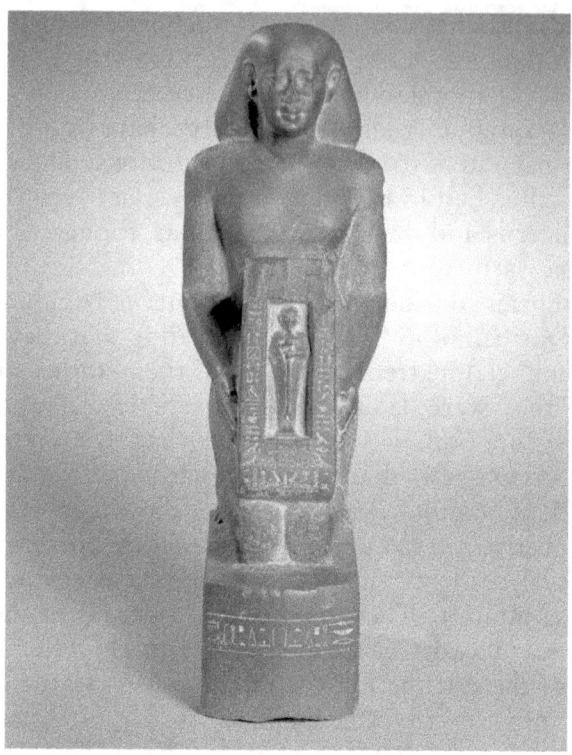

Fig. 4.16. Naophorous statue of Horwedja, c. 521–486 BC. Greywacke; H. 43 cm. Cleveland Museum of Art 1920.1978. Image in the public domain.

references in this statue to connections to political powers outside of Egypt itself, connections which his titles surely indicate he had. For Horwedja, these connections were not important in the context of this statue. Regardless of the political realities, for the purposes of this statue he drew his charismatic authority from Egypt alone.

This contrasts distinctly with the views of his contemporary Ptahhotep, who is known from several inscribed objects: a stela from the Serapeum at Saqqara, a shabti figurine and the lid of his sarcophagus (both probably from Campbell's Tomb at Giza), and an under-life-size statue (Fig. 4.17), now in the Brooklyn Museum (37.353; Cooney 1953b; Bothmer 1960, no. 64; Fazzini et al. 1989, no. 75; Colburn 2014a, 791–4). The inscriptions on these objects preserve Ptahhotep's titles, including 'Overseer of the Treasury' and *ḵppš*, a Persian title that was reserved for the most eminent officials and administrators (Posener 1986; Bresciani 1989, 30–1); they also indicate that had he gained this prominence in the reign of Darius I (Vittmann 2011, 390–2).

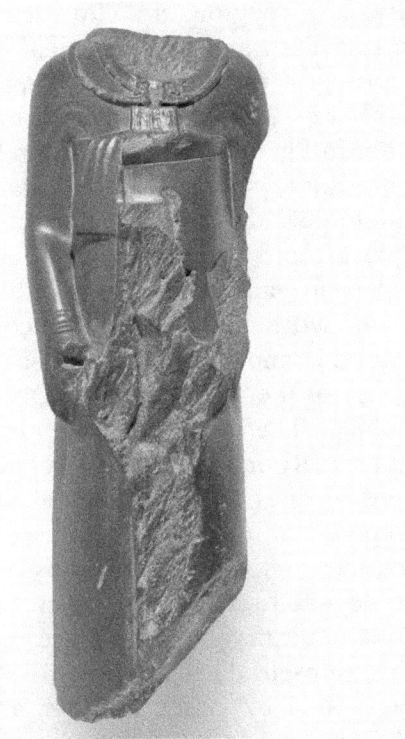

Fig. 4.17. Naophorous statue of Ptahhotep, c. 500–475 BC. Quartzite; H. 84.5 cm. New York, Brooklyn Museum 37.353. Reproduced under a Creative Commons licence (CC BY-3.0).

According to its inscription (Jansen-Winkeln 1998, 163–8), Ptahhotep's statue was dedicated in the temple of Ptah in Memphis, a location appropriate to his career in government service at the satrapal capital and not too far from the site of his burial at Giza. The statue depicts Ptahhotep standing and holding a shrine. The shrine itself is not preserved, but presumably it contained an image of Ptah. Ptahhotep wears the distinctive 'Persian garment', with wide sleeves (fully preserved on the right arm; the left arm is destroyed) and folds visible on his chest. Around his neck he wears a torque with caprid protomes and a pectoral featuring a scene of the pharaoh presenting a figure of Maat to Ptah and his wife, the goddess Sakhmet (Cooney 1953b, 10–11). The statue's head, unfortunately, is not preserved.

Certain features of Ptahhotep's statue clearly make Egyptian references. As discussed above, the naophorous statue type had specific meaning in an Egyptian religious context and served as a means of forging and maintaining a relationship with a god, in this case Ptah,

for all eternity. This religious attachment is also supported by the pectoral featuring Ptah and Sakhmet. The statue's significance and potency are rooted in the context of Egyptian cosmology and religion, and Ptahhotep's dedication of it demonstrates unequivocally his participation in Egyptian cultural and religious life.

But there are some features of this statue that attest to other aspects of Ptahhotep's identity as well, namely the 'Persian garment' and the torque around his neck. Ptahhotep chose to be depicted wearing the 'Persian garment' to signify that he identified with the elite Persians who wore the actual Persian court robe in the heartland capital of Persepolis and presumably at satrapal courts throughout the empire. The torque, with its caprid protomes, is an explicitly Achaemenid object. The ibex has a long history of representation in ancient Iranian art (Root 2002, 184–92), and it was a frequent motif on Achaemenid torques and bracelets, as attested on the Apadana reliefs at Persepolis and in extant metal examples (e.g., Rehm 1992, 31–8, 42–3, 65–9, 79–80, 86; Curtis 2005, nos. 152, 157–9, 164–8).

The torque depicted on Ptahhotep's statue is clearly intended to be Achaemenid, and it may in fact be a reference to a royal gift from the Great King himself. The practice of gift giving by the king is frequently mentioned by Greek authors, and Sancisi-Weerdenburg (1989) has shown persuasively that such gifts provided ideological cohesion to the empire by creating personal relationships between the king and key elites (see also Gunter and Root 1998 and Garrison 2014 for other examples of royal gifts). Udjahorresnet, for example, is depicted in his statue wearing a lion-headed bracelet of distinctly Achaemenid type (see Fig. 4.18), and the biographical inscription states that he received 'ornaments of gold' from the king (Moyer 2006, 244–7; Colburn 2017, 877). Whether or not Ptahhotep had in fact received the torque he is shown wearing as a similar mark of esteem from Darius, the adornment implies such a connection and creates a link with the Achaemenid rulers of Egypt. His pectoral, although certainly an object with an Egyptian cultural referent, also refers to the Persian king, since it features an image of the pharaoh presenting a figure of Maat to Ptah. In Ptahhotep's case, this pharaoh was Darius. This is an instructive example of how a decidedly Egyptian object could be used to intimate connections to the Great King.

Ptahhotep's statue neatly encapsulates the different components of the person he considered himself to be. His dedication of a naophorous statue, with an inscription asking for eternal sustenance from the living in the form of prayers and listing all his good and

pious acts, is intelligible only in an Egyptian religious and cultural context. It shows not only a potentially very real concern for the afterlife but also Ptahhotep's cultivation of a relationship with a very important Egyptian institution, the temple of Ptah. At the same time he deliberately chose a statue in which he was represented with clothing and ornaments associated with the elites who governed the Achaemenid Empire and with whom he identified. Horwedja, on the other hand, despite having a similar position in the satrapal administration of Egypt, made no explicit visual reference to it, preferring instead to construct his identity exclusively in Egyptian terms. In fact, it is entirely possible that if Ptahhotep had received gifts from the Great King, Horwedja had as well. Precisely why Horwedja chose to display his identity differently from Ptahhotep is impossible to say. But these two cases serve as an important reminder that Achaemenid imperialism could be experienced and expressed differently even by people whose circumstances were largely identical. A third case, that of the well-known naophorous statue of Udjahorresnet, provides yet another perspective, this time of an individual who served four successive kings, two Egyptian and two Persian, and appears to have travelled across the empire. To an extent this might mean his experience was exceptional, but it nevertheless provides another example of an individual Egyptian's experience with Achaemenid rule of Egypt.

Udjahorresnet

Aside from the statue of Darius, the now-headless naophorous statue of Udjahorresnet in the Vatican (Museo Gregoriano Egiziano 22690) introduced earlier in this chapter is perhaps the most emblematic representation of Achaemenid rule of Egypt (Fig. 4.18); certainly it is the most famous. The biographical inscription has received a great deal of scholarly attention, and rightly so. But this is only one aspect of Udjahorresnet's overall self-presentation for eternity, and the form and attributes of the statue itself warrant consideration as well. Indeed, the combination of these two elements is necessary for understanding how Udjahorresnet conceived of himself and his role in the social and political order during the first decades of Achaemenid rule in Egypt.

The modern reception of this statue has been heavily influenced by preconceived notions of the insidiousness of Achaemenid imperialism. This is best demonstrated by the common practice of labelling Egyptians like Udjahorresnet and Ptahhotep who held high positions

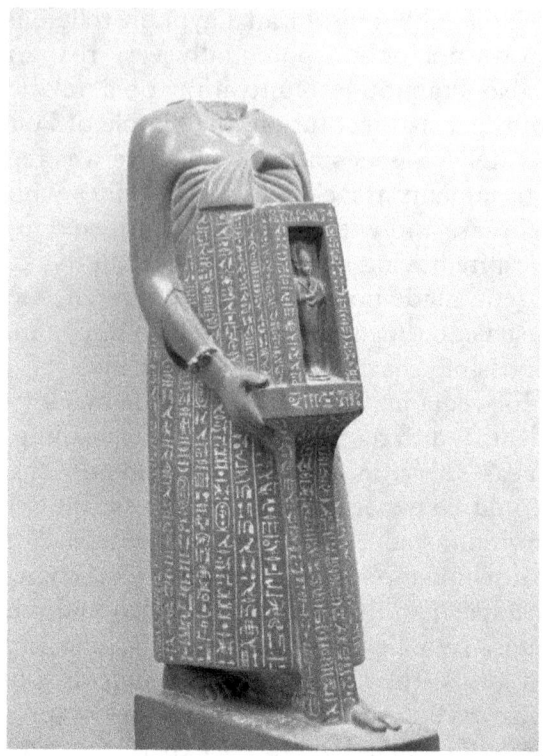

Fig. 4.18. Naophorous statue of Udjahorresnet, c. 519–510 BC. Basalt; H. 58 cm. Vatican, Museo Gregoriano Egiziano 22690. Image © Jona Lendering and reproduced by permission.

during the 27th Dynasty as 'collaborators'.[4] This term has inescapable associations with the governments of countries occupied by the Axis powers during the Second World War (Kalyvas 2008), especially Vichy France and the government of Vidkun Quisling in Norway. Its use to describe Udjahorresnet makes an implicit comparison between the Achaemenid Empire and the Axis, a comparison that is unequivocally negative. In fact, the earliest example known to me of this term being used to describe an Egyptian serving in the

[4] The following are examples known to me; it is not an exhaustive list by any means, but it illustrates the pervasiveness of this practice: Klasens 1945–8; Cooney 1953b; Yoyotte 1972, 223; Spalinger 1977, 235–6 n. 53; Aldred 1980, 233; Lloyd 1982; 2014, 188; Bresciani 1985, 3; Blenkinsopp 1987, 410, 413; Morschauser 1988, 216; Ray 1988, 258; 1999, 846 (the 'arch-collaborator'); Wessetzky 1991; Burkard 1994, 43–4; Depuydt 1995, 121; Huss 1997; Sternberg-el Hotabi 2002, 120–3; Chimko 2003, 29, 31; Tait 2003, 4–5; Fried 2004, 63–5; Ruzicka 2012, 197; Krebsbach 2016, 331–2. Yamauchi (1996, 374) calls Udjahorresnet a 'defector' instead, to similar effect. See also the critiques of the use of this term by Holm-Rasmussen (1988, 29), Bareš (1999, 38–43) and Vittmann (2009, 376).

satrapal administration was by the Dutch scholar Adolf Klasens in a 1948 article, shortly following the end of the Second World War (Johnson 1999, 218 n. 49). That his use of the term is not simply a condemnation of imperialism in general is made clear by the fact that no other figure in Egyptian history is ever called a collaborator in Egyptological literature before this. This is the case despite the fact that there are numerous examples of Egyptians who participated in Nubian and Greek rule in Egypt (Lloyd 2002), as well as various individuals who participated in Egyptian imperialism in the Levant during the New Kingdom. Thus Udjahorresnet's statue provides a very clear instance of the double standard in Egyptology wherein Egyptian imperialism is inherently good and Achaemenid imperialism is inherently bad (Colburn 2011, 97–8).

The labelling of Udjahorresnet as a collaborator has clearly affected the interpretation of his career based on the statue's inscriptions (translations in Lichtheim 1980, 36–41; Kuhrt 2007, 117–22; see further Posener 1936, 1–26; Lloyd 1982; Rößler-Köhler 1985; Baines 1996; Sternberg-el Hotabi 2017, 17–28). There are ten separate inscriptions in total, usually identified by the letters A to F, with inscriptions on the statue's right assigned uppercase letters and those on the left lowercase ones. On the top and front of the naos is the enumeration of Udjahorresnet's offerings to Osiris Hemag (A). The inscriptions on the sides of the naos, which continue onto the torso above the arms, list Udjahorresnet's pious deeds, including saving the people of Sais from a 'very great disaster' (D and d). The inscriptions underneath each arm, and continuing onto the plinth supporting the naos from below, list Udjahorresnet's titles under Amasis and Psammetichus III and describe his various interactions with Cambyses (B, b, C and c). The inscription on the dorsal pillar describes his interactions with Darius, including his return to Egypt from Elam in order to restore the 'House of Life' (E). Finally, the short inscription on the left side of the statue base is an appeal to the gods of Sais to remember Udjahorresnet's pious deeds (f), and in the inscription on the right side he states he was 'honoured by all his masters' who gave him 'ornaments of gold' and did for him 'every beneficence' (F).

These inscriptions are often presented as if they form a single continuous narrative. This is probably due in large part to Posener's presentation of the material as such, though his ordering of the individual inscriptions actually follows that established by Giulio Farina (1929). However, in order to read the inscription in Farina's and Posener's order, the viewer would start at the front (A), move to the

statue's right (B), then all the way around to the statue's left (b), then back to the right (C), then back to the left (c), then back to the right (D), then back to the left (d), then to the rear (E), then finally to the right (F) and left (f) of the socle. This is a tortuous sequence, and it is not informed by any discernible logic except the desire to place the 'very great disaster' in D (as well as the reference to 'turmoil' in the Saite nome in d) between Udjahorresnet's dealings with Cambyses and with Darius, on the assumption this refers to Cambyses' invasion (Posener 1936, 168–9). Thus this ordering of the inscriptions is based only on modern assumptions about the nature of Achaemenid rule (and the Egyptian reaction to it), not on an intrinsic feature of the statue itself. Rather, as John Baines (1996, 86) has pointed out, 'a work of art such as the statue may not impose any one sequence of viewing and reading, even if texts are necessarily more sequential than pictorial materials'. There is no single correct order for reading these texts. Instead the disposition of the inscriptions must be informed by some other organising principle.

In fact, the locations of the inscriptions pattern neatly according to their importance in terms of Udjahorresnet's afterlife. Inscription A on the front and top of the naos is Udjahorresnet's direct address to Osiris wherein he enumerates his many offerings to the god. This inscription is at once intimate and generic, but it is generic because it is so essential to the statue's function and therefore cannot risk deviation from the established canon. Its essentialness is the reason for its central position on the statue, front and centre where god and human alike could not miss it. The inscriptions on the outer walls of the naos (D and d), which continue onto Udjahorresnet's chest above his arms, describe his merits. This description is highly formulaic and stereotyped, a common feature of autobiographical inscriptions since the First Intermediate Period (Krebsbach 2016, 332–3). For example, on one of his statues Harwa, high steward of the Divine Consort of Amun during the 25th Dynasty, states:

> I am one beloved of his city, praised of his district, kind-hearted to his towns. I have done what people love and gods praise, one truly revered who had no fault, who gave bread to the hungry, clothes to the naked, removed pain, suppressed wrongdoing. (trans. Lichtheim 1980, 24–8)

These sorts of claims, along with the associated descriptions of the tumultuous conditions that Harwa and Udjahorresnet and their ilk work against, are commonplace, and invariably do not refer to specific historical circumstances. This is because, as Alan Lloyd (1982, 167) puts it, these autobiographical texts

embody the traditional Egyptian philosophy of history according to which historical events are assimilated, to a greater or lesser extent, to a mythological prototype, the cosmic conflict of order and chaos ... This gives rise to a marked tendency in Egyptian texts for the specifically historical elements in a particular event to be stripped away and ignored to enable the author to concentrate on what he considers to be its deeper cosmic significance.

Thus the most specific historical details are the least important parts of a statue's inscription, and are accordingly relegated to the most subsidiary positions. In this case the particulars of Udjahorresnet's career under Amasis and Psammetichus III and his dealings with Cambyses and Darius are recorded on the lower portions of the sides of the statue and at the rear.

The arrangement of the texts on the statue reflects their position on a spectrum from the generic and cosmically important to the detailed and cosmically insignificant. The texts at the front of the statue above the arms (A, D and d) are the most important and least specific, whereas those on the lower and rear portions of the statue (B, C, b, c and E) are the most detailed and least important to the success of Udjahorresnet's afterlife. They are in certain respects the footnotes to the inscriptions on the front, since they elaborate on Udjahorresnet's claims of piety and merit. The inscriptions on the base of the statue (F and f) admittedly do not fit neatly into this division, but they may well be exceptional for reasons now lost to us. It is important to recognise that the inscriptions that most interest the modern scholar were those that least interested Udjahorresnet, at least as far as the purposes of the statue were concerned. The importance of the disposition of the inscriptions for understanding Udjahorresnet's times and career is that the references to disaster and turmoil, often taken as recognition of the trauma of Achaemenid rule in Egypt, belong to the cosmic rather than the historical sphere.

The interpretation of the inscriptions (B, b, C, c and E) that record Udjahorresnet's titles and dealings with Cambyses and Darius has especially been affected by the labelling of him as a collaborator. Under Amasis and Psammetichus III he held several titles: 'Prince, Count, Royal Sealbearer, Sole Companion, True Beloved King's Friend, Scribe, Inspector of Council Scribes, Chief Scribe of the Great Outer Hall, Administrator of the Palace, and Overseer of the Royal *kbnwt* Vessels'. Many of these titles are attested as well on Udjahorresnet's sarcophagus and on a small statue of him from Memphis (discussed further below). His sarcophagus also preserves one more title: 'Overseer of Foreign Mercenaries' (Bareš 1999, 57, 60). It is not clear under which pharaoh he held this last title. Under

Cambyses he held these same titles, save for 'Overseer of the Royal *kbnwt* Vessels', and he notes specifically that Cambyses appointed him 'Chief Physician'. The bulk of the biographical section of the inscription is dedicated to Udjahorresnet's activities during the reign of Cambyses, the most prominent of which are the services he performed on behalf of the temple of Neith and the city of Sais, including the removal of foreigners from the temple precinct and saving the city from an unspecified 'very great disaster'. He also composed pharaonic titulary for Cambyses (Dillery 2003). Under Darius, Udjahorresnet held the titles 'Count and Duke, Sealbearer of the King of Lower Egypt, Sole Friend, Prophet' and again 'Chief Physician'. At Darius's instruction he left Elam for Egypt in order to restore the House of Life, a temple entity charged with maintaining and promoting all forms of Egyptian cultic knowledge, especially in written form (Eyre 2013, 311–15). Given the focus on Sais in the rest of the inscription it is very likely this was the House of Life in the temple of Neith in that city. What nature of restoration it required is unclear.

Much has been made of the ostensibly military nature of the title 'Overseer of the Royal *kbnwt* Vessels', which Udjahorresnet held under Amasis and Psammetichus III. Because Psammetichus's reign was so brief (less than a year), it is safely assumed that Udjahorresnet held this particular title at the time of the invasion. This in turn leads to assertions that he defected to the Persian side during the invasion, and that this was a major factor in Cambyses' success (e.g., Spalinger 1977, 244; Ray 1988, 258; Sternberg-el Hotabi 2017, 15).

These assertions are questionable for two reasons. First, the military character of Udjahorresnet's title is based on the assumption that *kbnwt* vessels were warships, possibly even triremes (Lloyd 2000, 86–7). This term refers, however, to all ocean-going vessels, including warships, so the title may not have had military implications at all, and may instead refer to a responsibility for trade fleets, such as those sent to Punt in both the New Kingdom and the Saite Period (Darnell 1992; Cruz-Uribe 2003a, 10–15). Even if this title was a military one there is still no proof that it was not honorary or a sinecure. To cite an illuminating modern parallel, someone familiar with only his title might assume Colonel Sanders was a war hero rather than a fried chicken magnate who served only a few months in the army as a muleteer (Pearce 2005, 131).

Second, there is no indication in the inscription as to when Udjahorresnet's relationship with Cambyses began. According to Herodotus (3.16) Cambyses went to Sais after his capture of Memphis,

that is, after Psammetichus had been defeated (Kahn 2007, 106). This is as probable an occasion for the beginning of Udjahorresnet's service to Cambyses as any time during the invasion itself. So the inscriptions on his statue do not in fact indicate that Udjahorresnet played any role whatsoever in the Achaemenid takeover of Egypt. Some scholars also read the reference to Udjahorresnet's saving the people of Sais from a 'very great disaster' as another indication of his treachery, assuming that this must refer specifically to Cambyses' invasion and that Udjahorresnet saved the city by surrendering it to the Persians (Olmstead 1948, 88). As discussed above, this is a stereotypical motif common in autobiographical inscriptions, not a specific historical event, and as such it cannot be connected to the historical Cambyses in any way (Krebsbach 2016, 332–3).

The inscriptions on Udjahorresnet's statue are proof only of his high status in the later decades of the sixth century BC. The turncoat seen by many scholars is a modern construction, the product of their own negative assumptions about the nature of Achaemenid rule in Egypt. In fact, there is some evidence for the reception of Udjahorresnet's activities by other Egyptians during the fourth century BC. This evidence is provided by an inscribed statue fragment excavated at Mit Rahinah in 1956 (Anthes 1965, 98–101; Bresciani 1985). According to the inscription, someone named Menuirdisu 'caused the name of the chief physician Udjahorresnet to live, who has completed 177 years after his time, because I found the statue while it was in a state of [decay]' (trans. Kuhrt 2007, 415–16). The implication here is that Udjahorresnet was venerated sometime between his death in the early 510s and c. 340 BC, 177 years later.

Veneration of this sort was typically the result of personal success, and it led to the individuals thus honoured being 'surrounded by the myth of a man of genius and mystery as being a favorite of the gods' (Wildung 1977, 31). So in Udjahorresnet's case, whatever modern scholars might think of him, at least some segment of the Egyptian population in the fourth century considered his actions to have been highly meritorious. What actions in particular prompted this response has been debated; some suggest his medical and scholarly prowess were his main achievements in the eyes of the Egyptians, and others that his pro-Persian political stance was the reason for his veneration (e.g., Godron 1986; Burkard 1994, 43–5). Certainly the concurrence of the restoration of his statue by Menuirdisu and the resumption of Achaemenid rule in Egypt seems like more than coincidence, but this does not prove anything about why the veneration began in the first place. At any rate, the positive reception

of Udjahorresnet by the Egyptians underscores the prejudice that occurs in modern interpretations of his career.

To understand Udjahorresnet on his own terms it is necessary to consider the formal features of the statue itself. The green basalt statue stands approximately 58 cm high, not including the various restored heads (Botti and Romanelli 1951, 32–40). It depicts a striding male figure in the traditional Egyptian pose, with his left foot ahead of his right, holding a small shrine in which the god Osiris is depicted. The figure wears an ankle-length 'Persian garment' knotted at the front of his chest over a sleeved garment. On his right arm he wears a bracelet with lion head protomes (the left arm is a modern restoration). The head is missing entirely.

Udjahorresnet's choice to be represented wearing the 'Persian garment' is clearly deliberate and derived from his belief that this was an appropriate garment for someone of his station, especially one who had served multiple pharaohs, both in Egypt and abroad, in very high offices. His bracelet with lion protomes can be understood in a similar manner. Numerous examples of such bracelets have been attributed to the Achaemenids on stylistic grounds (Rehm 1992, no. A116; Curtis 2005, nos. 154–6, 160–2; Razmjou 2005, no. 270; Colburn 2017, 876–8). Thus these bracelets (it is very likely he also had one on his left arm) were a clear reference to a superordinate centre outside of Egypt, namely the Achaemenid Great King and his court. His ornaments and clothing served to draw a visual connection between Udjahorresnet and the elite that governed the Achaemenid Empire.

At the same time his bracelets can be read in a different context, one that has clear Egyptian antecedents. In one of the inscriptions on the statue (F), Udjahorresnet says 'I was a learned man for all lords; my character was judged good by them. They gave me golden ornaments; they did everything needful for me' (trans. Kuhrt 2007, 119). This has been interpreted as a reference to the bracelets, which, given his close connections to Cambyses and Darius, could very well have been actual gifts from the Great King; even if they were not, their representation on the statue along with inscription F seems to have been intended to imply as much. But the practice of the king awarding gold ornaments (called 'gold of praise') to meritorious individuals has a very long history in Egypt. It is attested textually as early as the Old Kingdom and visually in the New Kingdom and Third Intermediate Period (Wasmuth 2017b, 248–9). So the inclusion of the bracelets on Udjahorresnet's statue and the reference to gold ornaments in inscription F can also be read in a distinctly

Egyptian context, even if the king awarding the gold was a Persian (Moyer 2006, 245–7).

The choice of statue type emphasises Udjahorresnet's particularly Egyptian religious concerns. As noted above, the naophorous statue type goes back to the New Kingdom, and it represents a uniquely Egyptian idea about the relationship between human and god (Klotz 2014). In choosing to be represented for all eternity in this manner Udjahorresnet was connecting himself to an explicitly Egyptian cultural context. Moreover, since the statue was most probably placed in a temple and thus would have been seen mainly by priests, this choice was essentially a private one, reflecting concerns beyond fads, trends, public opinion or short-term goals. In short, he did not believe the world had changed so much as a result of Cambyses' invasion that a purely Egyptian statue form was no longer the most appropriate way to represent himself for all eternity.

The statue's legibility in different settings is a result of the different ways in which Udjahorresnet constructed his identity. Though he may not have recognised explicitly the statue's multiple possible readings, he certainly considered it in its entirety to be an appropriate representation of himself. In many respects the statue is a quite conventional Egyptian monument of a high-ranking official in that it emphasises, both textually and visually, his service to and connections with the pharaoh, his pious acts and his personal achievements. At the same time the statue situates him within the imperial context more broadly, as a member of the imperial elite, participating in the project of empire. Nor was Udjahorresnet the only Egyptian to occupy such a position. A fragmentary naophorous statue in Karlsruhe (Badischen Ladesmuseum H 350; Rehm 2005 [2006], 507; Wasmuth 2017b, 247), which exhibits the same combination of sleeved garment and bracelets, suggests that there were others who similarly understood and constructed their identities in reference to both Achaemenid and Egyptian cultural practices and memory.

REPRESENTATION AND IDENTITY IN ACHAEMENID EGYPT

The individual identities examined above by way of their representation in personal monuments and other media are unified primarily by their variety and their multiplicity. Though it is hardly surprising that most of the individuals under consideration constructed their identities with reference to either Egyptian cultural memory or Achaemenid imperial ideology, or both, what is interesting is

that these orientations do not seem to cleave to ethnic, cultural or political affiliations in any clear manner. Darius himself draws on Egyptian visual culture in the statue found at Susa, and Egyptians, or at least residents of Egypt, made use of the Achaemenid iconographic repertoire in various ways in their own monuments. In both cases this was the result of the respective foreign features being somehow appropriate to the identities of the people selecting them. This variety in identity indicates variety in the experience of and reaction to Achaemenid imperialism in Egypt, and it is all the more striking when one considers that the above sample is limited mainly to elites, to those people who could most afford to make use of art. Also, most of these examples have features that are intelligible in both Egyptian and Achaemenid imperial contexts, implying that many people found it advantageous to be able to transition seamlessly between these two cultural spheres. Indeed in Egypt (perhaps at Memphis most of all), the various cultural identities were at times sufficiently overlaid so as to be indistinguishable from each other.

The variety of experience with Achaemenid rule attested in these monuments, as well as the apparent lack of concern with ethnicity, makes it quite difficult for us to conceive of the population of Achaemenid Egypt in the monolithic categories of 'Persian' and 'Egyptian', as well as their attendant implications of 'coloniser' and 'colonised', and 'oppressor' and 'oppressed'. Though it is indubitable that Egypt was part of an empire and extremely likely that at least some oppression and exploitation took place there, the evidence presented here indicates that these categories were fluid rather than fixed, and that membership in them occurred on an individual basis, as least insofar as the elites studied in this chapter were concerned. In this respect, the impact of Achaemenid imperialism on Egypt had as much to do with the proclivities of the individuals involved as it did with any systematic changes imposed from without.

5. Social Practices: Drinking Like a Persian

> It is usual for the Persians to be drunk when they are debating the most important issues. However, any decision they reach is put to them again on the next day, when they are sober ... And any issues they debate when sober are reconsidered by them when they are drunk.
>
> Herodotus of Halicarnassus

FOOD, IDENTITY AND STATUS

The previous chapter examined how the social conditions created by Achaemenid rule affected the decisions people made about how to represent themselves in a durable context, such as in the design of a statue. Such decisions were made infrequently and generally for significant occasions, and were carefully considered in order to achieve a specific effect. In contrast, this chapter considers how Achaemenid rule may have affected the decisions people made about identity on a daily basis. These decisions included how to dress, how to behave, how to speak, where to go, with whom to associate and what to eat and drink. Although less momentous than commissioning a statue, these decisions were informed nevertheless by an understanding of what was most suitable for the individual in question. Furthermore, because they were made on a daily basis they are part of the routine practices that comprise Bourdieu's *habitus*, the broader context that structures social practices (Bourdieu 1990, 52–65; see also Hastorf 2017, 21–2, 57–8). Though these decisions are no less deliberately made than any other, their social significance is not always actively considered. This means that such social practices can provide a somewhat different perspective on how Achaemenid rule affected life in Egypt.

Unfortunately for the archaeologist, most of these social practices do not leave recoverable material remains. The main exception is culinary practices, for which evidence is generally abundant in the form of ceramics. Culinary practices are a valuable avenue for studying identity because they are closely linked to ideas about culture and status. While ecological and economic factors can delimit the types of food and methods of preparation available to a given group of people, they cannot account for the idiosyncrasies of specific eating habits. For example, eating the meat of horses is taboo in many Anglophone countries, but not in many others, such as Belgium, Germany, Iceland, Italy, Kazakhstan, China, Japan and Tonga. Moreover, as Jack Goody (1982, 97–153) has argued, culinary practices create and reinforce social hierarchies. The most hierarchical societies develop the most differentiated practices, resulting in the creation of *haute cuisine*, usually characterised by a wide array of dishes, complex methods of preparation and exotic ingredients (Hastorf 2017, 39–42). When put on display in the course of communal banqueting, these characteristics become markers of the elite's access to resources and knowledge that are unavailable to everyone else. Thus culinary practices are complicit in the construction of both cultural and social identities.

With Goody's premise in mind, this chapter first considers the nature of *haute cuisine* in the Achaemenid Empire, both at the royal court and in the Persian heartland more broadly. It identifies the material correlates of this cuisine and the hierarchy that it supports, mainly idiosyncratic types of drinking vessels. Alcohol, after all, is a form of food, albeit one with psychoactive properties resulting from the manner of its preparation. While certain groups, ancient and modern, explicitly define alcohol in contrast to food, this is by no means a universal distinction (Dietler 2006, 231–2). This chapter then surveys the evidence for these Persian vessel types in Egypt, as a means of gauging the participation of people in Egypt in the social hierarchy of the empire. This is not at all a comprehensive study of culinary practices in Achaemenid Egypt, but the introduction and adaptation of these foreign drinking vessels, and perhaps also the drinking practices associated with them, illustrate the ways that Achaemenid rule may have altered social life in Egypt, even if only on a limited scale. Even minor changes are significant, since culinary practices in ancient Egypt, as in many ancient societies, were on the whole quite conservative.

DINING AND DRINKING IN PERSIA

Much of the evidence for Persian culinary practices comes from Greek literary sources. Some of these sources, such as Herodotus and Xenophon, had direct exposure to the Persians, albeit primarily in the western reaches of the empire, meaning their information about the Achaemenid court was second-hand at best. Other sources, such as Athenaeus and Polyaenus, wrote centuries after the destruction of the empire, and thus relied on the work of earlier writers whose sources of information are opaque. All of these authors had their own literary objectives and agendas and wrote in an intellectual milieu flavoured by Greek stereotypes developed after the Persian Wars. So while the information they present may indeed be accurate, their presentation of it cannot be accepted uncritically (Sancisi-Weerdenburg 1995). The texts of the Persepolis Fortification Archive are beginning to shed further light on this important topic, and they provide some corroboration for certain aspects of the Greek accounts (Sancisi-Weerdenburg 1997; Henkelman 2010). Even with these limitations it is fairly clear that drinking and dining practices in the Persian heartland were closely linked to social status. This is especially true of the royal table, which the Great King used as an instrument of cohesion in the empire.

The royal table

Polyaenus and Athenaeus were impressed by the sheer quantities and varieties of food served at the Achaemenid royal table. Polyaenus (4.3.32), writing in the second century AD, lists more than fifty foodstuffs which he claims were used daily by the Great King (Lewis 1987; Briant 2002, 286–92; Amigues 2003; Dusinberre 2013, 114–19; Llewellyn-Jones 2013, 90). These include several types of wheat and barley, a variety of animals (including horses and gazelles) and a large number of oils and spices, such as capers in brine, Ethiopian cumin and terebinth oil. Polyaenus and Athenaeus (4.142e; citing Heraclides of Cyme, who wrote in the mid-fourth century BC) also refer to huge quantities of food; both state, for example, that over a thousand animals were slaughtered every day for the royal table. Polyaenus even includes 300 wagonloads of wood, presumably representing the fuel required to do the cooking.

For the Greeks such quantities and types of food were symptomatic of Persian luxury and excess; for the Persians, however, they were appropriate for the table of the Great King (Sancisi-Weerdenburg

1995; 1997; Wilkins 2013). Indeed, these large quantities find some confirmation in the texts of the Persepolis Fortification Archive. When members of the royal family were supplied by the regional administration in Persepolis (the agency whose activities generated the texts of the Fortification Archive), they received vast quantities of food (Henkelman 2010). Individual tablets mention quantities in excess of 1,200 head of sheep or goats, 1,000 head of poultry, 126,000 quarts of flour, 12,000 quarts of wine and 5,000 quarts of *karukur* fruit (possibly pomegranates).

It is unknown how exactly this food was prepared. Herodotus (1.133) says wealthy Persians ate cows, horses, camels and donkeys which had been roasted whole (Sancisi-Weerdenburg 1997, 338–9). This would have required a great deal of fuel, and must be regarded as elite conspicuous consumption. Indeed, as noted above Polyaenus says the royal table required 300 wagonloads of wood per day. And it is fairly certain there were culinary specialists at court. Another text preserved in Athenaeus (13.608a), a letter by Parmenion, one of Alexander's generals, inventories the personnel and equipment captured from Darius III's baggage train at Damascus (Sancisi-Weerdenburg 1997, 334–8; Briant 2002, 293). Among these personnel were 277 cooks, as well as 29 'kettle-tenders' (χυτρεψοὺς), 13 'milk-workers' (γαλακτουργοὺς), 17 'drink-makers' (ποτηματοποιοὺς) and 70 'wine-strainers' (οἰνοηθητὰς). These last four terms are not attested in any other Greek text, and thus are likely to be translations of Old Persian terms for specialised culinary professions. Also, although in a moralising context, Xenophon (*Agesilaus* 9.3) says that 'the Persian king has vintners scouring every land to find some drink that will tickle his palate' (trans. E. C. Marchant). In a similar vein Athenaeus (12.529d; this time citing Clearchus of Soli, who wrote in the late fourth or early third century BC) says the king gave prizes to people who discovered new dishes for him. So while it may not be possible to say what exactly was served at the royal table, it should nevertheless be considered *haute cuisine* in the sense that it was doubtless much more complex and sophisticated than what the majority of Persians ate at home on a daily basis.

The royal table was also distinguished by its furnishings and utensils. According to Herodotus (9.82), after the battle of Plataea, the Greeks captured Xerxes' tent, which he had left for his general Mardonius. It apparently included gold and silver couches and tables, and embroidered hangings. Another extract of Parmenion's letter preserved in Athenaeus (11.781f) inventories the vessels captured at Damascus, namely gold cups totalling 73 Babylonian

talents and 52 minae, and cups inlaid with precious stones totalling 56 talents and 34 minae. The Babylonian talent equalled 30,240 g (Bivar 1985, 623–5) and the gold vessels alone would have weighed over two metric tonnes. It is impossible to say how many vessels this could have included. A gold bowl in the National Museum of Iran (7985) with a trilingual cuneiform inscription naming Xerxes weighs 1,407 g, so it would take more than 1,500 such bowls to equal Parmenion's figure, and many of the other gold vessels attributed to the Achaemenids are lighter than this specimen (see examples in Simpson 2005). At any rate, regardless of the figures preserved in Athenaeus's text, it is certain that the royal table was well supplied with opulent drinking vessels.

Several types of drinking vessels are associated with the Achaemenid court; phialai and rhyta are prominent among these. The term 'phiale' (plural 'phialai') is used by modern scholars to refer to several different vessel forms. For the purposes of this discussion it refers specifically to what could be called the 'Achaemenid phiale', a broad, shallow vessel with a carinated shoulder and an everted rim.[1] Often they feature lobed gadroons and an *omphalos*. The term 'rhyton' (plural 'rhyta'), from the Greek ῥέω, meaning 'flow', refers to a vessel with a spout or drain at the bottom. In the Achaemenid Empire rhyta were generally made in the shape of a curved horn with a decorated spout – usually a protome in the form of an animal or composite creature – at the bottom.

Few examples of these vessels come from controlled excavations. Two silver phialai with floral decorations were discovered at Persepolis (Sami 1954, 56), as was a glass horn-shaped rhyton with a protome in the form of a bull attacking a lion (Ghirshman 1962, 77; Simpson 2005, no. 121; Ebbinghaus 2018, 143). Unfortunately, it is not clear exactly where these vessels were found, and the rhyton lacks a pouring spout, raising the question of how it was intended to be used. A similar silver phiale decorated with floral motifs (Louvre Sb 2756; Harper et al. 1992, no. 170; Razmjou 2005, no. 277; Frank 2013, 352 fig. 392) was found in a tomb of fifth-century date (Elayi and Elayi 1992) on the Acropole at Susa (Fig. 5.1).

These vessels provide important confirmation that phialai and rhyta were in use at the Achaemenid capitals, even though the majority of such vessels have no provenance and were instead identified

[1] The term 'Achaemenid phiale' is also often used in the context of Athenian ceramics to refer to a deeper shape of vessel derived ultimately from the Achaemenid bowl (which is discussed further below). See discussion in Miller 1993, 118–20.

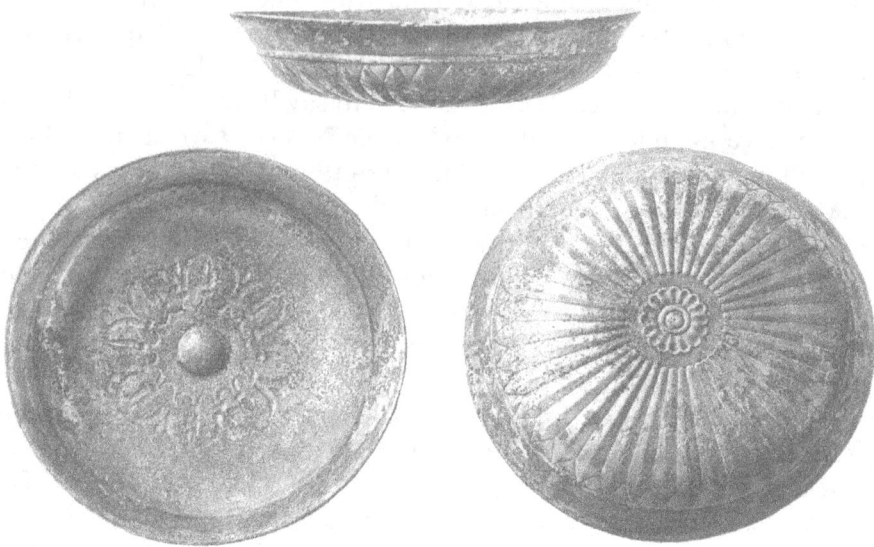

Fig. 5.1. Achaemenid phiale with floral motifs, c. late 5th century BC, excavated from a grave on the Acropole, Susa, Iran. Silver; H. 4.3 cm (1 5/8 in.), Diam. 18.4 cm (7 1/4 in.). Paris, Musée du Louvre, Sb 2756. Image in the public domain from de Morgan (1905, pl. 3).

on stylistic or epigraphic grounds. One likely reason for the scarcity of precious metal vessels is that they were melted down after the fall of the empire. According to Diodorus Siculus (17.80.3) and Strabo (15.3.9), Alexander looted some 180,000 talents of silver from the major cities of the empire. François de Callataÿ (1989) has ingeniously argued that this booty served as the raw material for the early Hellenistic coin issues. It is only those vessels that were hidden or dispersed before Alexander's invasion that have survived to the present day.

The most explicit link between the phiale shape and the Achaemenid court is made by the four large (29 cm rim diameter) silver phialai (Fig. 5.2) bearing Old Persian inscriptions reading 'Artaxerxes, the great king, king of kings, king of lands, son of Xerxes the king, Xerxes son of Darius the king, the Achaemenid: in his house this silver bowl was made' (trans. Kuhrt 2007, 316).[2] They were first published in 1935 by Ernst Herzfeld, who claimed they came from

[2] The phialai are now in the British Museum (1994,0217.1), the Metropolitan Museum of Art (47.100.84), the Freer and Sackler Gallery in the Smithsonian Institution (F1974.30) and the Reza Abbasi Museum in Tehran.

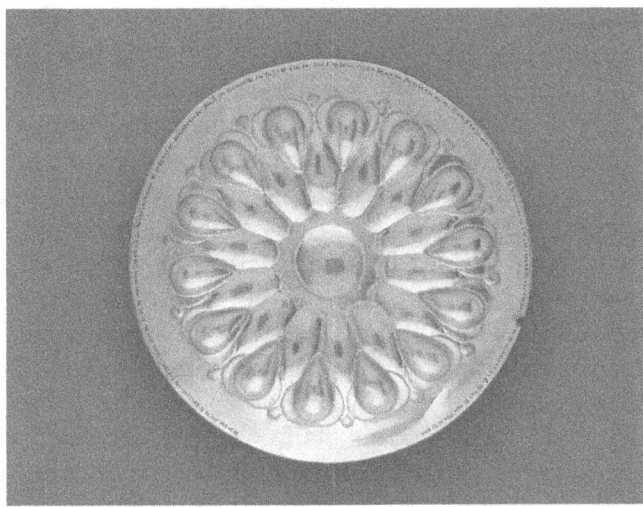

Fig. 5.2. Lobed Achaemenid phiale with Old Persian inscription naming Artaxerxes I, c. 465–424 BC. Silver; Diam. 29.2 cm. New York, Metropolitan Museum of Art 47.100.84. Image in the public domain.

Hamadan. The 'Hamadan' provenance is suspect, as the site was not systematically excavated until comparatively recently (Muscarella 1980, 31–5), and Herzfeld was never explicit about how or when he came to encounter these vessels. Doubts have thus been raised as to the authenticity of these phialai; however, recent research supports their genuineness. First, microscopic examination, X-ray fluorescence and neutron activation analysis carried out on these vessels indicate they have similar techniques of manufacture and metallic content to those of other, less suspect examples of Achaemenid silver (Curtis et al. 1995; Gunter and Root 1998, 8–12). Second, the combined weight of the four phialai equals 600 sigloi exactly, suggesting they were made as a set according to an ancient Persian weight standard (Vickers 2002, 333–6).

The inscriptions on the phialai have also been doubted, in large part on account of the presence of two suspicious words for 'bowl' and 'silver' respectively (Sims-Williams 2001; Schmitt 2007, 82–93). The word used for 'bowl' is a *hapax legomenon*, but this should be no great cause for concern given the small corpus of extant Old Persian texts. The word used for 'silver' seemingly derives from the Greek ἄσημος, meaning 'unmarked'. The use of this term without ἄργυρος to refer to uncoined silver is not attested directly in Greek until the first century AD. However, despite the minting of darics and sigloi, it seems that in most of the empire, including the Achaemenid heart-

land, bullion was the commonest form of precious metal currency (Zournatzi 2000; Le Rider 2001, 165–205). It is thus not difficult to envision a scenario in which ἄσημος entered the Persian lexicon, especially in the multilingual environment of the Persepolis region, where the use of Greek is attested (Rollinger and Henkelman 2009).

So it is possible that the inscriptions were added in the twentieth century, though in the 1930s relatively few people would have been capable of forging an Old Persian inscription. Of course, Herzfeld was one of those few. But there is no record of him owning or selling the vessels himself. In a letter to Ernst Kühnel, Herzfeld claimed that he first saw the phialai with Joseph Upton (Gunter and Hauser 2005, 29–30); a letter written by Upton at Persepolis dated 24 October 1932 supports this claim.[3] Upton described the vessels as having cuneiform inscriptions stating that they were made for the palace of Artaxerxes. So it would appear that the phialai were already inscribed when Herzfeld first encountered them. In fact, the earliest attested owner is not Herzfeld at all but Arthur Upham Pope, who sold one of the phialai to Joseph Brummer in 1940 (Allen 2016, 158–61). Since Pope lacked Herzfeld's linguistic expertise he could not have forged the inscriptions himself, so, as Lindsay Allen (2016, 160 n. 127) notes, 'one would have to imagine a collaboration in which the fake inscription were perhaps commissioned from Herzfeld by Pope'. Given the well-documented animosity between the two men this is very unlikely.

The connection between rhyta and the Achaemenid court is less explicit, but is nevertheless generally accepted. In addition to the glass rhyton mentioned above, other rhyta without secure archaeological provenance show iconographic links to Persepolis. Most notably, a gilded silver rhyton in the British Museum (1897,1231.178), said to be from Erzincan in eastern Turkey, features a spout in the form of a winged horned griffin with lion's paws (Simpson 2005, no. 119; Ebbinghaus 2018, no. 36). Comparable creatures appear at Persepolis in various settings, including glyptic (PFS 774, 844, 1072, 1598, 1135; Garrison and Root 2001, cat. nos. 58–9, 61, 63, 66) and as column capitals (Fig. 5.3). The Achaemenid rhyton incorporated features of both the zoomorphic ceramic vessels made in northwestern Iran during the Iron Age, and the metal animal-headed beakers used in Assyria beginning in the eighth century BC (Ebbinghaus

[3] The letter, to Maurice Dimand, is now in the archives of the Metropolitan Museum of Art's Persian (later Iranian) Expedition, housed in the Department of Ancient Near Eastern Art. I am grateful to Kim Benzel and Yelena Rakic for access to this material.

Social Practices: Drinking Like a Persian

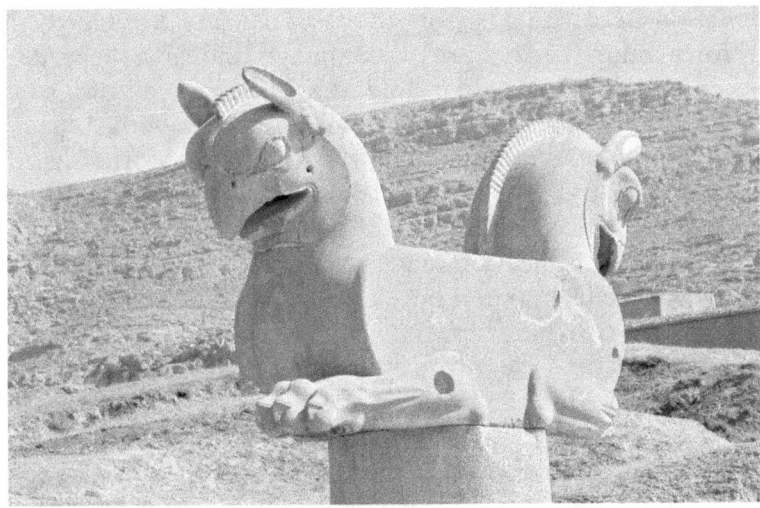

Fig. 5.3. Column capital in the form of a griffin from Persepolis, c. mid-4th century BC. Photograph by A. Davey from Wikimedia Commons reproduced under a Creative Commons licence (CC BY 2.0).

2018; Ebbinghaus and Colburn 2018). Those beakers were themselves closely tied to the Assyrian king and his court; images of them in the reliefs from the palace of Sargon at Khorsabad show them being used in a royal banquet and being carried to the king by figures interpreted as tribute-bearers. This royal connection was furthered by the Achaemenid kings, who added an Iranian element by combining the imagery of the beakers with that of the zoomorphic ceramic vessels of the Iron Age.

Other drinking paraphernalia were used at the Achaemenid court as well, such as hemispherical bowls, table amphoras, ladles and strainers (Moorey 1980b; Gunter 1988; Simpson 2005). But these items do not seem to have been exclusive to the royal table, and therefore lacked the strong association with the Great King that the Achaemenid phiale and rhyton had. It is worth noting too that the manner in which the king ate and drank was probably also significant. In the *Cyropaedia* (1.3.8) Xenophon states that Cyrus learned the proper way to hold a wine cup – 'conveying it with three fingers' – at the court of the Median king Astyages. The historical value of this text remains debatable, but, as will be discussed further below, this practice is depicted in a wide variety of artistic media throughout the empire (primarily in the west), suggesting that some such protocol did in fact exist (Miller 2011b). One of these depictions occurs on a cylinder seal (PFS 170; Fig. 5.4) attested in the Persepolis

Fortification Archive (Garrison 2017b, 91 fig. 2.34b; Garrison and Root forthcoming). The preserved image shows a bearded man seated on a high-backed chair holding a bowl in front of his face on his fingertips. Though there are some resonances with Achaemenid royal iconography, especially the lotus in the man's other hand, this does not appear to be an image of the Great King per se. But it does indicate this practice's currency at Persepolis.

Moreover, the physical characteristics of the rhyton required that it be used in a specific manner: once filled it could not be set down, nor could the flow of wine from the spout be stopped without making a mess. One of the reliefs from the Nereid Monument at Xanthos in Lycia (British Museum 1848,1020.97), dating to c. 390–380 BC, depicts a banqueter holding an Achaemenid rhyton over a shallow drinking bowl (Ebbinghaus 2000; 2018, 155–8; Simpson 2005, no. 123). The implication is that the wine pouring out of the rhyton was caught in another vessel, from which it was ultimately drunk. It is impossible to say whether or not this was the protocol for rhyton use at the Achaemenid court, but it is nevertheless suggestive of what the accepted procedure could have been.

The royal table fed a large number of people; Athenaeus (4.164c), for example, writes that the Great King fed 15,000 people at each meal. The accuracy of this figure is uncertain, and it does not mean that everyone who attended a banquet necessarily ate with the king or even entered his presence (Llewellyn-Jones 2013, 128). In describing Xerxes' bivouac at Acanthus during the invasion of 480 BC, Herodotus (7.119.3) distinguishes between the people who ate with the king in his tent and those who ate outside. But the quantities of food allocated to the royal table in the Persepolis Fortification Archive do suggest that royal meals were attended by many guests. Athenaeus (4.145e) also says that the king's guests were permitted to take leftover food with them, and some were honoured with gifts of the actual vessels from the table (Briant 1989; Sancisi-Weerdenburg 1989, 133–5; Gunter and Root 1998, 23; Kistler 2010). This last point is especially significant because it means that for certain guests their presence at the king's dinner was materialised, and these vessels became markers of status in their own right.

Perhaps the clearest indication of this practice of royal gifting is in a Greek law court speech written by Lysias (19.25) in the early fourth century BC. In this speech an Athenian named Demus, son of Pyrilampes (and Plato's stepbrother), is said to have received a gold phiale from Artaxerxes II as a token of esteem. Demus had served as an ambassador to the Great King, and presumably received his phiale

during one of his diplomatic missions. According to the speech, the possessor of the phiale 'on the strength of that token ... would then obtain plenty of goods and money all over that continent' (trans. W. R. M. Lamb). The 'continent' in question must be Asia, and the implication is that in addition to its monetary value, the phiale was a marker of one's high status and royal connections in the empire (Vickers 1984; Bivar 1999; von Reden 2002, 58–60).

The royal table thus established and maintained social hierarchies in two ways. The Great King's unique status in the empire was made manifest through the great quantities and varieties of food and drink served at the table, the elaborate and sophisticated preparation of that food, the distinctive and luxurious vessels used at the table and the courtly protocols that surrounded each meal. Likewise, the statuses of the guests were established and reiterated by their participation in the royal banquet, and, for some, their receipt of gifts from the king. These gifts, mainly drinking vessels, marked one's royal connections and elite standing. The royal table, then, distinguished at least four main tiers of social hierarchy: the king, those who received gifts, those who did not receive gifts but still attended the banquet in some capacity, and those who did not attend. Though direct evidence is lacking, it is quite likely that the tier closest to the king was comprised of elites who participated in the governance and propagation of the empire. An analogous situation existed with the royal name seals given by Darius to high-ranking administrators at Persepolis whose loyalty he wished to ensure in the face of his unorthodox rise to power (Garrison 2014). The lion-headed bracelet worn by Udjahorresnet in his naophorous statue (see Fig. 4.18) is another similar example. Such royal gifts conferred privilege, elite status and authority on their recipients, and at the same time created and sustained bonds of loyalty to the king. In this respect they were crucial to the cohesion of the empire.

The royal table was not limited to imperial capitals; it was replicated wherever the Great King went, even while he was on campaign (Briant 1988b; Llewellyn-Jones 2013, 89–92). It was also replicated to a lesser extent by satraps and members of the royal family (Briant 1989; Kistler 2010, 425–8; Miller 2010; Ebbinghaus 2018, 155–65; Fried 2018). In the Fortification Archive two royal women, Irdabama and Irtashduna, receive allocations of foodstuffs in a similar manner to that in which the royal table is supplied; a satrap, Karkish, also receives food in this way (Henkelman 2010, 693–713). Though the quantities they receive are smaller than the king's they are still considerable by the standards of Persepolis, and the implication is that

each had his or her own metaphorical 'table'. The case of Karkish is especially significant, because it provides the strongest evidence that the royal table, including the gifting of phialai and rhyta, was replicated outside the capitals. In the *Cyropaedia* (8.6.10), Xenophon says that Cyrus 'gave orders to all the satraps he sent out to imitate him in everything that they saw him do' (trans. W. Miller); in other words, to model satrapal courts on the royal court. This interpretation is borne out by the production of precious metal drinking vessels in the western satrapies of the empire, which Margaret Miller (2010) has persuasively argued met the demands of the satrapal courts there. In this manner the royal table and its material correlates spread to different parts of the empire, including Egypt.

Beyond the royal table

Dining practices created and reinforced social hierarchies outside of the royal table as well. This is most apparent in the Persepolis Fortification Archive, where, for example, men receive more food and drink than women do, supervisors receive more than non-supervisors, and skilled craftsmen receive more than unskilled (Lewis 1990, 1–2). These disbursements functioned as wages, so it is no surprise they were scaled according to rank, but it also shows how rank was conceptualised in terms of quantities of food. Likewise, Herodotus (1.133.1) says that on their birthdays, Persians ate a larger meal than usual, which was scaled according to wealth: 'well-off Persians serve an ox, a horse, a camel, or a donkey, roasted whole in an oven; poor Persians serve some smaller creature from their flocks' (trans. R. Waterfield). As noted above, the roasting of a whole animal would have required a great deal of fuel, and would certainly have been an act of conspicuous consumption that would have further distinguished high-status Persians from the rest of society.

The actual evidence for Persian culinary practices is limited. Greek authors were interested mainly in the eating habits of the Great King, and the Fortification Archive refers to disbursement of commodities, and not actual meals or dining. It does at least provide an overview of the range of foods and beverages consumed in Persia (Henkelman 2010, 734–53); these include barley, beer, cheese, chickens, ducks, geese, grapes, honey, lambs, candied peaches and plums, pomegranates, sesame oil, wheat and wine. The passage from Herodotus (1.133.2) cited above goes on to describe the typical meal: 'they do not eat many main courses as a rule, but they eat a lot of extra courses, and not all together' (trans. R. Waterfield;

Social Practices: Drinking Like a Persian

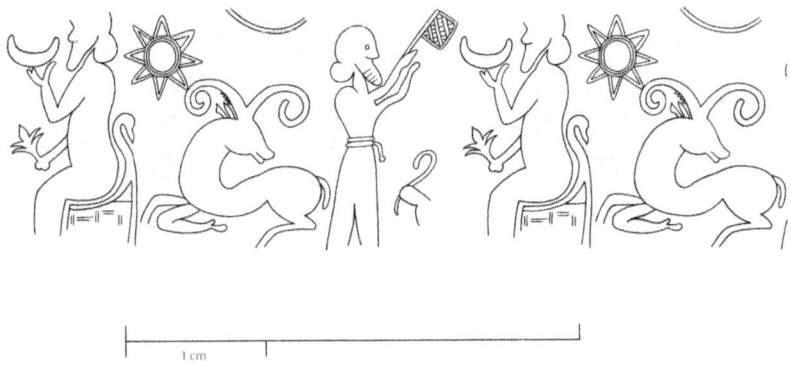

Fig. 5.4. Composite line drawing from impressions of PFS 170 (drawing by M. B. Garrison). Courtesy of the Persepolis Seal Project and the Persepolis Fortification Archive Project, the Oriental Institute of the University of Chicago.

see Sancisi-Weerdenburg 1997, 340). Finally he says the Persians 'are extremely fond of wine', and, in the passage that serves as the epigraph to this chapter (1.133–4), he explains their tradition of considering every decision while both sober and drunk (see further Daryaee 2012). This is not so much a dining practice per se as it is an indication that wine played a central role in Persian social behaviour.

The importance of wine is further supported by the appearance of drinking scenes on seals in the Fortification Archive (Figs 5.4, 5.5). For example, as discussed above, PFS 170 shows a seated man drinking from a bowl in the manner of the Achaemenid court. PFS 1601* features a similar scene, but with an attendant who appears to have just placed a vessel on a table in front of the seated man (Garrison 2017b, 91 fig. 2.34b). The details of this vessel are difficult to make out with any certainty, but its curved, slender shape suggests the form of a rhyton. PFATS 400 shows a scene with two drinkers facing one another across a table, on which sits a round vessel with a tall neck, seemingly some kind of bottle or decanter (Dusinberre forthcoming). The drinkers both hold bowls, and the scene has a charming air of conviviality. Finally, PFS 535* provides the richest array of representations of vessels and related items. It depicts a man seated on a high-backed chair holding a cup in front of his face with one hand and a flower in the other (Garrison 2017b, 51 fig. 2.17b; Ebbinghaus 2018, 144–5). Before him is a table on which sits a small horned animal (possibly meant to represent a rhyton) and a horizontally ribbed bowl. Next to the table is a stand on which sits a jug with a handle and a spout. A server stands to the left proffering an amphora and a ladle to the seated banqueter. These are only a few examples of

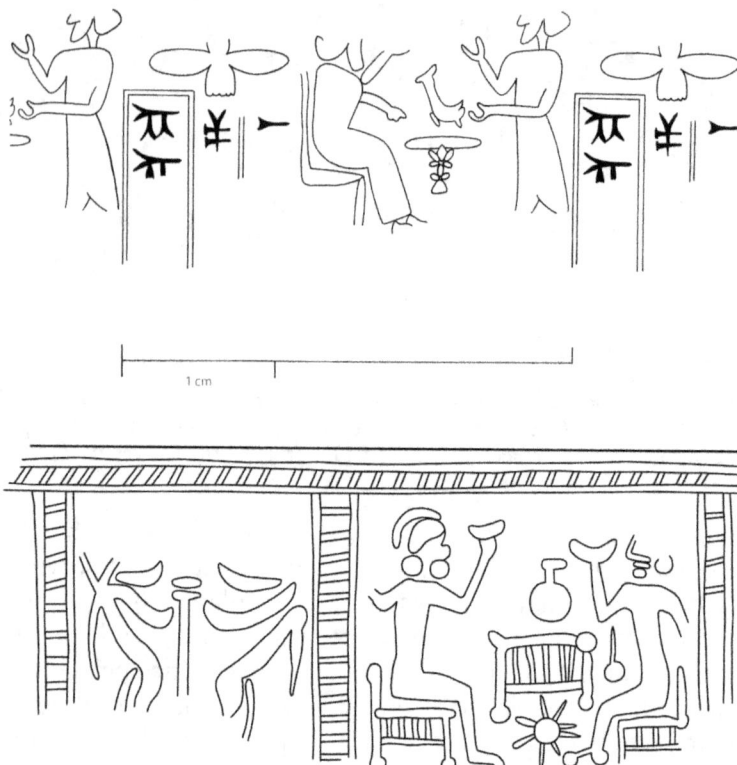

Fig. 5.5. **Top:** Composite line drawing from impressions of PFS 1601* (drawing by M. B. Garrison). **Bottom:** Composite line drawing from impressions of PFATS 400 (drawing by E. R. M. Dusinberre). Courtesy of the Persepolis Fortification Archive Project, the Oriental Institute of the University of Chicago.

the many banqueting scenes preserved in the Fortification Archive.[4] The prominence of drinking and drinking paraphernalia on these seals indicates the importance of this activity for the Persians, to the extent that it was even incorporated into these tangible markers of status and identity.

As discussed above, a range of drinking vessel types have been attributed to the Persians, and especially to the royal court. There is, however, one distinct shape of vessel which is both clearly Persian (or perhaps more generally imperial) and not directly associated with the court. This is the 'Achaemenid bowl', a deep bowl with

[4] M. C. Root, personal communication, 2013; these seals will be published in Garrison and Root forthcoming.

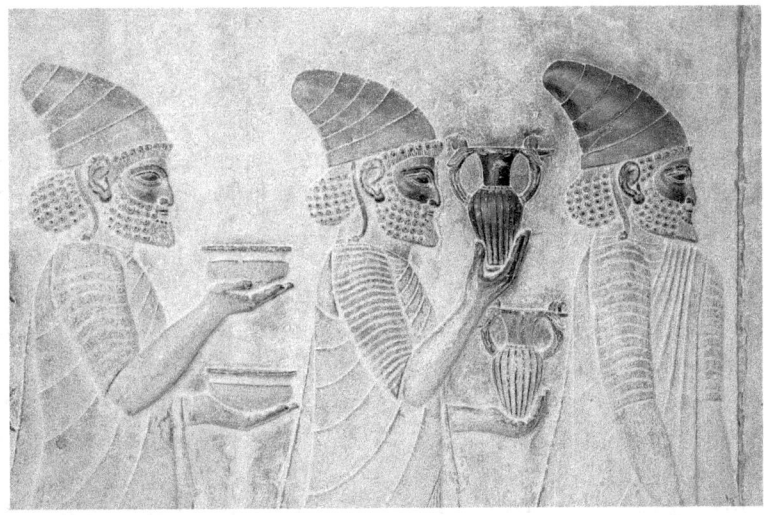

Fig. 5.6. Detail of a relief from the Persepolis Apadana showing Achaemenid bowls, c. 510–480 BC. Photograph by Phillip Maiwald from Wikimedia Commons reproduced under a Creative Commons licence (CC BY-SA 3.0).

a carinated shoulder and an everted rim, sometimes decorated with horizontal or vertical fluting or lobed gadroons. These bowls appear in the Apadana reliefs at Persepolis (Fig. 5.6), where they are carried by members of six geographically and culturally disparate delegations: Groups V (Babylonians), VI (Lydians or Syrians), VIII (Assyrians), XII (Ionians), XIII (Bactrians) and XV (Arachosians or Drangians).[5] Some of the bowls are plain; others are decorated with fluting. These decorations suggest that the bowls depicted on the Apadana are meant to be metal, and this idea receives some confirmation from the bronze Achaemenid bowls found in the Persepolis Treasury (Schmidt 1957, pl. 68). Additionally, two gold Achaemenid bowls with trilingual cuneiform inscriptions, one naming Darius and the other Xerxes, are said to come from Hamadan (Metropolitan Museum of Art 54.3.1, and National Museum of Iran 7985; Wilkinson 1955, 221–4; Simpson 2005, no. 97). Their true provenance cannot be ascertained, but they too support the possibility that precious metal versions of these bowls are represented on the Apadana reliefs. Although Achaemenid bowls are not shown in use as drinking vessels at Persepolis, this function is implied by the other vessels carried by delegates, especially beakers and table amphoras

[5] Schmidt 1953, pls. 31, 32, 34, 38, 39, 41. The identifications of some of these delegations remain unresolved; see discussions in Hachmann 1995 and Tourovets 2001.

with pouring spouts (Calmeyer 1993, 153–4; Miller 1993, 114–15; Paspalas 2000, 152–3; Simpson 2005, 104–6; Root 2007, 184).

The significance of the Achaemenid bowls lies in the fact that they are carried by multiple, geographically disparate delegates on the Apadana reliefs. This indicates that they were not associated with any one region; rather, they were an imperial phenomenon, used by people across the empire. Their representation on the Persepolis Apadana thus served to emphasise a common, imperial identity among the subject peoples (Calmeyer 1993, 160; Root 2007, 187). Yet presumably this significance went beyond the metaphorical level, since these bowls appear throughout the empire – in Egypt, Palestine, Cyprus, Anatolia and Bahrain – made from a variety of materials, including metal, glass and ceramic (Oliver 1970; Dusinberre 1999, 101–2; 2003, 177–8; 2013, 128–40; Potts 2010, 525–6). Ceramic versions have also been found in post-Achaemenid contexts in Gandhara, suggesting the bowls' dissemination in the eastern reaches of the empire as well (Petrie et al. 2008). Additionally, there are images of the Achaemenid bowl in several different media, including Anatolian stamp seals, a gold ring excavated at Vani in Georgia, and a silver calf-head rhyton found at Erebuni in Armenia (Miller 2011b). In these images the bowl is shown held on the fingertips on the manner of the Achaemenid court. This does not necessarily mean that Achaemenid bowls were used at the royal table, though certainly they could have been, but it does suggest these bowls were recognised as drinking vessels across the empire. It also suggests some overlap between the users of these bowls and people with some knowledge of the royal court.

The Achaemenid bowl was a marker of one's imperial identity and aspirations. Unlike the Achaemenid phiale, which, as a putative royal gift, was limited to the highest echelons of society, the Achaemenid bowl was more widely distributed across different social strata. Indeed, the range of materials used to make them suggests that a range of people owned them. Some of these people were emulating local elites; others may have emulated Persians, or imperial agents of any ethnic origin, who came to their community and brought bowls of this sort with them. Perhaps the best example of this is in the cemetery of Deve Hüyük in what is today southeastern Turkey. This cemetery contains the graves of soldiers who were probably part of an imperial installation somewhere nearby, since the armour and weapons contained in the burials have close parallels from Persia. The graves also contain a number of bronze Achaemenid bowls (Moorey 1980a, 34–8), and the implication is that these objects were

important symbols of the identities of the deceased. These soldiers were probably not of high status, but they would nevertheless have been targets of emulation by local residents who found their imperial connections, or other aspects of their non-local identities, appealing.

ACHAEMENID DRINKING VESSELS IN EGYPT

A number of Achaemenid phialai, rhyta and bowls have been found in Egypt at a range of sites and made of a range of materials. Their overall number is not great, but the diversity of findspots and materials suggests that the use of these vessels in Egypt was not restricted to any one zone or to any particular social class. Moreover, the total quantity of examples has been limited by certain factors. First, Egypt has few natural sources of silver, meaning that silver vessels were often melted down to make coins or other objects. Given the extreme financial measures taken by the fourth-century pharaohs Nectanebo I and Tachos (Will 1960; Davies 2004; Agut-Labordère 2011), and the intense efforts under the Ptolemies to institute coinage as the primary form of money in Egypt (de Callataÿ 2005; von Reden 2007), it is no surprise that so few silver vessels of Achaemenid date have survived. Second, many domestic sites in Egypt are heavily disturbed. In particular, many mounds (often known by the terms *tell* or *kom*), comprised in significant part of the remains of mudbrick structures, have been mined for fertiliser, known as *sebakh*, most intensively in the nineteenth and early twentieth centuries (Bailey 1999). In the process ceramic sherds become dislocated from their original depositional contexts, and spread across modern agricultural fields. This means that if ceramic versions of phialai, rhyta or Achaemenid bowls were in use in domestic contexts, the evidence for this has been destroyed in most cases. In light of these factors, the surviving quantity of material is actually quite significant, and doubtless can be bolstered by objects in museum collections around the world that lack secure provenance and are dated to later periods without clear basis (e.g., Lansing 1938), but which may well belong instead to the Achaemenid Period.

Phialai and rhyta

Given their elite connotations, it should come as no surprise that only a few Achaemenid phialai and rhyta have been found in Egypt. Three silver phialai (Fig. 5.7) were discovered at Tell Timai, ancient Thmuis in the Nile Delta, by Emile Brugsch in 1871 (Cairo CG

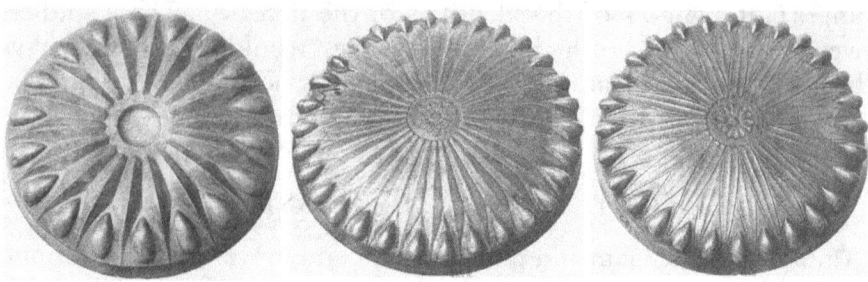

Fig. 5.7. Silver phialai excavated at Tell Timai, Egypt, c. 5th–4th century BC. Cairo CG 53267, 53275, 53277. Images in the public domain from Vernier (1927, pl. 109).

53267, 53275, 53277; von Bissing 1901, nos. 3581–3; Vernier 1927, 419–20, 423–5; Pfrommer 1987, 247).[6] They have been dated to the Ptolemaic Period without any clear reason since their earliest publications. But their closest parallels are the Artaxerxes phialai. All three of the Tell Timai phialai have narrow lobed gadroons, and the largest has an *omphalos* in the centre. Admittedly even the largest phiale is somewhat smaller than the Artaxerxes ones (it is only 22.2 cm in diameter), but its size is comparable to that of the two phialai found at Persepolis. Thus in the absence of compelling evidence for a later date, the Tell Timai phialai most likely date to the fifth century BC (Iliffe 1935, 184–5; Muscarella 1977, 193). Indeed, recent excavations at Tell Timai have recovered ceramics of fifth-century date, providing good evidence for Persian Period activity at the site (Hudson 2016).

Two more silver phialai (Fig. 5.8) have been attributed to Egypt in this period, as part of the hoard of vessels, gold-mounted stones and Athenian tetradrachms (IGCH 1649/CH 10.441) reportedly found at Tell el-Maskhuta in the eastern Nile Delta in 1947 (Brooklyn Museum 54.50.33–4; Cooney 1956, no. 50, pls. 70–1; Rabinowitz 1956, pls. 6–7; Dumbrell 1971, fig. 3). Both of these phialai have floral motifs that include lotuses, and one also has a dedicatory Aramaic inscription on its rim (TADAE D15.4), reading 'that which Kainu, son of Geshem, king of Kedar, offered to Hanilat'. The palaeography of this inscription, and that of the other inscribed bowls also believed to be part of this hoard, dates to c. 400 BC (Dumbrell 1971, 38). The inscriptions appear to have been added later, meaning

[6] These bowls are sometimes identified as coming from Mendes, a few hundred metres north of Tell Timai.

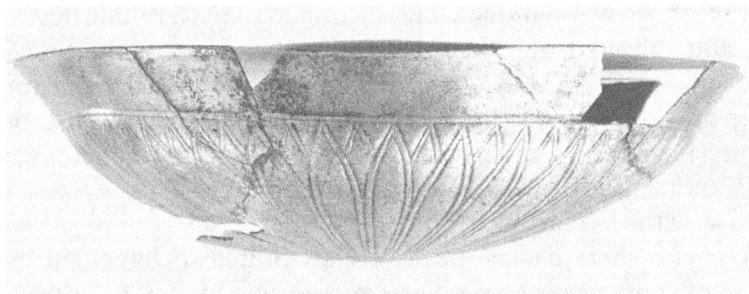

Fig. 5.8. Silver phiale from the Tell el-Maskhuta hoard, c. 5th century BC. Silver; Diam. 20.2 cm. New York, Brooklyn Museum, 54.50.33. Image from the Brooklyn Museum reproduced under a Creative Commons licence (CC BY 3.0).

the bowl dates generally to the fifth century BC. The dates of the latest coins in the hoard support the dating of the palaeography (Robinson 1947). Of course this provenance cannot be proven, and any conclusions drawn from this material must take this uncertainty into consideration.

The inscription on the Tell el-Maskhuta phiale provides an important clue as to the introduction of such vessels to Egypt. The Arabs of Kedar have been identified as a north Arabian group who were allied with the Achaemenid Empire at least until the end of the fifth century BC (Dumbrell 1971; Graf 1990, 139–43). Three other vessels in the Tell el-Maskhuta hoard also have dedicatory inscriptions naming Hanilat, a north Arabian goddess. In all likelihood these vessels, and perhaps the other objects in the hoard as well, were dedicated in a shrine to this goddess somewhere in the eastern Nile Delta. In the Ptolemaic Period there was an 'Arabian Nome' in this region (Giessen and Weber 2008, 277–9), implying there had been a permanent Arabian population there at some point. It is a good possibility this community originated as an Arabian garrison installed by the Persians to protect the Red Sea canal; perhaps they were even the same Arabians who assisted Cambyses' invasion in 526 BC (Hdt. 3.9; Graf 1990, 139; Cruz-Uribe 2003a, 20–4). Kainu's phiale, then, was probably a gift from either the Great King or a satrap, such as Arshama. Indeed, the two Achaemenid phialai in the Tell el-Maskhuta hoard both feature stylised lotus blossoms in their decorations, suggesting they were made in Egypt, presumably at the satrap's behest.

Achaemenid phialai thus entered circulation in Egypt as royal and satrapal gifts, and they served as markers of one's elite standing, or at least elite pretensions, by implying a direct connection to the king

by way of a royal banquet. These connections were not necessarily real, and reflected the identities and pretensions of the owners of these phialai. That said, given the scarcity of Achaemenid phialai in Egypt, they seem to have been limited to a very small group of people (Egyptians, Persians and others) for whom the iconography and significance of the phiale were meaningful. This is likely to be the case with rhyta as well.

No metal rhyta can be positively attributed to Egypt during the period of Achaemenid rule. Their presence is hinted at, however, by a letter quoted by Athenaeus (11.784b), which lists precious metal drinking vessels, including rhyta, as well as several types of bowls. This letter is thought to be an excerpt of an inventory of vessels (and other forms of wealth) captured from the satrapal court in Memphis, which was originally part of a report to Alexander written by Cleomenes of Naukratis (Briant 2002, 294–6). It unknown what these rhyta were made of or what form they took. But if the interpretation of this text is correct, it suggests that in Egypt, as in other parts of the empire, the satrap replicated aspects of the royal table, including the use of rhyta.

A handful of rhyta made of other materials either have been found in Egypt or were presumably made there. A fragmentary faience rhyton was found at Canopus on the Mediterranean coast (Cairo JE 18736; Adriani 1938–9, no. 1; Ebbinghaus 1998, 141–8). The vessel is in the shape of a drinking horn, but the animal protome that formed its spout cannot be identified as any creature in particular. The rhyton is decorated with rosettes and a chain of lotuses and buds. There are at least three more extant faience rhyta (Fig. 5.9), also in fragmentary condition, and possibly more which cannot be securely identified as such from their surviving remains (Brooklyn Museum 48.29, 65.3.1, and Louvre E 931; Riefstahl 1968, nos. 61–2; Pierrat-Bonnefois 2005, no. 423; Ebbinghaus 2018, no. 35).[7] Though they are without provenance, they are most likely of Egyptian origin. A ceramic rhyton with a spout in the form of a gazelle protome (Fig. 5.10) was discovered in a tomb at Suwa near modern Zagazig in the Nile Delta (Petrie 1906, 50, pl. 37A).[8] Its excavator dated it to the 18th Dynasty without explanation; however, imported Athenian ceramic vessels of fifth- or early fourth-century date were found in the same tomb, and it is more probable the rhyton dates to the period

[7] Five further pieces in the Louvre (Caubet 2007, nos. 261–4, 267) may in fact derive from rhyta as well.
[8] Plate 37A only appears in the 'double volume' edition of Petrie 1906.

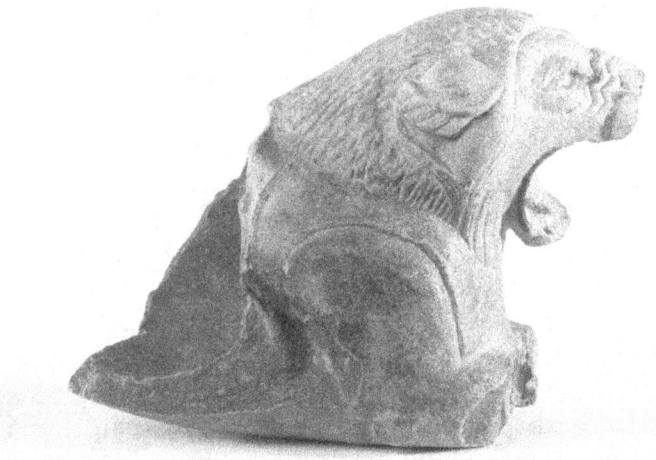

Fig. 5.9. Rhyton fragment, c. 5th century BC. Faience; H. 10.8 cm; L. 11.0 cm; W. 7.1 cm. New York, Brooklyn Museum, 48.29. Image from the Brooklyn Museum reproduced under a Creative Commons licence (CC BY 3.0).

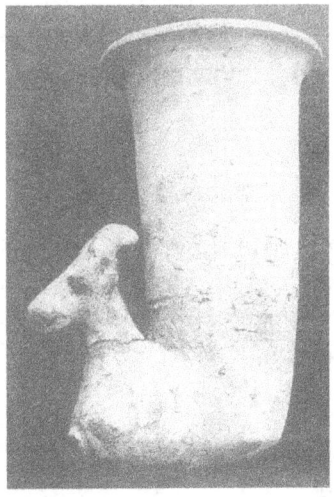

Fig. 5.10. Ceramic rhyton from Suwa, c. 5th–4th century BC. Image in the public domain from Petrie (1906, pl. 37A).

of Achaemenid rule (Ebbinghaus 1998, 146). It is made of a local ceramic fabric, meaning it was made in Egypt and not imported. Finally, a rhyton made of travertine was excavated at Tell el-Ḥesi in Palestine in a Persian Period context. Most travertine vessels found in Palestine were imported from Egypt, so this rhyton is likely to be Egyptian in origin (Stern 1982, 40).

These rhyta are all local adaptations of precious metal prototypes,

and as such they provide indirect evidence for the introduction of rhyta to Egypt during the 27th Dynasty. The prototypes themselves do not survive, most likely because they were melted down during the fourth century or the Ptolemaic Period, as mentioned above. These ceramic, faience and stone vessels indicate that not only was there an elite segment of the Egyptian population using rhyta as markers of status, but also that these rhyta were sufficiently widespread and well known to be emulated by people from lower rungs of society. For these people the appeal of the rhyton was not an implied royal connection, but an allusion to high social status. Indeed, the imported Athenian pottery found in the same grave as the rhyton from Suwa served a similar social purpose.

As discussed earlier, the distinct form of the rhyton mandated certain drinking behaviours on the part of its users. It had to be held aloft in such a way that the wine it contained would shoot out either directly into the drinker's mouth or into a bowl. Moreover, it could not be set down until it was empty. Accordingly, if the rhyta discussed above were used as drinking vessels, they indicate the adoption of a new drinking practice among certain members of Egyptian society. Unfortunately there is no evidence to indicate how these rhyta were actually used.

Achaemenid bowls

The Achaemenid bowls from Egypt come from a range of sites. Two silver Achaemenid bowls (Fig. 5.11) were found by Brugsch at Tell Timai, one with floral decorations on the base and the other with protruding lobes (Cairo CG 53274, 53276; von Bissing 1901, nos.

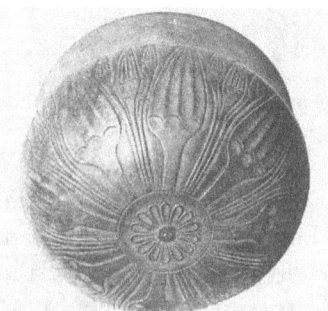 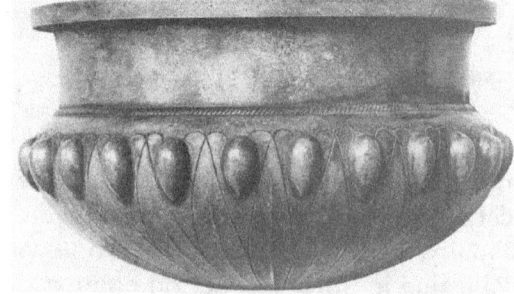

Fig. 5.11. Silver Achaemenid bowls excavated at Tell Timai, Egypt, c. 5th–4th century BC. Cairo CG 53274, 53276. Images in the public domain from Vernier (1927, pl. 109).

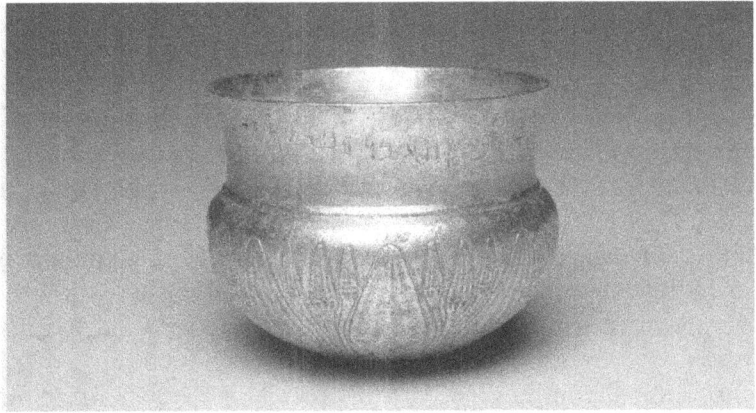

Fig. 5.12. Achaemenid bowl from the Tell el-Maskhuta hoard, c. 5th century BC. Silver; H. 8.5 cm; Diam. 11 cm. New York, Brooklyn Museum 54.50.32. Image from the Brooklyn Museum reproduced under a Creative Commons licence (CC BY 3.0).

3584–5; Vernier 1927, 422–4). Like the phialai discussed earlier, these bowls are usually dated to the Ptolemaic Period, but there is no need to date them so late, especially since their form is so distinctly Achaemenid. In fact, the bowl with floral decoration is a close match to another silver Achaemenid bowl (Fig. 5.12) from the Tell el-Maskhuta hoard (Brooklyn Museum 54.50.32; Cooney 1956, no. 50, pl. 69). The Tell el-Maskhuta bowl has a dedicatory Aramaic inscription on its neck, reading 'that which Ṣeḥa, son of Abdamru, offered to Hanilat' (TADAE D15.3). Like the Kainu phiale, it most likely dates to the fifth century BC, with the inscription added later c. 400. The bowls from Tell Timai are also most likely products of the Persian Period rather than the Ptolemaic. The same is true of another silver Achaemenid bowl excavated from a pyramid at Meroe in 1921 (Boston, Museum of Fine Arts 24.1041; Dunham 1957, 40–1; Török 1989, 119). Although the burial belongs to the fourth century or later, it is likely the bowl itself dates to the fifth century and came to Kush through trade or as a diplomatic gift, possibly even from the satrap.

Two undecorated bronze Achaemenid bowls (University of Pennsylvania Museum E14237–8) were found at Dra Abu Naga on the west bank of the Nile at Thebes by C. S. Fisher, though exactly where is unclear. They have been dated to the 18th Dynasty (Spalinger 1982, 117–18), yet Fisher's (1924) only published report on his excavations there indicates he recovered materials dating from the New Kingdom to the Ptolemaic Period, and there is also

ceramic evidence for a fifth-century BC settlement at the site (Aston 2003, 161–2). So a 27th Dynasty date for the bowls makes the most sense, and this is supported by their morphology. Another of the Tell el-Maskhuta bowls (Brooklyn Museum 57.121; Rabinowitz 1959; Dumbrell 1971, 37–8, fig. 4), with an Aramaic inscription reading 'that which Ḥarbek, son of Pasiri, offered to Hanilat the goddess' (TADAE D15.2), is a close match to their shape. There are also a number of unprovenanced silver and bronze Achaemenid bowls purportedly from Egypt, which suggest at least these bowls were more widespread in Egypt than previously understood (e.g., Petrie 1937, 28, pl. 40 nos. 57–67; Lansing 1938; Radwan 1983, nos. 279–80, 284; Pfrommer 1987, 238–40). These bowls are generally dated to the New Kingdom, the fourth century or the Ptolemaic Period on stylistic grounds (if indeed any grounds are given at all). But their shapes are good matches for the Achaemenid bowl, and in the absence of documented archaeological contexts proving otherwise they should be dated to the Persian Period instead.

Some of the Tell Timai and Tell el-Maskhuta bowls feature decorations drawn from an Egyptian visual tradition that do not appear on vessels made in the imperial heartland. One of the Tell Timai bowls has a repeating lotus-and-bud pattern on its base, as does the Tell el-Maskhuta bowl with the inscription naming Ṣeḥa. This is a very old motif in Egyptian toreutics, one that occurs, for example, on some of the vessels from the Tell Basta hoard of late New Kingdom date (Lilyquist 2012, nos. 22–3, figs 4, 8). The use of Egyptian motifs on these vessels points to their creation in Egypt for an Egyptian audience. As discussed above in reference to phialai, the Tell el-Maskhuta bowls were apparently dedicated to the goddess Hanilat by members of a north Arabian community in the eastern Nile Delta, who had probably originally received them as gifts from the satrap. If this interpretation is correct, it demonstrates how such bowls may have entered circulation in Egypt. While it is true that the Arabian experience may not be typical of the rest of Egypt, it is interesting to note that the names of both of the dedicators of Achaemenid bowls, Ṣeḥa and Ḥarbek, are Egyptian; Ḥarbek's father, Pasiri, also has an Egyptian name (Porten 2002, 298, 300). This means that they were as much a part of the complex social environment of Achaemenid Egypt as anyone else living there.

No glass examples of Achaemenid bowls are known from Egypt, but one was discovered at Aslaia in Cyrenaica in 1969 (Vickers 1972). It was recovered from a tomb datable to c. 425 BC on the basis of the Athenian black-glaze pottery found with it (Vickers

and Bazama 1971, 78–9). The small bowl is made of colourless glass and is decorated with vertical fluting on the body. According to Herodotus (4.165), Arcesilaus III, ruler of Cyrene, submitted to Cambyses shortly after the conquest of Egypt, and later the satrap Aryandes sent a military expedition to enforce this submission (Chamoux 1953, 144–59; Austin 2008, 211–14). Herodotus (3.91.2) further notes that Cyrene, Barca and parts of Libya were included with the sixth satrapy. At the very least this bowl suggests the possibility that glass versions of the Achaemenid bowl were also in use in Egypt during the 27th Dynasty. Though the form of this bowl probably emulates a precious metal prototype, colourless glass of this sort was also valued highly in antiquity (Stern 1997). It should accordingly be regarded as a luxury item, owned by an individual of some standing.

Ceramic Achaemenid bowls have been found in greater numbers. Petrie (1888, pl. 24 nos. 12–13; Spencer 2014, 100, pl. 31) found two at Tell Dafana in the Nile Delta (Fig. 5.13). He noted they were 'distinctly non-Egyptian, and yet not familiar in Greek types', and was unable to date them precisely. Dafana, or Daphnae in Greek, was a temple town, and according to Herodotus (2.30.2-3) it served as a guard post beginning in the reign of Psammetichus I, and continued that function through the 27th Dynasty (Leclère and Spencer 2014). Another bowl was found in the underwater excavations of Herakleion-Thonis, a port town in the western Nile Delta, in the same context as pottery dating from the second half of the fifth century BC to the end of the fourth (Grataloup 2010, 154 fig. 12.5.5). An Achaemenid bowl was found at Tell el-Herr, near Pelousion in the eastern Nile Delta, in a domestic context dating to the early fourth century (Defernez 2001, 330 no. 208, pl. 72). It is possible this bowl actually dates to the Achaemenid Period; if not, it indicates that these bowls continued to be made even after Egyptian

Fig. 5.13. Ceramic Achaemenid bowls from Tell Dafana. Image in the public domain from Petrie (1888, pl. 24).

independence, a point addressed in greater detail below. Tell el-Herr was the site of two successive fortresses, which have been interpreted as a Persian garrison, built to replace the Saite fortress at Tell Kedwa destroyed by Cambyses in 526 (Valbelle and Defernez 1995, 96–9; Valbelle 1998; Defernez 2001, 470–8). This interpretation has been further supported by the discovery of a Persian cylinder seal in a fifth-century level at the fortress (Stern 2001, 538 fig. III.48a). Achaemenid bowls are also reported from Buto, though they are not yet published (Defernez 2011a, 110 n. 6).

Petrie (Petrie and Mackay 1915, 7, pl. 10 nos. 19–21) discovered three more Achaemenid bowls at Heliopolis, north of Memphis, during prospection of the temple precinct. The exact context of the find is not entirely clear from his report, but it is interesting to note they were found in a single deposit along with eight storage jugs, a bowl and a small plate, all of which appear to be established Egyptian types. Petrie assumed that Heliopolis had been destroyed by the Persians, and therefore did not date any of his finds later than the Saite Period; however, Aston (1996, 31) places most of the pottery found at Heliopolis in the 27th Dynasty, which certainly fits the date suggested by the presence of Achaemenid bowls there. Fragments of a single lobed Achaemenid bowl made of faience were discovered in Memphis (Anthes 1965, 126 no. 233), albeit in an industrial area that appears to date primarily to the Ptolemaic and Roman Periods.

Moving to Upper Egypt, an Achaemenid bowl was excavated in the mortuary temple of Sety I at Dra Abu el-Naga on the Theban west bank (Myśliwiec 1987, 69 no. 594). It was found with a large quantity of pottery of fifth-century BC date, which has been interpreted as a dump from a settlement built around the disused temple in the second half of the sixth century (Aston 2003, 161–2). One was also found in the Chapel of Hakoris at Karnak, dating to the early fourth century BC (Lauffrey 1995, 89–91 no. 390). A number of fragmentary Achaemenid bowls were found in the Treasury of Thutmose I at Karnak (Jacquet-Gordon 2012, 229, 320, figs 89r, 133b–c). They have been dated to the Third Intermediate and Ptolemaic Periods. The latter dating is quite possible, since Achaemenid bowls continued to be made into the Ptolemaic Period, but the former dating is probably too early. By the end of the New Kingdom the Treasury seems to have become a residential area and dumping ground (Jacquet 1987, 110), meaning these bowls may have come from domestic contexts, but the archaeological context does not permit certainty on this point.

In the Western Desert, Achaemenid bowls have been found in both the Kharga and Dakhla Oases. At Ain Manawir in the southern Kharga Oasis two bowls were found in a building adjoining the temple of Osiris (Wuttmann et al. 1996, 417–18 [= Groupe 1, nos. 15–16]); a third bowl with painted surface decoration was also found in an unspecified context (Marchand 2002, 260 fig. 11). And at Ain Tirghi in Dakhla an Achaemenid bowl was found in a burial originally attributed to the Roman Period (Hope 1981, 237, pl. 23; Patten 2000, 55), but since reassigned to the fifth century BC (Miller 1997, 136 n. 7). In addition to these, there are probably more examples than those cited here, which have not yet been recognised as such. There is also at least one extant spouted handle in the form of a lion, which is made of faience (Louvre MN 1256; Caubet 2007, no. 266). It resembles the handles of Achaemenid table amphoras, such as those depicted on the Apadana at Persepolis, showing that these vessels were also made in Egypt alongside Achaemenid bowls.

Most of the Achaemenid bowls found in Egypt come from archaeological contexts that are either secondary or generally obscure. Thus it is unclear how they were actually used. But it is interesting that they come from a range of sites, and not necessarily from known loci of imperial activity. The exception to this is Ain Manawir in the Kharga Oasis, which, as discussed in Chapter 3, was the target of development and settlement under Achaemenid rule. This seemingly random distribution suggests that use of these bowls was not limited to places where the imperial presence was strongest; rather, it seems to have spread independently within Egypt. Furthermore, the bowls from Tell Dafana and Herakleion-Thonis have ring bases, and the bowl from Karnak has a flat base. These are adaptations of the normal Achaemenid bowl form that permitted these bowls to be set down while full. This is significant because it means that although the bowl itself was adopted by certain individuals in these places, the actual drinking behaviours of those individuals did not necessarily change. In other words, in some cases the bowls were integrated into existing dining practices.

DRINKING LIKE A PERSIAN

The introduction of Achaemenid drinking vessels to Egypt must have resulted from the belief on the part of certain individuals that these vessels were appropriate to their identities. Achaemenid phialai and rhyta, being vessels used at the royal and satrapal tables, were markers of connections to centres of political power and charismatic

authority. Achaemenid bowls were symbols of imperial unity, and therefore of an identity as a participant in the empire. These two identities were not mutually exclusive by any means, but in general phialai and rhyta were associated with the highest elites – the sort of people who might actually have dined with the Great King or his satraps – whereas Achaemenid bowls were more widespread. The only phiale among the Tell el-Maskhuta bowls, for example, bears the inscription naming Kainu, king of the Kedarite Arabs, whereas the Achaemenid bowls from the same hoard name non-royal individuals. That such bowls were produced in cheaper materials such as faience and clay shows that they also came to be regarded as markers of high social standing, and were therefore worthy of emulation by a broad subset of the population. This does not mean that their Achaemenid connections were lost on most people, but rather that they were effectively integrated into an Egyptian material culture repertoire. The addition of ring bases to some ceramic Achaemenid bowls shows how the shape was adapted to suit the needs of Egyptian practice.

In addition to the adoption of these Achaemenid vessel types, there is also evidence for the introduction of a distinctly Persian mode of drinking, with the bowl balanced on the fingertips. It occurs on the stela of Djedherbes from Saqqara (Cairo JE 98807; Mathieson et al. 1995; Wasmuth 2017c; see Fig. 4.14), discussed in the previous chapter. In the lower register of the stela, a man, perhaps meant to represent Djedherbes himself, is shown with a long beard, wearing the Achaemenid court robe and seated on a chair reminiscent of the thrones depicted in the Apadana reliefs at Persepolis. In one hand he holds a shallow drinking bowl on his fingertips. The bowl is not clearly represented as an Achaemenid bowl or phiale per se, as it lacks a carinated shoulder and everted rim. It may be a generic, simplified rendering of a bowl or another, less distinctive type of drinking vessel, perhaps even an Egyptian one.

This image indicates that Djedherbes had some knowledge of Persian drinking practices, possibly by way of their use at the satrapal court in Memphis. It is impossible to determine how widespread this knowledge was in Egypt; although only elites were likely to understand its full implications, as with many such refined behaviours it would have been emulated by people of lower status. That Djedherbes saw fit to include it on his funerary stela suggests that he believed it would be meaningful to his audience, however that might be construed. It is also significant that Djedherbes is not shown holding one of the distinctive Achaemenid vessel types, indicating

that this mode of drinking did not require the use of Achaemenid vessels specifically.

The stela of Djedherbes also links the Persian mode of drinking with high status through the depiction of foreign wine jars.[9] Beneath the table on the right side of the lower register are three storage vessels that appear to be foreign amphoras. The amphora in the middle, which has a biconical body, loop handles at the shoulder and a mud stopper in its mouth, is a close match to a well-known type of Palestinian amphora used to transport wine (Bettles 2003, 104 [Type A1]). Amphoras of this type have been found in a number of Persian Period tombs in the southern Levant, as well as in the 'Residency' at Lachish (Bettles 2003, 265–7), a major imperial centre in the region. The other two amphoras are more difficult to identify. The one on the left shares features with a number of Palestinian amphora types, ranging in date from the eighth to the late fourth centuries BC (Sagona 1982, 79–80, fig. 1), and the one on the right resembles a type of amphora from Cyprus or the Levant, ranging in date from the seventh to the fourth century (Sagona 1982, 88, 90, fig. 4; Mathieson et al. 1995, 32–3).

The presence of these amphoras on the stela implies that Djedherbes regarded imported wine as the most fitting drink for himself. Wine had been made in Egypt since the Old Kingdom, if not before. By the Late Period, however, Egypt was part of an eastern Mediterranean trade network by which wine and other products were imported from Greece and the Levant (Salles 1994, 191–200). This is most clearly attested in the Aramaic customs document found at Elephantine and dated to 475 BC (TADAE C3.7; Yardeni 1994; Briant and Descat 1998; Cottier 2012). It lists ships arriving at and departing from an unnamed Egyptian port and notes the contents of their cargoes. Wine occurs in the cargoes of both Greek and Phoenician ships (where it is called 'Sidonian' wine). It also occurs in the cargoes of ships of *kzd/ry*, now identified as being from Tell Ghazza in Palestine, where numerous amphoras of the same type as appears on the stela have been recovered (Tal 2009). These imported amphoras have also been found in the Nile Delta, and as far south as Elephantine (Bettles 2003, 254). Another Aramaic document (TADAE C3.12), possibly from Memphis and probably dating to late in the fifth century, lists quantities of Egyptian and Sidonian wine being allotted for meals and for ritual purposes.

It is unclear what social significance this imported wine had. It

[9] See Bettles 2003, 266 fig. 8.4, for an updated drawing of these jars.

could have been associated with the empire in some way. Perhaps, since the import duties levied on wine were paid in kind, imperial administrators were apt to drink foreign wine. Or possibly imported wine was considered better or more exotic than Egyptian wine, and this was thus a statement of socioeconomic standing. In this regard it is interesting to note that foreign amphoras were imitated by Egyptian potters (Defernez and Marchand 2006, 64–81; Defernez 2012), most likely because these amphoras had come to possess a degree of social cachet, on account of the cost and discernment implied by their contents. For Djedherbes, the combination of imported wine and sophisticated table manners was emblematic of his identity as an Achaemenid Egyptian; that he represented it on his funerary monument indicates that he expected others to be able to understand this combination, no doubt because it was not unique to him.

The adoption of Achaemenid phialai, rhyta and bowls was not the only way in which Egypt's inclusion in the empire affected the decisions people made about the vessels they owned and used. Catherine Defernez (2011b) has recently discussed several 'Bes vases' – ceramic containers decorated with raised facial features so as to represent the Egyptian god Bes – excavated at Tell el-Herr. Bes vases had been made since at least the New Kingdom, but the examples discussed by Defernez do not have clear precedents in the Egyptian ceramic repertoire. Rather, Defernez argues they are modelled on prototypes from elsewhere in the Achaemenid Empire. One of these Bes vases, a jug with a bulging profile and carinated shoulder, is modelled on Near Eastern metal *situlae*. Another, which is roughly cylindrical, resembles bronze drinking cups excavated at Deve Hüyük. A third, of which only a single sherd survives, was part of a thin-walled cup with a carinated shoulder and everted rim. Though it has some similarity to the Achaemenid bowl, its closest parallel is a shape found in the so-called 'eggshell ware' pottery of Achaemenid Mesopotamia.

Defernez's findings raise some important possibilities. First, she notes that while these vessels are unique among Bes vases, undecorated versions of them have been found elsewhere in Egypt in contemporary contexts. This suggests that Achaemenid phialai, rhyta and bowls were not the only Persian vessel shapes adopted by Egyptian potters during the 27th Dynasty, and, by extension, that dining and drinking practices may have changed in more complex ways than those discussed in this chapter. Second, although the precise function of Bes vases remains uncertain, the image of the god implies a close connection with religious practice and belief. It is interesting that

such vessels were an arena for innovation under Achaemenid rule. This may indicate the degree to which non-local elements were being integrated into Egyptian daily life, or it may illustrate the utilisation of Egyptian religious ideas by imperial agents stationed in the garrison at Tell el-Herr. Indeed, images of Bes were widely distributed throughout the empire in a variety of media (Abdi 1999; 2002), and these unusual Bes vases may be symptomatic of this phenomenon as well.

THE LEGACY OF PERSIAN DRINKING

The adoption of Achaemenid phialai, rhyta and bowls in Egypt, although not widespread, shows that elements of the social hierarchy established in the Persian heartland extended to Egypt. As putative gifts of the king, phialai and rhyta implied royal connections, and Achaemenid bowls served as markers of imperial (as opposed to local) identity. As with any form of identity, these were aspirational as much as actual; ownership of a phiale, for example, did not necessarily mean a person had dined with the Great King, only that he thought of himself as, or wished himself to be, the sort of person who might. But they nevertheless functioned as a means of creating new social distinctions at the expense of traditional elites, or maintaining existing ones in the face of social and political changes brought on by Achaemenid rule. This is further suggested by the production of these vessels in faience and ceramic; people of middling status recognised the social power of these vessels and emulated them accordingly in materials they could afford. The nuances of phialai and rhyta versus Achaemenid bowls were probably lost in the process, but they retained their appeal as signs of distinction.

The significance of Achaemenid drinking vessels as markers of elite and non-local identity persisted after the end of Achaemenid rule in Egypt c. 404 BC, through the fourth century, and even into the early Ptolemaic Period. The best evidence for this persistence is the tomb of Petosiris at Tuna el-Gebel (Lefebvre 1923-4; Cherpion et al. 2007), the necropolis of the ancient city of Hermopolis Magna, northwest of the modern city of Mallawi. The tomb, which is discussed further in Chapter 7, is usually dated to the last quarter of the fourth century BC. According to the biographical inscription carved on its walls the tomb's owner, Petosiris, was a high priest of Thoth whose career spanned the second half of the fourth century. The painted reliefs in the tomb's porch (see Fig. 7.1) depict the production of metal rhyta, as well as of an Achaemenid bowl and phiale (Cherpion et al. 2007,

34–5). The other reliefs in the tomb feature scenes of agricultural and other productive activities, a visual articulation of Petosiris's needs for the afterlife.

The inclusion of these Achaemenid vessel types in this early Ptolemaic tomb suggests that such vessels continued to be made in Egypt throughout the fourth century, and that they continued to be important correlates of elite identity even after the social order that had created them was removed. The depiction of production rather than use of the vessels is also significant, because it is a usurpation of the role of the satrap or the king. In this respect Petosiris is following in a long-established Egyptian tradition. During times of strife, such as the fourth century BC, local elites often portrayed themselves as taking on royal responsibilities. Indeed, in the inscriptions in his tomb Petosiris even claims to have founded a temple, normally an exclusive royal prerogative. And he used the production of distinctly Achaemenid drinking vessels to further this image of his royal stature (Colburn 2015, 186–94). That Petosiris was not alone in regarding these vessels as crucial markers of status is suggested by the assortment of Achaemenid bowls and rhyta dated to the Ptolemaic Period (Pfrommer 1987).

6. Coinage and the Egyptian Economy

And, bearing their wheat over a glittering sea,
Ships carry from Egypt vast wealth.

Bacchylides of Ceos

THE SATRAPAL ECONOMY

This chapter is concerned with the impact of Achaemenid rule on the Egyptian economy and what this may tell us about the experience of that rule in Egypt. The exaction of tribute is a frequent feature of ancient empires, and this was certainly true of the Achaemenids as well, in Egypt and across the entire empire (Briant 2002, 388–421; Klinkott 2007a). According to Herodotus (3.92.1), Egypt (including Cyrene and Barca) paid 700 Babylonian talents per year in tribute. When compared to the princely revenues of the Ptolemies (Fischer-Bovet 2014, 67–70), in excess of 12,000 talents per year according to Strabo (18.1.13) and St Jerome (*Daniel* 11.5), this is a rather modest sum (Bresciani 1989, 29–30). Yet at the same time Achaemenid tribute demands changed the Egyptian economy in certain fundamental ways. Following the advent of Achaemenid rule, coins were imported to Egypt for the first time. These coins came primarily from the Greek world, and they were imported in large part to satisfy the empire's tribute demands. Specifically, it was Athens that became Egypt's main supplier of coins (especially tetradrachms) at this time. At the height of its power in the fifth century BC Athens had a considerable need for grain, and thus its exchange of coins for grain was a critical one that served both economies perfectly. By the mid-fifth century the Athenian tetradrachm (also known as the Attic tetradrachm) was the most common coin in Egypt. By the last decade of the century it

was serving as a unit of account at Elephantine and at Ain Manawir in the Kharga Oasis. It became so embedded in economic practice that imitations of Athenian tetradrachms were struck in Egypt. The use of the tetradrachm as a bullion coin continued well into the fourth century. After the Persians regained control of Egypt c. 340 BC following a six-decade hiatus, there were coins struck in the names of Artaxerxes and the satraps Sabaces and Mazaces that retained the tetradrachm's weight and types.

Put simply, an important impact of Achaemenid rule on Egypt was the introduction of coinage into the economic system there. This put the country on the road to monetisation, a process later developed more fully under the Ptolemies. The use of coins affected temple administrations as well as the imperial offices of the satrapy. Temples were major economic actors and institutional lessors of farmland, and as such changes to the Egyptian economy had a significant impact on them. Coinage also affected individual Egyptian farmers and artisans, whose labour helped to provide much of the wealth used for tribute. How it affected each varied. Some people embraced coinage, while others chose to treat it as bullion; some temples began to strike their own coins, while others show no traces of doing so. What is clear is that even though the use of coins was limited to certain individuals and institutions, depending perhaps on their respective relationships with the empire and the outside world, Achaemenid rule caused distinctive and lasting changes in the Egyptian economy.

COINS AND MONEY IN FIFTH-CENTURY EGYPT

At the time of Cambyses' invasion coins were not in use in Egypt. Instead, as in many other premodern societies, the Egyptian economy consisted of systems of staple and wealth finance, in which food staples and wealth objects served as money (Colburn 2018c, 72–81). In Egypt, due to the enormous fertility of the Nile Valley and the predictability of the Nile floods, grain (specifically emmer wheat and hulled barley) was the main food staple. It was also used to store wealth and to make payments. Beginning in the New Kingdom, silver and copper especially were used as units of account for transactions, such as in the hieratic ostraca from the workmen's village at Deir el-Medina (Janssen 1988). There is evidence for the circulation of silver bullion as early as the fourteenth century BC, when the earliest securely dated *Hacksilber* hoard occurs. *Hacksilber*, a German term for chopped silver bullion, is the most common form of pre-

cious metal wealth in Egypt prior to the introduction of coinage, though any silver object could serve as a store of wealth or means of exchange. Hoards of *Hacksilber* continue well into the Late Period (van Alfen 2004–5a; Vargyas 2010, 147–64; Jurman 2015, 56–7), though these hoards are difficult to date precisely because of the generally mutilated condition of their contents.

Beginning in the ninth century BC with P. Berlin 3048, marriage contracts include references to weighed quantities of silver, which were typically to be paid to the wife in the event of divorce (Lüddeckens 1960). Similarly, loan agreements and the penalty clauses in contracts such as land leases and sale agreements also refer to weighed quantities of silver at this time (Vleeming 1991, 87, 103–5). In the earliest such documents silver is weighed against the 'stones' (weights) of the treasury of the temple of Heryshaf in Thebes; in Demotic they are simply called the 'stones of the Treasury of Thebes'. By the fifth century the stones of the temple of Ptah in Memphis supplanted those of Heryshaf (Vleeming 1991, 87–9; Vargyas 2010, 165–7; Jurman 2015, 60–3). The continued use of silver bullion as money during the fifth century is demonstrated by agreements detailing loans of weighed quantities of silver, such as P. BM 10113 (Donker van Heel 2012, 35–9), P. Hou 12 (Vleeming 1991, 156–77) and TADAE B3.1 and 4.2 (Porten et al. 1996, nos. B34, B48).

The lack of coins in Saite Egypt is demonstrated by the absence of hoards buried immediately on the eve of the arrival of the Achaemenid army in c. 526 BC. Threats of war or invasion create the sort of conditions in which hoards are often hidden and then not recovered because the hoarders are unable to return to reclaim them, especially soldiers concealing wealth before deployment (Casey 1986, 61–2). The only known coin hoard that could possibly predate Achaemenid rule is IGCH 1632, which contained at least five gold Lydian croeseids. Only their weights are known (Regling 1904, 25); no images of them were ever published. These indicate that the coins were minted on the lighter of the Lydian gold standards, meaning they could date as early as the reign of Croesus (560–547/6 BC), though they could just as well date later (Cahill and Kroll 2005, 609–13). Without pictures of them they cannot be dated more precisely. But even if the coins in this hoard were minted during the reign of Croesus this does not prove anything about the hoard's burial date, and it certainly does not indicate that coins played any role in the economy of the 26th Dynasty.

With the exception of IGCH 1632 the earliest coin hoards from

Table 6.1 Fifth-century coin hoards from Egypt.

Reference	Burial date (BC)	Findspot	Contents
IGCH 1632	6th century	Egypt	5 AU
IGCH 1635	c. 500	Fayum	2 AR
IGCH 1638	c. 500	Nile Delta	30 AR
IGCH 2.10	c. 500	Egypt	14+ AR
IGCH 1636/CH 3.2	c. 500–490 (Sheedy 2006, 144–5)	Memphis	23+ AR
IGCH 1637	c. 500–490 (Sheedy 2006, 145)	Damanhur	165 AR
IGCH 1639	Early 5th century	Xois	72+ AR
CH 8.57	Early 5th century	Egypt	14 AR
IGCH 1640	c. 485 (Sheedy 2006, 146)	Athribis	77+ AR
IGCH 1641	c. 480	Alexandria	4 AR
IGCH 1642	c. 480	Damietta	5+ AR
IGCH 1643	c. 480	Memphis	4 AR
CH 1.7	c. 480	Egypt	14+ AR
IGCH 1644/CH 10.435	c. 475–470	Assiut	900 AR
IGCH 1634/CH 9.681	c. 470–465 (Hardwick 1998, 125)	Egypt	4 AR
IGCH 1646	c. 460	Fayum	15 AR
IGCH 1645/CH 10.436	c. 450 (Sheedy 2006, 147)	Zagazig	84 AR
CH 10.437	c. 450	Egypt	19+ AR
IGCH 1647	c. 440–435 (Mattingly 1996, 448–9)	Naukratis	15 AR
Fischer-Bossert and Gitler 2010	c. 425–400	Ismailiya	14 AR
IGCH 1653/CH 9.682	c. 400	Giza	2 AR
CH 10.438	Late 5th–early 4th century	Egypt	2 AR

Egypt date to around 500 BC (see Table 6.1). From that point onwards they continue to occur throughout the fifth century in varying sizes from 900 coins down to two. The chronological distribution of these hoards tends to clump in certain places, especially around the year 480. This is probably because the Persian Wars, and especially the destruction of the Athenian acropolis, are used as chronological benchmarks by archaeologists and numismatists alike. The mints represented in these hoards are located all over the eastern Mediterranean, including mainland Greece, the Aegean islands, Macedonia, Thrace, Asia Minor and Cyprus. There are also coins from Sicily, Magna Graecia, Cyrenaica, the Levant and Sinope on the Black Sea. Hoards buried before 480 are characterised by a great

Table 6.2 Hoards with bullion or *Hacksilber* from Late Period Egypt.

Reference	Burial date (BC)	Findspot	Content
CH 2.10	c. 500	Egypt	5 AR
IGCH 1636	c. 500–490	Memphis	73 kg AR
IGCH 1637	c. 500–490	Damanhur	2 AR
IGCH 1639	Early 5th century	Xois	3+ AR
IGCH 1640	c. 485	Athribis	238.25 g AR
CH 1.7	c. 480	Egypt	19 AR
IGCH 1644	c. 475–470	Assiut	6 AR
IGCH 1645	c. 450	Zagazig	17 AR
CH 10.437	c. 450	Egypt	7 AR
IGCH 1647	c. 440–435	Naukratis	1,191 g AR
IGCH 1650	Late 5th century	Nile Delta	8.33 g AR
CH 10.438	Late 5th–early 4th century	Egypt	314.6 g AR
IGCH 1649/ CH 10.441	Early 4th century	Tell el-Maskhuta	4500+ g AR
IGCH 1652	c. 360	Naukratis	'a few' AR
IGCH 1651	Mid-4th century	Beni Hasan	2 AR
Van Alfen 2004–5b	Late 4th century	Egypt	39.93 g AR

diversity of mints, whereas in those deposited after 480 the coins of Athens have a 'virtual monopoly' (Thompson et al. 1973, 225).

The distribution of these hoards is almost entirely confined to the Nile Delta. The one exception to this is the famed Assiut Hoard (IGCH 1644), which was found at Assiut in Middle Egypt. Neither the date (c. 475–470 BC) nor the content of this hoard provides any clue as to the conditions of its burial. But ancient Assiut served as the border between Upper and Lower Egypt, and the presence of coins there, but no further south, indicates that coin use in the fifth century was on the whole limited to Lower Egypt.

Many of these hoards also include *Hacksilber* and other forms of unminted silver (Table 6.2).[1] Moreover, several of these fifth-century hoards have coins which were chopped up, implying they were

[1] IGCH 1649/CH 10.441, the Tell el-Maskhuta hoard, is included here because of the silver vessels (discussed in Chapter 5) associated with the hoard of (imitation) Athenian tetradrachms. The Brooklyn Museum acquired the bowls along with some gold-mounted stones in 1947 (Rabinowitz 1956), and an early report on the coins (Jungfleisch 1949) also mentioned gold-mounted stones, suggesting that all the objects had indeed been discovered in the same place. But Jungfleisch does not give his source for this information, and it is impossible to know for certain the provenance of these bowls. If they were part of the same hoard, they represent a store of wealth in the form of bullion, as well as a votive deposit.

treated as *Hacksilber*. Indeed, the test cuts one often finds on coins from Egyptian hoards further demonstrate that they were regarded as pieces of silver valued according to their weight and fineness. There is nothing to suggest that their face value had any meaning. In essence these coins represent imports of silver bullion into Egypt.

GREEK COINS AND EGYPTIAN TRIBUTE

The sudden presence of Greek coins in Egypt following the advent of Achaemenid rule cannot be coincidental. Some aspect of Achaemenid imperialism must have created a need to import silver, and the most obvious explanation pertains to the payment of tribute. As noted at the beginning of this chapter, Herodotus (3.92.1) states that Egypt paid 700 Babylonian talents per year in tribute following the implementation of Darius's reforms. Herodotus's source for this figure is unknown; suggestions that it, along with the other tribute figures he provides, is derived from an official Achaemenid imperial source are undermined by his presentation of the list of satrapies from a decidedly Greek geopolitical standpoint (Asheri 2007, 479–81; Ruffing 2009).

Although the figures cannot be verified, the payment of tribute in silver rather than in kind is extremely probable, at least in the case of Egypt. This is because the geographic dynamics of the empire inhibited payment in grain, Egypt's traditional form of wealth. First of all, southern Mesopotamia was extremely fertile (Potts 1997, 80–2). This means that if Persepolis, Susa, Ecbatana or Babylon (the four cities usually identified in classical sources as the empire's royal capitals) required significant quantities of grain, it could be supplied more easily and more readily from Mesopotamia than from Egypt. Also, none of these four cities was especially large; according to Boiy (2004, 229–34), for example, the population of Babylon in the fourth century did not exceed 50,000, and a recent estimate (Colburn forthcoming a) puts the population of Persepolis c. 493 BC at approximately 16,000. So it is unlikely there was any need for grain to be imported. Finally, the cost of overland transport would have significantly devalued any grain used as tribute. This cost can be overestimated in scholarly literature, but combined with southern Mesopotamia's fertility and the lack of a pressing need for large quantities of grain in the imperial capitals it would have made imported grain next to worthless as tribute. Silver, the other primary form of money in Egypt at the time of Darius's reforms, suffered from none of these shortcomings because of its density and intrinsic

value, and therefore was eminently serviceable as a form of tribute payment.

In Egypt, however, there were very few native sources of silver. Some was available in the form of 'aurian' silver which occurred in the same ore as gold (Gale and Stos-Gale 1981; Ogden 2000, 170–1); indeed, many of the silver objects from Egypt are made from such metal. In light of this it may seem illogical for tribute to have been imposed in silver instead of gold, which was seemingly more abundant, but there are several reasons for this. First, gold was never used as a unit of account in Egypt; in other words, it was not a recognised form of money. Grain, copper and silver were used as money prior to Achaemenid rule, and of these silver had the highest ratio of value to weight, making it suited to transport over long distances.

Second, although there are more natural sources of gold than silver in Egypt, these are primarily out in the Eastern Desert of Upper Egypt, closer to the Red Sea coast than to the Nile Valley (Klemm and Klemm 2013, 601–21). Many more are located in Kush. The exploitation of these sources normally required expeditions organised at the pharaonic level. So gold was not exactly easy to come by. The imposition of tribute payments in gold on Egypt would have been a departure from normal Egyptian monetary practice, and would have been difficult to implement using existing economic structures.

Finally, exploitation of Egypt's mineral resources was a pharaonic prerogative. If, as is argued below, the Great King and his satrap used temples as the primary mechanism for exacting tribute from Egypt, it stands to reason that the gold mined in the Eastern Desert was regarded as separate from tribute payments. When Darius came to Egypt, he would have seen silver used as money, so requiring tribute in silver would have seemed a sensible continuity of existing practice. He would not have been in a position to query its availability and ease of procurement relative to gold.

During the New Kingdom, Egypt received silver as tribute from its vassals in the Levant, and following the collapse of Egyptian power abroad some silver was probably received through trade (Pons Mellado 2006, 12–16). In general there was little pressure in this period to increase the overall amount of silver circulating in Egypt. But beginning with Darius's economic reforms, if not before, it became necessary to import silver in greater quantity than previously. The near exclusive presence of Greek coins in Egyptian hoards indicates that this silver was imported from the Greek world. That Greek coins do not survive in any vast quantity in the central

and eastern reaches of the empire is probably due to these coins being treated as bullion and chopped up or melted down as needed. According to Herodotus (3.96.2; see Zournatzi 2000),

> the Persian king stores this revenue of his by melting it down and pouring it into clay jars; then, when each jar is full, he removes the surrounding clay. Whenever he wants money, he slices off as much as he needs at that time. (trans. R. Waterfield)

Strabo (15.3.21) closely echoes this assertion. Also, as mentioned in the previous chapter, Diodorus (17.80.3) and Strabo (15.3.9) both report that Alexander looted some 180,000 talents of silver from the major cities of the empire, and de Callataÿ (1989) has proposed that this booty served as the raw material for the early Hellenistic coin issues. Furthermore, the few pre-Hellenistic coin hoards in the central and eastern parts of the empire contain Greek coins almost exclusively (Le Rider 2001, 179–85). So once shipped eastward the Greek coins used for Egypt's tribute payments essentially disappeared, as they were used to make Persian sigloi or other silver objects or were carried off by Alexander's army.

The availability of Greek coins in Egypt comes as no surprise because, in addition to silver resources in Attica, Macedonia and Thrace, there was also demand in the Greek world for grain, as well as for several of Egypt's more specialised products. During the Classical Period many Greek cities imported grain (Bissa 2009, 193–206), especially cities such as Aegina which were major commercial centres that had little farmland at their disposal. Athens in particular would have been a major importer of grain for much of the fifth century BC at the height of its imperial power. Exactly how much grain it needed to import remains a point of contention, but at the very least the high population estimates for the city are strongly indicative of a need to import grain, and the need apparently persisted into the fourth century when Athens's population and political power were both in decline (Moreno 2007, 3–33; Bissa 2009, 169–91). Egypt's role as a grain exporter is more often implied than articulated, and the evidence for it is allusive and indirect. The most explicit statement to this effect is in a poem by Bacchylides (fr. 20B.14–16; Fearn 2007, 35), quoted as the epigraph to this chapter, written in the mid-fifth century BC. But it is also worth noting here that the other purported major grain supplier to the Greek world, the Black Sea region, was not nearly so steady a producer as Egypt, and the Black Sea grain trade does not seem to have been very prominent until the end of the fifth century (Braund 2007, 42–51).

Other Egyptian products, particularly papyrus, linen and natron, were also in demand in Greece. Papyrus was the standard writing medium in the Greek world from at least the sixth century BC onwards, if not before, and Egypt was the only source of it in antiquity (Lewis 1974, 84–94; Roemer 2008). Linen was another sought-after Egyptian export. Although the production of linen was not exclusive to Egypt, it was produced there in greater quantity than anywhere else (Vogelsang-Eastwood 2000, 269–76). Natron and alum were again largely exclusive to Egypt, and were exported all over the Greek and Near Eastern worlds. The Aramaic customs document from Elephantine TADAE C3.7 refers to both Greek and Levantine ships departing from Egypt with cargoes of natron (Bresciani 1996; Briant and Descat 1998; Cottier 2012; Boardman 2013), and there is evidence in cuneiform tablets of alum being sold at Babylon only a few years before the Achaemenid conquest of Egypt (Oppenheim 1967). In addition to these products, which were uniquely Egyptian, there were others such as ivory from central Africa and aromatics from south Arabia for which Egypt was a major entrepôt (Sofia 2007). These too found a market among the Greeks.

The near absence of Phoenician and other Levantine coins in fifth-century Egyptian hoards does not necessarily indicate that the volume of the Levantine trade was less than that of the Greek trade. The hoard evidence demonstrates that Phoenician coins of the fifth and fourth centuries generally did not circulate far outside the Levant, and those few that did have been found primarily in Egypt (Elayi and Elayi 1993). It may well be that even though the cities of Phoenicia and Palestine did start minting their own coins in the mid-fifth century, Levantine merchants continued to use Greek coins for foreign commerce. As in Egypt, the Athenian tetradrachm became quite common in the Levant in the second half of the fifth century (Nicolet-Pierre 2000; Flament 2007a, 173–232).

The precise mechanisms for this trade are unclear, but certain aspects can be deduced. For example, Naukratis served as a port of trade between the Greeks and Egypt during the Saite Period (Posener 1947; Möller 2000, 182–215; Colburn 2018a, 85–7). It seems to have had a similar function in the fourth century as well, as indicated by the decree preserved on the Naukratis stela of Nectanebo I, which refers to the collection of an import duty there on items travelling on 'the sea of the Greeks' (Lichtheim 1976; 1980, 86–9). Naukratis surely served this same purpose during the fifth century, if not earlier. Indeed, the ceramic evidence from the site shows a gap in the Athenian pottery between 525 and 500 BC followed by a

resurgence after 500 (Boardman 1999, 125). This strongly suggests continued trade activity there. The decree of Nectanebo also refers to the nearby harbour of Herakleion-Thonis collecting duties, and recently a near identical copy of the decree was discovered there (von Bomhard 2012). Herakleion-Thonis's role as a port of trade during the 27th Dynasty is further confirmed by the shipwrecks of fifth-century date found there (Fabre 2011). In the eastern Nile Delta, Pelousion probably served a similar purpose to Naukratis, and many of the sites previously identified as Saite Period στρᾰτόπεδοα probably actually belong to the Achaemenid Period and were commercial rather than military in nature (Carrez-Maratray 2000). If so, there is significant evidence for the continued presence of Greek merchants in the Delta throughout the fifth century. Naukratis, Herakleion-Thonis and Pelousion served as the major points of interaction between Egypt and the eastern Mediterranean, and as collection points for import and export duties.

It is less apparent who the primary actors responsible for this trade were. On the Greek and Levantine side the main participants were presumably seaborne *caboteurs*, Braudel's (1972, 296) 'proletarians of the sea', who characterised Mediterranean trade in many periods of history. Certainly this is consistent with the varied cargoes coming into Egypt as listed in TADAE C3.7. But this customs register also attests to at least one case of a sea captain, Glaphyros by name, who made two voyages to Egypt in a single sailing season, implying he moved directly between two different ports rather than tramping along the coast (Lipiński 1994, 66–7). He was carrying natron rather than grain, but the same practice is implied with specific reference to grain in the Athenian law court speech *Against Dionysodorus* (Ps.-Demosthenes 56), dating to c. 322 BC. According to this speech the defendant entered into an agreement to sail to Egypt, buy a cargo of grain and return to Athens with it. Instead of doing this, he went to Rhodes. The plaintiff supposes that the defendant did this so he could make multiple trips between Egypt and Rhodes in a single sailing season, whereas had he returned to Athens as per the agreement he would have been compelled to remain there for the winter. This suggests that certain captains specialised in the transport of grain, and sailed directly between Egypt and potential markets such as Athens and Rhodes.

On the Egyptian side there is no direct evidence for who the traders were, but as the primary holders of arable land, the temples are very likely candidates. Papyrus Reinhardt offers a good indication of the extent of these landholdings (Gasse 1988, 139–66; Vleeming

1993), as do the later Demotic receipts for harvest taxes paid to the temples (Donker van Heel 2012, 101–13; Colburn 2018c, 73–6). Their usufruct of large areas of farmland gave them access to large quantities of grain, and of any of the economic actors in Egypt the temples were the best equipped to export it. Indeed, Egyptian temples have a long history of engaging in trade activities, including foreign trade (e.g., Castle 1992). Of course there may have been middlemen involved who bought grain from temples and sold it to Greek merchants.

It is also possible that the satrapal government was exporting grain. According to the pseudo-Aristotelian *Economics* (1352a–b), Cleomenes of Naukratis, satrap of Egypt under Alexander, bought grain directly from farmers for export. At the same time, however, he also explicitly banned the export of grain, apparently to create a monopoly for himself. The *Economics* (which dates to the early Hellenistic Period) provides the only direct evidence for satrapal involvement in the grain trade, and on the whole Cleomenes' activities are generally viewed as exceptional. But Alexander's rule of Egypt, including the appointment of Cleomenes as satrap, suggests continuity with Achaemenid practice rather than divergence (Burstein 2008), so it is entirely possible that Cleomenes simply excelled at this aspect of satrapal administration.

It is more likely, however, that the Achaemenid satraps simply used the Egyptian temples as instruments for collecting tribute by requiring payments in silver. Achaemenid administrative oversight of temple finances is documented in a few sources. In the Demotic letter P. Berlin 13536, an official named Khnemibre writes to the priests of the temple of Khnum in Elephantine demanding that they produce the temple accounts for the years 22 to 24 of Darius (500–498 BC). Khnemibre's title, *ḥry-ib-tpy*, suggests he was a high-ranking financial official in the satrapal administration, and the purpose of this requirement may have been to assess the temple's finances in order to determine how much tribute could be collected from it (Bresciani 1989, 31; Fried 2004, 80–1). The text on the verso of the Demotic Chronicle (Kuhrt 2007, 125–6), which preserves fragments of a decree of Cambyses regulating temple revenues, might also be read in this context. As Damien Agut-Labordère (2005a; 2005b) has argued, the goal of this decree was to increase the economic efficiency of temple estates, presumably with a view towards generating more tribute. This sort of approach to tribute exaction may also have been used in Achaemenid Palestine (Schaper 1995), and it represents a form of imperialism in which existing local institutions were

appropriated as intermediaries between imperial officials and the subjects of the empire. It is interesting to note as well that the introduction to Egypt of the *artaba*, a Persian unit of dry measure used for grain, also facilitated conversions between Greek and Egyptian units of dry measure (Vleeming 1981; Chauveau 2018). Thus the use of the *artaba* there may well have been an indirect result of tribute demands in silver, rather than a direct result of tribute demands in kind.

The appearance of Greek coins in Egypt for the first time at the end of the sixth century BC must be related to the imposition of tribute by the Persians. Since the geography of the empire compelled tribute in the form of precious metal, mainly silver, which Egypt did not have in abundance, it was necessary for the Egyptians to convert grain, the main form of wealth there, into silver through trade with the Greeks and Phoenicians. While this did not necessarily cause structural changes to the Egyptian economy, the increased presence and circulation of silver had distinctive consequences, and these are explored in the following sections.

'ARYANDIC' SILVER

An interesting corollary to the use of Greek coins for tribute payments is the potential for rereading Herodotus's account of the demise of the satrap Aryandes in an economic context, which in turn adds to our understanding of the role of coinage in fifth-century Egypt. According to Herodotus (4.166),

> Aryandes was the man Cambyses had made governor of Egypt. Later, he was to be executed for trying to claim equal status with Darius. What happened was that he realized – it was obvious – that Darius wanted to leave behind as a memorial to future generations something which no other king had achieved, and he proceeded to do likewise, until he received his reward for doing so. Darius had refined gold until it was as pure as it possibly could be and then struck coinage with it; when Aryandes was in charge of Egypt he did the same with silver. In fact, Aryandic silver is the purest silver even today. When Darius found out what Aryandes was doing, he brought a different charge, that of sedition, against him, and had him executed. (trans. R. Waterfield)

The date of Aryandes' removal from office and execution is not known, but it could have been as early as c. 518 BC (the putative date of Darius's return to Egypt as king) and he was certainly deposed before 492 when another satrap, Pherendates, is referred to in the Demotic documents from Elephantine (Chauveau 1999; Corcella 2007, 692–3). The numismatic context for this story places

Aryandes' demise around 510–505, as this is when Darius began to mint gold coins (Konuk 2012, 52).

Despite some novel dissenting views (Tuplin 1989; Sheedy and Gore 2011), it is generally agreed that Aryandes did not mint coins. Herodotus uses different terms to describe the activities of Darius and Aryandes respectively (νόμισμα ἐκόψατο for Darius versus ἀργύριον ἐποίεε for Aryandes), and no known coin can be safely attributed to Aryandes. The apparent absence of a factual basis for this episode has prompted scholars to look elsewhere to explain its function in Herodotus's narrative. Peter van Alfen (2004–5a, 24–6) has proposed that rather than minting coins Aryandes instead issued an edict defining a high grade of silver, referred to by the Greeks as 'Aryandic'. The purpose of this edict was to control the quality of the silver bullion in circulation, since there was no easy test for fineness and it was the nature of bullion to be melted and mixed indiscriminately. This would have been especially important in light of the need to pay tribute with silver of a certain guaranteed fineness. As noted in the previous section, Herodotus's remark (3.96.2) that the Great King melted down all precious metal tribute and then simply chipped off whatever was required on a given occasion has been taken to mean that the empire treated the tribute it received as bullion (Zournatzi 2000). Since the fineness of bullion was not guaranteed by a minting authority it had to be assured by other means, such as the definition of specific grades of metal purity, and their enforcement by the state where appropriate. In the case of Egypt, Aryandes added an additional, higher grade of silver to the existing scale in order to clarify the minimum fineness for the silver that was to be used for tribute. This was primarily a self-serving move, since as satrap he was ultimately responsible for making tribute payments.

Van Alfen (2004–5a, 23–4) identifies two grades of silver referred to in the Elephantine Aramaic papyri, one around 90 per cent fineness and the other around 95 per cent. He proposes that Aryandic silver was even finer than 95 per cent, probably closer to 100 per cent (see also Vargyas 2010, 247–56). Analyses of Achaemenid silver objects show a silver content of between 92.8 per cent and 98.9 per cent (Zournatzi 2000, 252, 262). The objects at the higher end of this range may thus qualify as Aryandic silver, but perhaps it is more likely that the 95 per cent fineness grade attested in the Aramaic documents was that which was defined by Aryandes. Indeed, limitations to ancient metallurgical technology would have made it difficult to achieve more than about 98 per cent fineness on a regular basis (Zournatzi 2000, 264 n. 97). Moreover, the methods of analysis

available in antiquity were not precise, and would not have been sufficient for distinguishing between silver of 95 per cent and 98 per cent fineness.

The association of Aryandic silver with the grade of about 95 per cent fineness is supported by the importation of Greek coins to Egypt. Analyses of a selection of coins from the Assiut Hoard (IGCH 1644) show a range of 95.2 per cent to 99.6 per cent fineness (Gale et al. 1980, 14–20). That these coins were not melted and recast may well be because they were identified as being of good fineness already, though test cuts indicate the sort of scrutiny to which they were subjected. Indeed, the high silver content of many of the Greek coins of the Archaic and Classical Periods would have made them quite desirable as imports in Achaemenid Egypt.

If, as argued here, Greek coins met the standard for Aryandic silver, it is possible to understand Herodotus's presentation of this incident in a new light. The coins of Aryandes were not coins that the satrap himself had issued, but rather foreign coins imported to Egypt. Their association with the satrap's name may result from an Egyptian perspective on coinage in the early years of Achaemenid rule, a view that lumped all Greek coins together as a single category of object equally capable of meeting the requirements of Aryandes' edict. This conclusion does not necessarily contradict other readings of this episode, such as Leslie Kurke's (1999, 68–80) view that it illustrates the structural tension in Greek society between the aristocracy, with their shrinking monopoly on precious metal objects, and the common people, who with the advent of coinage gained access to these same metals. This is because the story of Aryandes is an attempt on the part of Herodotus to analyse a historical event known to him through Egyptian cultural knowledge, which he does in a Greek intellectual context. But it also points to how the Egyptians may have thought about the Greek coins that came flowing into their country as a consequence of Achaemenid rule.

THE ATHENIAN TETRADRACHM IN EGYPT

While 'Aryandic' coins seem at the outset to have included any Greek issue that made its way to Egypt, by the middle of the fifth century BC the Athenian tetradrachm had become by far the most common coin there. Its popularity was not limited to Egypt, and it occurs frequently in hoards throughout the eastern Mediterranean littoral in the second half of the fifth century, and well into the fourth (Nicolet-Pierre 2000; Flament 2007a, 173–232). The reliability of

its weight and fineness must have contributed to the coin's desirability. With only occasional exceptions during times of crisis, the type (Athena on the obverse, an owl on the reverse), weight (17.2 g) and silver content of the Athenian tetradrachm remained constant from its introduction in the last decade of the sixth century BC down into the Hellenistic Period (van Alfen 2012a, 91–7).

The massive production of tetradrachms at the height of the Athenian Empire, using the copious output of the Laureion silver mines, made them widely available. Xenophon (*Poroi* 3.2) even remarks that merchants doing business in Athens could make a great profit by taking only silver with them when they departed from the city (Kroll 2011a, 28–33; van Alfen 2012b). Moreover, certain aspects of Athenian imperialism may have created conditions that favoured the use of the Athenian tetradrachm over local coinages (Kroll 2009), though the nature and chronology of the relevant decrees are still debated. The tetradrachm's prevalence in Egypt is attributable to both direct commercial interaction between Athens and Egypt, especially the grain trade, and the use of the coin by other Greek and Phoenician merchants doing business there.

Many Egyptians would have treated these coins like any other form of bullion, with the result that they were chopped up or melted down. But given the prevalence of Athenian tetradrachms, their consistent weight and fineness would not have gone unnoticed, and some Egyptians must have begun to treat them more like coins than bullion. At the very least an association must have developed between the coin's distinctive type and its weight and fineness, especially if it met the requirements for Aryandic silver. And indeed there is evidence for this association in the late fifth century BC from two separate corpora of documents. Six of the Demotic ostraca from Ain Manawir in the Kharga Oasis refer to staters; one (O. Man. 661) specifies that five staters are equal to one *deben* of silver, and another (O. Man. 620) equates one 'stater of Ionia' with two *kite* of silver (Chauveau 2000; Agut-Labordère 2014). Also, there are references in the Aramaic papyri from Elephantine to the 'stater of Ionia', which is worth two shekels (TADAE A4.2, B3.12, B4.5, B4.6; Porten et al. 1996, nos. B14, B45, B51).

In both cases these seem to be references to the Athenian tetradrachm. The term 'stater' applies to the major coin of a given monetary system, and thus certainly applied to the Athenian tetradrachm, while the word 'Ionian' is the normal term for 'Greek' in many Near Eastern languages (Sancisi-Weerdenburg 2001; Root 2007, 178–9). Furthermore, the specified equivalencies also support identification

with the Athenian tetradrachm. The *deben* was an Egyptian unit of weight equal to about 91 g; five Athenian tetradrachms of 17.2 g apiece are equal to 86 g. The difference is just enough to require legal definition in a contract. The *kite* was one tenth of a *deben*, and therefore two *kite* weighed 18.2 g, or one gram more than a full-weight tetradrachm. Likewise, in TADAE B4.6 we find the phrase '2 sh(ekels), that is [silve]r, 1 stater'; two Babylonian shekels of 8.3 g each make 16.6 g, half a gram shy of the Athenian tetradrachm.

All of these documents date to the last decade of the fifth century, and they give a sense of how long it took for the Athenian tetradrachm to be regarded as more than bullion. These documents suggest that at least by the end of Achaemenid rule in Egypt the coin was accepted at its face value rather than at its intrinsic worth, at least in certain places and among certain people. The people using these coins, like the Athenians themselves and many other Greeks, recognised the relationship between the type and the metal content, and, more importantly, had faith in it.

The importance of the tetradrachm in Egypt is also evidenced by the imitations of it that were struck there beginning in the last decade of the fifth century and continuing well into the fourth. These were 'anonymous imitations', that is, coins that featured the same type, weight and fineness as their authentic prototypes, and which bore no indications of who was responsible for minting them (van Alfen 2005). They are generally quite difficult to distinguish from genuine Athenian issues, in part because in 353 BC Athens recalled its coinage and re-struck it with a slightly different type, creating what is now known as the 'pi-style tetradrachm' (Kroll 2011b; 2011c). This destroyed a large number of the coins minted at Athens up to that point, and only those coins that were abroad at the time survived. Some of these were certainly Athenian, but many others were imitations, which were either minted and circulated locally, or had been excluded from circulation at Athens under the Law of Nicophon of 375/4 BC and thus were taken elsewhere.

The existence of these Egyptian imitations was first put forward by T. V. Buttrey (1982; 1984) in two short papers examining a hoard of tetradrachms (CH 10.442) purchased by the excavators of Karanis in the Fayum and now in the collection of the Kelsey Museum of Archaeology at the University of Michigan (see now van Alfen 2002, 16–20; 2011, 66–70; Nicolet-Pierre 2003; Colburn 2018c, 84–94). Buttrey identified three different styles in the hoard, all with profile eyes, which he arbitrarily labelled as X, B and M (Fig. 6.1). Based on numerous die links in styles X and B, their unusual stylistic features

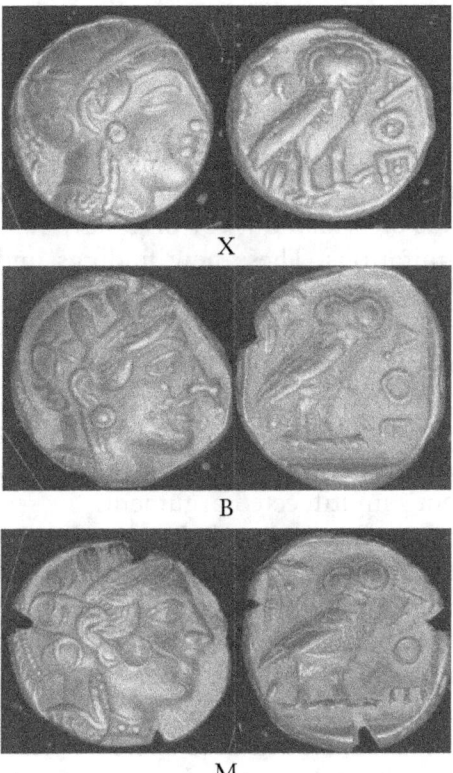

Fig. 6.1. Tetradrachms from the Fayum hoard (CH 10.442) illustrating Buttrey's styles X (KM 1984.01.0330), B (KM 1984.01.0042) and M (KM 1984.01.0041), c. 410–350 BC. Silver. Ann Arbor, Kelsey Museum of Archaeology. Reproduced by permission of the Kelsey Museum of Archaeology, University of Michigan.

and the hoard's Egyptian origin, he argued that these three styles were part of a larger coinage of imitation Athenian tetradrachms minted in Egypt in the fourth century.

Further support for their Egyptian origin comes from a 'cube die' used to strike such coins (Meadows 2011). This bronze cube has three obverse dies engraved on it, all with the Athena type of the Athenian tetradrachm. Two of these dies seem to be related to Buttrey's style M, and the third to style B. The die is now known only from an electrotype of it in the British Museum, but the original came from Egypt. Moreover, three reverse dies are also known from Egypt, one from Athribis and two from Sais. These dies indicate the minting of imitation Athenian tetradrachms in Lower Egypt, and without a die study to suggest otherwise they provide sufficient confirmation of Buttrey's attribution, at least for styles B and M.

The identification of these coins as Egyptian imitations has not been universally accepted, however. A re-examination of the Fayum Hoard has found fewer die links than Buttrey had originally identified (Arnold-Biucchi 2006–7, 91). In general a high number of die links in a single hoard indicates that the hoard was deposited not far from its mint of origin, and the high occurrence of die links was one of the grounds on which Buttrey originally suggested these coins were Egyptian imitations. These new findings undermine Buttrey's proposition somewhat, but they do not prove the coins were struck in Athens instead of Egypt. The most strenuous objections, however, have been made by Christophe Flament, who argues for an Athenian origin for all three of Buttrey's styles. Given the importance of coinage to our understanding of how Achaemenid rule may have affected the Egyptian economy, it is worth re-examining the salient aspects of Flament's multifaceted argument.

First, Flament (2005) points to CH 5.15, a hoard from the Piraeus containing both tetradrachms of styles B and M, and also drachms of similar styles. Since fractional issues do not travel as far from their mints as staters do, he argues these coins must have been produced at Athens. Contrary to this thesis, however, CH 10.439 (the hoard of imitation Athenian tetradrachms excavated from the House of Apis in Memphis) also included drachms. So by this same logic these coins would have to have been struck nearby (that is, in Egypt).

Second, Flament (2007b; Flament and Marchetti 2004) has carried out metal analysis on samples from the Tell el-Maskhuta hoard (IGCH 1649, c. 400 BC) using PIXE (proton-induced X-ray emission), in order to determine their elemental makeup. His findings are that the high lead content and low gold content in the coins are consistent with the metal content of earlier Athenian coins undoubtedly produced from Laureion silver. The reason for the high lead content is that Laureion silver was obtained from galena, rather than from gold ore, which was the main source of silver in Egypt. However, Egypt had long received silver from abroad, as tribute during the New Kingdom and in trade subsequently, and by the end of the fifth century the country's silver supply included metal from a variety of places and containing a variety of trace elements. For example, analysis of a silver statuette of a woman in the Metropolitan Museum of Art (30.8.93) bearing cartouches naming Necho II indicates that it too was probably made using silver derived from galena (Becker et al. 1994, 47). But this has not prompted anyone to suggest it was made in Athens. This admixed silver was the metal used to mint imitation tetradrachms. Indeed,

analyses of the metal content of Buttrey's style X coins show higher levels of trace elements than is normal for Laureion silver, and Flament (2007c, 92–7) argues that these coins were minted under economic duress when it was necessary to use imported silver (see also Kroll 2011b, 12–15). But this could just as easily be silver imported to Egypt as to Athens.

Third, a hoard (CH 10.378) excavated at Naxos on Sicily containing tetradrachms of styles B and M was found in a sealed context dating to 402 BC, and Flament (2003) argues that it must predate the Sicilian invasion of 415. While this latter assertion cannot be proven, the archaeological evidence does point to these imitations being struck as early as the 410s. In light of this dating, Flament argues that the unusual appearance of these coins is a result of inexperienced die carvers being employed at Athens after its defeat in the Peloponnesian War. But it is important to note that even at times of crisis Athenian coins were almost invariably struck from well-cut dies, and these dies were always stylistically related to their immediate predecessors (Anderson and van Alfen 2008, 165). Styles B and M, however, are clear stylistic departures from earlier issues, which is indeed why they were flagged as imitations in the first place.

Although the reattribution of Buttrey's styles B and M to Athens is not compelling, this third aspect of Flament's argument raises an important point for our understanding of the tetradrachm in Egypt. The redating of the beginning of these coins to the 410s BC (if not a few years earlier) means that they were first struck during the last years of Achaemenid rule there. Indeed, this was roughly the same time as when the Demotic ostraca and Aramaic papyri referring to 'staters of Ionia' were written. The implication is that by this time the Athenian tetradrachm was so common in Egypt that not only had certain individuals begun to recognise it as a fixed and reliable quantity of silver (that is, as a coin), but also it was being imitated there.

The actors responsible for minting these imitations were most likely temples (Colburn 2018c, 93). Not only were they the major economic institutions in Egypt, but also they had an interest in the weight standards used for precious metal. Their involvement as large landowners in the grain trade, in order to procure silver for tribute payments, made them especially prone to encountering Athenian tetradrachms. In fact, an ostracon from Ain Manawir of late fifth-century date even refers to 'staters of the temple of Ptah' (Agut-Labordère 2014, 79–80). This suggests that the author of this text associated Athenian tetradrachms with the major temple in Memphis,

not with the city of Athens. Moreover, a cube die for making imitations of pi-style tetradrachms was recovered at Herakleion-Thonis from a context containing material from a temple, lending further credence to the idea that imitation tetradrachms were struck in temples (Meadows 2011, 98).

The recognition and use of the tetradrachm did not necessarily penetrate every part of Egypt equally. The hoards listed above in Table 6.1 are limited to the Nile Delta, with only one exception, and the textual references to staters occur only in documents from Elephantine and Ain Manawir. It is probably not a coincidence that these two attested southern occurrences of tetradrachm use were also the sites of notable imperial interest. Most likely this resulted from the satrap using Egypt's wealth in the form of silver to carry out the Great King's instructions and further the empire's goals. It is also possible that these two communities made use of their imperial connections to gain better access to foreign merchants. Likewise, the absence of the tetradrachm at Thebes may be the result of a lack of imperial investment there, limited access to the grain trade for Theban temples, or a degree of conservatism regarding silver on the part of the Thebans.

The special role played by the Athenian tetradrachm in the Egyptian economy was a direct result of its prevalence, and its prevalence was a direct result of the imposition of tribute by the Persians. Certainly this was not the intent of imposing tribute, but it had the very real impact of introducing to Egypt the first coin to be recognised at face value rather than treated as bullion. Once imitations were being struck there, the tetradrachm became in essence Egypt's first native coinage, even though it was not issued by a central governmental authority. However, by the time the Persians returned to Egypt during the mid-fourth century the tetradrachm was so ingrained that imitations of it were issued bearing the names of Artaxerxes and two of his satraps.

TETRADRACHMS IN THE SECOND PERSIAN PERIOD

The prevalence of the Athenian tetradrachm in Egypt continued to grow throughout the period of Egyptian rule that interrupted Achaemenid control in the first half of the fourth century BC (Colburn 2018c, 84–94). Although Egypt was liberated, if only temporarily, from the requirement to make tribute payments, the pattern of exchanging grain for silver continued, no doubt fuelled

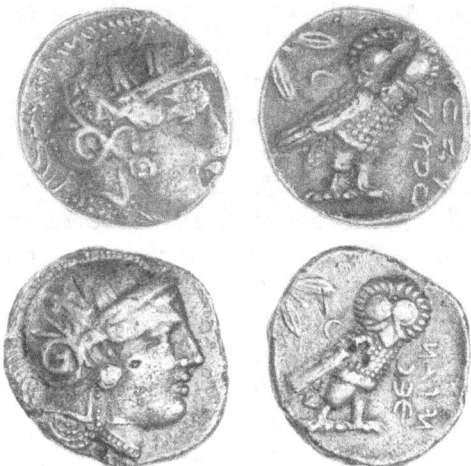

Fig. 6.2. Tetradrachms of Artaxerxes III, c. 340–338 BC (ANS 2008.15.39), and of Sabaces, c. 338–333 BC (ANS 1944.100.75462). Silver. New York, American Numismatic Society. Images in the public domain from the American Numismatic Society.

by the military and construction ambitions of the native pharaohs Nectanebo I, Tachos and Nectanebo II. When the Persians regained control of Egypt in 340 BC, the tetradrachm was the commonest coin in Egypt, and the only one the Egyptians were not inclined to treat solely as bullion, but rather to use according to its face value. The Achaemenid Empire retained control of Egypt until the arrival of Alexander in 332. During this short period three series of imitation tetradrachms were minted there bearing the names of Artaxerxes and the satraps Sabaces and Mazaces in place of the usual ethnic AΘE (for 'Athens') on the reverse (van Alfen 2002, 24–32; Colburn 2018c, 100–3). All of these coins share the same type as the Athenian tetradrachm, and they also all seem to be minted on the Attic weight standard, though some individual examples are underweight.

The coins in the name of Artaxerxes (Fig. 6.2) are clearly attributable to Artaxerxes III because they occur in the 1989 Syria hoard (CH 8.158), dating to the 330s, and the examples of them in that hoard exhibit very little wear (Mørkholm 1974; van Alfen 2002, 14). Four different variations of this coin have been distinguished among the twenty-three known examples of it (van Alfen 2002, 24–7). Three of these (Types I–III) bear inscriptions that clearly read 'Artaxerxes pharaoh' in Demotic. Coins of the fourth variation (Type IV) have multiple unintelligible inscriptions, some of which

seem to consist of Aramaic letters. These coins have close stylistic affinities to those of Type III, which is the reason for their attribution to Artaxerxes. A few examples also include the words *ankh, wedj, seneb*, again in Demotic, a pious Egyptian wish that follows the pharaoh's name and means 'life, prosperity, health' (Vleeming 2001, 1–4). Coins of Type I are also distinguished from the other three variations by their resemblance to the Buttrey styles. Types II–IV bear a strong resemblance to the pi-style tetradrachms minted at Athens starting in 353, and this provides further confirmation of their attribution to Artaxerxes III.

Several factors point to these coins being struck in multiple mints, rather than in a single centralised one. The variations in the inscriptions and appearances of the different types are probably not chronological developments, since this would not account for the garbled versions of the Demotic inscription. They would, however, be explained by the existence of several different die cutters working simultaneously in the short period between 340 and Artaxerxes' death in 338 BC (Vleeming 2001, 1–2). It may be that these die cutters were itinerant moneyers who travelled from one temple to another striking coins, as Meadows (2011, 110) has suggested for the anonymous issues of Egyptian imitation tetradrachms. The connection with temples also explains the choice of Demotic (rather than Aramaic) for the legend. These are the only coins naming an individual Great King. All known Achaemenid imperial issues (darics and sigloi) are anonymous, bearing no specific royal name. Furthermore, their types conform to tendencies in official Achaemenid art in general, eschewing focus on the individual ruler in favour of a larger notion of the concept of the ruler. It thus seems unlikely that the Artaxerxes tetradrachms were the result of a royal initiative. In general they are a continuation of the earlier imitation tetradrachms minted by Egyptian temples, but with the addition of the name of Artaxerxes, presumably for some political or religious purpose.

Sabaces and Mazaces were the penultimate and final Achaemenid satraps of Egypt respectively, serving under Darius III, and are known from the Greek accounts of Alexander's campaigns (Heckel 2006, 156, 246; Ruzicka 2012, 204–6). Both issued pi-style tetradrachms bearing their names in Aramaic (van Alfen 2002, 27–32; Colburn 2018c, 99). Some forty-nine examples of Sabaces' coins are known in three varieties (Fig. 6.2), and only three of Mazaces' (whose tenure as satrap was only a single year). In addition to the legends, these coins are distinguishable by symbols on the reverse that always co-

occur with the names. For Sabaces this symbol represents a lightning bolt; Mazaces' symbol is a raised dot. There are also a few fractional issues in silver and bronze attributed to each satrap. Their types seem to imitate coins of Phoenicia (especially Sidon) and Asia Minor. Only a few examples of each survive, and it is difficult to say what weight standards were intended.

Unlike those naming Artaxerxes, the coins of Sabaces and Mazaces do seem to be the product of a single mint, and this, along with their Aramaic inscriptions, indicates centralised production under the authority of the satrap. The impetus for this centralised production is not known, but it is quite possible that Sabaces was familiar with the coins issued by Achaemenid satraps elsewhere throughout the fourth century and regarded the absence of centralised minting in Egypt as a deficiency. Accordingly he began issuing coins in his own name, but retained the type and weight of the Athenian tetradrachm because of its persistence in the Egyptian economy. He also issued fractions as part of his effort to supply Egypt with a currency. The Phoenician appearance of some of his fractional issues may provide some hint as to where Sabaces developed his notions of coinage, as Phoenicia by this time featured several mints and widespread familiarity with coined money. Mazaces, who succeeded Sabaces when the latter led the Egyptian contingent to Issus, followed closely the minting practice of his predecessor. And the hoard evidence suggests that neither satrap actively prohibited the minting of imitation Athenian tetradrachms by temples, since these coins continue to appear in hoards throughout the 330s. Indeed, the satrapal issues usually appear in hoards alongside anonymous imitations.

Thus the Achaemenid satrap Sabaces gave Egypt its first national coinage. Admittedly it was modelled on a foreign coin, and it only worked because that foreign coin was already recognised as a reliable bullion coin. Indeed, at least one Demotic papyrus (P. Libbey; Cruz-Uribe 1977–8) from this period refers to the equation of five staters to the *deben*. Yet the coins of Sabaces also represent an attempt at fusing the prevailing Egyptian approach to money with the practice seen elsewhere in the empire of minting local coinages. The attempt was only partly successful, as shown by the poor survival of Sabaces' (and Mazaces') fractional issues. These coins, which lacked the recognisable Athenian types and were clearly not the expected weight, were mostly likely treated as *Hacksilber* and destroyed. This latter point attests to the great importance of the Athenian tetradrachm in the Egyptian economy in the fourth century.

THE IMPACT OF ACHAEMENID RULE ON THE EGYPTIAN ECONOMY

The integration of Egypt into the Achaemenid Empire had an indirect yet distinctive impact on the nature of the Egyptian economy. Since at least the New Kingdom, if not before, grain and precious metal bullion were the main forms of money in Egypt. Since grain was abundant in other parts of the empire such as Mesopotamia, Egypt had to pay tribute in silver. Natural sources of silver were limited in Egypt, so it was necessary to find some way to convert grain into silver on a scale as yet unparalleled. Thus Egypt began, or at least increased significantly, its grain exports to the Greeks, along with other products such as papyrus, natron and linen, in exchange for silver in the form of coins. As a result of this trade Greek coins, and the Athenian tetradrachm especially, became one of the more common forms of silver money in Egypt. Their popularity was no doubt furthered by meeting the standard of Aryandic silver as defined by the satrap.

By the middle of the fifth century BC the Athenian tetradrachm was by far the most prevalent coin in use in Egypt. The tetradrachm's unchanging types and its reliable weight and fineness made it appealing to Egyptians accustomed to the use of bullion. By the 410s the tetradrachm occurs in Demotic and Aramaic documents as a unit of account, and imitations of it began to be struck in Egypt itself. These imitations continued to be made during the fourth century, and when the Persians captured Egypt for the second time c. 340 the tetradrachm was so widely recognised as a distinctive form of money that the satraps Sabaces and Mazaces used it as the basis for their own coinages. In essence, the imposition of tribute by the empire indirectly promoted the use of coined money in Egypt.

Of course it was not the empire's intent to promote the use of coinage in Egypt, and especially not the coinage of a city outside of its borders. But in the process of exploiting Egypt's wealth the Persians inadvertently created the conditions in which the premier bullion coin of the Mediterranean world, the Athenian tetradrachm, became recognised and accepted in Egypt. In this respect Achaemenid tribute requirements put Egypt on the road to monetisation. It was only a small first step; the Ptolemies, as the recent study by Sitta von Reden (2007) has shown, had to go to great lengths to make coinage the standard form of money there (see also de Callataÿ 2005). Nevertheless, the impact of these changes was unquestionably felt by certain individuals and institutions. Notably, the Egyptian temples,

one of the traditional stewards of Egypt's wealth, found themselves compelled to engage in foreign trade in order to supply the satrap with silver. Indeed, this satrapal exploitation of the temples foreshadows the native pharaonic exploitation of them by Nectanebo I and Tachos in the fourth century (Will 1960; Davies 2004; Agut-Labordère 2011). More importantly, Achaemenid rule created a situation in which the temples eventually found it worthwhile to mint their own tetradrachms.

For individuals the impact was more varied. The tetradrachm became common in the Nile Delta, as the coin hoards there show, and especially those people who were directly involved with foreign trade would have found it advantageous to use this coin. It can also hardly be a coincidence that the two places where the tetradrachm first occurs as a unit of account, Ain Manawir and Elephantine, were both areas of imperial activity. The connections that these two communities had with the satrap and the empire more generally made them seemingly more apt to use the tetradrachm, either through the satrapal administration using coins themselves, or through better access to foreign merchants. For many other individuals, especially those who rarely encountered silver in the course of their everyday lives, there was little discernible change, except possibly that grain was in higher demand than it had been before.

It is difficult to identify clear winners and losers here. Certainly the empire benefitted from the collection of tribute from Egypt. And a successful satrap was doubtless able to enrich himself, though Aryandes' fate surely served as a cautionary tale. It might intuitively seem that the Egyptians were the major losers here. The text on the verso of the Demotic Chronicle referring to an effort on the part of Cambyses to curtail temple income, not to mention the strong negative traditions in Egypt that became attached to his name in later periods, is usually understood as evidence for the Egyptian temples suffering economic hardship under Achaemenid rule. But in addition to the historiographic problems surrounding the origins and interpretations of these texts, it is worth noting as well that in writing about taxation in the Roman Empire Keith Hopkins (1980; 2002) famously demonstrated how the need to export consumables in order to procure money for taxes could actually stimulate trade. Thus temples, as the major institutional lessors of farmland in Egypt, as well as individuals involved in the production, transport and sale of grain, were potentially beneficiaries of this stimulation. The tired notion that Achaemenid rule brought economic hardship on Egypt demands a new look.

7. Experiencing Achaemenid Egypt

> One ought to say such things as these, beside a fire in wintertime,
> Lying fully fed on a soft couch,
> Drinking sweet wine and eating chickpeas for dessert:
> Who among men are you and what family are you from?
> How old are you, good sir?
> And what age were you when the Mede came?
>
> <div align="right">Xenophanes of Colophon</div>

THE END OF ACHAEMENID RULE

According to the priest and historian Manetho of Sebennytos, the 27th Dynasty came to an end in 405/4 BC with the revolt of Amyrtaios, the first and only pharaoh of the 28th Dynasty. There had been periodic revolts in Egypt throughout the fifth century, some instigated perhaps by Athenian agitation (Rottpeter 2007), but none had ultimately succeeded until this one. Amyrtaios, however, in addition to whatever cunning or ability he possessed as a general, was extremely fortunate in the timing of his revolt. Not long after it began Darius II fell ill and died at Babylon, and within a few years his younger son Cyrus had assembled an army in Asia Minor with which he challenged his brother, Darius's elder son now enthroned as Artaxerxes II. The defeat of Cyrus's expedition is well known, thanks to the accounts of Xenophon and Ctesias, but it drew imperial attention away from Egypt long enough to ensure the success of Amyrtaios's efforts (Ruzicka 2012, 38–9).

Of course, this is not to say that the revolt was carried out with ease. Manetho's clean division of the 28th Dynasty from the 27th belies the slow progress made by the rebels. The Demotic ostraca from Ain Manawir continue to use regnal years of Artaxerxes II in

dating formulas until 402, as do the Aramaic papyri from Elephantine until 401 (Lemaire 1995; Chauveau 1996, 43–4). Amyrtaios, like the other pretenders before him, was based in the Delta, and the implication is that it took several years for him finally to assert control over the entirety of Egypt. If the resistance he faced had emanated solely from imperial strongholds defended by handfuls of loyalists, it is unlikely it would have taken this long for him to capture the rest of Egypt. Rather, the process was slow, slower than Cambyses' seizure of Egypt a century before. This suggests that the 'liberator' Amyrtaios was, for most people anyway, just another conqueror, and not their ticket to freedom from oppressive foreign rule.

This was the end of Achaemenid rule in Egypt, save for a brief period in the 330s that was brought to a close by the arrival of Alexander in 332 BC. But this was not the end of the Achaemenid presence on the conceptual landscape of Egypt. The spectre of another invasion always existed, and in several instances came to pass as the Great King's armies mounted attacks with the purpose of retaking the satrapy (Ruzicka 2012). The fourth-century pharaohs prepared for this eventuality by forming alliances with Greek cities and recruiting foreign mercenaries to bolster their forces. They also made financial reforms aimed at generating additional revenues to support these efforts (Will 1960; Davies 2004; Agut-Labordère 2011). Nectanebo I and II were both very active in the construction and renovation of temples, as attested by the frequent occurrence of their cartouches at cult sites throughout Egypt (Minas-Nerpal 2018). Given the political turmoil and threat of Persian invasion, it is no surprise these two long-reigning native pharaohs of the 30th Dynasty engaged in activities that reinforced their legitimacy and authority as rulers. But it may be that these activities were also intended to obscure or usurp the support given to cults by the Achaemenid pharaohs before. For example, the Hibis temple was enlarged in the fourth century, and the names of both Nectanebo I and II appear on the expansion (Winlock 1941, 20–32). Fourth-century Egypt was certainly a vibrant place, but it is clear this vibrancy was accompanied by the memory of Achaemenid rule and an awareness of the empire's political, military and cultural potency. As John Ray (1987, 80–1) has noted: 'the history of fourth-century Egypt has, at least on the surface, a strikingly "post-colonial" look to it. It is not simply Achaemenid Egypt without the Achaemenids; it is an Egypt in which the idea of the Achaemenids is always present.'

After several unsuccessful attempts the Persians returned to Egypt in c. 340 BC and ruled there until the arrival of Alexander in 332.

This Second Persian Period, as it is often called, was interrupted by the revolt of Khababash, which probably began c. 338 and lasted for over one year but less than two (Burstein 2000; Wojciechowska 2016, 19–20, 75–9). Achaemenid rule in this period thus lasted less than a decade, and there is comparatively little material, textual or archaeological, that can be safely attributed to it (Devauchelle 1995b). Despite this limited evidence, Achaemenid rule in the 330s is usually considered harsh and oppressive (e.g., Kienitz 1953, 107; Lloyd 2014, 185–7; see Colburn 2015, 166–7). This view is based largely on a passage in Diodorus Siculus (16.51.2) describing Artaxerxes III's treatment of Egypt following the invasion:

> Artaxerxes, after taking over all Egypt and demolishing the walls of the most important cities, by plundering the shrines gathered a vast quantity of silver and gold, and he carried off the inscribed records from the ancient temples, which later on Bagoas returned to the Egyptian priests on the payment of huge sums by way of ransom. (trans. C. H. Oldfather)

This account cannot be accepted uncritically. In the preceding sections Diodorus (16.46.4–51.1) describes the campaign in detail, including the assault on Pelousion and the surrender of Bubastis (Ruzicka 2012, 177–98). This remark, however, is generic and suggests a transition in source and tone from a detailed historical narrative to a stereotyped vision of Achaemenid rule current when Diodorus was writing in the first century BC. Indeed, his sentiments are echoed by later writers such as Plutarch (*De Iside et Osiride* 11) and Aelian (*Varia Historia* 4.8, 6.8), who go so far as to confuse Artaxerxes with Cambyses. The comment about Bagoas's role in this affair only furthers the stereotyped nature of this passage, since Diodorus (and Plutarch later on) consistently depicts Bagoas as the stereotypical cruel and effeminate oriental eunuch (Colburn 2015, 181–3).

This stereotyped history of the Second Persian Period must in significant part derive from the ideology developed by Ptolemy and his successors to legitimise their new dynasty. This ideology is usefully demonstrated by the so-called Satrap Stela (Cairo CG 22182; Schäfer 2011). Discovered in a Cairo mosque in 1871, the hieroglyphic inscription on this monument refers to the renewal of a land donation to the temple of Pe and Dep in the city of Buto in Lower Egypt. It dates to 311 BC, when Ptolemy I Soter still ruled Egypt as satrap in the name of Alexander IV; it is, however, clear from his epithets and self-presentation that Ptolemy was already aiming for royal power (Ockinga 2018). The stela's text gives lip service to King Alexander and then launches into an account of Ptolemy's exploits

as a victorious general. One of these feats was that he 'brought back the sacred images of the gods which were found within Asia, together with all the ritual implements and all the sacred scrolls of the temples of Upper and Lower Egypt' (trans. R. Ritner in Simpson 2003, 393). Ptolemy does not mention the Persians by name, but the implication is that he recovered statues of Egyptian gods looted from Egypt by the Persians, especially during the course of Artaxerxes III's reconquest in 340. In fact in subsequent decrees, his successors explicitly refer to the Persians in this context (Colburn 2015, 175–6, 178–9). But this claim is very difficult to reconcile with the events of the Diadoch Wars following Alexander's death, as Ptolemy's campaigns did not take him further east than Syria, and claims of returning statues are a common trope in the ancient world (Winnicki 1994).

Ptolemy's royal piety is then contrasted with that of his Achaemenid predecessors. After his military feats Ptolemy comes to Buto, where the priests of Pe and Dep tell him that Pharaoh Khababash, while making preparations to repel the forces of Asia, gave a marshland called the 'Land of Edjo' to the temple. This donation was revoked, however, by someone referred to as 'enemy *Ḫšryš*', usually identified with Xerxes (Ladynin 2005; Klinkott 2007b; Gorre 2017). As with Ptolemy's wartime exploits, the actions of this 'Xerxes' are usually interpreted literally and thus taken for evidence that the Persians curtailed the temple's revenues, if not pillaging it outright. But the chronology of these events makes little sense, as there is an enormous period of time between the reigns of Xerxes and those of Khababash and Ptolemy. It is possible that the 'Xerxes' identified in the text was actually meant to be Artaxerxes III, though these names are not as similar in Egyptian as they are in Greek, making simple confusion unlikely (Colburn 2015, 176–7).

The Satrap Stela is thus not a straightforward historical text. Rather, it makes ideological claims that are meant to depict Ptolemy as the successor to Alexander and a restorer of order in Egypt (Briant 2003; Colburn 2015, 168–81; Gorre 2017). To do this he emphasised his piety and fitness to rule, which he contrasted to the wantonness and impiety of the Persians. This ideology in turn informed the ensuing Greek historical tradition of the Second Persian Period, portraying it in grim terms to contrast with the piety and benevolence of Ptolemy.

Accounts such as Diodorus's have long obscured the path to assessing the nature and impact of Achaemenid rule in Egypt. Although the historicity of his account is uncertain, there can be no doubt that Artaxerxes' invasion, like that of Cambyses two centuries before,

was a traumatic event for the Egyptians. The problem is that it is unclear whether the trauma discernible in Diodorus is a reflection of the lived reality of contemporary Egyptians, or if it is a product of ancient and modern biases and agendas mutually reinforcing each other. So instead of relying on narratives with questionable foundations, this study has used material culture as a means of investigating the experience of Achaemenid rule in Egypt. As discussed in Chapter 1, it approaches experience from two different perspectives, first by identifying continuities and changes in the structures that comprised the social and economic fabric of Egyptian society, and second by examining the construction of identity by individuals and communities through decisions made about material culture. These two approaches show a wide variety of experiences, ranging from resistance, to apparent indifference, to enthusiastic participation. The satrapy of Egypt was neither an apartheid state nor a melting pot; it was a complex web of social, cultural and economic relationships between individuals, communities and institutions, as it had already been for millennia. The most distinctive and significant impact of Achaemenid rule was to add to that complexity.

STRUCTURAL CONTINUITIES AND CHANGES

From a *longue durée* perspective, the structures that comprised Egyptian society were seemingly stable under Achaemenid rule. The pharaoh, although now not Egyptian by birth and usually absent from Egypt, remained the primary intermediary between the divine and earthly realms. *Maat* was maintained by the king through the dedication of temples, notably in the Kharga Oasis, and through the king's participation in religious rituals, such as the burial of the Apis bull at Saqqara. This was accomplished through local proxies, such as the satrap. But the use of such proxies was not unto itself novel: Egypt had many cults, and the pharaoh could not be expected to participate in every single ritual or festival performed by each. In fact, the substitution of a priest for the pharaoh, presumably in the latter's absence, is attested in the sixth century BC in a hieratic document (Papyrus Brooklyn 47.218.50; Goyon 1972; see Verhoeven 2001, 318 for the date) detailing the annual ritual confirming the king's power. Despite the apparent importance of the ritual for king, there are references to a priest standing in for him, implying that in the Saite Period, if not before, there already existed mechanisms for accommodating an absent king without compromising the significance or potency of a given ritual. While the fortunes of individual

temples certainly varied under Achaemenid rule, they continued to be vital institutions in the fabric of Egyptian society.

Structures of political authority also remained mostly intact. The Palace of Apries in Memphis, which served as the seat of the satrap, continued to be an important locus of administrative and military power. Memphis continued to be a major cultural and religious centre in Egypt, as well as one of the great cosmopolitan cities of the Mediterranean and the Near East. It attracted merchants, mercenaries, tourists and even scholars like Herodotus and Hecataeus of Miletus, from both within and beyond the borders of the empire. The agricultural basis of the economy was unchanged, with grain still serving as Egypt's most prevalent form of both wealth and sustenance. Finally, the conceptual landscape of Egypt remained largely as it always had been. The grandees of the satrapal court at Memphis continued to be attracted to the ancient burial monuments at Saqqara and Abusir and they constructed their own tombs in the shadows of royal pyramids. The Apis bull, the animal incarnation of the god Ptah, continue to dwell in his house in Memphis, and the animal catacombs remained active cult places, where Egyptians and others came to demonstrate their piety or ask the gods for help.

But this stability belies the distinctive structural changes that can be firmly identified as results of Achaemenid rule. The introduction of the qanat to the Western Desert made extensive agriculture and settlement there feasible for the first time since the Old Kingdom. As part of this development new temples were built in the Kharga and Dakhla Oases, and they were transformed from a place once considered uninhabitable into a vibrant and seemingly prosperous region. Another major structural change concerns the forms of money used in Egypt. While grain continued to play an integral role in the Egyptian economy, the imposition of tribute by the Achaemenids created a new and increased demand for silver. Accordingly grain was converted to silver by exporting it to the Greeks, especially the Athenians, in exchange for coins. As a result of this process, the Egyptians became familiar with the Athenian tetradrachm to such an extent that by the end of the fifth century it was used alongside bullion as a form of silver money, and imitations of it were being struck in Egypt.

The integration of Egypt into the Achaemenid Empire created new links between Egypt and foreign lands and peoples. News, letters and information moved swiftly along the royal roads between Egypt and the rest of the empire. People and goods also moved along these roads, as well as by sea. Indeed, the construction of

the canal connecting the Nile to the Red Sea linked Egypt to the Arabian Peninsula more directly than ever before. Of course Egypt had never been truly isolated from neighbouring lands, but there was an air of xenophobia in its dealings with these places. The Report of Wenamun (Simpson 2003, 116–24), for example, a text written during the late New Kingdom or early Third Intermediate Period (Egberts 1998), recounts Wenamun's miserable experiences on a trip to Byblos to procure timber. He is robbed, humiliated and nearly killed, and he is always at the mercy of hostile local rulers. By comparison, Udjahorresnet's experience travelling abroad is markedly different. According to the biographical inscription on his naophorous statue, Udjahorresnet went to the court of Darius and remained there until Darius sent him back to Egypt to restore the House of Life in Sais. During his return trip, he says, 'the foreigners carried me from country to country'. These two texts reflect very different perceptions of going abroad. For Wenamun it was a daunting, even terrifying, prospect. For Udjahorresnet it was a great honour. There are different literary and historical factors informing each of these accounts, but the shift in attitude in Udjahorresnet's inscription is suggestive of a broader change in how Egyptians thought about foreign lands, resulting from Egypt's new status as part of the empire.

IDENTITY AND EXPERIENCE

The evidence for identity assembled in the preceding chapters points to a wide array of experiences with Achaemenid rule in Egypt, on the part of both individuals and communities. These identities were constructed based in significant part on how people conceived of themselves and their wider worlds, and these conceptions in turn were informed by broader social conditions, including experiences with Achaemenid rule. In the case of Ptahhotep, the overseer of the treasury in Memphis during the reign of Darius I, his experience led him to identify himself with the international elite who administered and governed the empire. This identity prompted him to have himself represented wearing a long robe suggestive of the Achaemenid 'court garb' as seen on the reliefs at Persepolis, as well as a torque that could have been a gift from the Great King himself. At the same time Ptahhotep clearly saw himself as Egyptian, evidenced by his participation in Egyptian religious activities such as his dedication of a naophorous statue in the temple of Ptah in Memphis.

Ptahhotep's contemporary Horwedja had a different experience with the empire. Horwedja was the *senti*, a financial officer who

reported directly to the satrap, and was therefore one of the most senior imperial officials in Egypt. Yet his statue suggests that unlike Ptahhotep he constructed his identity exclusively in Egyptian terms. No aspect of his statue makes any visual reference to Persepolis or to the empire. Of course he may well have worn a long robe like Ptahhotep's to work every day, but in commissioning a statue to represent himself for eternity he made reference only to Egyptian cultural memory. This indicates that Horwedja had a different experience with Achaemenid rule from that of Ptahhotep, and the difference in their identities is suggestive of the multicultural environment that characterised Egyptian society during the 27th Dynasty.

The comparative examples of Ptahhotep and Horwedja are enough to demonstrate the discrepant experiences two individuals of similar station could have under Achaemenid rule. The case of Memphis goes even further in demonstrating the full range and variability of experience that was possible. Because of the city's long history as a political and cultural centre, Egyptian cultural memory was abundant in Memphis. There were numerous highly visible reminders of Egypt's past glory, and the pull of this cultural memory was undoubtedly strong, for both Egyptian natives and resident foreigners alike. At the same time, Memphis was the centre of Achaemenid rule in Egypt, the seat of the satrap and the home of a sizeable garrison. Many residents thus interacted with the empire on a regular basis, including participation in the furtherance of imperial goals.

These experiences informed how individuals conceived of their identities, especially through the decisions they made about the designs of their funerary monuments, how and what they ate and drank, and the names they gave their children. While it is certainly the case that some people constructed their identities solely in terms of Egyptian cultural memory, others specifically did so with explicit reference to Achaemenid art and material culture and their connections with the empire. There are also many examples of identities that do not neatly cleave to one superordinate centre or the other. Indeed, this observation highlights an important point: neither these centres nor the varying shades of identity reflecting them were opposing poles on a single axis. Rather, they were like menu options; one could choose either, both or neither.

Memphis in particular had been a cosmopolitan city long before the arrival of the Persians, and the many foreign residents there only added to the range of cultural references one could make. Outside of Memphis the evidence for Achaemenid rule is unevenly distributed

and often lacks clear provenance. This is due in part to the inability to date much Late Period material with any accuracy. But in general the picture is much the same. Some individuals saw themselves as participants in something larger than Egypt itself, and constructed their identities accordingly, while others remained within traditional parameters of social options. The choice to operate within traditional parameters was not necessarily a rejection of the legitimacy of Achaemenid rule or some similar act of resistance. For example, the wooden naos found at Tuna el-Gebel showing Darius presenting a *wedjat* eye to Re makes no visual reference to the empire, but it does show de facto acceptance of Darius as pharaoh on the part of the naos's owner. As in the case of Memphis, the most discernible consequence of Achaemenid rule was the addition of new choices to the total range of potential social options. This is evident too in the occurrence of Achaemenid drinking vessels in Egypt. These vessels, namely phialai, rhyta and Achaemenid bowls, attest to the exposure to and adoption of new dining practices. These new practices did not necessarily supplant old ones, but the range of acceptable or current practices was now larger.

Achaemenid Egypt was a diverse place, and that diversity is visible across the spectrum of material culture, from statues to ceramics to seals. It is especially interesting to note that the evidence assembled and analysed here sustains a clear indication that it was acceptable, and even encouraged (Colburn 2017), to draw upon multiple cultural traditions in the course of self-presentation. In other words, there was no clear distinction between Egyptians and Persians. Though there is textual evidence for the use of ethnonyms in this period, these occur primarily in administrative documents rather than in the inscriptions on personal monuments or seals (Johnson 1999). So they are used to describe other people, especially groups of people, for administrative purposes. This practice parallels the use of ethnonyms in the Persepolis Fortification Archive (Henkelman and Stolper 2009). Furthermore, in the Ptolemaic Period, ethnonyms functioned as 'occupational-status designations', identifying specific groups for administrative and tax purposes (La'da 2002). Though these groups may have had common ethnic identities at one point, the integrity of these identities soon became lost because, from an administrative standpoint anyway, ethnicity was seemingly less important than other factors.

This is not to say that ethnicity was not important at all, but that it was one of many facets of an individual's identity, and it informed people's decisions about material culture in different ways.

For example, Horwedja had himself depicted wearing a linen kilt, a costume significant primarily in an Egyptian setting, whereas Ptahhotep was represented wearing an Egyptian garment that also had potential meaning in an Achaemenid context. Both men had Egyptian names and participated in Egyptian cultural and religious practices, but each materialised this 'Egyptianness' in different ways, because it was weighed against other facets of their respective identities.

EXPERIENCING ACHAEMENID RULE

In sum, the structural continuities in and changes to Egyptian society discussed in this book demonstrate the potential range of experiences of Achaemenid rule in Egypt. For some it represented a grave interruption of everyday life, for others it provided new opportunities, and for others still it had comparatively little effect. The diversity and multiplicity of the identities studied here suggest that the experience of Achaemenid rule in Egypt was not a uniform one. People of seemingly similar stations could construct their identities in noticeably different ways. These variations seem generally to transcend ethnicity, since in many cases individual identities contained elements of several different ethnicities. Someone like Ptahhotep could be simultaneously Egyptian and Achaemenid, as well as many other things. The implications of this are perhaps best understood in light of Amartya Sen's insightful discussion of identity. According to Sen (2006, 19),

> There are two distinct issues here. First, the recognition that identities are robustly plural, and that the importance of one identity need not obliterate the importance of others. Second, a person has to make choices – explicitly or by implication – about what relative importance to attach, in a particular context, to the divergent loyalties and priorities that may compete for precedence.

Ptahhotep's identity is indeed 'robustly plural'. He seems not to have been compelled to favour the Egyptian or the Achaemenid aspect of his identity at the expense of the other. This is of course a single case, but the broader implication is that Achaemenid rule created a social context in which Egyptian and Achaemenid identities were not necessarily at odds with each other. Rather, they represented two different qualities altogether, with the empire signifying an entirely different sort of affiliation from that of a reference to Egyptian cultural memory.

In fact, there is some evidence for the continued co-existence of these identities into the Ptolemaic Period. The tomb of Petosiris at Tuna el-Gebel, already discussed briefly in Chapter 5, is particularly revealing in this respect. Petosiris was high priest of Thoth at nearby Hermopolis, and the superstructure of his tomb, consisting of a porch and a small hypostyle hall behind it, is seemingly modelled on the temple of Thoth. The tomb is usually dated to the last quarter of the fourth century BC – the years immediately following the death of Alexander and Ptolemy's seizure of power in Egypt. In the inscription Petosiris states:

> I spent seven years as controller for this god,
> Administering his endowment without fault being found,
> While the Ruler-of-foreign-lands was Protector in Egypt,
> And nothing was in its former place,
> Since fighting had started inside Egypt,
> The South being in turmoil, the North in revolt;
> The people walked with head turned back,
> All temples were without their servants,
> The priests fled, not knowing what was happening.
> (trans. Lichtheim 1980, 46)

The 'Ruler-of-foreign-lands' is usually understood to be Artaxerxes III (or alternatively Darius III), on the assumption that Petosiris would not describe Alexander's tenure in Egypt in this manner (Menu 1998). As discussed in Chapter 4, narratives of chaos and destruction are common tropes in biographical inscriptions, and Petosiris continues this practice. In the next section of his inscription he describes how he 'put the temple of Thoth in its former condition', and he goes on to recount all of his good deeds on behalf of the people of Hermopolis. Thus the content of the inscription has more to do with the narrative effect Petosiris sought to create than with the historical realities of the time it purports to describe. Nevertheless, he must also have been aware that the reference to Artaxerxes created an implicit link between the chaos described in the inscription and the Second Persian Period. In terms of both genre and implied political allegiance this inscription represents Petosiris in a wholly Egyptian manner, in deliberate contrast to the Persians (Colburn 2015, 184–6).

The tomb's decorations, however, point to another aspect of Petosiris's identity. The interior walls of the tomb are richly decorated with painted reliefs displaying a range of scenes of daily life, including agriculture and craft production. Some of these crafting scenes (Fig. 7.1) show the production of metal vessels, including

Fig. 7.1. Drawings of reliefs from the tomb of Petosiris at Tuna el-Gebel, c. 325–300 BC. Images in the public domain from Lefebvre (1923-4, pls. 7-8).

phialai, rhyta and Achaemenid bowls (Cherpion et al. 2007, 34–6, 38, 126–7; Colburn 2015, 186–9). As discussed in Chapter 5, these vessels served as markers of status in the Achaemenid Empire and were adopted in Egypt by people who identified with the empire in certain respects. Petosiris may not have been aware of the specific cultural associations of these vessels, but his inclusion of them in the decoration of his tomb must have resulted from his belief that they were appropriate to his identity as a local grandee in Middle Egypt in the early years of Ptolemaic rule. Given the implied negative view of Achaemenid rule expressed in his biographical inscription, this suggests that by Petosiris's day vessels of these types, once so intimately connected to the empire, had taken on further meaning in an Egyptian context. In Petosiris's mind there was nothing incongruous about his use of these vessels to signify his elite political and social status while at the same time proclaiming his worthiness through his efforts to undo the putative ill effects of Achaemenid rule during the Second Persian Period (Colburn 2015, 193–4).

Achaemenid Egypt was a colonial situation like any other. Certainly there were 'winners' and 'losers', created by the conditions and circumstances of Achaemenid rule. But there was also a wide range of other experiences that become discernible when we look past the assumptions embedded in historical narratives of the Egyptian Late Period. Achaemenid rule of Egypt was neither entirely good nor entirely bad; such thinking obscures a much more complex reality. But it clearly had an impact on the people and institutions of Egypt, an impact whose importance, for the study both of Egypt and of the Achaemenid Empire, is undeniable.

Bibliography

Abd el-Rahman, S. Y. (2011), 'Amun-nakht fighting against an enemy in Dakhla Oasis: a rock drawing in Wadi al-Gemal', *Bulletin de l'Institut français d'archéologie orientale* 111, 13–22.
Abdi, K. (1999), 'Bes in the Achaemenid Empire', *Ars Orientalis* 29, 111–40.
Abdi, K. (2002), 'Notes on the Iranization of Bes in the Achaemenid Empire', *Ars Orientalis* 32, 133–62.
Adams, R. M. (1972), 'Settlement and irrigation patterns in ancient Akkad', in M. Gibson (ed.), *The City and Area of Kish*, Miami: Field Research Projects, pp. 182–208.
Adiego, I. J. (2007), *The Carian Language*, Leiden: Brill.
Adriani, A. (1938–9), 'Rhyta', *Bulletin de la Société royale d'archéologie d'Alexandrie* 33, 350–62.
Agius, D. A. (2008), *Classic Ships of Islam: From Mesopotamia to the Indian Ocean*, Leiden: Brill.
Agut-Labordère, D. (2005a), 'Le sens du *Decrét de Cambyse*', *Transeuphratène* 29, 9–16.
Agut-Labordère, D. (2005b), 'Le titre du "décret de Cambyse"', *Revue d'Égyptologie* 56, 45–54.
Agut-Labordère, D. (2011), 'L'oracle et l'hoplite: les élites sacerdotales et l'effort de guerre sous les dynasties égyptiennes indigènes', *Journal of the Economic and Social History of the Orient* 54, 627–45.
Agut-Labordère, D. (2014), 'L'orge et l'argent: les usages monetaires à 'Ayn Manawir à l'époque perse', *Annales: Histoires, Sciences Sociales* 69, 75–90.
Agut-Labordère, D. (2016), 'Oil and wine for silver: the economic agency of the Egyptian peasant communities in the Great Oasis during the Persian period', in J. C. Moreno García (ed.), *Dynamics of Production in the Ancient Near East, 1300–500 BC*, Oxford: Oxbow Books, pp. 41–52.
Agut-Labordère, D. (2017), 'Administrating Egypt under the First Persian Period: the empire as visible in Demotic sources', in B. Jacobs, W. F. M. Henkelman and M. W. Stolper (ed.), *Die Verwaltung im Achämenidenreich: Imperiale Muster und Strukturen = Administration*

in the Achaemenid Empire: Tracing the Imperial Signature, Wiesbaden: Harrassowitz, pp. 677–97.

Agut-Labordère, D. (2018a), 'The agricultural landscape of Ayn Manawir (Kharga Oasis, Egypt) through the Persian period ostraca (Vth-IVth century BC)', in L. Purdue, J. Charbonnier and L. Khalidi (ed.), From Refugia to Oases: Living in Arid Environments from Prehistoric Times to the Present Day = Des refuges aux oasis: vivre en milieu aride de la Préhistoire à aujord'hui, Antibes: Éditions APDCA, pp. 359–77.

Agut-Labordère, D. (2018b), 'L'introduction du dromedaire dans le désert occidental égyptien au Ier millénaire av. J.-C.', in G. Tallet and T. Sauzeau (ed.), Mer et désert de l'antiquité à nos jours: approches croisées, Rennes: Presses universitaires de Rennes, pp. 175–95.

Agut-Labordère, D. and Newton, C. (2013), 'L'économie végétale à 'Ayn-Manawir à l'époque perse: archéobotanique et sources démotiques', Achaemenid Research on Texts and Archaeology 2013.005, <http://www.achemenet.com/pdf/arta/ARTA_2013.005-Agut-Newton.pdf> (accessed 14 December 2018).

Aldred, C. (1980), Egyptian Art in the Days of the Pharaohs 3100–320 BC, London: Thames and Hudson.

Allen, L. (2013), 'The letter as object: on the experience of Achaemenid letters', Bulletin of the Institute of Classical Studies 56 (2), 21–36.

Allen, L. (2016), '"The greatest enterprise": Arthur Upham Pope, Persepolis and the Achaemenid Empire', in Y. Kadoi (ed.), Arthur Upham Pope and a New Survey of Persian Art, Leiden: Brill, pp. 127–67.

Alston, R. (1995), Soldier and Society in Roman Egypt: A Social History, London: Routledge.

Amigues, S. (2003), 'Pour la table du Grand Roi', Journal des Savants (1), 3–59.

Anderson, L. and van Alfen, P. G. (2008), 'A fourth century BC hoard from the Near East', American Journal of Numismatics 20, 155–98.

Anthes, R. (1959), Mit Rahineh 1955, Philadelphia: University Museum, University of Pennsylvania.

Anthes, R. (1965), Mit Rahineh 1956, Philadelphia: University Museum, University of Pennsylvania.

Arnold, D. (1999), Temples of the Last Pharaohs, New York: Oxford University Press.

Arnold-Biucchi, C. (2006–7), 'Les monnayages royaux hellénistiques: Sélimonte, Lysimaque et les imitations athéniennes du début du IVe s.', Annuaire de l'École pratique des hautes études, section des sciences historiques et philologiques: résumés des conférences et travaux 139, 87–91.

Asheri, D. (2007), 'Book III', in O. Murray and A. Moreno (ed.), A Commentary on Herodotus Books I–IV, Oxford: Oxford University Press, pp. 379–527.

Ashton, S.-A. (2010), 'Roman uses and abuses of Ptolemaic sculpture in Italy', in F. MacFarlane and C. Morgan (ed.), Exploring Ancient

Sculpture: Essays in Honour of Geoffrey Waywell, London: Institute of Classical Studies, University of London, pp. 213–23.
Assmann, J. (1992), 'Der Tempel der ägyptischen Spätzeit als Kanonisierung kultureller Identität', in J. Osing and E. K. Nielsen (ed.), *The Heritage of Ancient Egypt: Studies in Honor of Erik Iversen*, Copenhagen: Museum Tusculanum Press, pp. 9–25.
Assmann, J. (1995), 'Collective memory and cultural identity', *New German Critique* 65, 125–33.
Assmann, J. (2001), *Ma'at: Gerechtigkeit und Unsterblichkeit im Alten Ägypten*, 2nd edn, Munich: C. H. Beck.
Assmann, J. (2002), *The Mind of Egypt: History and Meaning in the Time of the Pharaohs*, New York: Metropolitan Books.
Assmann, J. (2011), *Cultural Memory and Early Civilization: Writing, Remembrance, and Political Imagination*, Cambridge: Cambridge University Press.
Aston, D. A. (1996), *Egyptian Pottery of the Late New Kingdom and Third Intermediate Period (Twelfth–Seventh Centuries BC): Tentative Footsteps in a Forbidding Terrain*, Heidelberg: Heidelberger Orientverlag.
Aston, D. A. (1999), 'Dynasty 26, Dynasty 30, or Dynasty 27? In search of the funerary archaeology of the Persian period', in A. Leahy and J. Tait (ed.), *Studies on Ancient Egypt in Honour of H. S. Smith*, London: Egypt Exploration Society, pp. 17–22.
Aston, D. A. (2003), 'The Theban west bank from the Twenty-Fifth Dynasty to the Ptolemaic period', in N. Strudwick and J. H. Taylor (ed.), *The Theban Necropolis: Past, Present and Future*, London: British Museum, pp. 138–66.
Aston, D. A. and Aston, B. G. (2010), *Late Period Pottery from the New Kingdom Necropolis at Saqqâra*, London: Egypt Exploration Society.
Atya, M. A., Kamei, H., Abbas, A. M., Shaaban, F. A., Hassaneen, A. G., Abd Alla, M. A., Soliman, M. N., Marukawa, Y., Ako, T. and Kobayashi, Y. (2005), 'Complementary integrated geophysical investigation around Al-Zayyan Temple, Kharga Oasis, Al-Wadi Al-Jadeed (New Valley), Egypt', *Archaeological Prospection* 12, 177–89.
Aubert, J.-J. (2004), 'Aux origines du canal de Suez? Le canal du Nil à la mer Rouge revisité', in M. Clavel-Lévêque and E. Hermon (ed.), *Espaces intégrés et ressources naturelles dans l'empire romain: actes du colloque de l'Université de Laval-Québec, 5–8 mars 2003*, Besançon: Presses universitaires de Franche-Comté, pp. 219–52.
Austin, M. (2008), 'The Greeks in Libya', in G. R. Tsetskhladze (ed.), *Greek Colonisation: An Account of Greek Colonies and Other Settlements Overseas, Vol. 2*, Leiden: Brill, pp. 187–217.
Azzoni, A. (2013), *The Private Lives of Women in Persian Egypt*, Winona Lake, IN: Eisenbrauns.
Azzoni, A. and Dusinberre, E. R M. (2014), 'Persepolis Fortification Aramaic Tablet Seal 0002 and the keeping of horses', in M. Kozuh,

W. F. M. Henkelman, C. E. Jones and C. Woods (ed.), *Extraction and Control: Studies in Honor of Matthew W. Stolper*, Chicago: Oriental Institute of the University of Chicago, pp. 1–16.

Bagh, T. (2011), *Finds from W. M. F. Petrie's Excavations in Egypt in the Ny Carlsberg Glyptotek*, Copenhagen: Ny Carlsberg Glyptotek.

Bagnall, R. S. (2004), 'The western oases', in R. S. Bagnall and D. W. Rathbone (ed.), *Egypt from Alexander to the Early Christians: An Archaeological and Historical Guide*, Los Angeles: J. Paul Getty Museum, pp. 249–77.

Bagnall, R. S., Aravecchia, N., Cribiore, R., Davoli, P., Kaper, O. E. and McFadden, S. (2015), *An Oasis City*, New York: Institute for the Study of the Ancient World, New York University Press.

Bailey, D. M. (1999), 'Sebakh, sherds and survey', *Journal of Egyptian Archaeology* 85, 211–18.

Baines, J. (1973), 'The destruction of the pyramid temple of Saḥure'', *Göttinger Miszellen* 4, 9–14.

Baines, J. (1996), 'On the composition and inscriptions of the Vatican statue of Udjahorresne', in P. Der Manuelian (ed.), *Studies in Honor of William Kelly Simpson, Vol. 1*, Boston: Museum of Fine Arts, pp. 83–92.

Baines, J. and Lacovara, P. (2002), 'Burial and the dead in ancient Egyptian society: respect, formalism, neglect', *Journal of Social Archaeology* 2, 5–36.

Bareš, L. (1996), 'Foundation deposits in the tomb of Udjahorresnet', *Zeitschrift für ägyptische Sprache und Altertumskunde* 123, 1–9.

Bareš, L. (1999), *Abusir, Vol. 4: The Shaft Tomb of Udjahorresnet at Abusir*, Prague: Universitas Carolina Pagensis.

Bareš, L. (2002), 'Demotic sources from the Saite–Persian cemetery at Abusir: a preliminary evaluation', in K. Ryholt (ed.), *Acts of the Seventh International Conference of Demotic Studies: Copenhagen, 23–27 August 1999*, Copenhagen: Museum Tusculanum Press, pp. 35–8.

Bareš, L. (2006a), 'Some notes on the religious texts and scenes in the tomb of Iufaa and other Late Period shaft tombs at Abusir', in H. Győry (ed.), *Aegyptus et Pannonia, Vol. 3: Acta symposii anno 2004*, Budapest: MEBT-ÓEB, pp. 1–9.

Bareš, L. (2006b), 'The social status of the owners of the large Late Period shaft tombs', in M. Bárta, F. Coppens and J. Krejčí (ed.), *Abusir and Saqqara in the Year 2005: Proceedings of the Conference Held in Prague, June 27–July 5, 2005*, Prague: Czech Institute of Egyptology, pp. 1–17.

Bareš, L. (2007), 'The Saite–Persian cemetery at Abusir', in J.-C. Goyon and C. Cardin (ed.), *Proceedings of the Ninth International Congress of Egyptologists, Grenoble, 6–12 septembre 2004*, Leuven: Peeters, pp. 145–50.

Bareš, L. (2009), 'The development of the Late Period cemetery at Abusir (in view of the Demotic sources)', in G. Widmer and D. Devauchelle (ed.), *Actes du IXe Congrès international des études démotiques: Paris, 31*

août-3 septembre 2005, Cairo: Institut français d'archéologie orientale, pp. 51–6.

Bareš, L., Bárta, M., Smoláriková, K. and Strouhal, E. (2003), 'Abusir: spring 2002', *Zeitschrift für ägyptische Sprache und Altertumskunde* 130, 147–59.

Bareš, L. and Smoláriková, K. (2008), *Abusir, Vol. 17: The Shaft Tomb of Iufaa*, Prague: Czech Institute of Egyptology.

Bareš, L. and Smoláriková, K. (2011), *Abusir, Vol. 25: The Shaft Tomb of Menekhibnekau*, Prague: Czech Institute of Egyptology.

Barnett, R. D. (1957), *A Catalogue of the Nimrud Ivories with Other Examples of Ancient Near Eastern Ivories in the British Museum*, London: British Museum.

Barocas, C. (1974), 'Les statues "realists" et l'arrivée des Perses dans l'Égypte saïte', in *Gururājamañjarikā: Studi in onore di Giuseppe Tucci*, Naples: Istituto universitario orientale, pp. 113–61.

Baxandall, M. (1985), *Patterns of Intention: On the Historical Explanation of Pictures*, New Haven: Yale University Press.

Beadnell, H. J. L. (1909), *An Egyptian Oasis: An Account of the Oasis of Kharga in the Libyan Desert, with Special Reference to Its History, Physical Geography, and Water-Supply*, London: John Murray.

Beck, P. (1972), 'A note on the reconstruction of the Achaemenid robe', *Iranica Antiqua* 9, 116–22.

Becker, L., Pilosi, L. and Schorsch, D. (1994), 'An Egyptian silver statuette of the Saite period: a technical study', *Metropolitan Museum Journal* 29, 37–56.

Berman, L. M. (1999), *Catalogue of Egyptian Art: The Cleveland Museum of Art*, New York: Hudson Hills Press.

Bettles, E. A. (2003), *Phoenician Amphora Production and Distribution in the Southern Levant: A Multi-Disciplinary Investigation into Carinated-Shoulder Amphorae of the Persian Period (539–332 BC)*, Oxford: Archaeopress.

Bichler, R. (2000), *Herodots Welt: Der Aufbau der Historie am Bild der fremden Länder und Völker, ihrer Zivilisation und ihrer Geschichte*, Berlin: Akademie Verlag.

Bingen, J. (1998), 'Life on the fringe: some conclusions', in O. E. Kaper (ed.), *Life on the Fringe: Living in the Southern Egyptian Deserts during the Roman and Early-Byzantine Periods*, Leiden: Research School CNWS, School of Asian, African and Amerindian Studies, pp. 287–300.

Bissa, E. M. A. (2009), *Governmental Intervention and Foreign Trade in Archaic and Classical Greece*, Leiden: Brill.

Bivar, A. D. H. (1985), 'Achaemenid coins, weights and measures', in I. Gershevitch (ed.), *The Cambridge History of Iran, Vol. 2: The Median and Achaemenian Periods*, Cambridge: Cambridge University Press, pp. 610–39.

Bivar, A. D. H. (1999), 'Σύμβολον: a noteworthy use for a Persian gold

phiale', in G. R. Tsetskhladze (ed.), *Ancient Greeks West and East*, Leiden: Brill, pp. 379–84.

Blenkinsopp, J. (1987), 'The mission of Udjahorresnet and those of Ezra and Nehemiah', *Journal of Biblical Literature* 106, 409–21.

Boardman, J. (1999), *The Greeks Overseas*, 4th edn, London: Thames and Hudson.

Boardman, J. (2013), 'Why Naucratis?', *Ancient West and East* 12, 265–7.

Boivin, N. and Fuller, D. Q. (2009), 'Shell middens, ships and seeds: exploring coastal subsistence, maritime trade and the dispersal of domesticates in and around the ancient Arabian peninsula', *Journal of World Prehistory* 22, 113–80.

Boiy, T. (2004), *Late Achaemenid and Hellenistic Babylon*, Leuven: Peeters.

Bosse, K. (1936), *Die menschliche Figur in der Rundplastik der ägyptischen Spätzeit von der XXII. bis zur XXX. Dynastie*, Darmstadt: Verlag J. J. Augustin.

Bothmer, B. V. (1960), *Egyptian Sculpture of the Late Period, 700 B.C. to A.D. 100*, Brooklyn: Brooklyn Museum.

Bothmer, B. V. (1974), 'Numbering systems of the Cairo Museum', in *Textes et langages de l'Égypte pharaonique: cent cinquante années de recherches*, Vol. 3, Cairo: Institut français d'archéologie orientale, pp. 111–22.

Botti, G. and Romanelli, P. (1951), *Le sculture del Museo gregoriano egizio*, Vatican City: Tipografia Poliglotta Vaticana.

Boucharlat, R. (2017), '*Qanāt* and *falaj*: polycentric and multi-period innovations – Iran and the United Arab Emirates as case studies', in A. N. Angelakis, E. Chiotis, S. Eslamian and H. Weingartner (ed.), *Underground Aqueducts Handbook*, Boca Raton, FL: CRC Press, pp. 279–301.

Bourdieu, P. (1990), *The Logic of Practice*, Stanford, CA: Stanford University Press.

Bousquet, B. (1996), *Tell-Douch et sa région: géographie d'une limite de milieu à une frontière d'empire*, Cairo: Institut français d'archéologie orientale.

Bousquet, B. and Robin, M. (1999), 'Les oasis de Kysis: essai de définition géo-archéologique', *Bulletin de l'Institut français d'archéologie orientale* 99, 21–40.

Bowman, R. A. (1941), 'An Aramaic journal page', *American Journal of Semitic Languages and Literatures* 58, 302–13.

Braudel, F. (1972), *The Mediterranean and the Mediterranean World in the Age of Philip II*, London: Collins.

Braund, D. (2007), 'Black Sea grain for Athens? From Herodotus to Demosthenes', in V. Gabrielsen and J. Lund (ed.), *The Black Sea in Antiquity: Regional and Interregional Economic Exchanges*, Aarhus: Aarhus University Press, pp. 39–68.

Bresciani, E. (1967), 'Una statua della XXVI dinastia con il cosiddetto "abito persiano"', *Studi classici e orientali* 16, 273–80.
Bresciani, E. (1985), 'Ugiahorresnet a Menfi', *Egitto e vicino oriente* 8, 1–6.
Bresciani, E. (1989), 'Osservazioni sul sistema tributario dell'Egitto durante la dominazione persiana', in P. Briant and C. Herrenschmidt (ed.), *Le tribut dans l'empire perse: actes de la table ronde de Paris 12–13 Décembre 1986*, Leuven: Peeters, pp. 29–33.
Bresciani, E. (1996), 'Plinio, el natron e le navi de Mediterraneo', in E. Acquaro (ed.), *Alle soglie della classicità: il Mediterraneo tra tradizione e innovazione*, Vol. 1, Pisa: Istituti editoriali e poligrafici internazionali, pp. 59–61.
Bresciani, E. (1998), 'L'Egitto achemenide: Dario I e il canale del Mar Rosso', *Transeuphratène* 14, 103–11.
Bresciani, E., el-Naggar, S., Pernigotti, S. and Silvano, F. (1983), *Saqqara, Vol. 1: Tomba di Boccori: la galleria di Padineit, visir di Nectanebo I*, Pisa: Giardini editori e stampatori.
Briant, P. (1988a), 'Ethno-classe dominante et populations soumises dans l'empire achéménide: le cas d'Égypte', in A. Kuhrt and H. Sancisi-Weerdenburg (ed.), *Achaemenid History, Vol. 3: Method and Theory*, Leiden: Nederlands Instituut voor het Nabije Oosten, pp. 137–73.
Briant, P. (1988b), 'Le nomadisme du grand roi', *Iranica Antiqua* 23, 253–73.
Briant, P. (1989), 'Table du roi, tribut et redistribution chez les Achéménides', in P. Briant and C. Herrenschmidt (ed.), *Le tribut dans l'empire perse: actes de la table ronde de Paris 12–13 Décembre 1986*, Leuven: Peeters, pp. 35–44.
Briant, P. (1994), 'Travaux hydrauliques et contrôle de l'eau dans l'Empire achéménide', in B. Menu (ed.), *Les problèmes institutionnels de l'eau en Égypte ancienne et dans l'Antiquité méditerranéenne*, Cairo: Institut français d'archéologie orientale, pp. 91–101.
Briant, P. (2001), 'Polybe X.28 et les qanāts: le témoignage et ses limites', in P. Briant (ed.), *Irrigation et drainage dans l'antiquité: qanāts et canalisations souterraines en Iran, en Égypte et en Grèce*, Paris: Thotm éditions, pp. 15–40.
Briant, P. (2002), *From Cyrus to Alexander: History of the Persian Empire*, Winona Lake, IN: Eisenbrauns.
Briant, P. (2003), 'Quand les rois écrivent l'histoire: la domination achéménide vue à travers les inscriptions officielles lagides', in N. Grimal and M. Baud (ed.), *Evénement, récit, histoire officielle: l'écriture de l'histoire dans les monarchies antiques*, Paris: Cybele, pp. 173–86.
Briant, P. (2012), 'From the Indus to the Mediterranean: the administrative organization and logistics of the great roads of the Achaemenid Empire', in S. E. Alcock, J. Bodel and R. J. A. Talbert (ed.), *Highways, Byways, and Road Systems in the Pre-Modern World*, Chichester: Wiley-Blackwell, pp. 185–201.

Briant, P. (2017), *Kings, Countries, Peoples: Selected Studies on the Achaemenid Empire*, Stuttgart: Franz Steiner Verlag.
Briant, P. and Descat, R. (1998), 'Un registre douanier de la satrapie d'Égypte à l'époque achéménide (*TAD* C3,7)', in N. Grimal and B. Menu (ed.), *Le commerce en Égypte ancienne*, Cairo: Institut français d'archéologie orientale, pp. 59–104.
Bricault, L. (2005), *Recueil des inscriptions concernant les cultes isiaques (RICIS)*, Paris: De Boccard.
Bunbury, J. and Jeffreys, D. (2011), 'Real and literary landscapes in ancient Egypt', *Cambridge Archaeological Journal* 21, 65–75.
Burchardt, M. (1911), 'Datierte Denkmäler der Berliner Sammlung aus der Achämenidenzeit', *Zeitschrift für ägyptische Sprache und Altertumskunde* 49, 69–80.
Burkard, G. (1994), 'Medizin und Politik: Altägyptische Heilkunst am persischen Königshof', *Studien zur altägyptishen Kultur* 21, 35–57.
Burstein, S. M. (2000), 'Prelude to Alexander: the reign of Khababash', *Ancient History Bulletin* 14, 149–54.
Burstein, S. M. (2008), 'Alexander's organization of Egypt: a note on the career of Cleomenes of Naucratis', in T. Howe and J. Reames (ed.), *Macedonian Legacies: Studies in Ancient Macedonian History and Culture in Honor of Eugene N. Borza*, Claremont, CA: Regina Books, pp. 183–94.
Buttrey, T. V. (1982), 'Pharaonic imitations of Athenian tetradrachms', in T. Hackens and R. Weiller (ed.), *Actes du 9ème congrès international de numismatique, Berne, Septembre 1979*, Louvain-la-Neuve: International Numismatic Commission and the International Association of Professional Numismatists, pp. 137–40.
Buttrey, T. V. (1984), 'Seldom what they seem: the case of the Athenian tetradrachm', in W. Heckel and R. Sullivan (ed.), *Ancient Coins of the Graeco-Roman World: The Nickle Numismatic Papers*, Waterloo, ON: Wilfred Laurier University Press, pp. 292–4.
Butzer, K. W. (1976), *Early Hydraulic Civilization in Egypt: A Study in Cultural Ecology*, Chicago: University of Chicago Press.
Cahill, N. (1985), 'The Treasury at Persepolis: gift-giving at the city of the Persians', *American Journal of Archaeology* 89, 373–89.
Cahill, N. and Kroll, J. H. (2005), 'New Archaic coin finds at Sardis', *American Journal of Archaeology* 109, 589–617.
Cailliaud, F. (1826), *Voyage a Méroé, au fleuve blanc, au-delà de Fâzoql dans le midi du royaume de Sennâr, a Syouah et dans cinq autres oasis, fait dans les années 1819, 1820, 1821 et 1822*, Vol. 1, Paris: Imprimerie royale.
Calmeyer, P. (1991), 'Ägyptischer Stil und reichsachaimenidische Inhalte auf dem Sockel der Dareios-Statue aus Susa/Heliopolis', in H. Sancisi-Weerdenburg and A. Kuhrt (ed.), *Achaemenid History, Vol. 6: Asia Minor and Egypt*, Leiden: Nederlands Instituut voor het Nabije Oosten, pp. 285–303.

Calmeyer, P. (1993), 'Die Gefäße auf den Gabenbringer-Reliefs in Persepolis', *Archäologische Mitteilungen aus Iran* 26, 147–60.
Cameron, G. G. (1943), 'Darius, Egypt, and the "Lands Beyond the Sea"', *Journal of Near Eastern Studies* 2, 307–13.
Cameron, G. G. (1948), *Persepolis Treasury Tablets*, Chicago: University of Chicago Press.
Caminos, R. A. (1977), *A Tale of Woe: From a Hieratic Papyrus in the A. S. Pushkin Museum of Fine Arts in Moscow*, Oxford: Griffith Institute.
Capart, J. (1940), 'Notes sur les fouilles d'El Kab', *Chronique d'Égypte* 15, 205–10.
Capriotti Vittozzi, G. (2013), *La terra del Nilo sulle sponde del Tevere*, Rome: Aracne editrice.
Carrez-Maratray, J.-Y. (2000), 'Le "monopole de Naucratis" et la "bataille de Péluse": ruptures ou continuités de la présence grecque en Égypte des Saïtes aux Perses', *Transeuphratène* 19, 159–72.
Carter, R. A., Challis, K., Priestman, S. M. N. and Tofighian, H. (2006), 'The Bushehr hinterland: results of the first season of the Iranian–British Archaeological Survey of Bushehr Province, November–December 2004', *Iran* 44, 63–103.
Casey, P. J. (1986), *Understanding Ancient Coins: An Introduction for Archaeologists and Historians*, Norman, OK: University of Oklahoma Press.
Castagna, G. (1981), 'Ἰl Τυρίων στρατόπεδον e lo ἱρόν το ... ξεινης Ἀφροδίτης a Menfi in Herod. II, 112', *Quaderni di lingue e letterature* 6, 195–204.
Castle, E. W. (1992), 'Shipping and trade in Ramesside Egypt', *Journal of the Economic and Social History of the Orient* 35, 239–77.
Caton-Thompson, G. (1952), *Kharga Oasis in Prehistory*, London: University of London, Athlone Press.
Caubet, A. (ed.) (2007), *Faïences et matières vitreuses de l'Orient ancien: étude physico-chimique et catalogue des oeuvres du department des Antiquités orientales*, Paris: Musée du Louvre.
Cavanagh, W. and Mee, C. (1995), 'Mourning before and after the Dark Age', in C. Morris (ed.), *Klados: Essays in Honour of J. N. Coldstream*, London: Institute of Classical Studies, University of London, pp. 45–61.
Chamoux, F. (1953), *Cyrène sous la monarchie des Battiades*, Paris: De Boccard.
Charles, M. B. (2012), 'Herodotus, body armour and Achaemenid infantry', *Historia* 61, 257–69.
Chauveau, M. (1996), 'Les archives d'un temple des oasis au temps des Perses', *Bulletin de la Société française d'Égyptologie* 137, 32–47.
Chauveau, M. (1999), 'La chronologie de la correspondance dite "de Phérendates"', *Revue d'Égyptologie* 50, 269–71.
Chauveau, M. (2000), 'La première mention du statère d'argent en Égypte', *Transeuphratène* 20, 137–43.

Chauveau, M. (2001), 'Les qanāts dans les ostraca de Manâwar', in P. Briant (ed.), *Irrigation et drainage dans l'antiquité: qanāts et canalisations souterraines en Iran, en Égypte et en Grèce*, Paris: Thotm éditions, pp. 137–42.

Chauveau, M. (2004), 'Inarôs, prince des rebelles', in F. Hoffmann and H. J. Thissen (ed.), *Res severa verum gaudium: Festschrift für Karl-Theodor Zauzich zum 65. Geburtstag am 8. Juni 2004*, Leuven: Peeters, pp. 39–46.

Chauveau, M. (2005), 'Irrigation et exploitation de la terre dans l'oasis de Kharga à l'époque perse', *Cahier de recherches de l'Institut de papyrologie et d'Égyptologie de Lille* 25, 157–63.

Chauveau, M. (2008), 'Les archives démotiques d'époque perse: à propos des archives démotiques d'Ayn-Manawîr', in P. Briant, W. F. M. Henkelman and M. W. Stolper (ed.), *L'archive des Fortifications de Persépolis: état des questions et perspectives de recherches*, Paris: De Boccard, pp. 517–24.

Chauveau, M. (2009), 'Titres et fonctions en Égypte perse d'après les sources égyptiennes', in P. Briant and M. Chauveau (ed.), *Organisation des pouvoirs et contacts culturels dans les pays de l'empire achéménide*, Paris: De Boccard, pp. 123–31.

Chauveau, M. (2011), 'Les archives démotiques du temple de Ayn Manawîr', *Achaemenid Research on Texts and Archaeology* 2011.002, <http://www.achemenet.com/pdf/arta/2011.002–Chauveau.pdf> (accessed 14 December 2018).

Chauveau, M. (2018), 'La plus ancienne attestation démotique de l'artabe?', in K. Donker van Heel, F. A. J. Hoogendijk and C. J. Martin (ed.), *Hieratic, Demotic and Greek Studies and Text Editions: Of Making Books There Is No End – Festschrift in Honour of Sven P. Vleeming*, Leiden: Brill, pp. 3–5.

Cherpion, N., Corteggiani, J.-P. and Gout, J.-F. (2007), *Le tombeau de Pétosiris à Touna el-Gebel: relevé photographique*, Cairo: Institut français d'archéologie orientale.

Chimko, C. J. (2003), 'Foreign pharaohs: self-legitimization and indigenous reaction in art and literature', *Journal of the Society for the Study of Egyptian Antiquities* 30, 15–57.

Çifçi, A. and Greaves, A. M. (2013), 'Urartian irrigation systems: a critical review', *Ancient Near Eastern Studies* 50, 191–214.

Clarysse, W. (1985), 'Greeks and Egyptians in the Ptolemaic army and administration', *Aegyptus* 65, 57–66.

Colburn, H. P. (2011), 'Orientalism, postcolonialism, and the Achaemenid Empire: meditations on Bruce Lincoln's *Religion, Empire and Torture*', *Bulletin of the Institute of Classical Studies* 54 (2), 87–103.

Colburn, H. P. (2013), 'Connectivity and communication in the Achaemenid Empire', *Journal of the Economic and Social History of the Orient* 56, 29–52.

Colburn, H. P. (2014a), 'Art of the Achaemenid Empire, and art in the

Achaemenid Empire', in B. A. Brown and M. H. Feldman (ed.), *Critical Approaches to Ancient Near Eastern Art*, Boston: De Gruyter, pp. 773–800.

Colburn, H. P. (2014b), *The Archaeology of Achaemenid Rule in Egypt*, PhD diss., University of Michigan.

Colburn, H. P. (2015), 'Memories of the Second Persian Period in Egypt', in J. M. Silverman and C. Waerzeggers (ed.), *Political Memory in and after the Persian Empire*, Atlanta: SBL Press, pp. 165–202.

Colburn, H. P. (2016), 'Roman collecting and the biographies of Egyptian Late Period statues', *World Archaeology* 48, 226–38.

Colburn, H. P. (2017), 'Globalization and the study of the Achaemenid Persian Empire', in T. Hodos (ed.), *The Routledge Handbook of Archaeology and Globalization*, Abingdon: Routledge, pp. 871–84.

Colburn, H. P. (2018a), 'Memphis, Naukratis and the Greek East', in J. Spier, T. Potts and S. E. Cole (ed.), *Beyond the Nile: Egypt and the Classical World*, Los Angeles: J. Paul Getty Museum, pp. 82–8.

Colburn, H. P. (2018b), 'Pioneers of the Western Desert: the Kharga Oasis in the Achaemenid Empire', in B. S. Düring and T. D. Stek (ed.), *The Archaeology of Imperial Landscapes: A Comparative Study of Empires in the Ancient Near East and Mediterranean World*, Cambridge: Cambridge University Press, pp. 86–114.

Colburn, H. P. (2018c), 'The role of coinage in the political economy of fourth century Egypt', in P. McKechnie and J. A. Cromwell (ed.), *Ptolemy I and the Transformation of Egypt, 404–282 BC*, Leiden: Brill, pp. 70–119.

Colburn, H. P. (forthcoming a), 'Seal production and the city of Persepolis', in E. R. M. Dusinberre and M. B. Garrison (ed.), *The Art of Empire in Achaemenid Persia: Festschrift in Honor of Margaret Cool Root*, Leiden: Nederlands Instituut voor het Nabije Oosten.

Colburn, H. P. (forthcoming b), 'Amasis (Persian general)', in C. Baron (ed.), *The Herodotus Encyclopedia*, Chichester: Wiley-Blackwell.

Cooney, J. D. (1953a), 'The papyri and their sealings, with a brief description of their unrolling', in E. G. Kraeling, *The Brooklyn Museum Aramaic Papyri: New Documents of the Fifth Century B.C. from the Jewish Colony at Elephantine*, New Haven: Yale University Press, pp. 123–7.

Cooney, J. D. (1953b), 'The portrait of an Egyptian collaborator', *Brooklyn Museum Bulletin* 15 (2), 1–16.

Cooney, J. D. (1956), *Five Years of Collecting Egyptian Art 1951–1956: Catalogue of an Exhibition Held at the Brooklyn Museum, 11 December, 1956 to 17 March, 1957*, Brooklyn: Brooklyn Museum.

Cooper, J. P. (2009), 'Egypt's Nile–Red Sea canals: chronology, location, seasonality and function', in L. Blue, J. Cooper, R. Thomas and J. Whitewright (ed.), *Connected Hinterlands: Proceedings of the Red Sea Project IV Held at the University of Southampton, September 2008*, Oxford: Archaeopress, pp. 195–209.

Coppens, F. and Smoláriková, K. (2009), *Abusir, Vol. 20: Lesser Late Period Tombs at Abusir*, Prague: Czech Institute of Egyptology.

Corcella, A. (2007), 'Book IV', in O. Murray and A. Moreno (ed.), *A Commentary on Herodotus Books I–IV*, Oxford: Oxford University Press, pp. 543–721.

Cottier, M. (2012), '*Retour à la source*: a fresh overview of the Persian customs register *TAD* C.3.7', in K. Konuk (ed.), *Stephanèphoros: de l'économie antique à l'Asie Mineure*, Pessac: Ausonius, pp. 53–61.

Cruz-Uribe, E. (1977–8), 'Papyrus Libbey, a reexamination', *Serapis* 4, 3–10.

Cruz-Uribe, E. (1986), 'The Hibis Temple Project: 1984–85 season, preliminary report', *Journal of the American Research Center in Egypt* 23, 157–66.

Cruz-Uribe, E. (1987), 'Hibis Temple Project: preliminary report, 1985–1986 and summer 1986 field seasons', *Varia Aegyptiaca* 3, 215–30.

Cruz-Uribe, E. (1988), *Hibis Temple Project, Vol. 1: Translations, Commentary, Discussions and Sign List*, San Antonio: Van Siclen Books.

Cruz-Uribe, E. (1992–3), 'The writing of the name of King Darius', *Enchoria* 19–20, 5–10.

Cruz-Uribe, E. (1999), 'Kharga Oasis, Late Period and Graeco-Roman sites', in K. A. Bard (ed.), *Encyclopedia of the Archaeology of Ancient Egypt*, London: Routledge, pp. 406–8.

Cruz-Uribe, E. (2003a), 'The invasion of Egypt by Cambyses', *Transeuphratène* 25, 9–60.

Cruz-Uribe, E. (2003b), 'Qanāts in the Achaemenid period', *Bibliotheca Orientalis* 60, 537–44.

Cruz-Uribe, E. (2008), 'The foundations of Hibis', in S. H. D'Auria (ed.), *Servant of Mut: Studies in Honor of Richard A. Fazzini*, Leiden: Brill, pp. 73–82.

Curtis, J. (1996), 'Assyrian furniture: the archaeological evidence', in G. Herrmann (ed.), *The Furniture of Western Asia, Ancient and Traditional: Papers of the Conference Held at the Institute of Archaeology, University College London, June 28 to 30, 1993*, Mainz: Philipp von Zabern, pp. 167–80.

Curtis, J. (2005), 'Jewellery and personal ornaments', in J. Curtis and N. Tallis (ed.), *Forgotten Empire: The World of Ancient Persia*, Berkeley: University of California Press, pp. 132–49.

Curtis, J. E., Cowell, M. R. and Walker, C. B. F. (1995), 'A silver bowl of Artaxerxes I', *Iran* 33, 149–53.

Darnell, D. (2000), 'Oasis Ware flasks and kegs from the Theban desert', *Cahiers de la céramique égyptienne* 6, 227–33.

Darnell, J. C. (1992), 'The *kbn.wt* vessels of the Late Period', in J. H. Johnson (ed.), *Life in a Multi-Cultural Society: Egypt from Cambyses to Constantine and Beyond*, Chicago: Oriental Institute of the University of Chicago, pp. 67–89.

Darnell, J. C. (2004), *The Enigmatic Netherworld Books of the Solar–Osirian Unity: Cryptographic Compositions in the Tombs of Tutankhamun, Ramesses VI and Ramesses IX*, Fribourg and Göttingen: Academic Press and Vandenhoeck and Ruprecht.

Darnell, J. C. (2007a), 'The deserts', in T. Wilkinson (ed.), *The Egyptian World*, London: Routledge, pp. 29–48.

Darnell, J. C. (2007b), 'The antiquity of Ghueita temple', *Göttinger Miszellen* 212, 29–40.

Darnell, J. C. (2010), 'Final report for the fifteenth field season of the Theban Desert Road Survey', *Annales du Service des antiquités de l'Égypte* 84, 97–127.

Darnell, J. C. (2013), 'A bureaucratic challenge? Archaeology and administration in a desert environment (second millennium B.C.E.)', in J. C. Moreno García (ed.), *Ancient Egyptian Administration*, Leiden: Brill, pp. 785–830.

Darnell, J. C. and Darnell, D. (2013), 'The Girga road: Abu Ziyâr, Tundaba, and the integration of the southern oases into the pharaonic state', in F. Förster and H. Reimer (ed.), *Desert Road Archaeology in Ancient Egypt and Beyond*, Cologne: Heinrich-Barth-Institut, pp. 221–63.

Darnell, J. C., Klotz, D. and Manassa, C. (2013), 'Gods on the road: the pantheon of Thebes at Qasr el-Ghueita', in C. Thiers (ed.), *Documents de Théologies Thébaines Tardives (D3T 2)*, Montpellier: Université Paul Valéry (Montpellier III) – CNRS, pp. 1–31.

Daryaee, T. (2012), 'Herodotus on drinking wine in the Achaemenid world: Greek and Persian perceptions', in B. Aghaei and M. R. Ghanoonparvar (ed.), *Iranian Languages and Culture: Essays in Honor of Gernot Ludwig Windfuhr*, Costa Mesa, CA: Mazda Publishers, pp. 38–43.

Daucé, N. (2013), 'The ornamental bricks', in J. Perrot (ed.), *The Palace of Darius at Susa: The Great Royal Residence of Achaemenid Persia*, London: I. B. Tauris, pp. 304–20.

Davies, J. (2004), 'Athenian fiscal expertise and its influence', *Mediterraneo Antico* 7, 491–512.

Davies, N. de G. (1953), *The Temple of Hibis in El Khārgeh Oasis, Vol. 3: The Decorations*, New York: Metropolitan Museum of Art.

Davies, S. (2006), *The Sacred Animal Necropolis at North Saqqara: The Mother of Apis and Baboon Catacombs*, London: Egypt Exploration Society.

Davies, S. (2009), '"Eine Kuh macht Muh, viele Kühe machen Mühe": the strange case of MoA 72/1 + N', in P. Briant and M. Chauveau (ed.), *Organisation des pouvoirs et contacts culturels dans les pays de l'empire achéménide*, Paris: De Boccard, pp. 79–87.

Davies, S. and Smith, H. S. (2005), *The Sacred Animal Necropolis at North Saqqara: The Falcon Complex and Catacomb*, London: Egypt Exploration Society.

De Angeli, S. (2013), '"Qanat landscapes" in the oases of the Western

Desert of Egypt: the cases of the Bahriya and Farafra Oases', in M. Dospěl and L. Suková (ed.), *Bahriya Oasis: Recent Research into the Past of an Egyptian Oasis*, Prague: Charles University in Prague, Faculty of Arts, pp. 271–85.

De Backer, F. (2012), 'Scale-armour in the Mediterranean area during the early Iron Age: A) from the IXth to the IIIrd century B.C.', *Revue des études militaires anciennes* 5, 1–38.

De Callataÿ, F. (1989), 'Les trésors achéménides et les monnayages d'Alexandre: espèces immobilisées et espèces circulantes?', *Revue des études anciennes* 89, 259–74.

De Callataÿ, F. (2005), 'L'instauration par Ptolémée Ier Sôter d'une économie monétaire fermée', in F. Duyrat and O. Picard (ed.), *L'exception égyptienne? Production et échanges monétaires en Égypte hellénistique et romaine*, Cairo: Institut français d'archéologie orientale, pp. 117–33.

Defernez, C. (2001), *La céramique d'époque perse à Tell El-Herr: étude chrono-typologique et comparative*, Lille: Université Charles-de-Gaulle Lille III.

Defernez, C. (2011a), 'Les témoignages d'un continuité de la culture matérielle saïte à l'époque perse: l'apport de l'industrie céramique', in D. Devauchelle (ed.), *La XXVIe dynastie, continuités et ruptures: promenade saïte avec Jean Yoyotte*, Paris: Cybèle, pp. 109–26.

Defernez, C. (2011b), 'Four Bes vases from Tell el-Herr (north Sinai): analytical description and correlation with the goldsmith's art of Achaemenid tradition', in D. Aston, B. Bader, C. Gallorini, P. Nicholson and S. Buckingham (ed.), *Under the Potter's Tree: Studies on Ancient Egypt Presented to Janine Bourriau on the Occasion of Her 70th Birthday*, Leuven: Peeters, pp. 287–323.

Defernez, C. (2012), 'Sur les traces des conteneurs égyptiens d'époque perse dans le Delta', in C. Zivie-Coche and I. Guermeur (ed.), *"Parcourir l'éternité": hommages à Jean Yoyotte*, Vol. 1, Turnhout: Brepols, pp. 387–407.

Defernez, C. and Marchand, S. (2006), 'Imitations égyptiennes de conteneurs d'origine égéenne et levantine (VIe s.–IIe s. av. J.-C.)', in B. Mathieu, D. Meeks and M. Wissa (ed.), *L'apport de l'Égypte à l'histoire des techniques: méthodes, chronologie et comparaisons*, Cairo: Institut français d'archéologie orientale, pp. 63–99.

De Meulenaere, H. (1966), *Le surnom égyptien à la basse époque*, Istanbul: Nederlands Historisch-Archaeologisch Instituut in het Nabije Oosten.

De Meulenaere, H. (1983), 'Une familie de hauts dignitaires saïtes', in H. de Meulenaere and L. Limme (ed.), *Artibus Aegypti: Studia in honorem Bernardi V. Bothmer a collegis amicis discipulis conscripta*, Brussels: Musées royaux d'art et d'histoire, pp. 35–43.

De Meulenaere, H. (2009), 'Personnage debout tenant un naos dans la statuaire de la Basse Époque', in W. Claes, H. de Meulenaere and

S. Hendrickx (ed.), *Elkab and Beyond: Studies in Honour of Luc Limme*, Leuven: Peeters, pp. 223–31.

De Morgan, J. (1905), 'Découverte d'une sépulture achéménide a Suse', in J. de Morgan (ed.), *Recherches archéologiques: troisième série*, Paris: Ernest Leroux, pp. 29–58.

Depauw, M. (1997), *A Companion to Demotic Studies*, Brussels: Fondation égyptologique Reine Élisabeth.

De Planhol, X. (2011), 'Kāriz', in E. Yarshater (ed.), *Encyclopaedia Iranica, Vol. 15*, New York: Encyclopaedia Iranica Foundation, pp. 564–83.

Depuydt, L. (1995), 'Murder in Memphis: the story of Cambyses' mortal wounding of the Apis Bull (ca. 523 B.C.E.)', *Journal of Near Eastern Studies* 54, 119–26.

Depuydt, L. (2010), 'New date for the second Persian conquest, end of Pharaonic and Manethonian Egypt: 340/39 B.C.', *Journal of Egyptian History* 3, 191–230.

De Rougé, E. (1851), 'Mémoire sur la statuette naophore du Musée grégorien, au Vatican', *Revue archéologique* 8, 37–60.

Devauchelle, D. (1994a), 'Les stèles du Serapéum de Memphis conservées au musée du Louvre', *Egitto e vicino oriente* 17, 95–114.

Devauchelle, D. (1994b), 'Notes et documents pour servir à l'histoire du Sérapéum de Memphis (I–V)', *Revue d'Égyptologie* 45, 75–86.

Devauchelle, D. (1995a), 'Le sentiment anti-perse chez les anciens Égyptiens', *Transeuphratène* 9, 67–80.

Devauchelle, D. (1995b), 'Réflexions sur les documents égyptiens datés de la Deuxième Domination perse', *Transeuphratène* 10, 35–43.

Devauchelle, D. (1998), 'Un problème de chronologie sous Cambyse', *Transeuphratène* 15, 9–17.

Devauchelle, D. (2000), 'Notes et documents pour servir à l'histoire du Sérapéum de Memphis (VI–X)', *Revue d'Égyptologie* 51, 21–37.

De Wit, C. (1964), 'Some remarks concerning the so-called "Isis" in the Museum Vleeshuis, Antwerp', *Chronique d'Égypte* 39, 61–6.

Di Cerbo, C. and Jasnow, R. (1996), 'Five Persian period Demotic and hieroglyphic graffiti from the site of Apa Tyrannos at Armant', *Enchoria* 23, 32–8.

Dietler, M. (2006), 'Alcohol: anthropological/archaeological perspectives', *Annual Review of Anthropology* 35, 229–49.

Dillery, J. (2003), 'Manetho and Udjahorresnet: designing royal names for non-Egyptian pharaohs', *Zeitschrift für Papyrologie und Epigraphik* 144, 201–2.

Dillery, J. (2005), 'Cambyses and the Egyptian *Chaosbeschreibung* tradition', *Classical Quarterly* 55, 387–406.

Dimick, J. (1958), 'The embalming house of the Apis bull', *Archaeology* 11, 183–9.

Dodson, A. (2001), 'Of bulls, pharaohs, Persians and Ptolemies: the latter

years of the Serapeum of Saqqara', *Bulletin of the Egyptological Seminar* 15, 27–38.

Dodson, A. (2005), 'Bull cults', in S. Ikram (ed.), *Divine Creatures: Animal Mummies in Ancient Egypt*, Cairo: American University in Cairo Press, pp. 72–105.

Dodson, A. (2012), *Afterglow of Empire: Egypt from the Fall of the New Kingdom to the Saite Renaissance*, Cairo: American University in Cairo Press.

Donker van Heel, K. (2012), *Djekhy & Son: Doing Business in Ancient Egypt*, Cairo: American University in Cairo Press.

Drioton, E. (1940), 'Recueil de cryptographie monumentale', *Annales du Service des antiquités de l'Égypte* 40, 305–427.

Driver, G. R. (1957), *Aramaic Documents of the Fifth Century B.C.*, Oxford: Clarendon Press.

Dumbrell, W. J. (1971), 'The Tell el-Maskhuṭa bowls and the "kingdom" of Qedar in the Persian period', *Bulletin of the American Schools of Oriental Research* 203, 33–44.

Dunham, D. (1943), 'An experiment with an Egyptian portrait: Ankh-haf in modern dress', *Bulletin of the Museum of Fine Arts* 41, 10.

Dunham, D. (1957), *Royal Cemeteries of Kush, Vol. 4: Royal Tombs at Meroë and Barkal*, Boston: Museum of Fine Arts.

Dušek, J. and Mynářová, J. (2011), 'Phoenician and Aramaic inscriptions on a Phoenician storage jar (Excav. no. 826/S/10): a preliminary report', in L. Bareš and K. Smoláriková, *Abusir, Vol. 25: The Shaft Tomb of Menekhibnekau*, Prague: Czech Institute of Egyptology, pp. 178–81.

Dušek, J. and Mynářová, J. (2013), 'Phoenician and Aramaic inscriptions from Abusir', in A. F. Botta (ed.), *In the Shadow of Bezalel: Aramaic, Biblical, and Ancient Near Eastern Studies in Honor of Bezalel Porten*, Leiden: Brill, pp. 53–69.

Dusinberre, E. R. M. (1997), 'Imperial style and constructed identity: a "Graeco-Persian" cylinder seal from Sardis', *Ars Orientalis* 27, 99–129.

Dusinberre, E. R. M. (1999), 'Satrapal Sardis: Achaemenid bowls in an Achaemenid capital', *American Journal of Archaeology* 103, 73–102.

Dusinberre, E. R. M. (2003), *Aspects of Empire in Achaemenid Sardis*, Cambridge: Cambridge University Press.

Dusinberre, E. R. M. (2008), 'Circles of light and Achaemenid hegemonic style in Gordion's Seal 100', in N. D. Cahill (ed.), *Love for Lydia: A Sardis Anniversary Volume Presented to Crawford H. Greenwalt, Jr.*, Cambridge, MA: Harvard University Press, pp. 87–98.

Dusinberre, E. R. M. (2013), *Empire, Authority, and Autonomy in Achaemenid Anatolia*, Cambridge: Cambridge University Press.

Dusinberre, E. R. M. (forthcoming), *Seals on the Persepolis Fortification Tablets, Vol. 4: The Aramaic Tablet Seals*, Chicago: Oriental Institute of the University of Chicago.

Eaton-Krauss, M. (2011), 'Sculpture in Early Dynastic Egypt', in D. C. Patch

(ed.), *Dawn of Egyptian Art*, New York: Metropolitan Museum of Art, pp. 180–93.
Ebbinghaus, S. (1998), *Rhyta with Animal Foreparts in the Achaemenid Empire and Their Reception in the West*, DPhil diss., University of Oxford.
Ebbinghaus, S. (2000), 'A banquet at Xanthos: seven rhyta on the northern cella frieze of the "Nereid" monument', in G. R. Tsetskhladze, A. J. N. Pragg and A. M. Snodgrass (ed.), *Periplous: Papers on Classical Art and Archaeology Presented to Sir John Boardman*, London: Thames and Hudson, pp. 98–109.
Ebbinghaus, S. (2018), 'Feasting like the Persian king', in S. Ebbinghaus (ed.), *Animal-Shaped Vessels from the Ancient World: Feasting with Gods, Heroes, and Kings*, Cambridge, MA: Harvard Art Museums, pp. 135–87.
Ebbinghaus, S. and Colburn, H. P. (2018), 'Emblematic animals at Iron Age feasts', in S. Ebbinghaus (ed.), *Animal-Shaped Vessels from the Ancient World: Feasting with Gods, Heroes, and Kings*, Cambridge, MA: Harvard Art Museums, pp. 87–133.
Egberts, A. (1998), 'Hard times: the chronology of "the report of Wenamun"', *Zeitschrift für ägyptische Sprache und Altertumskunde* 125, 93–108.
Eichler, S. (1984), *Götter, Genien und Mischwesen in der urartäischen Kunst*, Berlin: Dietrich Reimer.
El Amir, M. (1948), 'The Σηκος of Apis at Memphis: a season of excavations at Mīt Rahīnah in 1941', *Journal of Egyptian Archaeology* 34, 51–6.
Elayi, J. and Elayi, A. G. (1992), 'Nouvelle datation d'une tombe achéménide de Suse', *Studia Iranica* 21, 265–70.
Elayi, J. and Elayi, A. G. (1993), *Trésors de monnaies phéniciennes et circulation monétaire: Ve–IVe siècles avant J.-C.*, Paris: Gabalda.
El Naggar, S. (1978), 'Étude préliminaire du plan du tombeau de Bocchoris à Saqqara', *Egitto e vicino oriente* 1, 41–57.
El-Sadeek, W. (1984), *Twenty-Sixth Dynasty Necropolis at Gizeh*, Vienna: AFRO-PUB.
El-Sayed, R. (1975), *Documents relatifs à Saïs et ses divinités*, Cairo: Institut français d'archéologie orientale.
English, P. W. (1968), 'The origin and spread of qanats in the Old World', *Proceedings of the American Philosophical Society* 112, 170–81.
Evenari, M., Shannan, L. and Tadmor, N. (1982), *The Negev: The Challenge of a Desert*, 2nd edn, Cambridge, MA: Harvard University Press.
Eyre, C. (2013), *The Use of Documents in Pharaonic Egypt*, Oxford: Oxford University Press.
Fabre, D. (2011), 'The shipwrecks of Heracleion-Thonis: a preliminary study', in D. Robinson and A. Wilson (ed.), *Maritime Archaeology and Ancient Trade in the Mediterranean*, Oxford: School of Archaeology, University of Oxford, pp. 13–32.

Fakhry, A. (1941), 'A Roman temple between Kharga and Dakhla', *Annales du Service des antiquités de l'Égypte* 41, 761–8.
Fakhry, A. (1942), *Recent Explorations in the Oases of the Western Desert*, Cairo: French Institute of Oriental Archaeology.
Farina, G. (1929), 'La politica religiosa di Cambise in Egitto', *Bilychnis* 18, 449–57.
Fattahi, M. (2015), 'OSL dating of the Miam qanat (kāriz) system in NE Iran', *Journal of Archaeological Science* 59, 54–63.
Fazzini, R. A., Bianchi, R. S., Romano, J. F. and Spanel, D. B. (1989), *Ancient Egyptian Art in the Brooklyn Museum*, New York: Brooklyn Museum and Thames and Hudson.
Fearn, D. (2007), *Bacchylides: Politics, Performance, Poetic Tradition*, Oxford: Oxford University Press.
Finn, J. (2011), 'Gods, kings, men: trilingual inscriptions and symbolic visualizations in the Achaemenid Empire', *Ars Orientalis* 41, 219–75.
Finnestad, R. B. (1997), 'Temples of the Ptolemaic and Roman periods: ancient traditions in new contexts', in B. E. Shafer (ed.), *Temples of Ancient Egypt*, Ithaca, NY: Cornell University Press, pp. 185–237.
Fischer-Bossert, W. and Gitler, H. (2010), 'The Ismailiya Hoard 1983', *Israel Numismatic Research* 5, 3–12.
Fischer-Bovet, C. (2013), 'Egyptian warriors: the *Machimoi* of Herodotus and the Ptolemaic army', *Classical Quarterly* 63, 209–36.
Fischer-Bovet, C. (2014), *Army and Society in Ptolemaic Egypt*, Cambridge: Cambridge University Press.
Fisher, C. S. (1917), 'The Eckley B. Coxe Jr. Egyptian Expedition', *University of Pennsylvania Museum Journal* 8, 211–37.
Fisher, C. S. (1924), 'A group of Theban tombs: work of the Eckley B. Coxe Jr. Expedition to Egypt', *University of Pennsylvania Museum Journal* 15, 28–49.
Flament, C. (2003), 'Imitations athéniennes ou monnaies authentiques? Nouvelles considérations sur quelques chouettes athéniennes habituellement identifiées comme imitations', *Revue belge de numismatique et de sigillographie* 149, 1–10.
Flament, C. (2005), 'Un trésor de tétradrachmes athéniens dispersés suivi de considérations relatives au classement, à la frappe et à l'attribution de chouettes à des ateliers étrangers', *Revue belge de numismatique et de sigillographie* 151, 29–38.
Flament, C. (2007a), *Le monnayage en argent d'Athènes: de l'époque archaïque à l'époque hellénistique, c. 550–c. 40 av. J.-C.*, Louvain-la-Neuve: Association numismatique professeur Marcel Hoc.
Flament, C. (2007b), 'L'argent des chouettes: bilan de l'application des méthodes de laboratoire au monnayage athénien tirant parti de nouvelles analyses réalisées au moyen de la méthode PIXE', *Revue belge de numismatique et de sigilliographie* 153, 9–30.

Flament, C. (2007c), 'Quelques considérations sur les monnaies athéniennes émises au IVe s.', *Numismatica e antichità classiche* 36, 91–105.

Flament, C. and Marchetti, P. (2004), 'Analysis of ancient silver coins', *Nuclear Instruments and Methods in Physics Research B* 226, 179–84.

Förster, F. (2013), 'Beyond Dakhla: the Abu Ballas trail in the Libyan Desert', in F. Förster and H. Reimer (ed.), *Desert Road Archaeology in Ancient Egypt and Beyond*, Cologne: Heinrich-Barth-Institut, pp. 297–337.

Frank, C. (2013), 'The Acropolis tomb', in J. Perrot (ed.), *The Palace of Darius at Susa: The Great Royal Residence of Achaemenid Persia*, London: I. B. Tauris, pp. 347–55.

French, P. and Jones, M. (1993), 'Memphis: Temple of Apis', *Bulletin de liaison du Groupe international d'étude de la céramique égyptienne* 17, 21–3.

Fried, L. S. (2004), *The Priest and the Great King: Temple–Palace Relations in the Persian Empire*, Winona Lake, IN: Eisenbrauns.

Fried, L. S. (2018), '150 men at Nehemiah's table? The role of the governor's meals in the Achaemenid provincial economy', *Journal of Biblical Literature* 137, 821–31.

Gabra, S. (1945–6), 'Lettres araméens trouvées à Touna el Gebel Hermopolis ouest', *Bulletin de l'Institut d'Égypte* 28, 161–2.

Gale, N. H., Genter, W. and Wagner, G. A. (1980), 'Mineralogical and geographical silver sources of Archaic Greek coinage', in D. M. Metcalf and W. A. Oddy (ed.), *Metallurgy in Numismatics, Vol. 1*, London: Royal Numismatic Society, pp. 3–49.

Gale, N. H. and Stos-Gale, Z. A. (1981), 'Ancient Egyptian silver', *Journal of Egyptian Archaeology* 67, 103–15.

Gallo, P. and Masson, O. (1993), 'Une stèle "hellénomemphite" de l'ex-collection Nahman', *Bulletin de l'Institut français d'archéologie orientale* 93, 265–76.

Garrison, M. B. (1991), 'Seals and the elite at Persepolis: some observations on early Achaemenid art', *Ars Orientalis* 21, 1–29.

Garrison, M. B. (2000), 'Achaemenid iconography as evidenced by glyptic art: subject matter, social function, audience and diffusion', in C. Uehlinger (ed.), *Images as Media: Sources for the Cultural History of the Near East and the Eastern Mediterranean (1st Millennium BC)*, Fribourg and Göttingen: University Press and Vandenhoeck and Ruprecht, pp. 115–63.

Garrison, M. B. (2010), 'The heroic encounter in the visual arts of ancient Iraq and Iran ca. 1000–500 BC', in D. B. Counts and B. Arnold (ed.), *The Master of Animals in Old World Iconography*, Budapest: Archaeolingua, pp. 151–74.

Garrison, M. B. (2011), 'By the favor of Auramazdā: kingship and the divine in the early Achaemenid period', in P. P. Iossif, A. S. Chankowski and C. C. Lorber (ed.), *More than Men, Less than Gods: Studies on Royal Cult and Imperial Worship*, Leuven: Peeters, pp. 15–104.

Garrison, M. B. (2014), 'The royal name seals of Darius I', in M. Kozuh, W. F. M. Henkelman, C. E. Jones and C. Woods (ed.), *Extraction and Control: Studies in Honor of Matthew W. Stolper*, Chicago: Oriental Institute of the University of Chicago, pp. 67–104.

Garrison, M. B. (2017a), 'Sealing practice in Achaemenid times', in B. Jacobs, W. F. M. Henkelman and M. W. Stolper (ed.), *Die Verwaltung im Achämenidenreich: Imperiale Muster und Strukturen = Administration in the Achaemenid Empire: Tracing the Imperial Signature*, Wiesbaden: Harrassowitz, pp. 517–80.

Garrison, M. B. (2017b), *The Ritual Landscape at Persepolis: Glyptic Imagery from the Persepolis Fortification and Treasury Archives*, Chicago: Oriental Institute of the University of Chicago.

Garrison, M. B. (forthcoming), 'The seal of Aršāma', in J. Ma and C. Tuplin (ed.), *Arshama and Egypt: The World of an Achaemenid Satrap*, Oxford: Oxford University Press.

Garrison, M. B. and Ritner, R. K. (2010), 'From the Persepolis Fortification Archive Project, 2: seals with Egyptian hieroglyphic inscriptions at Persepolis', *Achaemenid Research on Texts and Archaeology* 2010.002, <http://www.achemenet.com/pdf/arta/2010.002-Garrison&Ritner.pdf> (accessed 18 December 2018).

Garrison, M. B. and Root, M. C. (2001), *Seals on the Persepolis Fortification Tablets, Vol. 1: Images of Heroic Encounter*, Chicago: Oriental Institute of the University of Chicago.

Garrison, M. B. and Root, M. C. (forthcoming), *Seals on the Persepolis Fortification Tablets, Vol. 2: Images of Human Activity*, Chicago: Oriental Institute of the University of Chicago.

Gasse, A. (1988), *Données nouvelles administratives et sacerdotales sur l'organisation du domaine d'Amon, XXe–XXIe dynasties à la lumière des papyrus Prachov, Reinhardt et Grundbuch (avec édition princeps des papyrus Louvre AF 6345 et 6346-7)*, Cairo: Institut français d'archéologie orientale.

Gates, J. E. (2002), 'The ethnicity name game: what lies behind "Graeco-Persian"?' *Ars Orientalis* 32, 105–32.

Gestermann, L. (2006), 'Das spätzeitliche Schachtgrab als memphitischer Grabtyp', in G. Moers, H. Behlmer, K. Demuß and K. Widmaier (ed.), *jn.t dr.w: Festschrift für Friedrich Junge*, Göttingen: Seminar für Ägyptologie und Koptologie, pp. 195–206.

Ghirshman, R. (1954), *Village perse-achéménide*, Paris: Presses universitaires de France.

Ghirshman, R. (1962), 'Notes iraniennes XI: le rhyton en Iran', *Artibus Asiae* 25, 57–80.

Giddy, L. L. (1987), *Egyptian Oases: Baḥariya, Dakhla, Farafra and Kharga during Pharaonic Times*, Warminster: Aris and Phillips.

Giddy, L. L. (1992), *The Anubieion at Saqqâra, Vol. 2: The Cemeteries*, London: Egypt Exploration Society.

Giddy, L. L., Jeffreys, D. G. and Malek, J. (1990), 'Memphis, 1989', *Journal of Egyptian Archaeology* 76, 1–15.
Giessen, A. and Weber, M. (2008), 'Untersuchungen zu den ägyptischen Nomenprägungen X', *Zeitschrift für Papyrologie und Epigraphik* 164, 277–305.
Giovino, M. (2006), 'Egyptian hieroglyphs on Achaemenid period cylinder seals', *Iran* 44, 105–14.
Goblot, H. (1979), *Les qanats: une technique d'acquisition de l'eau*, Paris: Mouton.
Godron, G. (1986), 'Notes sur l'histoire de la médecine et l'occupation perse en Égypte', in *Hommages à François Daumas*, Montpellier: Institut d'Égyptologie, Université Paul Valéry, pp. 285–97.
Goedicke, H. (1985), '*Zm3-T3wy*', in P. Posener-Kriéger (ed.), *Mélanges Gamal Eddin Mokhtar*, Cairo: Institut français d'archéologie orientale, pp. 307–24.
Golénischeff, W. (1890), 'Stèle de Darius aux environs de Tell el-Maskhouta', *Recueil de travaux relatifs a la philologie et a l'archéologie égyptiennes et assyriennes* 13, 99–109.
Gonon, T. (2005), 'Les qanats d'Ayn Manawir (Oasis de Kharga, Égypte): techniques de creusement et dynamique de l'exploitation d'une ressource épuisable de la Première Domination Perse au IIe siècle de l'Ere Commune', in *Internationales Frontinus-Symposium 'Wasserversorgung aus Qanaten – Qanate als Vorbilder im Tunnelbau' 2.–5. Oktober 2003, Walferdange, Luxemburg*, Bonn: Frontinus-Gesellschaft, pp. 39–57.
Goody, J. (1982), *Cooking, Cuisine and Class: A Study in Comparative Sociology*, Cambridge: Cambridge University Press.
Goody, J. (2006), *The Theft of History*, Cambridge: Cambridge University Press.
Gorre, G. (2017), 'The Satrap Stela: a Middle Ground approach', *Journal of Egyptian History* 10, 51–68.
Gosline, S. L. (1990), *Bahariya Oasis Expedition Season Report for 1988, Part 1: Survey of Qarat Hilwah*, San Antonio: Van Siclen Books.
Goyon, J.-C. (1972), *Confirmation du pouvoir royal au nouvel an: Brooklyn Museum Papyrus 47.218.50*, Cairo: Institut français d'archéologie orientale.
Graf, D. F. (1990), 'Arabia during Achaemenid times', in H. Sancisi-Weerdenburg and A. Kuhrt (ed.), *Achaemenid History, Vol. 4: Centre and Periphery*, Leiden: Nederlands Instituut voor het Nabije Oosten, pp. 131–48.
Graf, D. F. (1994), 'The Persian royal road system', in H. Sancisi-Weerdenburg, A. Kuhrt and M. C. Root (ed.), *Achaemenid History, Vol. 8: Continuity and Change*, Leiden: Nederlands Instituut voor het Nabije Oosten, pp. 167–89.
Grataloup, C. (2010), 'Occupation and trade at Heracleion-Thonis:

the evidence from the pottery', in D. Robinson and A. Wilson (ed.), *Alexandria and the North-Western Delta: Joint Conference Proceedings of Alexandria, City and Harbor (Oxford 2004) and The Trade and Topography of Egypt's North-West Delta, 8th Century BC to 8th Century AD (Berlin 2006)*, Oxford: School of Archaeology, University of Oxford, pp. 151–9.

Grelot, P. (1964), 'L'huile de ricin à Élephantine', *Semitica* 14, 64–70.

Grimal, N. (1997), 'Travaux de l'Institut français d'archéologie orientale en 1996–1997', *Bulletin de l'Institut françaíse d'archéologie orientale* 97, 313–429.

Grimal, N. (1999), 'Travaux de l'Institut français d'archéologie orientale en 1998–1999', *Bulletin de l'Institut françaíse d'archéologie orientale* 99, 447–566.

Guarducci, M. (1969), *Epigrafia greca, Vol. 2: Epigrafi di carattere pubblico*, Rome: Istituto poligrafico dello Stato, Libreria dello Stato.

Guentch-Ogloueff, M. (1941), 'Noms propres imprécatoires', *Bulletin de l'Institut français d'archéologie orientale* 40, 117–33.

Gunter, A. C. (1988), 'The art of eating and drinking in ancient Iran', *Asian Art* 1 (2), 7–52.

Gunter, A. C. and Hauser, S. R. (2005), 'Ernst Herzfeld and Near Eastern studies, 1900–1950', in A. C. Gunter and S. R. Hauser (ed.), *Ernst Herzfeld and the Development of Near Eastern Studies, 1900–1950*, Leiden: Brill, pp. 3–44.

Gunter, A. C. and Root, M. C. (1998), 'Replicating, inscribing, giving: Ernst Herzfeld and Artaxerxes' silver *phiale* in the Freer Gallery of Art', *Ars Orientalis* 28, 2–38.

Hachmann, R. (1995), 'Die Völkerschaften auf den Bildwerken von Persepolis', in U. Finkbeiner, R. Dittmann and H. Hauptmann (ed.), *Beiträge zur Kulturgeschichte Vorderasiens: Festschrift für Rainer Michael Boehmer*, Mainz: Philipp von Zabern, pp. 195–223.

Hallock, R. T. (1969), *Persepolis Fortification Tablets*, Chicago: University of Chicago Press.

Hardwick, N. (1998), 'The coinage of Terone from the fifth to the fourth centuries BC', in R. Ashton and S. Hurter (ed.), *Studies in Greek Numismatics in Memory of Martin Jessop Price*, London: Spink, pp. 119–34.

Harper, P. O., Aruz, J. and Tallon, F. (ed.) (1992), *The Royal City of Susa: Ancient Near Eastern Treasures in the Louvre*, New York: Metropolitan Museum of Art.

Harrison, T. (2011), *Writing Ancient Persia*, London: Duckworth.

Hassan, F. (1993) 'Town and village in ancient Egypt: ecology, society and urbanization', in T. Shaw, P. Sinclair, B. Andah and A. Okpoko (ed.), *The Archaeology of Africa: Foods, Metals and Towns*, London: Routledge, pp. 551–69.

Hastorf, C. A. (2017), *The Social Archaeology of Food: Thinking about*

Eating from Prehistory to the Present, Cambridge: Cambridge University Press.

Heckel, W. (2006), *Who's Who in the Age of Alexander the Great: Prosopography of Alexander's Empire*, Malden, MA: Blackwell.

Heise, J. (2007), *Erinnern und Gedenken: Aspekte der biographischen Inschriften der ägyptischen Spätzeit*, Fribourg and Göttingen: Academic Press and Vandenhoeck and Ruprecht.

Helms, M. W. (1993), *Craft and the Kingly Ideal: Art, Trade, and Power*, Austin: University of Texas Press.

Henkelman, W. F. M. (2008), 'From Gabae to Taoce: the geography of the central administrative province', in P. Briant, W. F. M. Henkelman and M. W. Stolper (ed.), *L'archive des Fortifications de Pérsepolis: état des questions et perspectives de recherches*, Paris: De Boccard, pp. 303–16.

Henkelman, W. F. M. (2010), '"Consumed before the king": the table of Darius, that of Irdabama and Irtaštuna, and that of his satrap Karkiš', in B. Jacobs and R. Rollinger (ed.), *Der Achämenidenhof = The Achaemenid Court: Akten des 2. Internationalen Kolloquiums zum Thema 'Vorderasien im Spannungsfeld klassicher und altorientalischer Überlieferungen', Landgut Castelen bei Basel, 23.-25. Mai 2007*, Wiesbaden: Harrassowitz, pp. 667–775.

Henkelman, W. F. M. and Folmer, M. L. (2016), 'Your tally is full! On wooden credit records in and after the Achaemenid Empire', in K. Kleber and R. Pirngruber (ed.), *Silver, Money and Credit: A Tribute to Robartus J. van der Spek on the Occasion of His 65th Birthday*, Leiden: Nederlands Instituut voor het Nabije Oosten, pp. 133–239.

Henkelman, W. F. M. and Stolper, M. W. (2009), 'Ethnic identity and ethnic labelling at Persepolis: the case of the Skudrians', in P. Briant and M. Chauveau (ed.), *Organisation des pouvoirs et contacts culturels dans les pays de l'empire achéménide*, Paris: De Boccard, pp. 271–329.

Herzfeld, E. E. (1935), 'Ein Silberschüssel Artaxerxes' I', *Archäologische Mitteilungen aus Iran* 7, 1–8.

Heyerdahl, T. (1981), *The Tigris Expedition: In Search of Our Beginnings*, Garden City, NY: Doubleday.

Hignett, C. (1963), *Xerxes' Invasion of Greece*, Oxford: Clarendon Press.

Höckmann, U. (2001), '"Bilinguen": zu Ikonographie und Stil der karisch-ägyptischen Grabstelen des 6. Jhs. v. Chr.', in U. Höckmann and D. Kreikenbom (ed.), *Naukratis: die Beziehungen zu Ostgriechenland, Ägypten und Zypern in archaischer Zeit*, Möhnesee: Bibliopolis, pp. 217–32.

Hofmann, B. (2005), *Die Königsnovelle: Strukturanalyse am Einzelwerk*, Wiesbaden: Harrassowitz.

Hollender, G. (2009), *Amenophis I. und Ahmes Nefertari: Untersuchungen zur Entwicklung ihres posthumen Kultes anhand der Privatgräber der thebanischen Nekropole*, Berlin: De Gruyter.

Holm-Rasmussen, T. (1988), 'Collaboration in early Achaemenid Egypt:

a new approach', in A. Damsgaard-Madsen, E. Christiansen and E. Hallager (ed.), *Studies in Ancient History and Numismatics Presented to Rudi Thomsen*, Aarhus: Aarhus University Press, pp. 29–38.

Hope, C. A. (1981), 'The Dakhleh Oasis Project: report on the study of pottery and kilns: third season – 1980', *Journal of the Society for the Study of Egyptian Antiquities* 11, 233–41.

Hopkins, K. (1980), 'Taxes and trade in the Roman Empire (200 B.C.–A.D. 400)', *Journal of Roman Studies* 70, 101–25.

Hopkins, K. (2002), 'Rome, taxes, rents and trade', in W. Scheidel and S. von Reden (ed.), *The Ancient Economy*, Edinburgh: Edinburgh University Press, pp. 190–230.

Hornblower, S. (2006), 'Herodotus' influence in antiquity', in C. Dewald and J. Marincola (ed.), *The Cambridge Companion to Herodotus*, Cambridge: Cambridge University Press, pp. 306–18.

Hornung, E. and Staehelin, E. (2006), *Neue Studien zum Sedfest*, Basel: Schwabe Verlag.

Hudson, N. (2016), 'Late Persian and early Hellenistic pottery at Tell Timai', *Bulletin de liaison de la céramique égyptienne* 26, 75–108.

Huss, W. (1997), 'Ägyptische Kollaborateure in persischer Zeit', *Tyche* 12, 131–43.

Huyse, P. (1992), '"Analecta Iranica" aus den demotischen Dokumenten von Nord-Saqqara', *Journal of Egyptian Archaeology* 78, 287–93.

Ikram, S. and Rossi, C. (2004), 'North Kharga Oasis Survey 2001–2002 preliminary report: Ain Gib and Qasr al-Sumayra', *Mitteilungen des Deutschen Archäologischen Instituts, Abteilung Kairo* 60, 165–82.

Iliffe, J. H. (1935), 'A Tell Fārʻa tomb group reconsidered: silver vessels of the Persian period', *Quarterly of the Department of Antiquities in Palestine* 4, 182–6.

Irwin, E. (forthcoming), 'Just why did Cambyses conquer Egypt? Herodotus' logos of Cambyses' Egyptian campaign: his story as history', in R. Rollinger (ed.), *Weltbild und Welterfassung zwischen Ost und West = Worldview and World Conception between East and West: Papers of an International Conference in Honor of Reinhold Bichler, Held in Obergurgl, Tyrol, 19–22 June, 2013*, Wiesbaden: Harrassowitz.

Ismail, F. T. (2009), *Cult and Ritual in Persian Period Egypt: An Analysis of the Decoration of the Cult Chapels F and G on the Lower Level and the Roof Chapels E1, E2, and H2 of the Temple of Hibis at Kharga Oasis*, PhD diss., Johns Hopkins University.

Jacquet, J. (1987), 'Excavations at Karnak-North: observations and interpretations', in J. Assmann, G. Burkard and V. Davies (ed.), *Problems and Priorities in Egyptian Archaeology*, London: KPI, pp. 105–12.

Jacquet-Gordon, H. (2012), *Karnak-Nord, Vol. 10, le trésor de Thoutmosis Ier: la céramique*, Cairo: Institut français d'archéologie orientale.

Jansen-Winkeln, K. (1998), 'Drei Denkmäler mit archaisierender Orthographie', *Orientalia* 67, 155–72.

Jansen-Winkeln, K. (2002), 'Die Quellen zur Eroberung Ägyptens durch Kambyses', in T. A. Bács (ed.), *A Tribute to Excellence: Studies Offered in Honor of Ernő Gaál, Ulrich Luft, László Török*, Budapest: Université Eötvös Lorand de Budapest, pp. 309–19.

Janssen, J. J. (1988), 'On prices and wages in ancient Egypt', *Altorientalische Forschungen* 15, 10–23.

Jeffreys, D. G. (1985), *The Survey of Memphis, Vol. 1: The Archaeological Report*, London: Egypt Exploration Society.

Jeffreys, D. G. (2001), 'Memphis', in D. B. Redford (ed.), *The Oxford Encyclopedia of Ancient Egypt, Vol. 2*, Oxford: Oxford University Press, pp. 373–6.

Jeffreys, D. G. (2010), *The Survey of Memphis, Vol. 7: The Hekekyan Papers and Other Sources for the Survey of Memphis*, London: Egypt Exploration Society.

Jeffreys, D. G. (2012), 'Climbing the White Walls: recent experiences of the Memphis Survey', in L. Evans (ed.), *Ancient Memphis, 'Enduring is the Perfection': Proceedings of the International Conference Held at Macquarie University, Sydney, on August 14–15, 2008*, Leuven: Peeters, pp. 221–36.

Jeffreys, D. G. and Smith, H. S. (1988), *The Anubieion at Saqqâra, Vol. 1: The Settlement and Temple Precinct*, London: Egypt Exploration Society.

Jeffreys, D. and Tavares, A. (1994), 'The historic landscape of Early Dynastic Memphis', *Mitteilungen des Deutschen Archäologischen Instituts, Abteilung Kairo* 50, 143–73.

Johnson, J. H. (1994), 'The Persians and the continuity of Egyptian culture', in H. Sancisi-Weerdenburg, A. Kuhrt and M. C. Root (ed.), *Achaemenid History, Vol. 8: Continuity and Change*, Leiden: Nederlands Instituut voor het Nabije Oosten, pp. 149–59.

Johnson, J. H. (1999), 'Ethnic considerations in Persian period Egypt', in E. Teeter and J. A. Larson (ed.), *Gold of Praise: Studies on Ancient Egypt in Honor of Edward F. Wente*, Chicago: Oriental Institute of the University of Chicago, pp. 211–22.

Jones, M. (1990), 'The temple of Apis in Memphis', *Journal of Egyptian Archaeology* 76, 141–7.

Jones, M. and Jones, A. M. (1988), 'The Apis House Project at Mit Rahinah: preliminary report of the sixth season, 1986', *Journal of the American Research Center in Egypt* 25, 105–16.

Jones, S. (1997), *The Archaeology of Ethnicity: Constructing Identities in the Past and Present*, London: Routledge.

Josephson, J. A. (1997), '*Egyptian Sculpture of the Late Period* revisited', *Journal of the American Research Center in Egypt* 34, 1–20.

Jungfleisch, M. (1949), 'Trouvailles faites aux abords de Tell el-Maskhouta', *Numismatic Circular* 57, 487–90.

Jurman, C. (2010), 'Running with Apis: the Memphite Apis cult as a point

of reference for social and religious practice in Late Period elite culture', in L. Bareš, F. Coppens and K. Smoláriková (ed.), *Egypt in Transition: Social and Religious Development of Egypt in the First Millennium* BC, Prague: Czech Institute of Egyptology, pp. 224–67.

Jurman, C. (2015), '"Silver of the treasury of Heryshaf": considering the origin and economic significance of silver in Egypt during the Third Intermediate Period', in A. Babbi, F. Bubenheimer-Erhart, B. Marín-Aguilera and S. Mühl (ed.), *The Mediterranean Mirror: Cultural Contacts in the Mediterranean Sea between 1200 and 750 B.C.*, Mainz: Verlag des Römisch-Germanischen Zentralmuseums, pp. 51–68.

Jursa, M. (2009), 'On aspects of taxation in Achaemenid Babylonia: new evidence from Borsippa', in P. Briant and M. Chauveau (ed.), *Organisation des pouvoirs et contacts culturels dans les pays de l'empire achéménide*, Paris: De Boccard, pp. 237–69.

Jursa, M. (2011), 'Taxation and service obligations in Babylonia from Nebuchadnezzar to Darius and the evidence for Darius' tax reform', in R. Rollinger, B. Truschnegg and R. Bichler (ed.), *Herodot und das Persische Weltreich = Herodotus and the Persian Empire: Akten des 3. Internationalen Kolloquiums zum Thema 'Vorderasien im Spannungsfeld klassischer und altorientalischer Überlieferungen'*, *Innsbruck, 24.–28. November 2008*, Wiesbaden: Harrassowitz, pp. 431–48.

Kahl, J. (2002), 'Zu den Namen spätzeitlicher Usurpatoren, Fremdherrscher, Gegen- und Lokalkönige', *Zeitschrift für ägyptische Sprache und Altertumskunde* 129, 31–42.

Kahn, D. (2007), 'Note on the time-factor in Cambyses' deeds in Egypt as told by Herodotus', *Transeuphratène* 34, 103–12.

Kahn, D. (2008), 'Inaros' rebellion against Artaxerxes I and the Athenian disaster in Egypt', *Classical Quarterly* 58, 424–40.

Kahn, D. and Tammuz, O. (2009), 'Egypt is difficult to enter: invading Egypt – a game plan (seventh–fourth centuries BC)', *Journal of the Society for the Study of Egyptian Antiquities* 36, 37–66.

Kaiser, W. (1987), 'Die dekorierte Torfassade des spätzeitlichen Palastbezirkes von Memphis', *Mitteilungen des Deutschen Archäologischen Instituts, Abteilung Kairo* 43, 123–54.

Kalyvas, S. N. (2008), 'Collaboration in comparative perspective', *European Review of History* 15, 109–11.

Kamei, H., Atya, M. A., Abdallatif, T. F., Mori, M. and Hemthavy, P. (2002), 'Ground-penetrating radar and magnetic survey to the west of Al-Zayyan temple, Kharga Oasis, Al-Wadi Al-Jadeed (New Valley), Egypt', *Archaeological Prospection* 9, 93–104.

Kaper, O. E. (2009), 'Epigraphic evidence from the Dakleh Oasis in the Libyan period', in G. P. F. Broekman, R. J. Demarée and O. E. Kaper (ed.), *The Libyan Period in Egypt: Historical and Cultural Studies into the 21st–24th Dynasties*, Leiden: Nederlands Instituut voor het Nabije Oosten, pp. 149–59.

Kaper, O. E. (2012), 'Epigraphic evidence from the Dakhleh Oasis in the Late Period', in R. S. Bagnall, P. Davoli and C. A. Hope (ed.), *The Oasis Papers 6: Proceedings of the Sixth International Conference of the Dakhleh Oasis Project*, Oxford: Oxbow Books, pp. 167–76.

Kaper, O. E. (2015), 'Petubastis IV in the Dakhla Oasis: new evidence about an early rebellion against Persian rule and its suppression in political memory', in J. M. Silverman and C. Waerzeggers (ed.), *Political Memory in and after the Persian Empire*, Atlanta: SBL Press, pp. 125–49.

Kaplan, P. (2003), 'Cross-cultural contacts among mercenary communities in Saite and Persian Egypt', *Mediterranean Historical Review* 18 (1), 1–31.

Kaptan, D. (2002), *The Daskyleion Bullae: Seal Images from the Western Achaemenid Empire*, Leiden: Nederlands Instituut voor het Nabije Oosten.

Kaptan, D. (forthcoming), 'Anatolian connections', in J. Ma and C. Tuplin (ed.), *Arshama and Egypt: The World of an Achaemenid Satrap*, Oxford: Oxford University Press.

Kees, H. (1961), *Ancient Egypt: A Cultural Topography*, Chicago: University of Chicago Press.

Kemp, B. J. (1977), 'The Palace of Apries at Memphis', *Mitteilungen des Deutschen Archäologischen Instituts, Abteilung Kairo* 33, 101–8.

Kemp, B. J. (2006), *Ancient Egypt: Anatomy of a Civilization*, 2nd edn, London: Routledge.

Kessler, D. (2003), 'Hermopolitanische Götterformen im Hibis-Tempel', in N. Kloth, K. Martin and E. Pardey (ed.), *Es werde niedergelegt als Schriftstück: Festschrift für Hartwig Altenmüller zum 65. Geburtstag*, Hamburg: Helmut Buske Verlag, pp. 211–33.

Kessler, D. and Nur el-Din, A. el H. (2005), 'Tuna el-Gebel: millions of ibises and other animals', in S. Ikram (ed.), *Divine Creatures: Animal Mummies in Ancient Egypt*, Cairo: American University in Cairo Press, pp. 120–63.

Khatchadourian, L. (2012), 'The Achaemenid provinces in archaeological perspective', in D. T. Potts (ed.), *A Companion to the Archaeology of the Ancient Near East*, Chichester: Wiley-Blackwell, pp. 963–83.

Khatchadourian, L. (2016), *Imperial Matter: Ancient Persia and the Archaeology of Empires*, Berkeley: University of California Press.

Kheirabadi, M. (2000), *Iranian Cities: Formation and Development*, Syracuse, NY: Syracuse University Press.

Kienitz, F. K. (1953), *Die politische Geschichte Ägyptens vom 7. bis zum 4. Jahrhundert vor der Zeitwende*, Berlin: Akademie Verlag.

Kistler, E. (2010), 'Achämenidische "Becher" und die Logik kommensaler Politik im Reich der Achämeniden (521–330 v. Chr.)', in B. Jacobs and R. Rollinger (ed.), *Der Achämenidenhof = The Achaemenid Court: Akten des 2. Internationalen Kolloquiums zum Thema 'Vorderasien im Spannungsfeld klassischer und altorientalischer Überlieferungen'*, Langut

Castelen bei Basel, 23.–25. Mai 2007, Wiesbaden: Harrassowitz, pp. 411–58.

Kitchen K. A. (1991), 'Towards a reconstruction of Ramesside Memphis', in E. Bleiberg and R. E. Freed (ed.), *Fragments of a Shattered Visage: The Proceedings of the International Symposium of Ramesses the Great*, Memphis, TN: Memphis State University, pp. 87–104.

Kitchen, K. A. (1998), 'Amenhotep III and Mesopotamia', in D. O'Connor and E. H. Cline (ed.), *Amenhotep III: Perspectives on His Reign*, Ann Arbor, MI: University of Michigan Press, pp. 250–61.

Klasens, A. (1945–8), 'Cambyses en Egypte', *Jaarbericht van het Vooraziatisch-Egyptisch Genootschap Ex Oriente Lux* 10, 339–49.

Klemm, R. and Klemm, D. (2013), *Gold and Gold Mining in Ancient Egypt and Nubia: Geoarchaeology of the Ancient Gold Mining Sites in the Egyptian and Sudanese Eastern Deserts*, Berlin: Springer.

Klinkott, H. (2007a), 'Steuern, Zölle und Tribute im Achaimenidenreich', in H. Klinkott, S. Kubisch and R. Müller-Wollermann (ed.), *Geschenke und Steuern, Zölle und Tribute: antike Abgabenformen in Auspruch und Wirklichkeit*, Leiden: Brill, pp. 263–90.

Klinkott, H. (2007b), 'Xerxes in Ägypten: Gedanken zum negativen Perserbild in der Satrapenstele', in S. Pfeiffer (ed.), *Ägypten unter fremden Herrschern zwischen Satrapie und römischer Provinz*, Frankfurt am Main: Verlag Antike, pp. 34–53.

Klotz, D. (2006), *Adoration of the Ram: Five Hymns to Amun-Re from Hibis Temple*, New Haven: Yale Egyptological Seminar.

Klotz, D. (2008), 'Darius with the letter *h*', *Chronique d'Égypte* 83, 109–15.

Klotz, D. (2009), 'The cult-topographical text at Qasr el-Zayyan', *Revue d'Égyptologie* 60, 17–40.

Klotz, D. (2010), 'Two studies on the Late Period temples at Abydos', *Bulletin de l'Institut français d'archéologie orientale* 110, 127–63.

Klotz, D. (2013), 'Administration of the deserts and oases: first millennium B.C.E.', in J. C. Moreno García (ed.), *Ancient Egyptian Administration*, Leiden: Brill, pp. 901–9.

Klotz, D. (2014), 'Replicas of Shu: on the theological significance of naophorous and theophorous statues', *Bulletin de l'Institut français d'archéologie orientale* 114, 291–337.

Klotz, D. (2015), 'Darius I and the Sabaeans: ancient partners in Red Sea navigation', *Journal of Near Eastern Studies* 74, 267–80.

Knapp, A. B. and van Dommelen, P. (2008), 'Past practices: rethinking individuals and agents in archaeology', *Cambridge Archaeological Journal* 18, 15–34.

Knobel, E. B., Midgley, W. W., Milne, J. G., Murray, M. A. and Petrie, W. M. F. (1911), *Historical Studies*, London: School of Archaeology in Egypt.

Konuk, K. (2012), 'Asia Minor to the Ionian revolt', in W. E. Metcalf (ed.),

The Oxford Handbook of Greek and Roman Coinage, Oxford: Oxford University Press, pp. 43–60.

Krebsbach, J. (2016), 'Achaemenid Persian patronage of Egyptian cults and religious institutions in the 27th Dynasty: a study of political acumen in the ancient world', in D. Edelman, A. Fitzpatrick-McKinley and P. Guillaume (ed.), *Religion in the Achaemenid Persian Empire: Emerging Judaisms and Trends*, Tübingen: Mohr Siebeck, pp. 329–48.

Kroll, J. H. (2009), 'What about coinage?', in J. Ma, N. Papazarkadas and R. Parker (ed.), *Interpreting the Athenian Empire*, London: Duckworth, pp. 195–209.

Kroll, J. H. (2011a), 'Minting for export: Athens, Aegina, and others', in T. Faucher, M.-C. Marcellesi and O. Picard (ed.), *Nomisma: la circulation monétaire dans le monde grec antique*, Athens: École française d'Athènes, pp. 27–38.

Kroll, J. H. (2011b), 'Athenian tetradrachm coinage of the first half of the fourth century BC', *Revue belge de numismatique et de sigillographie* 157, 3–26.

Kroll, J. H. (2011c), 'The reminting of Athenian silver coinage, 353 B.C.', *Hesperia* 80, 229–59.

Kuhlmann, K. P. (2002), 'The "oasis bypath" or the issue of desert trade in pharaonic times', in T. Lenssen-Erz, U. Tegtmeier and S. Kröpelin (ed.), *Tides of the Desert: Contributions to the Archaeology and Environmental History of Africa in Honour of Rudolph Kuper*, Cologne: Heinrich-Barth-Institut, pp. 127–70.

Kuhrt, A. (2007), *The Persian Empire: A Corpus of Sources from the Achaemenid Period*, London: Routledge.

Kuper, R. (2006), 'After 5000 BC: the Libyan Desert in transition', *Comptes rendus Palevol* 5, 409–19.

Kurke, L. (1999), *Coins, Bodies, Games, and Gold: The Politics of Meaning in Archaic Greece*, Princeton: Princeton University Press.

La'da, C. A. (2002), *Prosopographia Ptolemaica, Vol. 10: Foreign Ethnics in Hellenistic Egypt*, Leuven: Peeters.

Ladynin, I. A. (2005), '"Adversary Ḫšryš(3)": his name and deeds according to the Satrap Stela', *Chronique d'Égypte* 80, 87–113.

Lampre, G. (1905), 'Statue de la reine Napir-Asou', in J. de Morgan (ed.), *Recherches archéologiques: troisième série*, Paris: Ernest Leroux, pp. 245–50.

Lansing, A. (1938), 'A silver bottle of the Ptolemaic period', *Metropolitan Museum of Art Bulletin* 33, 199–200.

Lateiner, D. (1989), *The Historical Method of Herodotus*, Toronto: University of Toronto Press.

Lauffrey, J. (1995), *La chapelle d'Achôris à Karnak, Vol. 1: Les fouilles, l'architecture, le mobilier et l'anastylose*, Paris: Éditions Recherche sur les Civilisations.

Laurent, V. (1984), 'Une statue provenant de Tell el-Maskoutah', *Revue d'Égyptologie* 35, 139–58.
Leahy, A. (1984a), 'The date of Louvre A.93', *Göttinger Miszellen* 70, 45–58.
Leahy, A. (1984b), 'Saite royal sculpture: a review', *Göttinger Miszellen* 80, 59–76.
Leahy, L. M. (1988), *Private Tomb Reliefs of the Late Period from Lower Egypt*, DPhil diss., University of Oxford.
Leclère, F. (2008), *Les villes de Basse Égypte au Ier millénaire av. J.-C.: analyse archéologique et historique de la topographie urbaine*, Cairo: Institut français d'archéologie orientale.
Leclère, F. and Spencer, J. (ed.) (2014), *Tell Dafana Reconsidered: The Archaeology of an Egyptian Frontier Town*, London: British Museum.
Lefebvre, G. (1923–4), *Le tombeau de Petosiris*, 3 vols, Cairo: Institut français d'archéologie orientale.
Lemaire, A. (1987), 'Notes d'épigraphie nord-ouest sémitique', *Semitica* 37, 47–55.
Lemaire, A. (1995), 'La fin de la première période perse en Égypte et le chronologie judéenne vers 400 av. J.-C.', *Transeuphratène* 9, 51–61.
Le Rider, G. (2001), *La naissance de la monnaie: pratiques monétaires de l'Orient ancien*, Paris: Presses universitaires de France.
Levitt, S. D. and Dubner, S. J. (2005), *Freakonomics: A Rogue Economist Explores the Hidden Side of Everything*, New York: William Morrow.
Lewis, D. M. (1987), 'The king's dinner (Polyaenus IV 3.32)', in H. Sancisi-Weerdenburg and A. Kuhrt (ed.), *Achaemenid History, Vol. 2: The Greek Sources*, Leiden: Nederlands Instituut voor het Nabije Oosten, pp. 79–87.
Lewis, D. M. (1990), 'The Persepolis Fortification texts', in H. Sancisi-Weerdenburg and A. Kuhrt (ed.), *Achaemenid History, Vol. 4: Centre and Periphery*, Leiden: Nederlands Instituut voor het Nabije Oosten, pp. 1–6.
Lewis, N. (1974), *Papyrus in Classical Antiquity*, Oxford: Clarendon Press.
Lichtheim, M. (1976), 'The Naucratis stela once again', in J. H. Johnson and E. F. Wente (ed.), *Studies in Honor of George R. Hughes, January 12, 1977*, Chicago: Oriental Institute of the University of Chicago, pp. 139–46.
Lichtheim, M. (1980), *Ancient Egyptian Literature: A Book of Readings, Vol. 3*, Berkeley: University of California Press.
Lilyquist, C. (2012), 'Treasures from Tell Basta: goddesses, officials, and artists in an international age', *Metropolitan Museum Journal* 47, 9–72.
Lincoln, B. (2007), *Religion, Empire, and Torture: The Case of Achaemenian Persia with a Postscript on Abu Ghraib*, Chicago: University of Chicago Press.
Lipiński, E. (1994), 'Aramaic documents from ancient Egypt', *Orientalia Lovaniensia Periodica* 29, 61–8.
Lippert, S. (2016), 'Ein saitisch-persisches Puzzlespiel: Untersuchungen

zur Chronologie der Dekoration des Amun-Tempels von Hibis', in S. L. Lippert, M. Schentuleit and M. A. Stadler (ed.), *Sapientia Felicitas: Festschrift für Günter Vittmann zum 29. Februar 2016*, Montpellier: Université Paul-Valéry, Montpellier III, pp. 355–87.

Liverani, M. (2000), 'The Libyan caravan road in Herodotus IV.181–85', *Journal of the Economic and Social History of the Orient* 43, 496–520.

Llewellyn-Jones, L. (2013), *King and Court in Ancient Persia 559 to 331 BCE*, Edinburgh: Edinburgh University Press.

Lloyd, A. B. (1982), 'The inscription of Udjaḥorresnet: a collaborator's testament', *Journal of Egyptian Archaeology* 68, 166–80.

Lloyd, A. B. (1983), 'The Late Period (664–323 BC)', in B. G. Trigger, B. J. Kemp, D. O'Connor and A. B. Lloyd, *Ancient Egypt: A Social History*, Cambridge: Cambridge University Press, pp. 279–348.

Lloyd, A. B. (1994), 'Cambyses in late tradition', in C. Eyre, A. Leahy and L. M. Leahy (ed.), *The Unbroken Reed: Studies in the Culture and Heritage of Ancient Egypt in Honour of A. F. Shore*, London: Egypt Exploration Society, pp. 195–204.

Lloyd, A. B. (2000), 'Saite navy', in G. J. Oliver, R. Brock, T. J. Cornell and S. Hodkinson (ed.), *The Sea in Antiquity*, Oxford: Archaeopress, pp. 81–91.

Lloyd, A. B. (2002), 'The Egyptian elite in the early Ptolemaic period: some hieroglyphic evidence', in D. Ogden (ed.), *The Hellenistic World: New Perspectives*, Swansea: Classical Press of Wales, pp. 117–36.

Lloyd, A. B. (2007a), 'Book II', in O. Murray and A. Moreno (ed.), *A Commentary on Herodotus Books I–IV*, Oxford: Oxford University Press, pp. 219–378.

Lloyd, A. B. (2007b), 'Darius in Egypt: Suez and Hibis', in C. Tuplin (ed.), *Persian Responses: Political and Cultural Interaction with(in) the Achaemenid Empire*, Swansea: Classical Press of Wales, pp. 99–115.

Lloyd, A. B. (ed.) (2010), *A Companion to Ancient Egypt*, Chichester: Wiley-Blackwell.

Lloyd, A. B. (2014), 'The Egyptian attitude to the Persians', in A. M. Dodson, J. J. Johnston and W. Monkhouse (ed.), *A Good Scribe and an Exceedingly Wise Man: Studies in Honour of W. J. Tait*, London: Golden House, pp. 185–98.

Lockyear, K. (2012), 'Dating coins, dating with coins', *Oxford Journal of Archaeology* 31, 191–211.

Lozachmeur, H. (1998), 'Un nouveau graffito araméen provent a Saqqâra', *Semitica* 48, 147–9.

Lozachmeur, H. (2006), *La collection Clermont-Ganneau: ostraca, épigraphes sur jarre, étiquettes de bois*, Paris: De Boccard.

Lucas, A. (1943), 'Ancient Egyptian measures of capacity', *Annales du Service des antiquités de l'Égypte* 42, 165–6.

Lüddeckens, E. (1960), *Ägyptische Eheverträge*, Wiesbaden: Harrassowitz.

Luschey, H. (1983), 'Die Darius-Statuen aus Susa und ihre Rekonstrctuktion',

in H. Koch and D. N. MacKenzie (ed.), *Kunst, Kultur und Geschichte der Achämenidenzeit und ihr Fortleben*, Berlin: Dietrich Reimer, pp. 191–206.

Mac Sweeney, N. (2009), 'Beyond ethnicity: the overlooked diversity of group identities', *Journal of Mediterranean Archaeology* 22 (1), 101–26.

Magee, P. (2005), 'The chronology and environmental background of Iron Age settlement in southeastern Iran and the question of the origin of the qanat Irrigation system', *Iranica Antiqua* 40, 217–31.

Mahran, H. (2008), 'The naos of King Darius I', *Bulletin of the Australian Centre for Egyptology* 19, 111–18.

Malaise, M. (2004), 'Statues égyptiennes naophores et cultes isiaques', *Bulletin de la Société d'Égyptologie de Genève* 26, 63–80.

Malinine, M., Posener, G. and Vercoutter, J. (1968), *Catalogue des stèles du Sérapéum de Memphis*, Paris: Imprimerie nationale.

Manning, J. G. (2002), 'Irrigation et état en Égypte antique', *Annales: histoire, sciences sociales* 57, 611–23.

Manning, J. G. (2010), *The Last Pharaohs: Egypt under the Ptolemies, 305–30 BC*, Princeton: Princeton University Press.

Marchand, S. (2000), 'Les siga des Oasis datées de la XXVIIe–XXIXe dynastie et de l'époque ptolémaïque ancienne trouvées à 'Ayn Manâwir (oasis de Kharga) et à Tebtynis (Fayoum)', *Cahiers de la céramique égyptienne* 6, 221–5.

Marchand, S. (2002), 'Le maintien de la tradition pharaonique pour les productions des céramiques datées de l'époque ptolémaïque en Égypte', in F. Blondé, P. Ballet and J.-F. Salles (ed.), *Céramiques hellénistiques et romaines: productions et diffusion en Méditerranée orientale (Chypre, Égypte et côte syro-palestinienne)*, Lyon: Maison de l'Orient méditerranéen-Jean Pouilloux, pp. 247–61.

Mariette, A. (1882), *Le Sérapeum de Memphis*, Paris: F. Vieweg.

Marković, N. (2016), 'A look through his window: the sanctuary of the divine Apis bull at Memphis', *Journal of Ancient Egyptian Architecture* 1, 57–70.

Marković, N. (2017), 'The majesty of Apis has gone to Heaven: burial of the Apis bull in the sacred landscape of Memphis during the Late Period (664–332 BC)', in K. A. Kóthay (ed.), *Burial and Mortuary Practices in Late Period and Graeco-Roman Egypt: Proceedings of the International Conference Held at the Museum of Fine Arts, Budapest, 17–19 July 2014*, Budapest: Museum of Fine Arts, pp. 145–54.

Martin, G. T. (1981), *The Sacred Animal Necropolis at North Saqqâra: The Southern Dependencies of the Main Temple Complex*, London: Egypt Exploration Society.

Masson, O. (1978), *Carian Inscriptions from North Saqqâra and Buhen*, London: Egypt Exploration Society.

Mathieson, I., Bettles, E., Davies, S. and Smith, H. S. (1995), 'A stele of

the Persian period from Saqqara', *Journal of Egyptian Archaeology* 81, 23–41.
Mattingly, D. J. (2011), *Imperialism, Power, and Identity: Experiencing the Roman Empire*, Princeton: Princeton University Press.
Mattingly, D., Edwards, D. and Dore, J. (2002), 'Radiocarbon dates from Fazzan, southern Libya', *Libyan Studies* 33, 9–19.
Mattingly, H. B. (1996), *The Athenian Empire Restored: Epigraphic and Historical Studies*, Ann Arbor, MI: University of Michigan Press.
McAnally, J. (2016), 'Herodotus 2.61.2 and the *Mwdon-* of Caromemphitae', *Ancient Near Eastern Studies* 53, 195–218.
McCaskie, T. C. (2012), '"As on a darkling plain": practitioners, publics, propagandists, and ancient historiography', *Comparative Studies in Society and History* 54, 145–73.
McDonald, M. M. A. (1999), 'Dakhla Oasis, prehistoric sites', in K. A. Bard (ed.), *Encyclopedia of the Archaeology of Ancient Egypt*, London: Routledge, pp. 226–9.
Meadows, A. (2011), 'Athenian coin dies from Egypt: the new discovery from Herakleion', *Revue belge de numismatique et de sigillographie* 157, 95–116.
Ménant, J. (1887), 'La stèle de Chalouf', *Recueil de travaux relatifs a la philologie et a l'archéologie égyptiennes et assyriennes* 9, 131–57.
Menu, B. (1998), 'La tombeau de Pétosiris (4): le souverain de l'Égypte', *Bulletin de l'Institut français d'archéologie orientale* 98, 247–62.
Merrillees, P. H. (2005), *Western Asiatic Seals in the British Museum, Cylinder Seals, Vol. 6: Pre-Achaemenid and Achaemenid Periods*, London: British Museum.
Meskell, L. (2001), 'Archaeologies of identity', in I. Hodder (ed.), *Archaeological Theory Today*, Cambridge: Polity, pp. 187–213.
Miller, M. C. (1993), 'Adoption and adaptation of Achaemenid metalware forms in Attic black-gloss ware of the fifth century', *Archäologische Mitteilungen aus Iran* 26, 109–46.
Miller, M. C. (1997), *Athens and Persia in the Fifth Century BC: A Study in Cultural Receptivity*, Cambridge: Cambridge University Press.
Miller, M. C. (2010), 'Luxury toreutic in the western satrapies: court-inspired gift-exchange diffusion', in B. Jacobs and R. Rollinger (ed.), *Der Achämenidenhof = The Achaemenid Court: Akten des 2. Internationalen Kolloquiums zum Thema 'Vorderasien im Spannungsfeld klassicher und altorientalischer Überlieferungen', Langut Castelen bei Basel, 23.–25. Mai 2007*, Wiesbaden: Harrassowitz, pp. 853–97.
Miller, M. C. (2011a), 'Imagining Persians in the age of Herodotus', in R. Rollinger, B. Truschnegg and R. Bichler (ed.), *Herodot und das Persische Weltreich = Herodotus and the Persian Empire: Akten des 3. Internationalen Kolloquiums zum Thema 'Vorderasien im Spannungsfeld klassicund und altorientalischer Überlieferungen', Innsbruck, 24.–28. November 2008*, Wiesbaden: Harrassowitz, pp. 123–57.

Miller, M. C. (2011b), '"Manners makyth man": diacritical drinking in Achaemenid Anatolia', in E. S. Gruen (ed.), *Cultural Identity in the Ancient Mediterranean*, Los Angeles: Getty Research Institute, pp. 97–134.

Minas-Nerpal, M. (2018), 'Pharaoh and temple building in the fourth century BC', in P. McKechnie and J. A. Cromwell (ed.), *Ptolemy I and the Transformation of Egypt, 404–282 BC*, Leiden: Brill, pp. 120–65.

Möller, A. (2000), *Naukratis: Trade in Archaic Greece*, Oxford: Oxford University Press.

Moorey, P. R. S. (1980a), *Cemeteries of the First Millennium B.C. at Deve Hüyük, near Carmemish, Salvaged by T. E. Lawrence and C. L. Woolley in 1913 (with a Catalogue raisonné of the Objects in Berlin, Cambridge, Liverpool, London, and Oxford)*, Oxford: B.A.R.

Moorey, P. R. S. (1980b), 'Metal wine-sets in the ancient Near East', *Iranica Antiqua* 15, 181–97.

Moorey, P. R. S. (1998), 'Did easterners sail round Arabia to Egypt in the fourth millennium B.C.?', in C. S. Phillips, D. T. Potts and S. Searight (ed.), *Arabia and Its Neighbors: Essays on Prehistorical and Historical Developments Presented in Honour of Beatrice di Cardi*, Turnhout: Brepols, pp. 189–206.

Moreno, A. (2007), *Feeding the Democracy: The Athenian Grain Supply in the Fifth and Fourth Centuries BC*, Oxford: Oxford University Press.

Mørkholm, O. (1974), 'A coin of Artaxerxes III', *Numismatic Chronicle* (seventh ser.) 14, 1–4.

Morkot, R. (1996), 'Darb el-Arbain, the Kharga Oasis and its forts, and other desert routes', in D. M. Bailey (ed.), *Archaeological Research in Roman Egypt: The Proceedings of the Seventeenth Classical Colloquium of the Department of Greek and Roman Antiquities, British Museum, Held on 1–4 December, 1993*, Ann Arbor, MI: Journal of Roman Archaeology, pp. 82–94.

Morkot, R. (2003), 'Archaism and innovation in art from the New Kingdom to the Twenty-Sixth Dynasty', in J. Tait (ed.), *'Never had the Like Occurred': Egypt's View of Its Past*, London: UCL Press, Institute of Archaeology, pp. 79–99.

Morkot, R. (2007), 'Tradition, innovation, and researching the past in Libyan, Kushite, and Saite Egypt', in H. Crawford (ed.), *Regime Change in the Ancient Near East and Egypt: From Sargon of Agade to Saddam Hussein*, Oxford: Oxford University Press, pp. 141–64.

Morris, E. F. (2010a), 'Insularity and island identity in the oases bordering Egypt's great sand sea', in Z. Hawass and S. Ikram (ed.), *Thebes and Beyond: Studies in Honor of Kent Weeks*, Cairo: Conseil Suprême des Antiquités de l'Égypte, pp. 129–44.

Morris, E. F. (2010b), 'The pharaoh and pharaonic office', in A. B. Lloyd (ed.), *A Companion to Ancient Egypt*, Chichester: Wiley-Blackwell, pp. 201–17.

Morschauser, S. N. (1988), 'Using history: reflections on the Bentresh Stela', *Studien zur altägyptischen Kultur* 15, 203–23.
Moyer, I. S. (2006), 'Golden fetters and economies of cultural exchange', *Journal of Ancient Near Eastern Religions* 6, 225–56.
Moyer, I. S. (2011), *Egypt and the Limits of Hellenism*, Cambridge: Cambridge University Press.
Müller, M. (2016), 'Among the priests of Elephantine Island: Elephantine Island seen from Egyptian sources', *Die Welt des Orients* 46, 213–46.
Muscarella, O. W. (1977), 'Unexcavated objects and ancient Near Eastern art', in L. D. Levene and T. C. Young, Jr. (ed.), *Mountains and Lowlands: Essays in the Archaeology of Greater Mesopotamia*, Malibu, CA: Undena, pp. 153–207.
Muscarella, O. W. (1980), 'Excavated and unexcavated Achaemenian art', in D. Schmandt-Besserat (ed.), *Ancient Persia: Art of an Empire*, Malibu, CA: Undena, pp. 23–42.
Muscarella, O. W. (1988), *Bronze and Iron: Ancient Near Eastern Artifacts in the Metropolitan Museum of Art*, New York: Metropolitan Museum of Art.
Muscarella, O. W. (2003), 'Von Bissing's *Memphis Stela*: a product of cultural transfer?', in T. Potts, M. Roaf and D. Stein (ed.), *Culture through Objects: Ancient Near Eastern Studies in Honour of P. R. S. Moorey*, Oxford: Griffith Institute, pp. 109–21.
Myśliwiec, K. (1987), *Keramik und Kleinfunde aus der Grabung im Tempel Sethos' I. in Gurna*, Mainz: Philipp von Zabern.
Myśliwiec, K. (1988), *Royal Portraiture of the Dynasties XXI–XXX*, Mainz: Philipp von Zabern.
Myśliwiec, K. (1991), 'Un naos de Darius: roi d'Égypte', in M. Mori, H. Ogawa and M. Yoshikawa (ed.), *Near Eastern Studies Dedicated to H. I. H. Prince Takahito Mikasa on the Occasion of His Seventy-Fifth Birthday*, Wiesbaden: Harrassowitz, pp. 221–46.
Myśliwiec, K. (2000), *The Twilight of Ancient Egypt: First Millennium BC*, Ithaca, NY: Cornell University Press.
Naveh, J. (1971), 'The palaeography of the Hermopolis papyri', *Israel Oriental Studies* 1, 120–2.
Neely, J. A. (2010), 'Water management during the later Early Dynastic, Elamite, and Achaemenid periods on the Deh Lurān plain', in H. T. Wright and J. A. Neely (ed.), *Elamite and Achaemenid Settlement on the Deh Luran Plain: Towns and Villages of the Early Empires in Southwestern Iran*, Ann Arbor, MI: Museum of Anthropology, University of Michigan, 95–104.
Newton, C., Terral, J.-F. and Ivorra, S. (2006), 'The Egyptian olive (*Olea europaea* subsp. *europaea*) in the late first millennium BC: origins and history using the morphometric analysis of olive stones', *Antiquity* 80, 405–14.
Newton, C., Whitbread, T., Agut-Labordère, D. and Wuttmann, M. (2013),

'L'agriculture oasienne à l'époque perse dans le sud de l'oasis de Kharga (Égypte, Ve–IVe s. AEC)', *Revue d'Ethnoécologie* 4, <https://journals.openedition.org/ethnoecologie/1294> (accessed 14 December 2018).

Nicholson, P. T. (2005), 'The Sacred Animal Necropolis at North Saqqara: the cults and their catacombs', in S. Ikram (ed.), *Divine Creatures: Animal Mummies in Ancient Egypt*, Cairo: American University in Cairo Press, pp. 44–71.

Nicolet-Pierre, H. (2000), 'Tétradrachmes athéniens en Transeuphratène', *Transeuphratène* 20, 107–19.

Nicolet-Pierre, H. (2003 [2005]), 'Les imitations égyptiennes des tétradrachmes athéniens d'époque classique (Ve–IVe s. av. J.-C.)', *Αρχαιολογικη Εφημερις* 142, 139–54.

Nielsen, I. (1999), *Hellenistic Palaces: Tradition and Renewal*, 2nd edn, Aarhus: Aarhus University Press.

Ockinga, B. G. (2018), 'The Satrap Stela of Ptolemy: a reassessment', in P. McKechnie and J. A. Cromwell (ed.), *Ptolemy I and the Transformation of Egypt, 404–282 BCE*, Leiden: Brill, pp. 166–98.

Ogden, J. (2000), 'Metals', in P. T. Nicholson and I. Shaw (ed.), *Ancient Egyptian Materials and Technology*, Cambridge: Cambridge University Press, pp. 148–76.

Oliver, A., Jr. (1970), 'Persian export glass', *Journal of Glass Studies* 12, 9–16.

Olmstead, A. T. (1948), *History of the Persian Empire*, Chicago: University of Chicago Press.

Oppenheim, A. L. (1967), 'Essay on overland trade in the first millennium B.C.', *Journal of Cuneiform Studies* 21, 236–54.

Osing, J. (1985), 'Seth in Dachla und Charga', *Mitteilungen des Deutschen Archäologischen Instituts, Abteilung Kairo* 41, 229–33.

Osing, J. (1986a), 'Zu den Osiris-Räume im Tempel von Hibis', in *Hommages à François Daumas*, Montpellier: Institut d'Égyptologie, Université Paul Valéry, pp. 511–16.

Osing, J. (1986b), 'Notizien zu den Oasen Charga und Dachla', *Göttinger Miszellen* 92, 79–85.

Osing, J. (1990), 'Zur Anlage und Dekoration des Templs von Hibis', in S. Israelit-Groll (ed.), *Studies in Egyptology Presented to Miriam Lichtheim*, Jerusalem: Magnes Press, Hebrew University, pp. 751–67.

Osing, J. (1992), 'Zu zwei literarische Werken des Mittleren Reiches', in J. Osing and E. K. Nielsen (ed.), *The Heritage of Ancient Egypt: Studies in Honor of Erik Iversen*, Copenhagen: Museum Tusculanum Press, pp. 101–19.

Osing, J. (1998), 'Beiträge zu den Oasen', in W. Clarysse, A. Schoors and H. Willems (ed.), *Egyptian Religion, the Last Thousand Years: Studies Dedicated to the Memory of Jan Quaegebeur*, Leuven: Uitgeverij Peeters en Department Oosterse Studies, pp. 1443–8.

Pantalacci, L. (2013), 'Balat, a frontier town and its archive', in J. C. Moreno García (ed.), *Ancient Egyptian Administration*, Leiden: Brill, pp. 197–214.

Parker Pearson, M. (2000), *The Archaeology of Death and Burial*, College Station, TX: Texas A&M University Press.

Parkinson, R. B. (1991), *Voices from Ancient Egypt: An Anthology of Middle Kingdom Writings*, London: British Museum.

Paspalas, S. A. (2000), 'A Persianizing cup from Lydia', *Oxford Journal of Archaeology* 19, 135–74.

Patten, S. F. (2000), *Pottery from the Late Period to the Early Roman Period from Dakhleh Oasis, Egypt*, PhD diss., Macquarie University.

Pearce, J. E. (2005), 'Harland Sanders: the man who would be colonel', in J. C. Klotter (ed.), *The Human Tradition in the New South*, Lanham, MD: Rowman and Littlefield, pp. 129–56.

Perdu, O. and Meffre, R. (ed.) (2012), *Le crépuscule des pharaons: chefs-d'oeuvre des dernières dynasties égyptiennes*, Brussels: Fonds Mercator.

Petrie, C. A., Magee, P. and Nasim Khan, M. (2008), 'Emulation at the edge of empire: the adoption of non-local vessel forms in the NWFP, Pakistan during the mid-late 1st millennium BC', *Gandhāran Studies* 2, 1–16.

Petrie, W. M. F. (1888), *Tanis, Vol. 2: Nebesheh (Am) and Defenneh (Tahpanhes)*, London: Trübner.

Petrie, W. M. F. (1906), *Hyksos and Israelite Cities*, London: British School of Archaeology in Egypt.

Petrie, W. M. F. (1909a), *Memphis, Vol. 1*, London: British School of Archaeology in Egypt.

Petrie, W. M. F. (1909b), *The Palace of Apries (Memphis, Vol. 2)*, London: British School of Archaeology in Egypt.

Petrie, W. M. F. (1937), *Funeral Furniture and Stone Vases*, London: British School of Egyptian Archaeology.

Petrie, W. M. F. and Mackay, E. (1915), *Heliopolis, Kafr Ammar and Shurafa*, London: School of Archaeology in Egypt.

Petrie, W. M. F., Mackay, E. and Wainwright, G. (1910), *Meydum and Memphis (Vol. 3)*, London: British School of Archaeology in Egypt.

Petropoulou, A. (2008), 'The death of Masistios and the mourning for his loss', in S. M. R. Darbandi and A. Zournatzi (ed.), *Ancient Greece and Ancient Iran: Cross-Cultural Encounters*, Athens: National Hellenic Research Foundation, pp. 9–30.

Pfrommer, M. (1987), *Studien zur alexandrinischer und grossgriechischer Toreutik frühhellenistischer Zeit*, Berlin: Gebr. Mann Verlag.

Piccato, A. (1997), 'The Berlin Leather Roll and the Egyptian sense of history', *Lingua Aegyptia* 5, 137–59.

Pierrat-Bonnefois, G. (2005), 'Flacons héritiers des forms de Grèce orientale', in A. Caubet and G. Pierrat-Bonnefois (ed.), *Faïences de l'antiquité: de l'Égypte à l'Iran*, Paris: Musée du Louvre, pp. 157–61.

Pietrangeli, C. (1951), 'La provenienza dei monumenti del Museo Egizio

Vaticano', in G. Botti and P. Romanelli, *Le sculture del Museo gregoriano egizio*, Vatican City: Tipografia Poliglotta Vaticana, pp. 135–42.
Pons Mellado, E. (2006), 'Trade of metals between Egypt and other countries from the Old until the New Kingdom', *Chronique d'Égypte* 81, 7–16.
Porada, E. (1980), 'A lapis lazuli figurine from Hierakonpolis in Egypt', *Iranica Antiqua* 15, 175–80.
Porten, B. (1979), 'Aramaic papyri and parchments: a new look', *Biblical Archaeologist* 42, 74–104.
Porten, B. (2002), 'Egyptian names in Aramaic texts', in K. Ryholt (ed.), *Acts of the Seventh International Conference of Demotic Studies, Copenhagen, 23–27 August 1999*, Copenhagen: Museum Tusculanum Press, pp. 283–327.
Porten, B. (2003), 'Persian names in Aramaic documents from ancient Egypt', in S. Shaked and A. Netzer (ed.), *Irano-Judaica, Vol. 5: Studies Relating to Jewish Contacts with Persian Culture throughout the Ages*, Jerusalem: Ben-Zvi Institute for the Study of Jewish Communities in the East, pp. 165–86.
Porten, B., Farber, J. J., Martin, C. J. and Vittmann, G. (1996), *The Elephantine Papyri in English: Three Millennia of Cross-Cultural Continuity and Change*, Leiden: Brill.
Porten, B. and Gee, J. (2001), 'Aramaic funerary practices in Egypt', in P. M. M. Daviau, J. W. Wevers and M. Weigl (ed.), *The World of the Aramaeans, Vol. 2: Studies in History and Archaeology in Honour of Paul-Eugène Dion*, Sheffield: Sheffield Academic Press, pp. 270–308.
Porten, B. and Yardeni, A. (1986–99), *Textbook of Aramaic Documents from Ancient Egypt*, 4 vols, Jerusalem: Hebrew University of Jerusalem, Department of the History of the Jewish People.
Porter, B. and Moss, R. L. B. (1952), *Topographical Bibliography of Ancient Egyptian Hieroglyphic Texts, Reliefs, and Paintings, Vol. 7: Nubia, the Deserts, and Outside Egypt*, Oxford: Griffith Institute.
Porter, B. and Moss, R. L. B. (1981), *Topographical Bibliography of Ancient Egyptian Hieroglyphic Texts, Reliefs, and Paintings, Vol. 3: Memphis*, 2nd edn, Oxford: Griffith Institute.
Posener, G. (1936), *La première domination perse en Égypte: recueil d'inscriptions hiéroglyphiques*, Cairo: Institut français d'archéologie orientale.
Posener, G. (1938), 'Le canal du Nil à la mer rouge avant les Ptolémées', *Chronique d'Égypte* 13, 259–73.
Posener, G. (1947), 'Les douanes de la Méditeranée dans l'Égypte saïte', *Revue de philologie, de littérature, et d'histoire anciennes* 73, 117–31.
Posener, G. (1951), 'La date de la statue A 94 du Louvre', *Revue d'Égyptologie* 6, 234–5.
Posener, G. (1986), 'Du nouveau sur Kombabos', *Revue d'Égyptologie* 37, 91–6.

Potts, D. T. (1997), *Mesopotamian Civilization: The Material Foundations*, Ithaca, NY: Cornell University Press.

Potts, D. T. (2006), 'Elamites and Kassites in the Persian Gulf', *Journal of Near Eastern Studies* 65, 111–19.

Potts, D. T. (2010), 'Achaemenid interests in the Persian Gulf', in J. Curtis and St J. Simpson (ed.), *The World of Achaemenid Persia: History, Art and Society in Iran and the Ancient Near East*, London: I. B. Tauris, pp. 522–33.

Quack, J. F. (2011), 'Zum Datum der persischen Eroberung Ägyptens unter Kambyses', *Journal of Egyptian History* 4, 228–46.

Rabinowitz, I. (1956), 'Aramaic inscriptions of the fifth century B.C.E. from a North-Arab shrine in Egypt', *Journal of Near Eastern Studies* 15, 1–9.

Rabinowitz, I. (1959), 'Another Aramaic record of the North-Arabian goddess HAN-'ILAT', *Journal of Near Eastern Studies* 18, 154–5.

Radner, K. (2013), 'Assyria and the Medes', in D. T. Potts (ed.), *The Oxford Handbook of Ancient Iran*, Oxford: Oxford University Press, pp. 443–56.

Radwan, A. (1983), *Die Kupfer- und Bronzegefäße Ägyptens (von den Anfängen bis zum Beginn der Spätzeit)*, Munich: C. H. Beck.

Ranke, H. (1926), 'Zu Namengebung der Ägypter', *Orientalistische Literaturzeitung* 29, 733–5.

Ranke, H. (1935), *Die ägyptischen Personennamen, Vol. 1: Verzeichnis der Namen*, Glückstadt: Verlag J. J. Augustin.

Rawson, J. (1984), *Chinese Ornament: The Lotus and the Dragon*, London: British Museum.

Ray, J. D. (1978), 'The world of North Saqqâra', *World Archaeology* 10, 149–57.

Ray, J. D. (1987), 'Egypt: dependence and independence (425–343 B.C.)', in H. Sancisi-Weerdenburg (ed.), *Achaemenid History, Vol. 1: Sources, Structures, and Synthesis*, Leiden: Nederlands Instituut voor het Nabije Oosten, pp. 79–95.

Ray, J. D. (1988), 'Egypt 525–404 B.C.', in J. Boardman, N. G. L. Hammond, D. M. Lewis and M. Ostwald (ed.), *The Cambridge Ancient History, Vol. 4: Persia, Greece and the Western Mediterranean c. 525 to 479 B.C.*, Cambridge: Cambridge University Press, pp. 254–86.

Ray, J. D. (1999), 'Saqqara, Late Period and Graeco-Roman tombs', in K. A. Bard (ed.), *Encyclopedia of the Archaeology of Ancient Egypt*, London: Routledge, pp. 844–7.

Razmjou, S. (2002), 'Assessing the damage: notes on the life and demise of the statue of Darius from Susa', *Ars Orientalis* 32, 81–104.

Razmjou, S. (2005), 'Religion and burial customs', in J. Curtis and N. Tallis (ed.), *Forgotten Empire: The World of Ancient Persia*, Berkeley: University of California Press, pp. 150–80.

Reddé, M. (2004), *Douch, Vol. 3: Kysis – fouilles de l'Ifao à Douch, oasis de Kharga (1985–1990)*, Cairo: Institut français d'archéologie orientale.

Redmount, C. A. (1995), 'The Wadi Tumilat and the "canal of the pharaohs"', *Journal of Near Eastern Studies* 54, 127–35.
Regling, K. (1904), 'Jahresberichte über die numismatische Literatur, 1901–1902: antike Münzkunde', *Zeitschrift für Numismatik* 24, 3–59.
Rehm, E. (1992), *Der Schmuck der Achämeniden*, Münster: Ugarit-Verlag.
Rehm, E. (2005 [2006]), '"Auf zu den Ufern des Niles": Vorderasiatica in Ägypten im 1. Jahrtausend v. Chr.', *Ugarit-Forschungen* 37, 491–516.
Reid, D. M. (2002), *Whose Pharaohs? Archaeology, Museums, and Egyptian National Identity from Napoleon to World War I*, Berkeley: University of California Press.
Richards, J. E. (1999), 'Conceptual landscapes in the Egyptian Nile Valley', in W. Ashmore and A. B. Knapp (ed.), *Archaeologies of Landscape: Contemporary Perspectives*, Malden, MA: Blackwell, pp. 83–100.
Riefstahl, E. (1968), *Ancient Egyptian Glass and Glazes in the Brooklyn Museum*, Brooklyn: Brooklyn Museum.
Ritner, R. K. (1993), *The Mechanics of Ancient Egyptian Magical Practice*, Chicago: Oriental Institute of the University of Chicago.
Ritner, R. K. (1996), 'The earliest attestation of the *kpḏ*-measure', in P. Der Manuelian and R. E. Freed (ed.), *Studies in Honor of William Kelly Simpson*, Vol. 2, Boston: Museum of Fine Arts, pp. 683–8.
Ritner, R. K. (2009), *The Libyan Anarchy: Inscriptions from Egypt's Third Intermediate Period*, Atlanta: Society of Biblical Literature.
Roaf, M. (1974), 'The subject peoples on the base of the statue of Darius', *Cahiers de la Délégation archéologique française en Iran* 4, 73–160.
Robinson, E. S. G. (1947), 'The Tell el-Maskhuta hoard of Athenian tetradrachms', *Numismatic Chronicle* (sixth ser.) 7, 115–21.
Roe, A. (2005–6), 'The old Darb al Arbein caravan route and the Kharga Oasis in antiquity', *Journal of the American Research Center in Egypt* 42, 119–29.
Roemer, C. (2008), 'The papyrus roll in Egypt, Greece, and Rome', in S. Eliot and J. Rose (ed.), *A Companion to the History of the Book*, Chichester: Wiley-Blackwell, pp. 84–94.
Rollinger, R. and Henkelman, W. F. M. (2009), 'New observations on "Greeks" in the Achaemenid Empire according to cuneiform texts from Babylonia and Persepolis', in P. Briant and M. Chauveau (ed.), *Organisation des pouvoirs et contacts culturels dans les pays de l'empire achéménide*, Paris: De Boccard, pp. 331–51.
Root, M. C. (1979), *The King and Kingship in Achaemenid Art: Essays on the Creation of an Iconography of Empire*, Leiden: Brill.
Root, M. C. (1991), 'From the heart: powerful Persianisms in the art of the western empire', in H. Sancisi-Weerdenburg and A. Kuhrt (ed.), *Achaemenid History, Vol. 6: Asia Minor and Egypt*, Leiden: Nederlands Instituut voor het Nabije Oosten, pp. 1–29.
Root, M. C. (1997), 'Cultural pluralisms on the Persepolis Fortification Tablets', *Topoi Orient-Occident* Suppl. 1, 229–52.

Root, M. C. (1998), 'Pyramidal stamp seals: the Persepolis connection', in M. Brosius and A. Kuhrt (ed.), *Studies in Persian History: Essays in Memory of David M. Lewis*, Leiden: Nederlands Instituut voor het Nabije Oosten, pp. 257–306.
Root, M. C. (2002), 'Animals in the art of ancient Iran', in B. J. Collins (ed.), *A History of the Animal World in the Ancient Near East*, Leiden: Brill, pp. 169–209.
Root, M. C. (2007), 'Reading Persepolis in Greek: gifts of the Yauna', in C. Tuplin (ed.), *Persian Responses: Political and Cultural Interaction with(in) the Achaemenid Empire*, Swansea: Classical Press of Wales, pp. 177–225.
Root, M. C. (2008), 'The legible image: how did seals and sealing matter in Persepolis?', in P. Briant, W. F. M. Henkelman and M. W. Stolper (ed.), *L'archive des Fortifications de Persépolis: état des questions et perspectives de recherches*, Paris: De Boccard, pp. 85–150.
Root, M. C. (2010), 'Palace to temple – king to cosmos: Achaemenid foundation texts in Iran', in M. J. Boda and J. Novotny (ed.), *From the Foundations to the Crenellations: Essays on Temple Building in the Ancient Near East and Hebrew Bible*, Münster: Ugarit-Verlag, pp. 165–210.
Root, M. C. (2011), 'Elam in the imperial imagination: from Nineveh to Persepolis', in J. Álvarez-Mon and M. B. Garrison (ed.), *Elam and Persia*, Winona Lake, IN: Eisenbrauns, pp. 419–74.
Root, M. C. (forthcoming), 'Medes in the imperial imagination', in K. Abdi (ed.), *Ō Šābuhr kē čihr az yazdān dāšt: Essays in Memory of A. Shapur Shahbazi*, Tehran: Iran University Press and Parsa-Pasargadae Research Foundation.
Rossi, C. (2000), 'Umm el-Dabadib, Roman settlement in the Kharga Oasis: description of the visible remains, with a note on 'Ayn Amur', *Mitteilungen des Deutschen Archäologischen Instituts, Abteilung Kairo* 56, 335–56.
Rossi, C. and Ikram, S. (2006), 'North Kharga Oasis Survey 2003 preliminary report: Umm el-Dabadib', *Mitteilungen des Deutschen Archäologischen Instituts, Abteilung Kairo* 62, 279–306.
Rossi, C. and Ikram, S. (2010), 'North Kharga Oasis Survey 2007 – preliminary report: Ain Lebekha and Ain Amur', *Mitteilungen des Deutschen Archäologischen Instituts, Abteilung Kairo* 66, 235–42.
Rossi, C. and Ikram, S. (2013), 'Evidence of desert routes across northern Kharga (Egypt's Western Desert)', in F. Förster and H. Reimer (ed.), *Desert Road Archaeology in Ancient Egypt and Beyond*, Cologne: Heinrich-Barth-Institut, pp. 265–82.
Rößler-Köhler, U. (1985), 'Zur Textkomposition der naophoren Statue des Udjahorresnet/Vatikan inv.-nr. 196', *Göttinger Miszellen* 85, 43–54.
Rottpeter, M. (2007), 'Initiatoren und Träger der "Aufstände" im perischen Ägypten', in S. Pfeiffer (ed.), *Ägypten unter fremden Herrschern zwischen*

persischer Satrapie und römischer Provinz, Frankfurt am Main: Verlag Antike, pp. 9–33.

Roullet, A. (1972), *The Egyptian and Egyptianizing Monuments of Imperial Rome*, Leiden: Brill.

Ruffing, K. (2009), 'Die "Satrapienliste" des Dareios: Herodoteisches Konstrukt oder Realität?', *Archäologische Mitteilungen aus Iran und Turan* 41, 323–50.

Russmann, E. R. (1995), 'Kushite headdresses and "Kushite" style', *Journal of Egyptian Archaeology* 81, 227–32.

Ruzicka, S. (2012), *Trouble in the West: Egypt and the Persian Empire, 525–332 BC*, Oxford: Oxford University Press.

Sachau, E. (1911), *Aramäische Papyrus und Ostraka au seiner jüdischen Militär-Kolonie zu Elephantine: altorientalische Sprachdenkäler des 5. Jahrhunderts vor Chr.*, Leipzig: J. C. Hinrichs'sche Buchhandlung.

Sagona, A. G. (1982), 'Levantine storage jars of the 13th to 4th century B.C.', *Opuscula Atheniensia* 14, 73–110.

Said, E. (1978), *Orientalism*, New York: Vintage Books.

Salles, J.-F. (1994), 'Du blé, de l'huile et du vin . . . notes sur les échanges commerciaux en Mediterranée orientale vers le milieu du 1er millénaire av. J.C.', in H. Sancisi-Weerdenburg, A. Kuhrt and M. C. Root (ed.), *Achaemenid History, Vol. 8: Continuity and Change*, Leiden: Nederlands Instituut voor het Nabije Oosten, pp. 191–215.

Sami, A. (1954), *Persepolis (Takht-i-Jamshid)*, Shiraz: Musavi Printing Office.

Sancisi-Weerdenburg, H. (1987), 'The fifth oriental monarchy and hellenocentrism: *Cyropaedia* VIII and its influence', in H. Sancisi-Weerdenburg and A. Kuhrt (ed.), *Achaemenid History, Vol. 2: The Greek Sources*, Leiden: Nederlands Instituut voor het Nabije Oosten, pp. 117–31.

Sancisi-Weerdenburg, H. (1989), 'Gifts in the Persian Empire', in P. Briant and C. Herrenschmidt (ed.), *Le tribut dans l'empire perse: actes de la table ronde de Paris 12–13 Décembre 1986*, Leuven: Peeters, pp. 129–46.

Sancisi-Weerdenburg, H. (1990), 'The quest for an elusive empire', in H. Sancisi-Weerdenburg and A. Kuhrt (ed.), *Achaemenid History, Vol. 4: Centre and Periphery*, Leiden: Nederlands Instituut voor het Nabije Oosten, pp. 263–74.

Sancisi-Weerdenburg, H. (1995), 'Persian food: stereotypes and political identity', in J. Wilkins, D. Harvey and M. Dobson (ed.), *Food in Antiquity*, Exeter: University of Exeter Press, pp. 286–302.

Sancisi-Weerdenburg, H. (1997), 'Crumbs from the royal table: foodnotes on Briant (pp. 297–306)', *Topoi Orient-Occident* Suppl. 1, 333–45.

Sancisi-Weerdenburg, H. (2001), '*Yaunā* by the sea and across the sea', in I. Malkin (ed.), *Ancient Perceptions of Greek Ethnicity*, Washington, DC: Center for Hellenic Studies, pp. 323–46.

Sayce, A. H. and Cowley, A. E. (1906), *Aramaic Papyri Discovered at Assuan*, London: Alexander Moring.

Scagliarini, F. (2001–2), 'The origin of the qanāt system in the Al-'Ulā area and the Ğabal 'Ikma inscriptions', *Aram* 13–14, 569–79.
Schacht, I. (2003), 'A preliminary survey of the ancient qanat systems of the northern Kharga Oasis', *Mitteilungen des Deutschen Archäologischen Instituts, Abteilung Kairo* 59, 411–23.
Schäfer, D. (2011), *Makedonische Pharaonen und hieroglyphische Stelen: historische Untersuchungen zur Satrapenstele und verwandten Denkmälern*, Leuven: Peeters.
Schaper, J. (1995), 'The Jerusalem temple as an instrument of the Achaemenid fiscal administration', *Vetus Testamentum* 45, 528–39.
Schiffer, M. B. (1985), 'Is there a "Pompeii premise" in archaeology?', *Journal of Anthropological Research* 41, 18–41.
Schiffer, M. B. (1987), *Formation Processes of the Archaeological Record*, Albuquerque, NM: University of New Mexico Press.
Schmidt, E. F. (1953), *Persepolis, Vol. 1: Structures, Reliefs, Inscriptions*, Chicago: University of Chicago Press.
Schmidt, E. F. (1957), *Persepolis, Vol. 2: Contents of the Treasury and Other Discoveries*, Chicago: University of Chicago Press.
Schmidt, E. F. (1970), *Persepolis, Vol. 3: The Royal Tombs and Other Monuments*, Chicago: University of Chicago Press.
Schmitt, R. (1981), *Altpersische Siegel-Inschriften*, Vienna: Verlag der Österreichischen Akademie der Wissenschaften.
Schmitt, R. (1985), 'Ein iranischer Name auf einem demotischen Papyrus', *Münchner Studien zur Sprachwissenschaft* 45, 201–10.
Schmitt, R. (2007), *Pseudo-altpersische Inschriften: Inschriftenfälschungen und moderne Nachbildungen in altpersischer Keilschrift*, Vienna: Verlag der Österreichischen Akademie der Wissenschaften.
Schneider, T. (2010), 'The west beyond the west: the mysterious "Wernes" of the Egyptian underworld and the Chad palaeolakes', *Journal of Ancient Egyptian Interconnections* 2 (4), 1–14.
Schott, E. (1967), 'Eine datierte Apisbronze', *Revue d'Égyptologie* 19, 87–98.
Schulman, A. R. (1981), 'A "Persian gesture" from Memphis', *Bulletin of the Egyptological Seminar* 3, 103–11.
Schulman, A. R. (1988), 'Memphis 1915–1923: the trivia of an excavation', in A.-P. Zivie (ed.), *Memphis et ses nécropoles au Nouvel Empire: nouvelles données, nouvelles questions*, Paris: Editions du Centre national de la recherche scientifique, pp. 81–91.
Schütze, A. (2017), 'Local administration in Persian period Egypt according to Aramaic and Demotic sources', in B. Jacobs, W. F. M. Henkelman and M. W. Stolper (ed.), *Die Verwaltung im Achämenidenreich: Imperiale Muster und Strukturen = Administration in the Achaemenid Empire: Tracing the Imperial Signature*, Wiesbaden: Harrassowitz, pp. 489–515.
Segal, J. B. (1983), *Aramaic Texts from North Saqqâra, with Some Fragments in Phoenician*, London: Egypt Exploration Society.

Selden, D. L. (1999), 'Cambyses' madness, or the reason of history', *Materiali e discussioni per l'analisi dei testi classici* 42, 33–63.

Sen, A. (2006), *Identity and Violence: The Illusion of Destiny*, New York: W. W. Norton.

Serrano Delgado, J. M. (2004), 'Cambyses in Sais: political and religious context in Achaemenid Egypt', *Chronique d'Égypte* 79, 31–52.

Sheedy, K. A. (2006), *The Archaic and Early Classical Coinages of the Cyclades*, London: Royal Numismatic Society.

Sheedy, K. A. and Gore, D B. (2011), 'Asyut 422, Seltman Group P, and the imitation of Attic coins', *Revue belge de numismatique et de sigillographie* 157, 37–54.

Shubert, S. B. (1989 [1993]), 'Realistic currents in portrait sculpture of the Saite and Persian periods in Egypt', *Journal of the Society for the Study of Egyptian Antiquities* 19, 27–47.

Sidebotham, S. E. (1986), *Roman Economic Policy in the Erythra Thalassa, 30 B.C.–A.D. 217*, Leiden: Brill.

Sidebotham, S. E. (2012), 'The Red Sea and Indian Ocean in the age of the great empires', in D. T. Potts (ed.), *A Companion to the Archaeology of the Ancient Near East*, Chichester: Wiley-Blackwell, pp. 1041–59.

Simpson, St J. (2005), 'The royal table', in J. Curtis and N. Tallis (ed.), *Forgotten Empire: The World of Achaemenid Persia*, Berkeley: University of California Press, pp. 104–31.

Simpson, W. K. (ed.) (2003), *The Literature of Ancient Egypt: An Anthology of Stories, Instructions, Stelae, Autobiographies, and Poetry*, 3rd edn, New Haven: Yale University Press.

Sims-Williams, N. (2001), 'The inscriptions on the Miho bowl and some comparable objects', *Studia Iranica* 30, 187–98.

Smith, H. S. (1972), 'The dates of the obsequies of the Mother of Apis', *Revue d'Égyptologie* 24, 176–87.

Smith, H. S. (1974), *A Visit to Ancient Egypt: Life at Memphis and Saqqara (c. 500–30 BC)*, Warminster: Aris and Phillips.

Smith, H. S. (1992), 'Foreigners in the documents from the Sacred Animal Necropolis, Saqqara', in J. H. Johnson (ed.), *Life in a Multi-Cultural Society: Egypt from Cambyses to Constantine and Beyond*, Chicago: Oriental Institute of the University of Chicago, pp. 295–301.

Smith, H. S., Andrews, C. A. R. and Davies, S. (2011), *The Sacred Animal Necropolis at North Saqqara: The Mother of Apis Inscriptions*, London: Egypt Exploration Society.

Smith, H. S., Davies, S. and Frazer, K. J. (2006), *The Sacred Animal Necropolis at North Saqqara: The Main Temple Complex*, London: Egypt Exploration Society.

Smith, H. S. and Jeffreys, D. G. (1986), 'A survey of Memphis, Egypt', *Antiquity* 60, 88–95.

Smith, H. S. and Kuhrt, A. (1982), 'A letter to a foreign general', *Journal of Egyptian Archaeology* 68, 199–209.

Smith, H. S. and Martin, C. J. (2009), 'Demotic papyri from the Sacred Animal Necropolis of North Saqqara: certainly or possibly of Achaemenid date', in P. Briant and M. Chauveau (ed.), *Organisation des pouvoirs et contacts culturels dans les pays de l'empire achéménide*, Paris: De Boccard, pp. 23–78.

Smith, H. S. and Tait, W. J. (1983), *Saqqâra Demotic Papyri*, London: Egypt Exploration Society.

Smith, S. T. (2018), 'Middle and New Kingdom sealing practice in Egypt and Nubia: a comparison', in M. Ameri, S. K. Costello, G. Jamison and S. J. Scott (ed.), *Seals and Sealing in the Ancient World: Case Studies from the Near East, Egypt, the Aegean, and South Asia*, Cambridge: Cambridge University Press, pp. 302–24.

Smoláriková, K. (2003), 'À propos *Wynn* and their presence in Memphis', in N. Kloth, K. Martin and E. Pardey (ed.), *Es werde niedergelegt als Schriftstück: Festschrift für Hartwig Altenmüller zum 65. Geburtstag*, Hamburg: Helmut Buske Verlag, pp. 410–13.

Smoláriková, K. (2008), *Saite Forts in Egypt: Political-Military History of the Saite Dynasty*, Prague: Czech Institute of Egyptology.

Smoláriková, K. (2015), 'Udjahorresnet: the founder of the Saite–Persian cemetery at Abusir and his engagement as leading political person during the troubled years at the beginning of the Twenty-Seventh Dynasty', in J. M. Silverman and C. Waerzeggers (ed.), *Political Memory in and after the Persian Period*, Atlanta: SBL Press, pp. 151–64.

Sofia, A. (2007), 'Prodotti egizi ad Atene: testimonianze nella commedia antica e di mezzo', *Aegyptus* 87, 143–80.

Sosin, J. D., Bagnall, R. S., Cowey, J., Depauw, M., Wilfong, T. G. and Worp, K. A. (ed.) (2011), *Checklist of Editions of Greek, Latin, Demotic, and Coptic Papyri, Ostraca and Tablets*, <https://library.duke.edu/ruben stein/scriptorium/papyrus/texts/clist.html> (accessed 11 May 2019).

Spalinger, A. (1977), 'Egypt and Babylonia: a survey (c. 620 B.C.–550 B.C.)', *Studien zur altägyptischen Kultur* 5, 221–44.

Spalinger, A. (1986), 'Udjahorresnet', in W. Helck and E. Otto (ed.), *Lexikon der Ägyptologie, Vol. 6*, Wiesbaden: Harrassowitz, pp. 822–4.

Spalinger, G. L. (1982), 'Metal vessels', in *Egypt's Golden Age: The Art of Living in the New Kingdom 1558–1085 B.C.*, Boston: Museum of Fine Arts, pp. 116–25.

Spencer, J. (2014), 'Catalogue of Egyptian pottery, transport amphorae and ostraca from Tell Dafana in the British Museum', in F. Leclère and J. Spencer (ed.), *Tell Dafana Reconsidered: The Archaeology of an Egyptian Frontier Town*, London: British Museum, pp. 99–117.

Spencer, N. (2006), *A Naos of Nekhthorheb from Bubastis: Religious Iconography and Temple Building in the Thirtieth Dynasty*, London: British Museum.

Spencer, N. (2010), 'Sustaining Egyptian culture? Non-royal initiatives in the Late Period temple building', in L. Bareš, F. Coppens and K. Smoláriková

(ed.), *Egypt in Transition: Social and Religious Development of Egypt in the First Millennium* BC, Prague: Czech Institute of Egyptology, pp. 441–90.

Spiegelberg, W. (1909a), *Ausgewählte Kunst-Denkmäler der ägyptischen Sammlung der Kaiser Wilhelms-Universität Strassburg*, Strasbourg: Schlesier and Schweikhardt.

Spiegelberg, W. (1909b), 'Egyptian texts', in J. E. Quibell (ed.), *Excavations at Saqqara (1907–1908)*, Cairo: Institut français d'archéologie orientale, pp. 79–93.

Spieser, C. (2010), 'Cartouche', in W. Wendrich (ed.), *UCLA Encyclopedia of Egyptology*, <https://escholarship.org/uc/item/3g726122> (accessed 14 December 2018).

Stammers, M. (2009), *The Elite Late Period Tombs at Memphis*, Oxford: Archaeopress.

Stern, E. (1982), 'Achaemenid clay rhyta from Palestine', *Israel Exploration Journal* 32, 36–43.

Stern, E. (2001), *The Archaeology of the Land of the Bible, Vol. 2: The Assyrian, Babylonian, and Persian Periods 732–332* BC, New York: Doubleday.

Stern, E. M. (1997), 'Glass and rock crystal: a multifaceted relationship', *Journal of Roman Archaeology* 10, 192–206.

Sternberg-el Hotabi, H. (1994), 'Die "Götterliste" des Sanktuars im Hibis-Tempel von El-Chargeh: Überlegungen zur Tradierung und Kodifizierung religiösen und Kulttopographischen Gedankengutes', in M. Minas and J. Zeidler (ed.), *Aspekte spätägyptischer Kultur: Festschrift für Erich Winter zum 65. Geburtstag*, Mainz: Philipp von Zabern, pp. 238–54.

Sternberg-el Hotabi, H. (2000), 'Politische und sozio-ökonomische Strukturen im perserzeitlichen Ägypten: neue Perspektiven', *Zeitschrift für ägyptische Sprache und Altertumskunde* 127, 153–67.

Sternberg-el Hotabi, H. (2002), 'Die persische Herrschaft in Ägypten', in R. G. Kratz (ed.), *Religion und Religionskontakte im Zeitalter der Achämeniden*, Gütersloh: Chr. Kaiser/Gütersloher Verlagshaus, pp. 111–49.

Sternberg-el Hotabi, H. (2006), 'Der Raum "M" im Hibistempel von El-Chargeh: Dekorationsprogramm und Vorlagen', in G. Moers, H. Behlmer, K. Demuß and K. Widmaier (ed.), *jn.t dr.w: Festschrift für Friedrich Junge*, Göttingen: Seminar für Ägyptologie und Koptologie, pp. 597–623.

Sternberg-el Hotabi, H. (2016), *Ägypter und Perser: eine Begegnung zwischen Anpassung und Widerstand*, Rahden: Verlag Marie Leidorf.

Sternberg-el Hotabi, H. (2017), *Quellentexte zur Geschichte der ersten und zweiten Perserzeit in Ägypten*, Berlin: Lit Verlag.

Stiros, S. C. (2006), 'Accurate measurement with primitive instruments: the "paradox" of the qanat design', *Journal of Archaeological Science* 33, 1058–64.

Stronach, D. (1978), *Pasargadae: A Report on the Excavations Conducted by the British Institute of Persian Studies from 1961 to 1963*, Oxford: Clarendon Press.
Stronach, D. (2011), 'Court dress and riding dress at Persepolis: new approaches to old questions', in J. Álvarez-Mon and M. B. Garrison (ed.), *Elam and Persia*, Winona Lake, IN: Eisenbrauns, pp. 475–87.
Swetnam-Burland, M. (2015), *Egypt in Italy: Visions of Egypt in Roman Imperial Culture*, Cambridge: Cambridge University Press.
Tait, J. (2003), 'Introduction: "... since the time of the gods"', in J. Tait (ed.), *'Never Had the Like Occurred': Egypt's View of Its Past*, London: UCL Press, Institute of Archaeology, pp. 1–13.
Tal, O. (2005), 'Some remarks on the coastal plain of Palestine under Achaemenid rule: an archaeological synopsis', in P. Briant and R. Boucharlat (ed.), *L'archéologie dans l'empire achéménide: nouvelles recherches*, Paris: De Boccard, pp. 71–96.
Tal, O. (2009), 'On the identification of the ships of *kzd/ry* in the erased customs account from Elephantine', *Journal of Near Eastern Studies* 68, 1–8.
Tanner, J. (2000), 'Portraits, power, and patronage in the late Roman Republic', *Journal of Roman Studies* 90, 18–50.
Tavares, A. (1999), 'Saqqara, north, Early Dynastic tombs', in K. A. Bard (ed.), *Encyclopedia of the Archaeology of Ancient Egypt*, London: Routledge, pp. 854–9.
Tavernier, J. (2002), 'Zu einigen iranischen Namen aus Ägypten', *Göttinger Miszellen* 186, 107–11.
Tavernier, J. (2007), *Iranica in the Achaemenid Period (ca. 550–330 B.C.): Lexicon of Old Iranian Proper Names and Loanwords, Attested in Non-Iranian Texts*, Leuven: Peeters.
Tavernier, J. (2008), 'Multilingualism in the Fortification and Treasury archives', in P. Briant, W. F. M. Henkelman and M. W. Stolper (ed.), *L'archive des Fortifications de Persépolis: état des questions et perspectives de recherches*, Paris: De Boccard, pp. 59–86.
Taylor, J. H. (2010), *Journey through the Afterlife: Ancient Egyptian Book of the Dead*, London: British Museum.
Te Velde, H. (1967), *Seth, God of Confusion: A Study of His Role in Egyptian Mythology and Religion*, Leiden: Brill.
Thompson, D. J. (2012), *Memphis under the Ptolemies*, 2nd edn, Princeton: Princeton University Press.
Thompson, M., Mørkholm, O. and Kraay, C. M. (1973), *An Inventory of Greek Coin Hoards*, New York: American Numismatic Society.
Tiradritti, F. (2008), *Egyptian Wall Painting*, New York: Abbeville Press.
Török, L. (1989), 'Kush and the external world', in S. Donadoni and S. Wenig (ed.), *Studia Meroitica 1984: Proceedings of the Fifth International Conference for Meroitic Studies, Rome 1984*, Berlin: Akademie Verlag, pp. 49–215.

Toscanne, P. (1916), 'Motifs nouveaux de decoration susienne', *Revue d'Assyriologie et d'archéologie orientale* 13, 69–89.
Tourovets, A. (2001), 'Nouvelles propositions et problèmes relatifs à l'identification des delegations de l'escalier est de l'Apadana (Persépolis)', *Archäologische Mitteilungen aus Iran und Turan* 33, 219–56.
Traunecker, C. (1995), 'Un portrait ignoré d'un roi perse: la tête "Strasbourg 1604"', *Transeuphratène* 9, 101–17.
Traunecker, C. (2008), 'Les deux enfants du temple de Teudjoï (à propos du P. Rylands IX)', in L. Gabolde (ed.), *Hommages à Jean-Claude Goyon offerts pour son 70e anniversaire*, Cairo: Institut français d'archéologie orientale, pp. 381–96.
Trindade Lopes, M. H. (2016), 'What are we talking about when we talk about Memphis?', *Trabajos de Egiptología* 7, 59–66.
Trindade Lopes, M. H. and Fonseca Braga, S. (2011), 'The Apries Palace, Memphis/Kôm Tumân: the first Portuguese mission in Egypt', *Journal of the American Research Center in Egypt* 47, 247–58.
Tuplin, C. (1989), 'The coinage of Aryandes', *Revue des études anciennes* 91, 61–83.
Tuplin, C. (1991), 'Darius' Suez canal and Persian imperialism', in H. Sancisi-Weerdenburg and A. Kuhrt (ed.), *Achaemenid History, Vol. 6: Asia Minor and Egypt*, Leiden: Nederlands Instituut voor het Nabije Oosten, pp. 237–81.
Tuplin, C. (2009), 'Culture and power: some concluding remarks', in P. Briant and M. Chauveau (ed.), *Organisation des pouvoirs et contacts culturels dans les pays de l'empire achéménide*, Paris: De Boccard, pp. 415–28.
Tuplin, C. (2018), 'Dogs who do not (always) bark: Herodotus on Persian Egypt', in T. Harrison and E. Irwin (ed.), *Interpreting Herodotus*, Oxford: Oxford University Press, pp. 99–123.
Tuplin, C. J. and Ma, J. (ed.) (2013), *The Arshama Letters from the Bodleian Library*, <http://arshama.bodleian.ox.ac.uk/publications/> (accessed 21 December 2013).
Ur, J., de Jong, L., Giraud, J., Osborne, J. F. and MacGinnis, J. (2013), 'Ancient cities and landscapes in the Kurdistan region of Iraq: the Erbil Plain Archaeological Survey 2012 season', *Iraq* 75, 89–117.
Valbelle, D. (1998), 'Les garnisons de Migdol (Tell el-Herr) de l'époque achéménide au Bas-Empire: état de la question in 1998', *Comptes rendus des séances de l'Academie des Inscriptions et Belles-Lettres*, 799–817.
Valbelle, D. and Defernez, C. (1995), 'Les sites de la frontière égypto-palestinienne à l'époque perse', *Transeuphratène* 9, 93–100.
Van Alfen, P. G. (2002), 'The "owls" from the 1989 Syria Hoard, with a review of pre-Macedonian coinage in Egypt', *American Journal of Numismatics* 14, 1–57.
Van Alfen, P. G. (2004–5a), 'Herodotus' "Aryandic" silver and bullion use in Persian-period Egypt', *American Journal of Numismatics* 16–17, 7–46.

Van Alfen, P. G. (2004–5b), 'A new Athenian "owl" and bullion hoard from the Near East', *American Journal of Numismatics* 16–17, 47–61.
Van Alfen, P. G. (2005), 'Problems in ancient imitative and counterfeit coinage', in Z. H. Archibald, J. K. Davies and V. Gabrielsen (ed.), *Making, Moving and Managing: The New World of Hellenistic Economies, 323–31 BC*, Oxford: Oxbow Books, pp. 322–54.
Van Alfen, P. G. (2011), 'Mechanisms for the imitation of Athenian coinage: Dekeleia and mercenaries reconsidered', *Revue belge de numismatique et de sigillographie* 157, 55–93.
Van Alfen, P. G. (2012a), 'The coinage of Athens, sixth to first century B.C.', in W. E. Metcalf (ed.), *The Oxford Handbook of Greek and Roman Coinage*, Oxford: Oxford University Press, pp. 88–104.
Van Alfen, P. G. (2012b), 'Xenophon *Poroi* 3.2 and Athenian "owls" in Aegean–Near Eastern long distance trade', in M. Asolati and G. Gorini (ed.), *I ritrovamenti monetali e i processi storico-economici nel mondo antico*, Padua: Esedra editrice, pp. 11–32.
Van Dijk, J. (1983), 'A Ramesside naophorous statue from the Teti Pyramid Cemetery', *Oudheidkundige Mededelingen uit het Rijksmuseum van Oudheden* 64, 49–60.
Van Dijk, J. (1986), 'The symbolism of the Mempite Djed-Pillar', *Oudheidkundige Mededelingen uit het Rijksmuseum van Oudheden* 66, 7–20.
Vandorpe, K. (1996), 'Seals in and on the papyri of Greco-Roman and Byzantine Egypt', in M.-F. Boussac and A. Invernizzi (ed.), *Archives et sceaux du monde hellénistique*, Athens: École française d'Athènes, pp. 231–91.
Vargyas, P. (2010), *From Elephantine to Babylon: Selected Studies of Péter Vargyas on Ancient Near Eastern Economy*, Budapest: L'Harmattan.
Vasunia, P. (2001), *The Gift of the Nile: Hellenizing Egypt from Aeschylus to Alexander*, Berkeley: University of California Press.
Vasunia, P. (2003), 'Hellenism and empire: reading Edward Said', *Parallax* 9 (3), 88–97.
Venticinque, P. F. (2006), 'What's in a name? Greek, Egyptian and Biblical traditions in the *Cambyses Romance*', *Bulletin of the American Society of Papyrologists* 43, 139–58.
Vercoutter, J. (1962), *Textes biographiques du Sérapéum de Memphis: contribution à l'étude des stèles votives du Sérapéum*, Paris: Libraire ancienne Honoré Champion.
Verhoeven, U. (2001), *Untersuchungen zur spāthieratischen Buchschrift*, Leuven: Peeters.
Verner, M. (2017), *Abusir: The Necropolis of the Sons of the Sun*, Cairo: American University in Cairo Press.
Vernier, É. (1927), *Bijoux et orfèvreries*, Cairo: Institut français d'archéologie orientale.
Versluys, M. J. (2010), 'Understanding Egypt in Egypt and beyond', in

L. Bricault and M. J. Versluys (ed.), *Isis on the Nile: Egyptian Gods in Hellenistic and Roman Egypt*, Leiden: Brill, pp. 7–36.

Vickers, M. (1972), 'An Achaemenid glass bowl in a dated context', *Journal of Glass Studies* 14, 15–16.

Vickers, M. (1984 [1988]), 'Demus' gold phiale (Lysias 19.25)', *American Journal of Ancient History* 9, 48–53.

Vickers, M. (2002), '"Shed no tears?" Three studies in ancient metrology', in A. J. Clark and J. Gaunt (ed.), *Essays in Honor of Dietrich von Bothmer*, Amsterdam: Allard Pierson Museum, pp. 333–8.

Vickers, M. and Bazama, A. (1971), 'A fifth century B.C. tomb in Cyrenaica', *Libya Antiqua* 8, 69–84.

Vittmann, G. (1998), *Der demotische Papyrus Rylands 9*, Wiesbaden: Harrassowitz.

Vittmann, G. (2003), *Ägypten und die Fremden im ersten vorchristlichen Jahrtausend*, Mainz: Philipp von Zabern.

Vittmann, G. (2004), 'Iranisches Sprachgut in ägyptischer Überlieferung', in T. Schneider (ed.), *Das Ägyptische und die Sprachen Vorderasiens, Nordafrikas und der Ägäis: Akten des Basler Kolloquiums zum ägyptisch-nichtsemitischen Sprachkontakt, Basel 9.–11. Juli 2003*, Münster: Ugarit-Verlag, pp. 129–82.

Vittmann, G. (2009), 'Rupture and continuity: on priests and officials in Egypt during the Persian period', in P. Briant and M. Chauveau (ed.), *Organisation des pouvoirs et contacts culturels dans les pays de l'empire achéménide*, Paris: De Boccard, pp. 89–121.

Vittmann, G. (2011), 'Ägypten zur Zeit der Perserherrschaft', in R. Rollinger, B. Truschnegg and R. Bichler (ed.), *Herodot und das Persische Weltreich = Herodotus and the Persian Empire: Akten des 3. Internationalen Kolloquiums zum Thema 'Vorderasien im Spannungsfeld klassischer und altorientalischer Überlieferungen', Innsbruck, 24.–28. November 2008*, Wiesbaden: Harrassowitz, pp. 373–429.

Vittmann, G. (2013a), 'Personal names: function and significance', in W. Wendrich (ed.), *UCLA Encyclopedia of Egyptology*, <https://escholarship.org/uc/item/7t12z11t> (accessed 14 December 2018).

Vittmann, G. (2013b), 'Personal names: structures and patterns', in W. Wendrich (ed.), *UCLA Encyclopedia of Egyptology*, <https://escholarship.org/uc/item/42v9x6xp> (accessed 14 December 2018).

Vittmann, G. (2015), 'Two administrative letters from Meidum (P. Ashmolean 1984.87 and 1984.89)', in F. Haikal (ed.), *Mélanges offerts à Ola el-Aguizy*, Cairo: Institut français d'archéologie orientale, pp. 433–50.

Vleeming, S. (1981), 'The artaba, and Egyptian grain measures', in R. S. Bagnall, G. M. Browne, A. E. Hanson and L. Koenen (ed.), *Proceedings of the XVIth International Congress of Papyrology, New York, 24–31 July 1980*, Chico, CA: Scholars Press, pp. 537–45.

Vleeming, S. P. (1991), *The Gooseherds of Hou (Pap. Hou): A Dossier*

Relating to Various Agricultural Affairs from Provincial Egypt of the Early Fifth Century B.C., Leuven: Peeters.

Vleeming, S. P. (1993), *Papyrus Reinhardt: An Egyptian Land List from the Tenth Century B.C.*, Berlin: Akademie Verlag.

Vleeming, S. P. (2001), *Some Coins of Artaxerxes and Other Short Texts in Demotic Script Found on Various Objects and Gathered from Many Publications*, Leuven: Peeters.

Vogelsang-Eastwood, G. (1993), *Pharaonic Egyptian Clothing*, Leiden: Brill.

Vogelsang-Eastwood, G. (2000), 'Textiles', in P. T. Nicholson and I. Shaw (ed.), *Ancient Egyptian Materials and Technology*, Cambridge: Cambridge University Press, pp. 268–98.

Von Beckerath, J. (1999), *Handbuch der ägyptischen Königsnamen*, Mainz: Philipp von Zabern.

Von Bissing, F. W. (1901), *Metallgefässe*, Vienna: Imprimerie Adolf Holzhausen.

Von Bissing, F. W. (1930), 'Totenstele eines persischen Großen aus Memphis', *Zeitschrift der Deutschen Morgenländischen Gesellschaft* 84, 226–38.

Von Bomhard, A.-S. (2012), *The Decree of Sais*, Oxford: School of Archaeology, University of Oxford.

Von Reden, S. (2002), 'Demus' *phialê* and the rhetoric of money in fourth-century Athens', in P. Cartledge, E. E. Cohen and L. Foxhall (ed.), *Money, Labour and Land: Approaches to the Economy of Ancient Greece*, London: Routledge, pp. 52–66.

Von Reden, S. (2007), *Money in Ptolemaic Egypt: From the Macedonian Conquest to the End of the Third Century BC*, Cambridge: Cambridge University Press.

Ward, W. A. (1994), 'Beetles in stone: the Egyptian scarab', *Biblical Archaeologist* 57, 186–202.

Wasmuth, M. (2017a), *Ägypto-persische Herrscher- und Herrschaftspräsentation in der Achämenidenzeit*, Stuttgart: Franz Steiner Verlag.

Wasmuth, M. (2017b), 'Persika in der Repräsentation der ägyptischen Elite', *Journal of Egyptian Archaeology* 103, 241–50.

Wasmuth, M. (2017c), 'Die Stele des Djedherbes als kulturelles Zeugnis ihrer Zeit', *Archäologischer Anzeiger* (1), 85–123.

Wegner, J. (2018), 'The evolution of ancient Egyptian seals and sealing systems', in M. Ameri, S. K. Costello, G. Jamison and S. J. Scott (ed.), *Seals and Sealing in the Ancient World: Case Studies from the Near East, Egypt, the Aegean, and South Asia*, Cambridge: Cambridge University Press, pp. 229–57.

Weinberg, J. (1999), 'The international elite of the Achaemenid Empire: reality and fiction', *Zeitschrift für die alttestamentliche Wissenschaft* 111, 583–608.

Weinstein, J. M. (1973), *Foundation Deposits in Ancient Egypt*, PhD diss., University of Pennsylvania.
Wendrich, W. (2010), 'Identity and personhood', in W. Wendrich (ed.), *Egyptian Archaeology*, Chichester: Wiley-Blackwell, pp. 200–19.
Wesselius, J. W. (1984), 'An Aramaic note concerning the rent on royal domains (Saqqara 31)', *Bibliotheca Orientalis* 41, 704–7.
Wessetzky, V. (1991), 'Fragen zum Verhalten der mit Persern zusammenarbeitenden Ägypter', *Göttinger Miszellen* 124, 83–9.
Whitcomb, D. S. (1987), 'Bushire and the Angali canal', *Mesopotamia* 22, 311–36.
Wijnsma, U. (2018), 'The worst revolt of the Bisitun crisis: a chronological reconstruction of the Egyptian revolt under Petubastis IV', *Journal of Near Eastern Studies* 77, 157–73.
Wildung, D. (1977), *Egyptian Saints: Deification in Pharaonic Egypt*, New York: New York University Press.
Wilkins, J. (2013), 'Le banquet royal perse vu par les Grecs', in C. Grandjean, C. Hugoniot and B. Lion (ed.), *Le banquet du monarque dans le monde antique: table des hommes*, Rennes and Tours: Presses universitaires de Rennes and Presses universitaires François-Rabelais de Tours, pp. 162–72.
Wilkinson, C. K. (1955), 'Assyrian and Persian art', *Metropolitan Museum of Art Bulletin* 13, 213–24.
Wilkinson, T. J. and Rayne, L. (2010), 'Hydraulic landscapes and imperial power in the Near East', *Water History* 2, 115–44.
Will, É. (1960), 'Chabrias et les finances de Tachôs', *Revue des études anciennes* 62, 254–75.
Willeitner, J. (2003), *Die ägyptischen Oasen: Städte, Tempel und Gräber in der libyschen Wüste*, Mainz: Philipp von Zabern.
Wilson, A. (2006), 'The spread of foggara-based irrigation in the ancient Sahara', in D. Mattingly, S. McLaren, E. Savage, Y. al-Fasatwi and K. Gadgood (ed.), *The Libyan Desert: Natural Resources and Cultural Heritage*, London: Society for Libyan Studies, pp. 205–16.
Winckelmann, G. (1783), *Storia della arti del disegno presso gli antichi*, Vol. 1, Rome: Stamperia Pagliarini.
Winlock, H. E. (1909), 'The Egyptian Expedition', *Metropolitan Museum of Art Bulletin* 4 (1909), 199–203.
Winlock, H. E. (1936), *Ed Dākhleh Oasis: Journal of a Camel Trip Made in 1908*, New York: Metropolitan Museum of Art.
Winlock, H. E. (1941), *The Temple of Hibis in El Khārgeh Oasis, Vol. 1: The Excavations*, New York: Metropolitan Museum of Art.
Winnicki, J. K. (1994), 'Carrying off and bringing home the statues of the gods: on an aspect of the religious policy of the Ptolemies towards the Egyptians', *Journal of Juristic Papyrology* 24, 149–90.
Winnicki, J. K. (2006), 'Der libysche Stamm der Bakaler im pharaonischen, persischen und ptolemäischen Ägypten', *Ancient Society* 36, 135–42.

Wiseman, M. E. (1999), 'Kharga Oasis, prehistoric sites', in K. A. Bard (ed.), *Encyclopedia of the Archaeology of Ancient Egypt*, London: Routledge, pp. 408–11.
Wittfogel, K. A. (1957), *Oriental Despotism: A Comparative Study of Total Power*, New Haven: Yale University Press.
Wojciechowska, A. (2016), *From Amyrtaeus to Ptolemy: Egypt in the Fourth Century B.C.*, Wiesbaden: Harrassowitz.
Worp, K. A. (2012), *A New Survey of Greek, Coptic, Demotic and Latin* Tabulae *Preserved from Classical Antiquity*, Cologne: Trismegistos.
Wu, X. (2014), '"Oh young man ... make known what kind you are": warfare, history, and elite ideology in the Achaemenid Persian Empire', *Iranica Antiqua* 49, 209–99.
Wuttmann, M. (2001), 'Les qanāts de 'Ayn-Manâwîr (oasis de Kharga, Égypte)', in P. Briant (ed.), *Irrigation et drainage dans l'antiquité: qanāts et canalisations souterraines en Iran, en Égypte et en Grèce*, Paris: Thotm éditions, pp. 109–36.
Wuttmann, M., Barakat, H., Bousquet, B., Chauveau, M., Gonon, T., Marchand, S., Robin, M. and Schweitzer, A. (1998), ''Ayn Manāwīr (oasis de Kharga): deuxième rapport préliminaire', *Bulletin de l'Institut français d'archéologie orientale* 98, 367–462.
Wuttmann, M., Bousquet, B., Chauveau, M., Dils, P., Marchand, S., Schweitzer, A. and Volay, L. (1996), 'Premier rapport préliminaire des travaux sur le site de 'Ayn Manāwīr (oasis de Kharga)', *Bulletin de l'Institut français d'archéologie orientale* 96, 385–451.
Wuttmann, M., Coulon, L. and Gombert, F. (2007), 'An assemblage of bronze statuettes in a cult context: the temple of 'Ayn Manâwîr', in M. Hill and D. Schorsch (ed.), *Gifts for the Gods: Images from Egyptian Temples*, New York: Metropolitan Museum of Art, pp. 167–73.
Wuttmann, M., Gonon, T. and Thiers, C. (2000), 'The qanats of 'Ayn-Manâwîr, Kharga Oasis, Egypt', in *Proceedings of the International Symposium on Qanat, Yazd, Iran, May 8–11, 2000, Vol. 4*, Yazd: Islamic Republic of Iran, Ministry of Energy, pp. 162–9.
Wuttmann, M. and Marchand, S. (2005), 'Égypte', in P. Briant and R. Boucharlat (ed.), *L'archéologie dans l'empire achéménide: nouvelles recherches*, Paris: De Boccard, pp. 97–128.
Yamauchi, E. (1996), 'Cambyses in Egypt', in J. E. Coleson and V. H. Matthews (ed.), *'Go to the Land I Will Show You': Studies in Honor of Dwight W. Young*, Winona Lake, IN: Eisenbrauns, pp. 371–92.
Yardeni, A. (1994), 'Maritime trade and royal accountancy in an erased customs account from 475 B.C.E. on the Aḥiqar scroll from Elephantine', *Bulletin of the American Schools of Oriental Research* 293, 67–78.
Yoyotte, J. (1972), 'Pétoubastis III', *Revue d'Égyptologie* 24, 216–23.
Yoyotte, J. (1989), 'Le nom égyptien du "ministre de l'économie": de Saïs à Méroé', *Comptes rendus des séances de l'Academie des Inscriptions et Belles-Lettres*, 73–90.

Yoyette, J. (2013), 'The Egyptian statue of Darius', in J. Perrot (ed.), *The Palace of Darius at Susa: The Great Royal Residence of Achaemenid Persia*, London: I. B. Tauris, pp. 240–79.

Zadok, R. (1986), 'On some Iranian names in Aramaic documents from Egypt', *Indo-Iranian Journal* 29, 41–4.

Ziegler, C. (ed.) (2013), *Les tombes hypogées de Basse Époque*, Leuven: Peeters.

Zivie, A. and Lichtenberg, R. (2005), 'The cats of the goddess Bastet', in S. Ikram (ed.), *Divine Creatures: Animal Mummies in Ancient Egypt*, Cairo: American University in Cairo Press, pp. 106–19.

Zivie, C. M. (1982), 'Memphis', in W. Helck and E. Otto (ed.), *Lexikon der Ägyptologie, Vol. 4*, Wiesbaden: Harrassowitz, 24–41.

Zivie-Coche, C. M. (1991), *Giza au premier millénaire: autor du temple d'Isis, dame des Pyramides*, Boston: Museum of Fine Arts.

Zivie-Coche, C. (2008), 'Late Period temples', in W. Wendrich (ed.), *UCLA Encyclopedia of Egyptology*, <https://escholarship.org/uc/item/30k472wh> (accessed 13 July 2017).

Zournatzi, A. (2000), 'The processing of gold and silver tax in the Achaemenid Empire: Herodotus 3.96.2 and the archaeological realities', *Studia Iranica* 29, 241–71.

Index

Abu Ballas trail, 97, 107
Abusir, 24, 29, 34–6, 81, 84–8, 92–3, 251
Abydos, 122, 142
Acanthus, 198
Achaemenid bowls, 25–6, 128–9, 202–5, 210–16, 257
Aelian, 248
Aeschylus, 3, 7
Ahiram, 69
Ain Amur, 109
Ain Boreq, 102
Ain Gib, 102
Ain Lebeka, 102
Ain Manawir, 25, 99, 101–3, 106, 107, 108, 109–12, 126, 128–9, 215, 222, 239
Ain Tirghi, 129, 215
Ain Ziyada, 102
Akhmim, 127
Akkadian, 71, 104, 157–8
Alexander the Great, 2, 75, 192, 194, 208, 228, 231, 241, 242, 247, 249, 256
Alexander IV of Macedon, 248
Alexandria, 150, 224
Altıntepe, 74
al-'Ula Oasis (Arabia), 106
Amarna, 69
Amasis, 8, 44, 47, 60, 62, 64–7, 71, 76, 78, 82, 87, 106, 124, 146, 148, 165, 181, 183, 184
Amduat, 97
Amenhotep I, 62
Amenhotep III, 139
Amheida, 98, 99, 123–4
Amun, 113, 114, 117–18, 122, 126–7, 148
Amyrtaios, 1, 246–7
Anatolia, 3, 104, 204, 224, 243, 246

Anubis, 37, 89, 162, 169
Apep (demon), 119
Apep (Hyksos king), 99
Apis, 8–9, 37, 74–81, 250, 251
 Mother of, 37–8, 78
Apries, 38, 40, 60, 62, 65, 82–3, 146
 Palace of, 31–2, 38–74, 86–7, 92, 140, 251
Arabian Peninsula, 13, 14, 106, 159–61, 252
Arabs, Kedarite, 206–7, 211, 216
Aramaic, 5, 26, 31, 36, 44, 48–9, 51–3, 63, 71, 81–2, 83, 84, 89–90, 163–4, 206–7, 211, 217, 229, 233, 235–6, 242, 244, 246–7
Arcesilas III, 213
Aristotle, 7
 ps.-Aristotle, 231
Armant, 127
Armenia, 3, 74, 204
Arshama, 1, 13, 52–3, 57, 58, 63, 207
Arslan Tash, 69
artaba, 48, 232
Artaxerxes I, 1, 78, 194–5
Artaxerxes II, 44, 246
Artaxerxes III, 1n, 26, 198, 222, 241–2, 248–50, 256
Artystone *see* Irtashduna
Aryandes, 213, 232–4
Ashdod, 47
Asia Minor *see* Anatolia
Assiut, 127, 225
 Assiut hoard, 224, 225, 234
Assmann, Jan, 9, 23
Assyria, Assyrians, 69, 104, 196–7
Aston, David, 4
Astyages, 197
Athenaeus, 191–3, 198

Athens, Athenians, 3, 208–9, 212–13, 221, 228, 230, 235, 236, 238–9, 246
Athribis, 224, 225, 237
Attica *see* Athens
Atum, 153, 156, 174, 182

Babylon, 34n, 226, 229
Bacchylides, 228
Bactra, Bactria, 13, 15, 52
Bagoas, 248
Bahariya Oasis, 97, 99, 105
Bahr el Libeini *see* Phchet
Bahrain, 204
Bakenrenef, 83, 86
Balat, 98
Banishment Stela, 98
Barca, 67, 213, 221
Bastet, 37
Beadnell, H. J. Llewellyn, 101, 103, 108
Beni Hasan, 225
Berlin Leather Roll, 124–5
Bes vases, 218–19
Black Sea, 224, 228
Book of the Dead, 86, 169, 171, 173
Bosse, Käthe, 134, 151
Bothmer, Bernard, 134–5, 139, 144–5
Bourdieu, Pierre, 5, 189
Braudel, Fernand, 19–20
Briant, Pierre, 16
Bubastis, 248
bullion, 222–3, 225–6, 235
Bushehr Peninsula, 15
Buto, 214, 248–9
Byblos, 69, 252

Cailliaud, Frédéric, 101
Cambyses, 1, 8–10, 13, 17, 27–8, 44, 76–7, 95, 99, 123, 124, 162, 181, 183–4, 184–5, 207, 213, 214, 231, 232, 245, 248
Campbell's Tomb, 82–3, 176
canal of Darius (Red Sea), 13–15, 21, 153, 158–62, 207, 251–2
Canopus, 150, 208
Carian, Carians, 36, 71, 170–1
Carter, Howard, 175
cartouches, 38–40, 43, 44, 60, 64–6, 72, 85, 99, 113, 116, 123–4, 141, 142, 149, 155–6, 159, 163
Chad Basin, 97
charismatic authority, 23, 30, 70, 74, 91, 94, 149, 158, 176, 215–16

Cilicia, 69
Clearchus of Soli, 192
Cleomenes of Naukratis, 208, 231
Coffin Texts, 86
coins, coinage, 26, 80, 128, 195–6, 207, 221–2, 223–6, 232–45, 251
'collaborators', 17, 139–40, 180–1, 183
Colonel Sanders, 184
Coptic Cambyses Romance, 9
Coptos, 127
court robe, Persian, 65, 67, 140–1, 143, 157, 159, 170, 178, 216
Ctesias, 7, 246
cultural memory, 21, 23, 24, 28, 29, 38, 64, 71, 74, 86, 94, 95, 174, 187–8, 253, 255
Cyprus, 204, 217, 224
Cyrenaica, Cyrene, 212–13, 221, 224
Cyrus, 7, 197, 200
Cyrus the Younger, 246

Dadanitic, 106
Dakhla Oasis, 24–5, 95–101, 109, 123–4, 126–30, 215, 251
Damanhur, 224, 225
Damietta, 224
Daphnae *see* Tell Dafana
Darb al Arbein, 97
Darb Rayayna, 127
Darius I, 1, 7, 10, 13, 14, 17, 21, 60, 62, 75, 78, 79, 93, 113, 115–16, 117–18, 119, 120–1, 122, 123–4, 125–6, 140–1, 153–67, 178, 181, 183, 184, 188, 199, 226, 227, 232–3, 252, 254
Darius II, 78, 80, 115–16, 130, 242, 246
Darius III, 192, 256
Daskyleion, 57, 58, 62, 63, 66
Deh Luran, 105
Deir el-Medina, 222
Delta *see* Nile Delta
(ps.-) Demosthenes, 230
Demotic, 5, 25, 26, 44, 49, 51–3, 81, 83, 89–90, 99, 103, 107, 111, 112, 126, 127–8, 169, 223, 231, 235–6, 242, 244, 246–7
Demotic Chronicle (verso), 231, 245
Demus, 198–9
Deve Hüyük, 47, 204–5, 218
Dikura, 102
Diodorus Siculus, 194, 228, 248, 249–50
Djedherbes, 16, 89, 167–71, 216–18

Djoser, Pyramid of, 21, 35, 36, 37, 38
Dra Abu Naga *see* Thebes
drinking practices, 25–6, 170, 189–220
Dur-Katlimmu, 69
Dush, 102, 112

Eastern Desert, 227
Ecbatana, 12, 194–5, 226
Edfu, 123
Elam, Elamite, Elamites, 13, 48, 53, 57, 71, 105, 136–8, 157–8, 181
Elephantine, 49, 50, 52, 57, 71, 90, 126, 128, 217, 222, 231, 233, 235, 240, 245, 247
Elkab, 130
Erebuni, 204
Erzincan, 196
ethno-classe dominante, 16–17

Farafa Oasis, 97
Fayum, 107–8, 122, 166, 224, 236–7, 238
Fea, Carlo, 151

Gandhara, 204
Garamantes, 106–7
Geb, 113, 127
Georgia, 204
Ghuweida *see* Qasr el-Ghuweida
Gilf Kebir, 97
Giza, 82–3, 176, 177, 224
Goody, Jack, 190
Gordion, 63, 69–70
Great Harris Papyrus, 105
Greek, Greeks, 2, 3, 7–8, 11, 26, 27, 36, 44, 47, 64, 71, 84, 149, 191–3, 195–6, 198–9, 223–5, 228–30, 234
Gudea, 136

Hacksilber see bullion
Hadrian's Villa, 149, 150–1
Hakoris, 214
Hamadan *see* Ecbatana
Hanilat, 206–7, 211, 212
Harwa, 182
Hathor, 85, 124
Hecataeus of Miletus, 251
Heliopolis, 29, 122, 150, 214
Helms, Mary, 23
Helwan, 29
Heraclides of Cyme, 191
Herakleion-Thonis, 213, 215, 230, 239
Herakleopolis, 122

Hermopolis *see* Tuna el-Gebel
Herodotus, 1, 3, 8–9, 14, 15, 45–8, 81, 95, 173, 183–5, 191, 192, 198, 200–1, 213, 221, 226, 228, 232–3, 251
Heryshaf, 223
Herzfeld, Ernst, 194–6
Heyerdahl, Thor, 14
Hibis temple, 114–23, 126–7
Hierakonpolis, 139
Hippocratic corpus, 7
Hopkins, Keith, 245
Horus, 20, 37, 110, 117, 165, 166
Horwedja, 17, 25, 175–6, 179, 252–3
House of Life (Sais), 125, 181, 184, 252
houses, 31–2
Hyksos, 99, 120

identity, 21–4, 131–90, 204, 216, 219–20, 254–5
Inarus, 99
Irtashduna, 57, 199
Isis, 112, 113, 149, 151, 162, 169, 170
Ismailiya, 158, 224
Italy, 133, 149–51

Jerome, 221
John of Nikiu, 9

Kabret, 158–9, 161
Kainu (Kedarite king), 206, 207, 211, 216
Kamose, 99
Karanis, 236
Karatepe, 69
Karnak, 148, 151, 214, 215
Khababash, 50, 248, 249
Kharga Oasis, 24–5, 95–103, 109–23, 126–30, 215, 250
Khendjer, 83
Khnemibre, 17, 231
Khnum, 126
Khons, 110, 113, 117, 122
Khorsabad, 69, 197
Kom el-Qala, 31, 40
Kom Ombo, 122
Kom Tuman *see* Apries, Palace of
Kufra Oasis, 97
Kush, Kusites, 30, 99, 165, 181, 211, 227
Kysis *see* Dush

Lachish, 217
Late Period, 2
Laureion, 235, 238–9
Leontopolis, 122
Levant, 13, 53, 69, 106, 181, 217, 224, 227, 229, 230
Libya, 97, 106–7, 121–2
longue durée, 20, 28, 250
lotuses, 68–70, 170
Lycia, 198
Lydia, 223
Lysias, 198–9

maat, 20, 250
Maat (goddess), 113, 177–8
Macedonia, 224, 228
Manetho, 1–2, 246
Masistius, 173
Mattingly, David, 18
Mazaces, 26, 222, 242–3
Media, Medes, 197
Memphis, 13, 21, 24, 27–34, 38–81, 92–3, 96, 122, 150, 175, 185, 188, 214, 217, 223, 224, 253–4
Merenptah, 31–2, 40
Merimutef, 127
Mesopotamia, 14, 15, 53, 55, 56, 69, 104–5, 108, 136–9, 157–8, 218, 226, 244
Min, 113, 118, 127
Mit Rahina, 30–1, 75, 88, 185
Mut, 113, 117, 122, 124, 126, 165
Mut el-Kharab, 98

Nakhthor, 53
names, 89–92
naoi, 111, 162–6, 174, 254
naophorous statues, 149, 174–87
Napir-Asu, 138
Naqš-e Rustam, 155, 157
Naukratis, 2, 224, 225, 229–30
Naxos (Sicily), 238
Necho, 60, 62
Necho II, 76, 124, 146, 238
Nectanebo I, 115, 205, 229–30, 240–1, 245, 247
Nectanebo II, 79–80, 115, 205, 240–1, 245, 247
Neferhotep, 124
Neferirkara, Pyramid of, 36
Negev, 106
Neith, 122–3, 184
Nekhen, 122
Nephthys, 124, 169, 170

Nereid Monument, 198
Nile, 13, 20, 21, 24, 29, 30, 31, 95, 96, 97, 107, 159, 222, 252
 Delta, 2, 13, 27, 31, 47, 122, 127, 153, 205, 206, 207, 208, 212, 213, 217, 224, 225, 230, 240, 245
Nimrud, 69
Nineveh, 69
Nubia, Nubians *see* Kush, Kushites
Nut, 113, 127, 165

Olympia, 69
Oman, 104–5
orientalism, 6–8, 133
Osiris, 86, 101, 107, 110–11, 112, 117, 124, 149, 169, 182, 186

Palestine, 47, 204, 209, 217, 229, 231
Papyrus Pushkin, 127, 98, 128
Papyrus Reinhardt, 107, 230–1
Parmenion, 192–3
Parnakka, 63
Pasargadae, 46
Peloponnesian War, 239
Pelousion, 213, 230, 248
Periplus Maris Erythraei, 14
Persepolis, 12, 13, 15, 23, 28, 34n, 46–7, 48, 53, 56, 62, 64–5, 66, 67, 68, 72, 89, 136, 138, 140, 155, 157, 170, 193, 196–7, 226, 252
 Apadana, 26, 47, 89, 129, 136–7, 138, 140, 170, 172, 178, 202–4, 215, 216, 252
 Fortification Archive, 15, 48, 49, 52, 53, 56–7, 58, 62, 63, 64, 66, 67, 68, 93, 191, 192, 196, 197–8, 199–200, 201–2, 254
 Treasury, 59, 64, 65, 68, 137, 203
 Treasury Archive, 59, 62, 64, 68
'Persian gesture', 136–40
'Persian garment', 140–3, 170, 178, 186
Persian Gulf, 13–15
Persian, Old, 61–2, 71, 157–8, 194–6
Persian Wars, 1, 7, 45–6, 47, 48, 173, 191, 192, 198, 224
Petiese, Petition of, 10, 148
Petosiris, tomb of, 219–20, 256–7
Petubaste IV, 99, 124, 165
Phchet, 31, 32, 34, 37
Pherendates, 126, 232
phialai, 25–6, 193–6, 205–8, 215–16, 219–20, 257
Philae, 122

Phoenicia, Phoenicians, 14, 36, 49, 69, 85, 171, 217, 229, 235, 243
Piraeus, 238
Pithom *see* Tell el-Maskhuta
Plutarch, 248
Polyaenus, 191–2
Polybius, 104
'Pompeii premise', 146
Pope, Arthur Upham, 196
Posener, Georges, 5, 181–2
priests, 20, 75, 111, 124, 175
Psammetichus I, 146, 213
Psammetichus II, 61, 62, 64, 85, 116, 124, 146, 162
Psammetichus III, 27, 146, 181, 183, 184
Ptah, 27, 31, 37, 60, 62, 74–5, 81, 86, 91, 175, 177–8, 223, 239
Ptahhotep, 17, 25, 83, 176–9, 252, 255
Ptolemy I, 248–9
Ptolemy X, 80
Pyramid Texts, 86

qanat, 24, 96, 100–9, 126, 251
Qasr el-Ghuweida, 98, 112–13, 121, 127
Qasr el-Sumayra, 102
Qasr el-Zayyan, 109

Ramesses III, 105
Ramesses X, 60, 62
Raneferef, Pyramid of, 36
Re, 110, 113, 118, 165
realism in sculpture, 143–4
Red Sea, 13–15, 158, 227
Rhind Mathematical Papyrus, 48
Rhodes, 230
rhyta, 25–6, 193, 196–8, 201, 208–10, 215–16, 219–20, 257
roads, 12–13, 97, 107, 127
Rome, Romans, 18, 71, 133, 148–51
Root, Margaret, 10–11, 132

Sabaces, 26, 222, 242–3
Sacred Animal Necropolis *see* Saqqara
Sahure, Pyramid of, 30
Said, Edward, 6–7, 18
Sais, 122–3, 125, 150, 181, 182, 184–5, 237
Sakhmet, 177–8
Samaria, 69
Sancisi-Weerdenburg, Heleen, 7–8, 11, 15–16, 178
Saqqara, 8, 21, 24, 28, 29, 30, 34–8, 49, 81–3, 85–6, 89–93, 169, 176, 216, 250, 251
Serapeum, 8, 37, 75, 78, 82, 136
Sardis, 13, 63
Sargon II, 104, 197
satrap of Egypt, 1, 10, 13, 24, 28, 41, 44, 45, 49, 52, 59, 81, 93, 125, 126, 150, 165–6, 170, 175, 199–200, 207–8, 211, 212, 215–16, 221, 227, 231, 233, 240, 243, 244–5, 250, 253
Satrap Stela, 248–50
scarabs, 59–62
Schiffer, Michael, 147
sculpture, 4, 25, 41–3, 73, 132–3, 146–52, 153–62, 166–87, 248–9
Scylax of Caryanda, 14–15
Scythians, 75
seals, sealings, 50, 52, 53–71, 74, 196, 197–8, 199, 201–2, 214
Sebennytos, 122
Second Persian Period, 240–3, 247–50, 256–7
Sed festival, 42
Sen, Amartya, 255
senti, 17, 175, 252
Senusret I, 125
Senusret III, 144
Serapeum *see* Saqqara
Serapis, 149, 151
Sesostris, 75
Seth, 119–20
Sety I, 60, 62
Shu, 174
Sicily, 224, 239
Sidon, 217, 243
sigha-pots, 127
Sinai Peninsula, 13
Sinope, 224
Siwa Oasis, 95, 97
statues *see* sculpture
Strabo, 76, 96, 194, 221, 228
Susa, 12, 13, 15, 28, 47, 68, 69, 122, 130, 138, 140, 153–5, 158, 159–61, 193–4, 226
Suwa, 208–9, 210, 224, 225
Syria, 69, 170, 249

Tachos, 205, 241, 245
Taoce, 15
Tell Basta, 212
Tell Dafana, 213, 215
Tell el-Herr, 213–14, 218–19
Tell el-Ḥesi, 209

Tell el-Maskhuta, 153, 158–60, 206–7, 211, 212, 216, 224, 225, 238
Tell Ghazza, 217
Tell Kedwa, 214
Tell Timai, 205–6, 210–11, 212
temples, 74–81, 108–27, 230–1, 239–40, 244–5
tetradrachms *see* coins
Thebes, 98, 126–7, 211–12, 214, 223, 240
Thmuis *see* Tell Timai
Thoth, 37, 60, 62, 124, 164, 219, 256
Thrace, 224, 228
Thucydides, 3
Thutmose I, 214
Til Barsip, 69
Tivoli *see* Hadrian's Villa
Tjeku *see* Tell el-Maskhuta
tombs, 34–6, 38, 81–8, 219–20, 256–7
tribute, 26, 221, 226–32, 240
Tuna el-Gebel, 163–6, 219–20, 254, 256–7
Tyrian camp (Memphis), 33, 47, 49

Udjahorresnet, 17, 36, 82, 83–7, 93, 122–3, 125–6, 150–1, 178, 179–87, 199, 252
Umm el-Dabadib, 102–3, 108

Umm Mawagir, 98
Unas, Pyramid of, 36, 38, 83
'Uniting of the Two Lands', 117–18, 155, 159
Upton, Joseph, 196
Urartu, Urartians, 67, 104

Vani, 204
verism, 144
von Bissing, F. W., 88, 171

Wadi el-Gemel, 101
Wadi Hammamat, 92
Wadi Tumilat, 13
Wenamun, Report of, 252
Western Desert, 21, 24, 25, 95–130, 215, 251
Winckelmann, Johann Joachim, 151
wine, 217–18
Wittfogel, Karl, 107–8

Xanthos *see* Nereid Monument
Xenophon, 7, 191, 192, 197, 200, 235, 246
Xerxes, 78, 192–3, 198, 203, 249
Xois, 224, 225

Zagazig *see* Suwa

EU representative:
Easy Access System Europe
Mustamäe tee 50, 10621 Tallinn, Estonia
Gpsr.requests@easproject.com

www.ingramcontent.com/pod-product-compliance
Lightning Source LLC
Chambersburg PA
CBHW071827230426
43672CB00013B/2781